MODERN LATIN
AMERICAN ART

Book Illustration and Decoration: A Guide to Research
Compiled by Vito J. Brenni

American Ceramics Before 1930: A Bibliography
Compiled by Ruth Irwin Weidner

MODERN LATIN AMERICAN ART

A Bibliography

Compiled by James A. Findlay

Art Reference Collection, Number 3

Greenwood Press
Westport, Connecticut • London, England

Partial funding for this project was provided by The National
Endowment for the Humanities.

Library of Congress Cataloging in Publication Data

Findlay, James A.
 Modern Latin American art.

 (Art reference collection, ISSN 0193-6867 ; no. 3)
 Bibliography: p.
 Includes index.
 1. Art, Latin American—Bibliography. 2. Art, Modern—
20th century—Latin America—Bibliography. I. Title.
II. Series.
Z5961.L3F56 1983 [N6502.5] 016.7'098 83-10743
ISBN 0-313-23757-3 (lib. bdg.)

Library of Congress Catalog Card Number: 83-10743
ISBN: 0-313-23757-3
ISSN: 0193-6867

First published in 1983

Greenwood Press
A division of Congressional Information Service, Inc.
88 Post Road West, Westport, Connecticut 06881

Printed in the United States of America

10 9 8 7 6 5 4 3 2 1

CONTENTS

CONTENTS

ACKNOWLEDGMENTS

That The International Council, The International Program, and The Library of The Museum of Modern Art, New York City, along with The National Endowment for the Humanities, had the foresight to fund this bibliography is indicative of the increasing importance attached to the field of Latin American modern art.

The Library of The Museum of Modern Art, New York City, is perhaps the finest repository in the United States of printed material on the modern art of Latin America. Therefore, the content of this bibliography strongly reflects its collection, although sources from many additional collections are also included. To the staff of The Library of The Museum of Modern Art, I would like to formally acknowledge my indebtedness: Daniel Starr, senior cataloger; David Wanger, cataloger; Daniel Pearl, periodicals librarian and indexer; and particularly former reference librarian, Janette Rozene, for her constant professional and collegial support and genuine friendship during periods of difficulty and discouragement.

To Waldo Rasmussen, director, and Elizabeth Streibert, assistant director of The International Program, and to Carol Coffin, administrator of The International Council of The Museum of Modern Art, I also wish to express my profound gratefulness. Their tenacious dedication to the preparation and dissemination of this bibliography nourished my own resolve to see the project to fruition.

In addition, I would like also to extend my gratitude to the staffs of the libraries and museums of modern art, both in the United States and Latin America, for their grandly generous help and encouragement.

To the staff of the Composing Room of *The Providence Journal-Bulletin,* Providence, Rhode Island, and Mr. Ray Oakley, who over the course of ten months interpreted to me patiently the complexities of the automated typesetting system, I am respectfully appreciative.

Finally, I would like to thank my family and friends for the sustaining support of love and friendship which has made it all worthwhile.

SCOPE

Art historians and other researchers have long expressed regret at the lack of a comprehensive general bibliography of modern Latin American art. It is the intent of this volume, therefore, to document systematically the growing body of literature, including exhibition catalogs, of modern Latin American art history.

The entries cover the history of twentieth-century Latin American art, and include, when appropriate, the transitional period of the late nineteenth century. Since modern art reference volumes for most Latin American countries do not exist, monographs and exhibition catalogs are emphasized. Latin American art periodical *titles* are also included, but citations to individual articles are not. Monographs on individual artists and references to periodical articles have been omitted, since they can generally be found through the use of bibliographies, handbooks, histories, and other works that make up this and other bibliographies, or through the catalogs of academic, museum, or large public libraries.

ARRANGEMENT

The bibliography is arranged first by broad geographic area: LATIN AMERICA, CARIBBEAN, AND CENTRAL AMERICA, and then by country: ARGENTINA, BARBADOS, etc. Within each geographic area or country, subarrangement is by subject: ARGENTINA—GENERAL, BRAZIL—ARCHITECTURE, etc. Each subject is further subdivided by type of material: ARGENTINA—GENERAL—DICTIONARIES, ETC., BRAZIL—ARCHITECTURE—BIBLIOGRAPHIES, etc.

Each bibliographic entry *may* contain the following elements: AUTHOR (personal or corporate), TITLE, SUBTITLE (including exhibition dates, etc.), PLACE OF PUBLICATION, PUBLISHER, DATE OF PUBLICATION, NUMBER OF PAGES, AND NOTES. For example:

Buenos Aires (Argentina). Museo Nacional de Bellas Artes. *Pintura argentina actual; dos tendencias, geometria, surrealismo.* Buenos Aires, 1976. 34 p.

Catalog of an exhibition held Sept.-Oct., 1976

In cases where the museum or other corporate author is the author as well as the publisher, the publisher's statement is not repeated.

Museums are entered under the name of the city in which they are located: BOGOTA (COLOMBIA). MUSEO DE ARTE MODERNO. Private galleries are entered under the most important segment of the name: BENZACAR, RUTH, GALERIA (BUENOS AIRES, ARGENTINA). Foundations, salons, and private art organizations are entered directly: FUNDACION NEWMANN (CARACAS, VENEZUELA), and SALON SWIFT (BUENOS AIRES, ARGENTINA). Numerous cross-references may be found in the index.

Spanish compound names are entered under the *first* surname: GARCIA CANCLINI, NESTOR. Cross-references from the final surname are found in the index. Portuguese names are entered under the *final* surname: TELLES, AUGUSTO CARLOS DA SILVA.

MODERN LATIN AMERICAN ART

Latin America

1. Acha, Juan. *Arte y sociedad; Latinoamérica; sistemas de producción.* Mexico City, Mexico: Fondo de Cultura Económica, 1979. 323 p.

2. Amherst (Massachusetts). University of Massachusetts. University Art Gallery. *Tropic of Cancer, Tropic of Capricorn; contemporary Latin American art; {exhibition}, February 21 to March 25, 1973.* Amherst, 1973. 48 p.

 Text by Jacqueline Barnitz.

3. Angulo Iñíguez, Diego. *Historia del arte hispano-americano.* Barcelona, Spain: Salvat, 1950- . 3 v.

4. Ann Arbor (Michigan). University of Michigan. Institute of Latin American Studies. *Catalogue of a loan exhibition of Latin American pre-Columbian art, shown at the Horace H. Rackham School of Graduate Studies, Ann Arbor, {Michigan}.* Ann Arbor, 1939.

 Exhibition, July 7-25, 1939.

5. Antwerp (Belgium). International Cultureel Centrum. *Kunstsystemen in Latinjns-Amerika, 1974, van 25 April tot en met 19 Mei, 1974.* Antwerp, 1974.

 Sponsored by the Centro de Arte y Comunicación, Buenos Aires, Argentina.

6. Art News Annual (18th). *Art of the Americas; from before Columbus to the present day; a pictorial survey by the Art News Annual.* New York, N.Y.: The Art Foundation, 1948. 132 p.

7. Austin (Texas). University of Texas. Art Museum. *12 Latin American artists today = 12 artistas latinoamericanos de hoy; {exhibition, Sept. 28-Nov. 2, 1975}.* Mexico City, Mexico: Plural, c1975. 46 p.

8. Bayón, Damián. *Adventures in modern Hispano-American art; painting, kinetic and action arts.* Austin, 1973. 2 v.

 This English edition lacks a table of contents, an index, a bibliography and illustrations.

9. Bayón, Damián. *América Latina en sus artes.* Mexico City, Mexico: Siglo Veintiuno Editores, 1974. 237 p.

 Bibliography; English edition, see number 13.

10. Bayón, Damián. *El arte de ruptura.* Mexico City, Mexico, 1973.

11. Bayón, Damián. *El artista latinoamericano y sus identidad.* Caracas, Venezuela: Monte Avila, 1977. 150 p.

 Bibliography: p. 49-50; partial transcription of a conference on contemporary Latin American art held at the University of Texas, Austin, Texas, October 27-29, 1975.

12. Bayón, Damián. *Aventura plástica de Hispanoamérica; pintura cinetismo, artes de la acción, 1940-1972.* la. ed. Mexico City, Mexico: Fondo de Cultura Económica, 1974.

 Also published in English.

13. Bayón, Damián. *Latin America in its arts.* New York, N.Y.: Holmes & Meier, 1980. ca. 250 p.

 Translation from Spanish; Spanish edition, see number 9.

14. Bayón, Damián. *Qué es la crítica de arte.* Buenos Aires, Argentina, 1970.

15. Bedoya, Jorge M., and Gil, Noemi A. *El arte en América Latina.* Buenos Aires, Argentina: Centro Editor de América, 1973. 156 p.

 Bibliography.

16. Berkeley (California). University of California. Art Museum. *The fifth sun; contemporary/traditional Chicano & Latino art; {exhibition, October 12-November20,1977}.* Berkeley, c1977. {46} p.

17. Bienal Americana de Arte (1st : 1962 : Córdoba, Argentina). *Bienal Americana de Arte, 1962- .* Córdoba, 1962- .

18. Bienal Americana de Arte (1st : 1962 : Córdoba, Argentina). *BAA, Primera Bienal Americana de Arte, Córdoba-Buenos Aires.* Córdoba, {1962}. {80} p.

 Catalog of an exhibition held at the Museo Provincial de Bellas Artes Emilio A. Caraffa, Córdoba, Argentina, June 26, 1962, and at the Museo de Arte Moderno, Buenos Aires, Argentina, August 1, 1962.

19. Bienal Americana de Arte (2nd : 1964 : Córdoba, Argentina). *BAA, II Bienal Americana de Arte.* {1a. ed.} Córdoba, 1964. {164} p., 32 slides.

 Exhibition held at the Universidad Nacional de Córdoba, Argentina, Sept. 25-Oct. 12, 1964.

20. Bienal Americana de Arte (2nd : 1964 : Córdoba, Argentina). *BAA, II Bienal Americana de Arte.* 2a. ed. Córdoba, 1964.

 Exhibition held at the Universidad Nacional de Córdoba, Argentina, Sept. 25-Oct. 12, 1964.

21. Bienal Americana de Arte (2nd : 1964 : Córdoba, Argentina). *BAA, II Bienal Americana de Arte; 20 South American artists; a selection.* Córdoba, {1964?}. {24} p., 32 slides (col.).

 Exhibition catalog.

22. Bienal Americana de Arte (3rd : 1966 : Córdoba, Argentina). *III Bienal Americana de Arte; diapositivas de los premios adjudicados y una obra de cada artista...* Córdoba, {1966}. 90 slides (col.).

23. Bienal Americana de Arte (3rd : 1966 : Córdoba, Argentina). *III Bienal Americana de Arte.* Córdoba, 1966. {156} p.

 Exhibition held at the Universidad Nacional de Córdoba, Argentina, October 1966.

24. Bienal Hispanoamericana de Arte (1st : 1951 : Madrid, Spain). *Bienal Hispanoamericana de Arte, 1951- .* Madrid, 1951- .

25. Bienal Hispanoamericana de Arte (1st : 1951 : Madrid, Spain). *Primera Bienal Hispanoamericana de Arte; catálogo.* Madrid, Spain, 1951. 253 p.

26. Bienal Interamericana de México (2nd : 1960 : Mexico City, Mexico). *Segunda Bienal Interamericana de México.* Mexico City, Mexico, 1960. unpaged.

27. Bienal Internacional del Deporte en las Artes Plásticas (1st : 1981 : Montevideo, Uruguay). *Bienal Internacional del Deporte en las Artes Plásticas, 1981- .* Montevideo: Museo Nacional de Artes Plásticas, 1981- .

28. Bienal Latino Americana de São Paulo (1st : 1978 : São Paulo, Brazil). *Bienal Latino Americana de São Paulo, 1978- .* São Paulo, 1978- .

29. Bienal Latino Americana de São Paulo (1st : 1978 : São Paulo, Brazil). *I Bienal Latino Americana de São Paulo; {exposição}, 3 de novembro de 1978.* São Paulo, 1978. 139 p.

30. Biennale de Paris (10th : Paris, France). *Amerique Latine: 10 Biennale de Paris; {exposition}.* Paris, {1977}. 32 p.

 Text in French, English and Spanish, by Angel Kalenberg.

31. Bignami, Ariel. *Arte, ideologia y sociedad.* Buenos Aires, Argentina: Ediciones Silaba, 1973. 109 p.

32. Bogotá (Colombia). Museo Nacional. *Universidad Nacional de Colombia, Escuela de Bellas Artes, presenta desde el 7 hasta el 17 de febrero de 1949 en el Museo Nacional, Bogotá, 32 artistas de las Américas.* Bogotá: Universidad Nacional, 1949. 12 p.

 Organized by the Pan American Union, Washington, D.C.

33. Boston Vistual Artists Union (Boston, Massachusetts). *Artists in exile; an exhibition of artists of the Americas.* Boston, 1977? 16 p.

34. Caracas (Venezuela). Galería de Arte National. *El paisaje libérrimo: {exposición}, del 2 al 31 de agosto de 1981: José Antonio Quintero, Carlos Hernández Guerra, Galaor Carbonell, Ana Mercedes Hoyos.* Caracas, 1981. 32 p.

35. Caracas (Venezuela). Museo de Bellas Artes. *Arte figurativo en América Latino.* Caracas, 1979. 4 p.

 Typescript.

36. Carpani, Ricardo. *Arte y revolución en América Latina.* Buenos Aires, Argentina: Ediciones Coyoacán, 1960. 79 p.

37. Carpani, Ricardo. *La política en el arte.* Buenos Aires, Argentina: Editorial Coyoacán, 1962. 63 p.

38. Castedo, Leopoldo. *Historia del arte y de la arquitectura latinoamericana.* Mexico City, Mexico; Santiago, Chile, 1970.

✓39. Castedo, Leopoldo. *A history of Latin American art and architecture from pre-Columbian times to the present.* New York, N.Y.: Praeger, {1969}. 320 p.

> Bibliography: p. 297-299; translated from Spanish by Phyllis Freeman.

40. Catlin, Stanton Loomis. *Artists of the Western Hemisphere; precursors of modernism, 1860-1930.* New York, N.Y.? Interbook, 1967.

41. Celorio, Gonzalo. *El surrealismo y lo real maravilloso americano.* Mexico City, Mexico: Secretaría de Educación Pública, 1976. 175 p.

> Bibliography

42. Center for Inter-American Relations (New York, N.Y.). *Latin America; new paintings and sculpture; Juan Downey, Agustín Fernández, Gego, Gabriel Morera, {exhibition}, November 20, 1969 to January 18, 1970.* New York, c1969. 20 p.

43. Center for Inter-American Relations (New York, N.Y.). *Modern Latin American paintings, drawings and sculpture; exhibition, September 27 through October 8, 1979.* New York, 1979. 16 p.

> Typescript checklist.

44. Centro de Arte y Comunicación (Buenos Aires, Argentina). *Arte e ideología; CAYC al aire libre: arte de sistemas II, participación Argentina, {exposición, setiembre 1972?}.* Buenos Aires, 1972? 70 p.

45. Centro de Arte y Comunicación (Buenos Aires, Argentina). *Hacia un perfil del arte latinoamericano, {exposición, 13 al 25 de octubre de 1972}.* Buenos Aires, 1972. 6 p.

> Exhibition held at the Museo Emilio A. Caraffa, Córdoba, Argentina.

46. Charlot, Jean. *Art-making from Mexico to China.* New York, N.Y.: Sheed and Ward, 1950.

47. Chase, Gilbert. *Contemporary art in Latin America; painting, graphic art, sculpture, architecture.* New York, N.Y.: The Free Press, 1970. 292 p.

> Bibliography: p. 275-279.

48. Chicago (Illinois.) Art Institute. *The United States collects Pan American art.* Chicago, c1959. {49} p.

 Catalog of an exhibition of contemporary Canadian and Latin American art, July 22-Sept. 7, 1959.

49. Coloquio Latinoamericano sobre Arte No Objetual (1st : 1980 : Medellín, Colombia). *{Papers presented at the Primer Coloquio Latinoamericano sobre Arte No Objetual}.* Medellín, Colombia, May 1981. 19 pieces.

 Organized by the Museo de Arte Moderno de Medellín, Colombia.

50. Conference on Latin American Fine Artes (1951 : Austin, Texas).*Proceedings of the Conference on Latin American Fine Arts, June 14-17, 1951, co-sponsored by the College of Fine Arts and the Institute of Latin-American Studies, The University of Texas.* Austin: University of Texas Press, 1952. 132 p.

51. Congreso Iberoamericano de Critícos de Arte y Artistas Plásticos (1st : 1978 : Buenos Aires, Argentina). *Primer Congreso Iberoamericano de Critícos de Arte y Artistas Plásticos; Museo de Bellas Artes; aproximación metodológica para una comprensión de la retórica del arte latinoamericano.* Buenos Aires, 1978. 47 p.

 Text by Jorge Glusberg.

52. *The Connisseur.* London, England: National Magazine Co., 1975. 92 p.

 Special South American art issue, May 1975.

53. Contreras y López de Ayala, Juan. *Historia de arte hispánico.* Barcelona, Spain: Salvat, 1945. (v. 4). 684 p.

 Bibliography.

54. Dallas (Texas). Museum of Fine Arts. *South American art today.* Dallas, 1959. {59} p.

 Catalog of an exhibition held October 10-November 29, 1959.

55. Damaz, Paul E. *Art in Latin American architecture.* New York, N.Y.: Reinhold, c1963. 232 p.

 Bibliography.

56. *Dos encuentros; Encuentro de artistas plásticas del Cono Sur (Chile); Encuentro de plástica latinoamericana (Cuba).* Santiago, Chile: Andrés Bello, 1973. 40 p.

57. Encuentro Iberoamericano de Críticos de Arte y Artistas Plásticos (1st : 1978 : Caracas, Venezuela). *Encuentro Iberoamericano de Críticos de Arte y Artistas Plásticos, 1978- . Caracas, 1978- .

58. Encuentro Iberoamericano de Críticos de Arte y Artistas Plásticos (1st : 1978 : Caracas, Venezuela). *Arte iberoamericano de hoy; {exposición, 18 de junio al 16 de julio 1978}.* Caracas: Consejo Nacional de la Cultura, 1978. 90 p.

59. Esso Salon of Young Artists = Salón Esso de Artistas Jovenes (1965 : Washington, D.C.). *Esso Salon of Young Artists = Salón Esso de Artistas Jovenes: {exhibition, April 21, 1965}.* Washington, D.C.: Pan American Union, 1965. 68 p.

60. Fernández, Justino. *El retablo de los reyes; estética del arte de la Nueva España.* Mexico City, Mexico: Instituto de Investigaciones Estéticas, 1959. 389 p.

61. Flushing (New York). Queens College. Godwin-Ternbach Museum. *Latin American artists in the U.S. before 1950; {exhibition}, April 28-May 14, 1981.* Flushing, 1981. 36 p.

 Text by Jaqueline Barnitz.

62. García Canclini, Néstor. *Arte popular y sociedad en América Latina; teorias estéticas y ensayos de transformación.* Mexico City, Mexico: Grijalbo, 1977. 287 p.

63. Geo, Charles. *Art baroque en Amérique Latine.* Paris, France: Editorial d'Histoire de d'Art, Librairie Plon, 1954.

64. Glusberg, Jorge. *La retórica del arte latinoamericano.* Buenos Aires, Argentina: Editorial Nueva Visión, 1979?

65. Gómez Sicre, José. *4 artists of the Americas; Roberto Burle-Marx, Alexander Calder, Amelia Peláez, Rufino Tamayo.* Washington, D.C.: Pan American Union, 1957. 98 p.

66. Gómez Sicre, José. *New names in Latin American art.* Washington, D.C.: Smithsonian Institution, 1966. {16} p.

 Painting, sculpture, drawings and prints selected by Gómez Sicre and circulated by the Smithsonian Institution Travelling Exhibition Service.

67. Guido, Angel. *América frente a Europa en el arte.* Santa Fé, Argentina: Imprenta de la Universidad Nacional del Litoral, 1936. 19 p.

68. Guido, Angel. *Redescubrimiento de América en el arte.* Rosario, Argentina: Universidad Nacional del Litoral, 1941. 359 p.

 Revised edition, Buenos Aires, Argentina: El Ateneo, 1944. 769 p.

69. Havana (Cuba). Casa de las Américas. *Enceuntro de plástica latinoamericana; {exposición}, octubre 1973.* Havana, 1973.

70. Havana (Cuba). Casa de las Américas. Galería Latinoamericana. *Exposición de plástica latinoamericana, desde mayo 30 de 1972.* Havana, 1972. 10 p.

71. Havana (Cuba). Casa de las Américas. Galería Latinoamericana. *Plástica latinoamericana en homenaje al Uruguay en lucha, {exposición}, desde enero 14 de 1977.* Havana, 1977.

72. Herbert, David, Gallery (New York, N.Y.). *Spanish and Latin-American artists; {exhibition}, February 1-March 31, 1961.* New York, 1961. 16 p.

73. IBM. *Arte contemporáneo del Hemisferio Occidental.* New York, N.Y.? 1941.

 English edition, see number 75.

74. IBM. *Contemporary art of 79 countries.* New York, N.Y., 1939?

 Exhibition held at the New York World's Fair, New York, N.Y., 1939. Each Latin American republic is represented by one work of art.

75. IBM. *Contemporary art of the Western Hemisphere.* New York, N.Y.? 1941. ca. 200 p.

 Spanish edition, see number 73.

76. International Conference on Computers in the Humanities (1975 : Minneapolis, Minnesota). *Arte y computadoras en Latinoamerica = Art and computers in Latin America, {July 1973}.* Buenos Aires, Argentina: CAYC, 1973. 34 p.

 Organized by the Centro de Arte y Comunicación, Buenos Aires, Argentina.

77. International Congress of the History of Art (20th : 1963 : Princeton, New Jersey). *Acts; studies in Western art; v. 3, Latin American art and the baroque period in Europe.* Princeton, N.J.: Princeton University Press, 1963. 229 p.

78. International Institute of Communications (1977 : Washington, D.C.). Annual Conference. *Rhetoric of art and technology in Latin America; September 11-15, 1977, Washington, D.C.* Buenos Aires, Argentina: CAYC, 1977. 16 p.

 Text by Jorge Glusberg.

79. *Journal; Southern California Art Magazine.* Los Angeles, California: Los Angeles Institute of Contemporary Art, 1979.

 Special issue: Art in Latin America; text in English and Spanish; November-December 1979, no. 25.

80. Juan, Adelaida de. *Encuentro Chile Cuba.* Santiago, Chile: Andrés-Bello, 1973. 32 p.

81. Kelemen, Pal. *Vanishing art of the Americas.* New York, N.Y.: Walker, 1977. 232 p.

 Colonial Latin American art.

82. Knoedler Galleries (New York, N.Y.). *An exhibition of paintings and drawings of Latin America.* New York, 1947.

83. Kusch, Rodolfo. *Anotaciones para una estética de lo americano.* Buenos Aires, Argentina, 1955.

 Offprint of the magazine Comentario, Buenos Aires, Argentina, no. 9.

84. La Jolla (California). Art Center. *20th century Latin American naive art; {exhibition}, March 15 through April 22, 1964.* La Jolla, 1964. 24 p.

85. *Lateinamerikanische Kunst der Gegenwart.* Germany? Information Centers Branch, Office of the Land Commissioner for Wuerttemberg-Baden, {1951?}. 28 p.

 Exhibition catalog.

86. London (England). Institute of Contemporary Art. *Art systems in Latin America; {exhibition, December 1974}.* London, 1974. 84 p.

 Also exhibited at Espace Pierre Cardin, Paris, France, February-March 1975; text in English and Spanish.

87. London (England). Institute of Contemporary Art. *Latin American week in London, November 28th-December 6th, 1974.* London, 1974. 18 p.

 Organized by the Centro de Arte y Comunicación, Buenos Aires, Argentina.

88. Lyceum y Lawn Tennis Club (Havana, Cuba). *El Lyceum y Lawn Tennis Club, La Habana, presenta desde el 30 agosto hasta el 12 de septiembre de 1949, 33 artistas de las Américas.* Washington, D.C.: Pan American Union, 1949. 12 p.

89. Macy's (New York, N.Y.). *Macy's Latin American fair.* New York, N.Y., 1942. 2 parts.

90. Madrid (Spain). Instituto de Cultura Hispánica. *Arte actual de Iberoamerica; exposición presentada por el Instituto de Cultura Hispánica en el Centro Cultural de la Ville de Madrid.* Madrid: Ediciones Cultura Hispánica, 1977. 148 p.

 Catalog of an exhibition held at the Centro Cultural de la Ville de Madrid, Spain, May 15-Sept. 15, 1977.

91. Marco Dorta, Enrique. *Fuentes para la historia del arte hispano-americano; estudios y documentos.* Seville, Spain: Escuela de Estudios Hispano-Americanos, Instituto Diego Velázquez, Sección de Seville, 1951.

92. Mena Villamar, Claudio. *Trazos.* Quito, Ecuador: La Unión, 1964. 98 p.

 Four unillustrated essays on art.

93. Mexico City (Mexico). Museo de Arte Moderno. *Creadores latino-americanos contemporáneos, 1950-1976; pintura y relieves; {exposición}, octubre/noviembre 1976.* Mexico City, 1976. 84 p.

94. Mexico City (Mexico). Universidad Nacional Autónoma de México. Museo Universitario de Ciencias y Arte. *Arte conceptual frente a los problemas latinoamericanos; {exposición}, enero-febrero de 1974.* Mexico City, 1974. 72 p.

95. Miller, Louise Fenton. *A tourist sees art in South America.* Caldwell, Idaho: Caxton, 1941. 100 p.

96. Morais, Federico. *Artes plásticas no América Latina; do transe ao transitório.* Rio de Janeiro, Brazil: Civilização Brasileira, 1979. 214 p.

 Bibliography: p. 211-214.

97. *Naifs del Brasile = Naifs de Haiti; presentati nella Spoleto de Festival dei Due Mondi dall'Instituto Italo Latino Americano, Spoleto, 28 Giugno-12 Luglio 1970: catalogo.* Venice, Italy: Alfieri, 1970. ca. 60 p.

98. New Haven (Connecticut). Yale University. *Intellectual backgrounds of artistic evolution in Latin America; 18 essays presented at Symposium held March 2-5, 1966, Yale University.* New Haven: Yale University, Council on Latin American Studies, 1966.

 Typescript.

99. New Haven (Connecticut). Yale University. Art Gallery. *Art of Latin America since Independence.* {Rev. ed.}. New Haven: Yale University Art Gallery; Austin, Texas: University of Texas Art Museum, 1966. 246 p.

 Bibliography: p. 205-207; text by Stanton Loomis Catlin and Terence Greider; catalog of an exhibition organized by the Yale University Art Gallery and the University of Texas Art Museum and shown at Yale University Art Museum, Jan. 27-Mar. 13, 1966. Also shown at the University of Texas Art Museum, April 17-May 15, 1966; at the San Francisco Museum of Art, July 2-Aug. 7, 1966; at the La Jolla Museum of Art, La Jolla, California, Aug. 27-Sept. 30, 1966; and at the Isaac Delgado Museum of Art, New Orleans, Louisana, Oct. 29-Nov. 27, 1966.

100. New York (N.Y.). Metropolitan Museum of Art. *Spanish American painters and sculptors; {exhibition, October 5-November 1, 1976}.* New York, 1976. 17 p.

101. New York (N.Y.). Museo del Barrio. *Resurgimiento; Museo del Barrio, abril 1978; {a collective exhibition of Latin American artists living in New York}.* New York, 1978. 39 p.

102. New York (N.Y.). Museum of Modern Art. *American sources of modern art; {exhibition}, May 10 to June 30, 1933.* New York, 1933. 50 p.

 Bibliography: p. 23-28; also published under the title: Aztec, Incan and Mayan art.

103. New York (N.Y.). Riverside Museum. *Latin American exhibition of fine and applied art—sponsored by the United States New York World's Fair Commission—June 2 to September 17, 1939.* New York, 1939.

104. New York (N.Y.). Riverside Museum. *Latin American exhibition of fine arts, sponsored by the United States New York World's Fair Commission, July 23 to October 20, 1940.* New York, 1940. 53 p.

105. New York University. Loeb Student Center. *Contemporary Latinoamericano art exhibit; {Mexico, Colombia, Rep. Dominicana, Argentina, Peru, Puerto Rico, Cuba}, Sept. 18-Oct. 5, 1972.* New York, 1972. 16 p.

106. Noble-Polans Gallery (New York, N.Y.). *Inaugural Group show, January 31, 1978; {Latin American art today.}* New York, 1978. 24 p.

107. Noé, Luis Felipe. *El arte de América Latina es la revolución.* Santiago, Chile: Andrés Bello, 1973. 33 p.

108. Noel, Martín S. *Palabras en acción, apologías y temas de historia, arte, y urbanismo.* Buenos Aires, Argentina: Peuser, n.d. 253 p.

109. Oglesby, Catharine. *Modern primitive arts of Mexico, Guatemala, and the Southwest.* New York, N.Y.: Wittlesey House, 1939. 226 p.

110. Omaha (Nebraska). Joslyn Art Museum. *Spain; major exhibitions for 1962.* Omaha, 1962. 29 p.

 Includes works by 27 Latin American artists.

111. Osborn, Elodie Courter. *Study book: exhibitions of contemporary Latin American art.* New York, N.Y., n.d. {4}, 194, {5}, 93 leaves.

 Typescript; reference copy of Miss Elodie Courter Osborn; record of contents of two volume Study Book, furnished with each exhibition of contemporary Latin American art. Prepared by the San Francisco Museum of Art for the Office of the Coordinator of Inter-American Affairs. Circulated by The Museum of Modern Art, New York, in the East and Middle West, by The San Francisco Museum of Art, Civic Center, San Francisco, California.

112. Oslo (Norway). Kunstnernes Hus. *Latin Amerika i Skandinavia; {utstillingen}, 16 Januar-7. Februar 1971.* Oslo, 1971. 31 p.

 Text in Norwegian and French.

113. Pan American Union (Washington, D.C.). *Art in Latin America.* Washington, D.C., 1950. 91 p.

 Bibliography: p. 86-91.

114. Pan American Union (Washington, D.C.). *Art in Latin America today.* Washington, D.C., 1959.

115. Pan American Union (Washington, D.C.). *Highlights of Latin American art.* Washington, D.C., 1955. {2} p., 24 plates.

116. Pan American Union (Washington, D.C.). *Literature-art-music.* Washington, D.C., 1942. 3 v. in 1.

117. Pan American Union (Washington, D.C.). *Primitive artists of the Americas, in celebration of Pan American Week, 1963, {April 15th through 28th, 1963; exhibition}.* Washington, D.C., 1963. 12 p.

118. Pan American Union (Washington, D.C.). *La Unión Panamericana al servicio de las artes visuales en América.* Washington, D.C., 196-?.

119. Pan American Union (Washington, D.C.). Division of Intellectual Cooperation. *Contemporary art in Latin America.* Washington, D.C., n.d. 14 p.

120. Pan American Union (Washington, D.C.). Division of Intellectual Cooperation. *Contemporary artists in Latin America.* Washington, D.C., 1945. 14 p.

121. Paris (France). Hôtel de Ville de Paris. *Jeunes artistes latino américains.* Paris, 1981. 72 p.

 Catalog of an exhibition, March 10-April 13, 1981.

122. Paris (France). Maison de l'Amérique Latine. *Ars americana; Argentine, Chile, Uruguay; peintures, art populaire, photos; {exposition}, 18 oct.-5 nov., 1946.* Paris, 1946. 44 p.

123. Paris (France). Musée d'Art Moderne de la Ville de Paris. *Totems et tabous; Lam, Matta, Penalba, dans une installation improvisée par Pierre Faucheux; {exposition}, Musée... 25 avril-10 juin 1968.* Paris, 1968. 1 v.

 Bibliography.

124. Ponce (Puerto Rico). Museo de Arte de Ponce. *15 artistas de Argetina, Bolivia, Brasil, Chile, Colombia, Perú, Puerto Rico, República Dominicana...* Ponce, {1981}. {16} p.

 Exhibition held June 4-July 20, 1981.

125. Pontual, Roberto. *América Latina; geometrica sensível.* Rio de Janeiro, Brazil: Edições Jornal do Brasil/GBM, 1978. 235 p.

 Issued to accompany exhibition 'Arte agora III/América Latina: geometrica sensível,' shown at the Museu de Arte Moderna, Rio de Janeiro, Brazil, June 8-July 22, 1978.

126. Premio Internacional Instituto Torcuato Di Tella (1st? : 1965 : Buenos Aires, Argentina). *Premio Internacional Instituto Torcuato Di Tella, 1965- . Buenos Aires, 1965- .*

127. Premio Internacional Instituto Torcuato Di Tella (1967 : Buenos Aires, Argentina). *Premio Internacional Instituto Torcuato Di Tella, 1967: {exposición}, 29 de setiembre-29 de octubre de 1967.* Buenos Aires, c1967. 50 p.

128. Rodríguez Prampolini, Ida. *Dada y América Latina: Primer Encuentro Iberoamericano de Críticos de Arte y Artistas Plásticos.* n.p., 1978. 10 leaves.

 Typescript.

129. Romero Brest, Jorge. *Política artistico-visual en Latinoamérica.* Buenos Aires, Argentina: Crisis, 1974.

130. Salón de Artistas Jovenes de Latinoamerica (1st : 1964 : Caracas, Venezuela). *Primer Salón de Artistas Jovenes de Latinoamerica; {exposición}, diciembre 1964.* Caracas: Museo de Bellas Artes, 1964. 14 p.

131. Santiago (Chile). Museo Nacional de Bellas Artes. *Exposición de obras de 32 artistas de las Americas...30 de mayo al 14 de junio de 1949.* Santiago, 1949. 8 p.

 Organized by the Pan American Union, Washington, D.C.

132. Santiago (Chile). Universidad de Chile. *Catálogo de la exposición de arte populares americanas; realizada con motivo del primer centenario de la Universidad de Chile.* Santiago, 1943.

 Exhibition held at the Museo de Bellas Artes, Santiago, Chile, April-May, 1943.

133. São Paulo (Brazil). Universidade de São Paulo. Museu de Arte Contemporânea. *Poéticas visuais, {exposição, 29 de setembro a 30 de outubro de 1977.}* São Paulo, 1977. 60 p.

 Text in Portuguese and English; exhibition of concrete poetry, artists' books, etc.

134. Sarastoa (Florida). John and Mable Ringling Museum of Art. *Latin American horizons, 1976.* {Sarasota, 1976.} {36} p.

 Catalog of an exhibition held April 8-May 16, 1976.

135. Simposium Latinoamericano (1st? : 1977 : Buenos Aires, Argentina). *Simposium Latinoamericano, 1977- . Buenos Aires: Asociación Argentina de Críticos de Arte, 1977- .

136. Solá. Miguel. *Historia del arte hispano-americano.* Barcelona, Spain: Talleres Gráficos Ibero-Americanos, 1935. 2 v.

137. Torres-García, Joaquín. *Universalismo constructivo; contribución a la unificación del arte y la cultura de América, 253 dibujos y 3 citocromías, obras del autor.* Buenos Aires, Argentina: Poseidón, 1944. 1011 p.

138. Traba, Marta. *Dos décadas vulnerables en las artes plásticas latinoamericanos, 1950-1970.* la. ed. Mexico City, Mexico: Siglo Veintiuno, 1973. 179 p.

139. Traba, Marta. *El museo vacio; un ensayo sobre el arte moderno.* Bogotá, Colombia, 1958.

140. Trabia-Morris Gallery (New York, N.Y.). *Art of the Americas; {exhibition}, October 16th to November 10th, 1962...* New York, 1962. 16 p.

141. Trenton (New Jersey). New Jersey State Museum. *Panorama of contemporary Latin American artists = Panorama de artistas latinoamericanos contemporáneos.* {Trenton: New Jersey State Council on the Arts, 1975}. 60 p.

 Bibliography; catalog of an exhibition held at the New Jersey State Museum, Trenton, New Jersey, Sept. 5-Oct. 27, 1975, and at four other New Jersey museums.

142. Trienal de Arte Coltejer (1st : 1975 : Medellín, Colombia). *Trienal de Arte Coltejer, 1975- .* Medellín, Colombia, 1975- .

 Title varies: Trienal de Arte de Medellín.

143. UNESCO. *The arts of Latin America; Unesco travelling exhibition.* Paris, France, c1977. 116 p.

144. Washington (D.D.). Museum of Modern Art of Latin America. *Hispanic-American artists of the United States; Argentina, Bolivia, Chile, Cuba, Uruguay; {exhibition}, November 7-December 7, 1978.* Washington, D.C., 1978. 8 p.

145. Washington (D.C.). National Collection of Fine Arts. *Raíces y visiones = Roots and visions; {exhibition, July 9-October 2, 1977}.* Washington, D.C., 1977? 16 p.

146. Washington (D.C.). National Gallery of Art. *Report of the Inter-American Office, National Gallery of Art, January 1944-May 1946.* Washington, D.C.: U.S. Government Printing Office, 1946. 14 p.

 Description of recent Latin American art exhibitions.

147. Washington (D.C.). National Gallery of Art. Inter-American Office. *Traveling exhibitions of Latin American art; a list of titles and sources of exhibitions now available for circulation in the United States.* Washington, D.C., {1946}. 15 p.

148. Wilder, Elizabeth, editor. *Studies in Latin American art; proceedings of a Conference held in The Museum of Modern Art, 28-31 May 1945, under the auspices of the Joint Committee on Latin American Studies of the American Council of Learned Societies, The National Research Council, and The Social Science Research Council.* Washington, D.C.: The American Council of Learned Societies, 1949. 106 p.

LATIN AMERICA—GENERAL—BIBLIOGRAPHIES

149. *Anuário Plástico, 1938-* . Buenos Aires, Argentina: Taller Gráfica de Iglesias y Matera, 1938- .

 Annual summary of exhibitions held in Argentina, Bolivia, Chile and Uruguay.

150. *Bibliografía de arte español y americano.* v. 1 (1936/40)- . Madrid, Spain: Gráficas Uguina, 1942- .

151. Findlay, James A. *A selected bibliography on modern Latin American art.* New York, N.Y., 1981. 47 leaves.

 Typescript; available from ARLIS/NA {Art Libraries Society of North America}.

152. Grieder, Terence, and Berry, Charles. *Bibliography of Latin American philosophy and art since Independence.* Austin, Texas: University of Texas, Institute of Latin American Studies, 1964. 116 p.

 Typescript; some items are annotated.

153. *Handbook of Latin American Studies.* Cambridge, Massachusetts: Harvard University Press; Gainesville, Florida: University of Florida Press, 1936- .

154. Kupfer, Monica E. *A bibliography of contemporary art in Latin America: books, articles and exhibition catalogs in the Tulane University Library, 1950-1980.* New Orleans, Louisana, c1981. 74 leaves.

 Masters thesis, Tulane University, New Orleans, Louisana, 1981.

155. Lassalle, Emilie Sansten, and Beust, Nora. *Arts, crafts, and customs of our neighbor republics; a bibliography.* Washington, D.C.: Coordinator of Inter-American Affairs, 1942. {85} p.

 Typescript.

156. Mexico City (Mexico). Biblioteca Benjamín Franklin. *Libros y revistas sobre arte y arquitectura existentes en nuestro archivo, enero de 1944.* Mexico City, 1944. 21 p.

157. Montignani, John B. *Books on Latin America and its art in the Metropolitan Museum of Art Library.* New York, N.Y.: Metropolitan Museum of Art, 1943. 63 p.

 A classified list of 350 volumes on art of all periods in Latin America.

158. New York (N.Y.). Museum of Modern Art. Library. *Catalog of the Library of The Museum of Modern Art, New York City, New York, 1976.* Boston, Massachusetts: G.K. Hall, 1976. 14 v.

 V. 14; Latin American Archives, p. 553-771.

159. Smith, Robert Chester, and Wilder, Elizabeth. *A guide to the art of Latin America.* Washington, D.C.: U.S. Government Printing Office, 1948. 480 p.

 Classified and annotated bibliography of a selected list of books and periodical articles on Latin American art published before 1943.

160. U.S. Library of Congress. Hispanic Foundation. *The fine and folk arts of the other American republics; a bibliography of publications in English.* Washington, D.C.: Library of Congress, 1942. 18 p.

 Prepared by The Archive of Hispanic Culture, Hispanic Foundation, Library of Congress, for the Division of Inter-American Activities of the United States Office of the Coordinator of Inter-American Affairs.

161. Austin (Texas). University of Texas. University Art Museum. *University of Texas Art Museum, Latin American component, Art of The Americas Collection.* Austin, {1978?}. 26 leaves.

 Typescript.

162. Caracas (Venezuela). Museo de Bellas Artes. *Catálogo general; colección pintura y escultura latinoamericana.* Caracas, 1979. 345 p.

 Bibliography: p. 341-345.

163. Center for Inter-American Relations (New York, N.Y.). *Latin American paintings and drawings from the Collection of John and Barbara Duncan.* New York, N.Y., {1970}. 32 p.

 Catalog of an exhibition held July 9-August 30, 1970.

164. Center for Inter-American Relations (New York, N.Y.). *Looking south; Latin American art in New York collections.* New York, N.Y., 1972. 58 p.

 Selected by Monroe Wheeler; exhibition held May 16-July 28, 1972.

165. Havana (Cuba). Museo Nacional de Cuba. *Plástica latino americana; colección patrimonio.* Havana: Editorial Orbe, 1978. 45 p.

166. Instituto Cultural Hispánica (Madrid, Spain). *Arte de America y España; catálogo general; {exposición}, mayo-junio 1963.* 2a. ed. Madrid, Spain, 1963. 170 p.

167. Instituto Ibero-Americano (Berlin, West Germany). *Obras de arte en el Instituto Ibero-Americano de Berlin = Kunstwerke im Ibero-Amerikanischen Institut Berlin.* Berlin: Colloquium Verlag {1966}. 43 p.

168. Kirstein, Lincoln. *{Photographs of works by Latin American artists}.* n.p., n.d. 7 v. mounted photos. (part col.).

 Miscellaneous photographs of works assembled by Lincoln Kirstein, ca. 1942, for 'The Latin American Collection of The Museum of Modern Art' exhibition held March 30-June, 1943. Arranged alphabetically by name of artist.

169. New Orleans (Louisana). Isaac Delgado Museum of Art. *The art of ancient and modern Latin America; selections from public and private collections in the United States.* New Orleans, {1968}. unpaged.

 Bibliography; exhibition held May 10-June 16, 1968.

170. New York (N.Y.). Hispanic Society of America. *Catalogue of paintings (19 and 20th centuries) in the collection of the Hispanic Society of America.* New York, 1932. 2 v.

Text by Elizabeth du Gué Trapier.

171. New York (N.Y). Museum of Modern Art. *The Latin-American collection of The Museum of Modern Art.* New York, 1943. 110 p.

Bibliography: p. 104-110; text by Lincoln Kirstein; catalog of an exhibition held March 30-June 1943.

172. Northhampton (Massachusetts). Smith College. Museum of Art. *Latin-American art from the collection: shown as part of 'The Exhibition of the Century—one hundred years of collecting at the Smith College Museum of Art, 1879-1979', September 7-October 14; November 30-December 21, 1979.* Northhampton, {1979?}. 10 leaves.

Mimeographed.

173. Organization of American States (Washington, D.C.). *Tribute to the arts of the Americas; {exhibition, March 15,-April 7, 1974}.* Washington, D.C., {c1974}. {60} p.

Cover title: Art of the Americas in Washington private collections.

174. Providence (Rhode Island). Rhode Island School of Design. Museum of Art. *Nancy Sayles Day Collection of modern Latin American art; {exhibition}, October 23-December 24, 1966.* Providence, 1966. 16 p.

175. Providence (Rhode Island). Rhode Island School of Design. Museum of Art. *Nancy Sayles Day Collection of modern Latin American art; supplementary catalogue; {exhibition}, August-October, 1968.* Providence, 1968. 32 p.

176. Santiago (Chile). Museo de la Solidaridad Chile. *Museo de la Solidaridad Chile: donación de los artistas del mundo al Gobierno Popular de Chile.* Santiago: Instituto de Arte Latinoamericano, Universidad de Chile, 1972. {20} p.

177. Coleman, Laurence Vail. *Directory of museums in South America.* Washington, D.C.: American Association of Museums, 1929. 133 p.

178. *Directory of historians of Latin American art.* San Antonio, Texas: Research Center for the Arts, University of Texas at San Antonio, c1979. 36 p.

> Compiled and edited by Elizabeth H. Boone.

179. *Enciclopedia del arte en América.* {Buenos Aires, Argentina}: Bibliografía OMEBA, c1969. 5 v.

> Contents: v. 1-2, Historia; v. 3-5, Biografías.

180. Hill, Roscoe R. *The National Archives of Latin America.* Cambridge, Massachusetts: Harvard University Press, 1945. 169 p.

> Edited for the Joint Committee on Latin American Studies of the National Research Council, The American Council of Learned Societies and The Social Science Research Council.

181. Naylor, Bernard. *Directory of libraries and special collections on Latin America and the West Indies.* London, England: Published for The Institute of Latin American Studies by Athlone Press, University of London, 1975. 161 p.

182. Pan American Union (Washington, D.C.). *Guía de las colecciones públicas de arte en la América Latina.* Washington, D.C., 1956. 191 p.

> V. l, Región del Golfo de México y del Caribe; directory of 62 public museums in Mexico, Guatemala, El Salvador, Honduras, Nicaragua, Costa Rica, Panama, Colombia, Venezuela, Puerto Rico, Dominican Republic, Haiti and Cuba.

183. Pan American Union (Washington, D.C.). Division of Intellectual Cooperation. *Thirty Latin American artists; biographical notes.* Washington, D.C., {1943}. 15 leaves.

184. Vargas Ugarte, Ruben. *Ensayo de un diccionario de artifices coloniales de la America meridional.* {Lima, Peru?}: Baiocco, 1947. 391 p.

> 16th through 19th century South American artists; *Apendice.* {Lima, Peru?}: Baiocco, 1955. 118 p.

185. Washington (D.C.). Office of Inter-American Affairs. *Preliminary directory of the field of art in the other American republics.* Washington, D.C., 1942. 169 p.

> Guide to museum and other institutions of art; mimeographed.

186. Washington (D.C.). Office of the Coordinator of Inter-American Affairs. *Supplement to the Preliminary directory of the field of art in the other American republics; artists and writers on art.* Washington, D.C., 1942.

Compiled and edited by Mildred Constantine.

LATIN AMERICA—GENERAL—PERIODICALS

187. *Art of the Americas bulletin.* v. 1 (1966)- . Washington, D.C.: Pan American Union, 1966- .

Annual.

188. *Artes hispánicas = Hispanic arts.* v. 1, no. 1-3/4 (Spring/Summer 1967-Winter/Spring 1968). New York, 1966-68.

189. *Boletín de artes visuales.* no. 1 (June 1956-June 1957)- . Washington, D.C.: Pan American Union, 1956- .

Annual?

190. *Boletín música y artes visuales.* no. 1 (March 1950)- . Washington, D.C.: Pan American Union, 1950- .

191. *Buro Interamericano de Arte; boletín.* no. 1 (1951?)- . Mexico City, Mexico, 1951- .

192. *Estudios de arte y estética.* v. 1 (1958)- . Mexico City, Mexico: Instituto de Investigaciones Estéticas, Universidad Nacional Autónoma de México, 1958- .

193. Christie, Manson & Woods International (New York, N.Y.). *19th and 20th century Latin American paintings, drawings and sculpture.* New York, 1981. 121 p.

Auction catalog, Dec. 1, 1981.

194. Sotheby Parke Bernet (New York, N.Y.). *Pre-Columbian art and colonial paintings of Latin America.* New York, 1979.

Auction catalog, May 12, 1979.

195. Sotheby Parke Bernet (New York, N.Y.). *Modern Latin American paintings, drawings, and sculpture.* New York, 1979.

Auction catalog, October 17, 1979.

196. Sotheby Parke Bernet (New York, N.Y.). *19th and 20th century Latin American paintings, drawings, sculpture and prints.* New York, 1980. {150} p.

Auction catalog, November 6-7, 1980.

197. Sotheby Parke Bernet (New York, N.Y.). *Haitian and Latin American paintings and drawings.* New York, 1980.

Auction catalog, December 20, 1980

198. Sotheby Parke Bernet (New York, N.Y.). *19th and 20th century Latin American paintings, sculpture, prints.* New York, 1981.

Auction catalog, May 7-9, 1981.

199. Sotheby Parke Bernet (New York, N.Y.). *Haitian and Latin American paintings, drawings, and prints.* New York, 1981.

Auction catalog, July 9, 1981.

200. Sotheby Parke Bernet (New York, N.Y.). *18th, 19th and 20th century Latin American paintings, drawings, sculpture and prints.* New York, 1981. ca. 200 p.

Auction catalog, Dec. 2-3, 1981.

201. Sotheby Parke Bernet (New York, N.Y.). *Modern, Latin American and contemporary paintings, drawings and sculpture.* New York, 1981. ca. 50 p.

Auction catalog, Dec. 12, 1981; Sale number 4759M.

202. Bayón, Damián. *The changing shape of Latin American architecture: conversations with ten leading architects.* Chichester, New York: J. Wiley, c1979. 254 p.

 Translated from Spanish.

203. Bayón, Damián. *Panorámica de la arquitectura latino-americana.* la. ed. Barcelona, Spain; Paris, France: UNESCO, 1977. 215 p.

 English edition also published.

204. Bienal de São Paulo (11th : 1972). *Escolas de arquitetura no XI Bienal.* São Paulo, Brazil: Fundação Bienal de São Paulo, 1972. 94 p.

205. Bullrich, Francisco. *New directions in Latin American architecture.* New York, N.Y.: Braziller, 1969. 128 p.

 Bibliography: p. 121-122.

206. Congreso Panamericano de Arquitectos (3rd : 1927 : Buenos Aires, Argentina). *III Congreso Panamericano de Arquitectos: actas y trabajos.* Buenos Aires, 1927. 492 p.

207. Fry, Edwin Maxwell, and Drew, Jane. *Tropical architecture in the humid zone.* New York, N.Y.: Reinhold, 1956. 320 p.

 A section treats South America.

208. Gasparini, Graziano. *América; barroco y arquitectura.* Caracas, Venezuela: Ernesto Armitano Editor, 1972. 528 p.

209. Ino, Yuichi, editor. *World's contemporary architecture.* Tokyo, Japan: Shokokusha Publishing Co., 1953-54. 12 v.

 v. 11, Latin America.

210. Lo Celso, Angel T. *Sentido espiritual de la arquitectura en América.* Córdoba, Argentina: Universidad Nacional de Córdoba, 1948. 89 p.

211. Neutra, Richad. *Architecture of social concern in regions of mild climate.* São Paulo, Brazil: Gerth Todtmann, 1948. 221 p.

212. New York (N.Y.). Museum of Modern Art. *Latin American architecture since 1945.* New York, 1955. 203 p.

 Catalog of an exhibition held Nov. 23, 1955-Feb. 19, 1956; text by Henry Russell Hitchcock.

LATIN AMERICA—ARCHITECTURE

213. Stockholm (Sweden). *Ibero-Amerikarska arkitektur utetällningen.* Stockholm, 1946?

 Catalog of an exhibition, May 4-19, 1946?

214. Testa, Clorindo. *Hacia una arquitectura topológica.* Buenos Aires, Argentina: Espacio Editora, 1977. 80 p.

 Partial text by Jorge Glusberg.

215. UNESCO. *América Latina en su arquitectura.* la. ed. Mexico City, Mexico: Siglo Veintiuno; Paris, France: UNESCO, 1975. 317 p.

 Bibliography: p. 301-313; edited by Roberto Serge.

216. UNESCO. *Latin America in its architecture.* New York, N.Y.: Holmes & Meier, 1980. ca. 200 p.

 Translated from Spanish by Edith Grossman.

217. Volich, Francis. *Cities of Latin America.* New York, N.Y.: Reinhold, 1944.

LATIN AMERICA—ARCHITECTURE—DICTIONARIES, ETC.

218. Sartoris, Alberto. *Encyclopédie de l'architecture nouvelle-ordre et climat américain.* Milan, Italy: Ulrico Hoepli, 1954.

LATIN AMERICA—COSTUMES AND NATIVE DRESS

219. Halouze, Edouard. *Costumes of South America.* New York, N.Y.: French & European, 1941. 2 v.

220. Annual Latin American Print Show (15th : 1969 : New York, N.Y.).
*15th Annual Latin American Print Show, January 7-31, 1969, Zegrí
Gallery.* New York: Zegrí Gallery, {1969}. 6 leaves.

221. Bienal Americana de Artes Gráficas (1st : 1971 : Cali, Colombia).
*Primera Bienal Americana de Artes Gráficas: dibujo, grabado, diseño
gráfico; {exposición}, Museo La Tertulia, julio y agosto 1971.* Cali,
Colombia, 1971. 250 p.

 Sponsored by Cartón de Colombia.

222. Bienal Americana de Grabado (1st : 1963 : Santiago, Chile). *1a. Bienal
Americana de Grabado: {exposición, 20 de noviembre de 1963}.*
Santiago, Chile: Universidad de Chile, Museo de Arte Contemporáneo,
1963. 94 p.

223. Bienal Americana de Grabado (3rd : 1968 : Santiago, Chile). *III Bienal
Americana de Grabado.* Santiago, Chile, 1968. 32 p.

 English version.

224. Bienal de San Juan del Grabado Latinoamericano (1st : 1970 : San
Juan, Puerto Rico). *Bienal de San Juan del Grabado Latinoamericano;
catálogo general.* San Juan, Puerto Rico, 1970- .

225. Bienal Latinoamericana de Grabado = Latin American Graphic Arts
Biennial (1st : 1980 : New York, N.Y.). *Primera Bienal Latinoameri-
cana de Grabado = First Latin American Graphic Arts Biennial, April-
May 24, 1980.* New York: Cayman Gallery, 1980. {35} p.

226. Cali (Colombia.). Museo de Arte Moderna La Tertulia. *Exposición
panamericana de artes gráficas; noviembre-diciembre 1970.* Cali, 1970.
182 p.

227. Caracas (Venezuela). Museo de Bellas Artes. *34 estampadores latino-
americanos; {exposición}.* Caracas, 1971. 22 p.

228. Caracas (Venezuela). Museo de Bellas Artes. *21 estampadores de
Colombia, México y Venezuela; {exposición, noviembre 1972}.* Caracas,
1972. 16 p.

229. Caracas (Venezuela). Universidad Central de Venezuela. *Exposición
latinoamericana de dibujo y grabado.* Caracas, 1967. 64 p.

 Catalog of an exhibition, Nov. 19-Dec. 19, 1967.

230. Cartón de Colombia (Bogotá, Colombia). *Grabados '73; serie internacional.* Bogotá, Colombia, 1973? 26 p.

Works by 31 artists from eight Latin American countries.

231. Cartón de Venezuela (Caracas, Venezuela). *35 estampadores de Brasil, Chile, Colombia, Ecuador, Estados Unidos, Guatemala, Holanda, Italia, México, Perú, Puerto Rico, Venezuela.* Caracas, 1974? 24 p.

232. Cartón y Papel de México (Mexico City, Mexico). *AGPA; actualidad gráfica, panorama artístico; {exposición, noviembre al 8 de diciembre de 1978}.* Mexico City, 1978. 42 p.

233. Círculo Femenino Boliviano de Cultura Hispánica (La Paz, Bolivia). *Concurso hispanoamericano femenino de grabado y dibujo; exposición, Universidad Mayor de San Andrés, 6 al 21 de abril de 1956.* La Paz, 1956. unpaged.

Catalog of an exhibition of prints by women from Argentina, Bolivia, Brazil, Chile, Cuba, Paraguay, Uruguay and Spain.

234. Exposición de La Habana (1967 : Havana, Cuba). *Exposición de La Habana, 1967, {noviembre 1966, grabados}.* Havana, 1967. 12 p.

Exhibition held at the Casa de las Américas, Havana, Cuba.

235. Exposición de La Habana (1971 : Havana, Cuba). *Exposición de La Habana, 1971; exposición Cuba-Chile; encuentro de artistas plásticos, desde julio 28 de 1971.* Havana, 1971. 4 p.

Exhibition held at Casa de las Américas, Havana, Cuba.

236. García Esteban, Fernando {et al.}. *Dibujantes y grabadores de América; Uruguay, México, Argentina.* Buenos Aires, Argentina: Centro Editor de América Latina, 1976. 96 p.

237. Haight, Anne Lyon. *Portrait of Latin America as seen by her print makers.* New York, N.Y.: Hastings House, {c1946}. 180 p.

Edited by Anne Lyon Haight; foreword by Monroe Wheeler; introduction by Jean Charlot.

238. IBM. *Seventy-five Latin-American prints; a survey of contemporary printmaking in eighteen countries of Central and South America.* New York, N.Y., 1941? {8} p.

Exhibition catalog; assembled by the American National Committee of Engraving and acquired by International Business Machines Corporation.

239. International Exhibitions Foundation (Washington, D.C.). *Recent Latin American drawings (1969-1976); lines of vision.* Washington, D.C., c1977. 79 p.

> Exhibition held at the Center for Inter-American Relations, New York, N.Y., and elsewhere in the U.S.

240. La Tour, Galerie (Geneva, Switzerland). *La gravure d'Amérique Latine; {exposition}.* Geneva, n.d., 20 p.

241. Salón Austral y Colombiano de Dibujo y Grabado (1st : 1968 : Cali, Colombia). *Catálogo; {exposición}, junio de 1968.* Cali, 1968. 36 p.

242. Salón Latinoamericano de Grabado Universitario (1st : 1964 : Córdoba, Argentina). *Ier. Salón Latinoamericano de Grabado Universitario, 1964- .* Córdoba: Universidad Nacional de Córdoba, Escuela de Artes, 1964. 43 plates.

243. Signs Gallery (New York, N.Y.). *Graphics from America: Pedro Alcántara...{et al.}.* New York, N.Y., 1981. {18} p.

> Text in English and Spanish; exhibition held May 27-June 27, 1981.

244. Torre, Mario de la. *AGPA {artes gráficas panamericanas}.* Mexico City, Mexico: Cartón y Papel, c1979. 346 p.

> Edited by Mario de la Torre; texts by Octavio Paz and Stanton Loomis Catlin.

245. Trienal Latinoamericana del Grabado (1st : 1979 : Buenos Aires, Argentina). *Trienal Latinoamericana del Grabado, 1979- .* Buenos Aires: Asociación Internacional de Críticos de Arte, Sección Argentina, 1979. 16 p.

LATIN AMERICA—GRAPHIC ARTS—COLLECTIONS

246. Center for Inter-American Relations (New York, N.Y.). *Latin American prints from The Museum of Modern Art.* New York, 1974. {60} p.

> Catalog of an exhibition organized by the International Council of The Museum of Modern Art, New York, N.Y., and exhibited at the Center, Jan. 30-March 24, 1974; text in English and Spanish.

247. Constantine, Mildred. *Posters from Latin America.* New York, N.Y., 1941. 6 p.

Posters from the William Morris Collection.

248. Havana (Cuba). Casa de las Américas. Galería Latinoamericana. *Exposición de La Habana; premios y menciones; colección de grabados, Casa de las Américas.* Havana, n.d. {20} p.

Summaries of six exhibitions of 'Exposición de La Habana,' from 1962-1967; includes prize winners.

249. New York (N.Y.). Museum of Modern Art. International Council. *Grabados latinoamericanos del Museo de Arte Moderno, New York; exhibición, Sala de Arte Rosa María, Santo Domingo, República Dominicana.* New York, {1976}. {6} p.

Checklist of an exhibition held July 15-31, 1976, in the Dominican Republic.

LATIN AMERICA—PAINTING

250. Aele, Galería (Madrid, Spain). *Surrealistas del nuevo mundo; {exposición, 26 de abril al 19 de mayo 1972?}.* Madrid, 1972? 22 p.

251. Austin (Texas). University of Texas. Art Museum. *12 Latin American artists today = 12 artistas latino-americanos de hoy.* Mexico City, Mexico: Plural, 1975. 46 p.

Exhibition catalog.

252. Baden-Baden (West Germany). Staatliche Kunsthalle. *Südamerikanische Malerei der Gegenwart; {Ausstellung}, Staatliche Kunsthalle, Baden-Baden, Mærz 1964; Kunst- und Kunstgewerbeverein, Pforzheim, Reuchlinhaus, April 1964.* Baden-Baden, 1964. 52 p.

253. Benson & Hedges (Buenos Aires, Argentina). *Panorama Benson & Hedges de la nueva pintura latinoamericana, {exposición, 1980}.* Buenos Aires, 1980. {120} p.

Exhibition held in various Argentine and Uruguayan museums.

254. Berlin (West Germany). Akademie der Künste. *Südamerikanische Malerei der Gegenwart.* Berlin, 1974. 52 p.

Exhibition catalog, Jan. 12-Feb. 9, 1974.

255. Bienal de Lima (2nd : 1968 : Lima, Peru). *Festival Americano de Pintura: II Bienal de Lima; {exposición}, octubre-noviembre 1968.* Lima, 1968. 66 p.

256. Bienal Iberoamericana de Pintura Coltejer (1st : 1968 : Medellín, Colombia). *Bienal Iberoamericana de Pintura Coltejer, 1968-* . Medellín, 1968- .

 Title varies: 1970, no. 2, Bienal de Arte Coltejer.

257. Bienal Latino Americano de São Paulo (1st : 1978 : São Paulo, Brazil). *Simpósio.* São Paulo, 1978? 2 v.

258. Bogotá (Colombia). Biblioteca Luis Angel Arango. *Pinturas suramericanas de hoy; {exposición, del 25 de octubre al 6 de noviembre de 1962}.* Bogotá, 1962.

259. Bonino, Galería (New York, N.Y.). *Magnet New York: a selection of paintings by Latin American artists living in New York.* New York, 1964. {36} p.

 Exhibition organized by the Inter-American Foundation for the Arts, N.Y., and held at the Galería Bonino, New York, N.Y., Sept. 21-Oct. 10, 1964, and the Museo de Bellas Artes, Mexico City, Mexico, Nov. 3-Nov. 15, 1964.

260. Bonn (West Germany). Museum Stadtische Kunstsammlungen. *Südamerikanische Malerei der Gegenwart: Argentinien, Bolivien, Brasilien, Chile, Columbien, Peru, Uruguay, Venezuela: {Ausstellung}, 30. Juni bis 1. September, 1963.* Bonn, 1963. 28 p.

261. Boston (Massachusetts). Institute of Contemporary Art. *Latin America, new departures: {exhibition}, 1962.* Boston, 1961. 44 p.

262. Carcas (Venezuela). Museo de Bellas Artes. *El arte figurativo en América Latina.* Caracas, 1979. {64} p.

 Bibliography: p. {63}; catalog of an exhibition, Dec., 1979.

263. Caracas (Venezuela). Museo de Bellas Artes. *Evaulación de la pintura latinoamericana: años '60, del 10 de enero al 10 de febrero de 1965.* Caracas, 1965. 12 p.

 Presented jointly by the Ateneo de Caracas, El Museo de Bellas Artes, Fundación Neumann, Cornell University, and the Solomon R. Guggenheim Museum, New York, N.Y.

264. Caracas (Venezuela). Museo de Bellas Artes. *Exposición panamericana de pintura moderna, con motivo de la toma de posesión de Romulo Gallegos, presidente electo de Venezuela, 16 de febrero de 1948*. Caracas, 1948. 12 p.

265. Carvacho Herrera, Víctor, {et al.}. *La pintura informalista*. Santiago, Chile: Orbe, 1964. 172 p.

> Contains a brief analysis of contemporary painting in Latin America.

266. Cayman Gallery (New York, N.Y.). *Latin American primitives*. New York, n.d. 20 p.

> Exhibition catalog.

267. Center for Inter-American Relations (New York, N.Y.). *Artists of the Western Hemisphere; precursors of modernism, 1860-1930; inaugural loan exhibition, September 19-November 12, 1967*. New York, 1967. 60 p.

268. Cossio del Pomar, Felipe. *La rebelión de los pintores; ensayo para una sociología del arte*. Mexico City, Mexico: Editorial Leyenda, 1945. 346 p.

269. Dallas (Texas). Museum of Fine Arts. *South American art today; {exhibition}, October 10-November 29, 1959*. Dallas, 1959. 60 p.

270. Düsseldorf (West Germany). Stædtische Kunsthalle. *Barocke Malerei aus den Anden: Gemælde des 17. und 18. Jahrhunderts aus Bolivien, Ecuador, Kolumbien und Peru; Ausstellung, 10. Dezember 1976 bis 27. Februar 1977*. Düsseldorf, 1977? 89 p.

271. García Cisneros, Florencio. *Latin-American painters in New York = Pintores latino-americanos en Nueva York; a monographic book*. New York, 1964? 273 p.

> Miami, Florida: Rema Press, 1964?

272. Instituto Ibero-Americano (Berlin, West Germany). *Artistas alemanes en Latinoamerica; pintores y naturalistas del siglo XIX ilustran un continente*. Berlin, 1978. 148 p.

> Also exhibited at the Museo Nacional de Bellas Artes, Buenos Aires, Argentina.

273. Inter-American Development Bank (Washington, D.C.). *14 Latin American painters; {exhibition}, October 5-October 17, 1970*. Washington, D.C., 1970. 28 p.

274. Lima (Peru). Instituto de Arte Contemporáneo. *Primera exposición de pintura contemporáneo de los países del área andina*. Lima, 1970. 48 p.

275. New York (N.Y.). Solomon R. Guggenheim Museum. *The emergent decade; Latin American painters and painting in the 1960's*. Ithaca, N.Y.: Cornell University Press, 1966. 172 p.

> Bibliography: p. 170-172; text by Thomas Messer, artists' profiles in text and pictures by Cornell Capa; prepared under the auspices of the Cornell University Latin American Year, 1965-66, and The Solomon R. Guggenheim Museum.

276. Organization of American States (Washington, D.C.). *Latin American painting*. Washington, D.C., 1969. 32 p.

> Organized by the Organization of American States and The Carroll Reece Museum, 2 April 1969-30 April 1969; presented in conjunction with the Latin American Humanities Festival, Johnson City, Tennessee, 2 April 1969-30 April 1969.

277. Queens (New York). County Art and Cultural Center. *Bellas Artes; an exhibition of Latin American painting, September 8 to October 7, 1973*. Queens, N.Y., 1973. 20 p.

278. Rio Piedras (Puerto Rico). University of Puerto Rico. Museo de Antropologia, Historia y Arte. *Pintura hispanoamericana en Puerto Rico, siglos XVII a XIX*. Rio Piedras, 1976. 112 p.

> Bibliography: p. 107-109.

279. Sanz y Díaz, José. *Pintores hispanoamericanos contemporáneos*. Barcelona, Spain: Editorial Iberia, 1953.

280. Salón Austral y Colombiano de Pintura (1st : 1968 : Cali, Colombia). *Salón Austral y Colombiano de Pintura, 1968- *. Cali, 1968- .

281. Salón de las Américas de Pintura (1969 : Cali, Colombia). *Salón de las Américas de Pintura, 1969- *. Cali, 1969- .

282. San Salvador (El Salvador). Sala Nacional de Exposiciones. *Homenaje a la pintura latinoamericana: {exposición}, mayo 1977*. San Salvador, 1977. {156} p.

283. Texas Quarterly. *Contemporary painting in South America*.

> Special issue, Autumn 1965 {v. 8, no. 3}, consisting of preliminary section of eleven essays, followed by a SPECIAL SECTION, The Braniff International Airways Collection, with reproductions and biographies.

LATIN AMERICA—PAINTING

284. Traba, Marta. *La pintura nueva en Latinoamerica*. Bogotá, Colombia: Ediciones Libreria Central, 1961. 163 p.

LATIN AMERICA—PAINTING—COLLECTIONS

285. Center for Inter-American Relations (New York, N.Y.). *Latin American paintings from the collection of the Solomon R. Guggenheim Museum*. New York, 1969. 39 p.

Bibliography; catalog of an exhibition, July 2-Sept. 14, 1969.

LATIN AMERICA—PAINTING—DICTIONARIES, ETC.

286. Lira, Pedro. *Diccionario biográfico de pintores*. Santiago, Chile: Esmeralda, 1902. 552 p.

Biographical dictionary of Latin American painters, with emphasis on Chilean artists.

LATIN AMERICA—PAINTING—SALES

287. Sotheby Parke Bernet (New York, N.Y.). *Colonial paintings of Latin America*. New York, 1980.

Auction catalog, May 9, 1980.

LATIN AMERICA—PHOTOGRAPHY

288. Consejo Mexicano de Fotografía (Mexico City, Mexico). *Hecho en Latinoamerica; primera muestra de la fotografía latinoamericana contemporánea*. Mexico City, 1978. 29, 127 p., 192 plates.

Exhibition held at the Museo de Arte Moderno, Mexico City, May 1978.

289. Consejo Mexicano de Fotografía (Mexico City, Mexico). *Memorias del Primer Coloquio Latinoamericano de Fotografía.* Mexico City, 1978. 100 p.

290. En Foco (New York, N.Y.). *La familía = The Latin Family: an En Foco exhibition, {July 23-Nov. 25, 1979}.* New York: En Foco Press, c1979. portfolio.

291. Gasparini, Paolo. *Para verte mejor, América Latina.* Mexico City, Mexico: Siglo XXI, 1972. 159 p.

> Photography by Paolo Gasparini; text by Edmundo Desnoes; design by Umberto Peña.

292. Havana (Cuba). Casa de las Américas. Galería Latinoamericana. *Premio de fotografía contemporánea latinoamericana y del Caribe.* Havana, {1981}. {16} p.

> Catalog of an exhibition, April 7, 1981.

293. Pan American Union (Washington, D.C.). *First International Exhibition of Latin American Photography, January 12 to February 15, 1949.* Washington, D.C., 1949. 8 p.

294. Salón Internacional de Arte Fotográfico en México (3rd : 1954 : Mexico City, Mexico). *Catálogo del Tercer Salón Internacional de Arte Fotográfico en México; exhibición del 21 de octubre al 11 de noviembre de 1954...* Mexico City, 1954. 48 p.

295. Zürich (Switzerland). Kunsthaus. *Fotografie Lateinamerika von 1860 bis heute: {Ausstellung}, 20. August-15. November 1981.* Zürich, 1981. 416 p.

> Bibliography: p. 415-416; one of the most comprehensive surveys of Latin American photography to date.

LATIN AMERICA—SCULPTURE

296. IBM (New York, N.Y.). *Sculpture of the Western hemisphere representing the Latin-American countries, the Dominion of Canada, the U.S. and its possessions.* New York, 1942. ca 200 p.

297. Furlong, Guillermo. *Origenes del arte tipográfico en America, especialmente en la República Argentina.* Buenos Aires, Argentina: Huarpes, {1947}. 225 p.

 Bibliography.

Caribbean and Central America

298. Carifesta (1972 : Georgetown, Guyana). *Carifesta '72: art exhibition, August 26-September 15, 1972.* Georgetown, 1972. 82 p.

299. Center for Inter-American Relations (New York, N.Y.). *Art of Haiti and Jamaica: a loan exhibition, October 10-27, 1968.* New York, {1968}. {33} p.

 Bibliography: p. {32}-{33}.

300. Certamen Nacional de Cultura (lst : 1954? : San Salvador, El Salvador). *Certamen Nacional de Cultura, 1954- .* San Salvador, 1954- .

301. Esso Standard Oil (Coral Gables, Florida). *Arte de Centroamérica y Panamá.* Coral Gables, n.d. 24 p.

 Exhibition catalog; also published in English.

302. Havana (Cuba). Casa de las Américas. Galería Latinoamericana. *Centroamérica: Costa Rica, El Salvador, Honduras, Guatemala, Nicaragua, Panamá: {exposición}, desde febrero de 1979.* Havana, 1979.

303. Havana (Cuba). Casa de las Américas. Galería Latinoamericana. *Cinco años de amistad caribeña: muestra cultural de Barbados, Guyana, Jamaica, Trinidad-Tobago, {exposición desde dic. 9, 1977}.* Havana, 1977.

304. Havana (Cuba). Casa de las Américas. Galería Latinoamericana. *Encuentro de Plástica Latinoamericana, 1976: Puerto Rico, República Dominicana y Cuba, {exposición}, desde mayo 20 de 1976.* Havana, 1976. 16 p.

305. Houston (Texas). Museum of Fine Arts. *Gulf-Caribbean art exhibition...* Houston, 1956. {67} p.

 Catalog of an exhibition, April 4-May 6, 1956.

306. Organization of American States (Washington, D.C.). *Contemporary art from the Caribbean: Barbados, Jamaica, Trinidad and Tobago, {exhibition, December 14, 1972-January 7, 1973}.* Washington, D.C., 1972?

307. Robinson, Joe L. *The fine arts and Central American integration.* Princeton, New Jersey: Woodrow Wilson School of Public and International Affairs, 1965.

CARIBBEAN AND CENTRAL AMERICA—ARCHITECTURE

308. Acworth, A.W. *Treasure in the Caribbean: a first study of Georgian buildings in the British West Indies.* London, England: Pleiades Books, 1949. 36 p.

309. Braithwaite, Joan A., editor. *Handbook of churches in the Caribbean.* Bridgetown, Barbados: CADEC, 1973. 234 p.

CARIBBEAN AND CENTRAL AMERICA— ARCHITECTURE— BIBLIOGRAPHIES

310. Rivera de Figueroa, Carmen A. *Architecture for the tropics: a bibliographical synthesis (from the beginnings to 1972): con una versión castellana resumida.* Rio Piedras, Puerto Rico: Editorial Univesitaria, 1980. 199 p.

CARIBBEAN AND CENTRAL—PAINTING

311. Certamen Nacional de Cultura (10th : 1964 : San Salvador, El Salvador). *X Certamen Nacional de Cultura, correspondiente al año de 1964, {pintura}.* San Salvador: Ministerio de Educación, Dirección General de Bellas Artes, 1964? 32 p.

312. Instituto Italo-Latino Americano (Rome, Italy). *Pintura contemporánea centroamericana.* Rome, 1969.

 Contains biographical information on 42 artists from Guatemala, El Salvador, Honduras, Nicaragua and Costa Rica; exhibition catalog.

313. Lawrence (Kansas). University of Kansas. Museum of Art. *Pintores centroamericanos: an exhibition of contemporary art from Central America, December 1962-January 1963.* Lawrence, 1962? 63 p.

 Text in English and Spanish.

CARIBBEAN AND CENTRAL AMERICA—SCULPTURE

314. Certamen Nacional de Cultura (11th : 1965 : San Salvador, El Salvador). *XI Certamen Nacional de Cultura, correspondiente a 1965: {la escultura en la Certamen}.* San Salvador: Ministerio de Educación, Dirección General de Bellas Artes, 1965? 12 p.

Argentina

315. American Federation of Arts (New York, N.Y.). *Contemporary Argentine art; paintings, sculptures, prints; an exhibition circulated by the {AFA}.* New York, 1940? 8 p.

316. Arena, Héctor L. *El arte argentino en Europa; informe de una misión cultural.* Buenos Aires, Argentina: Galería Van Riel, 1960. 62 p.

317. Argentina. Academia Nacional de Bellas Artes. *Art-nouveau en Buenos Aires.* Buenos Aires, Argentina, 1965. 100 p.

318. Argentina. Dirección General de Cultura del Ministério de Educación y Justicia. *Primera exposición internacional de arte moderno argentina, 1960, {catálogo}.* Buenos Aires, Argentina, 1960. {330} p.

319. Argentina. Dirección General de Cultura del Ministério de Educación y Justicia. *Primera Exposición Internacional de Arte Moderno, 1960 = First International Modern Art Exposition = Première Exposition Internationale d'Art Moderne.* Buenos Aires, 1960. ca. 500 p.

320. Argentina. Ministério de Educación y Justicia. *Veinte pintores y escultores...* Buenos Aires: Ediciones Culturales Argentinas, n.d. 30 p.

321. Argentina. Ministério de Relaciones Exteriores y Culto. *Argentina en el mundo; artes visuales, 2; {exposición}, del 16 al 31 de diciembre de 1965, y del 1 al 20 de febrero de 1966.* Buenos Aires, 1965? 46 p.

322. Arte Madí (Buenos Aires, Argentina).*Movimiento Arte Madí; qué es Madí, quienes lo integran.* Buenos Aires, Argentina: Arte Madí, c1955. 12 p.

> Dictionary with photographs of the artists involved in the Arte Madí movement.

323. Arts Council of Great Britain (London, England). *Modern Argentine painting and sculpture, {exhibition}, 1961.* London, 1961? 8 p.

324. Asociación Argentina de Críticos de Arte (Buenos Aires, Argentina). *Crítica de arte, Argentina, 1962-1963.* Buenos Aires: Imprenta Anzilotti, 1963. 51 p.

325. Asociación Argentina de Críticos de Arte (Buenos Aires, Argentina). *XIII Congress of The International Association of Art Critics, AICA, Switzerland, August-September, 1978: {art criticism in Argentina...}.* Buenos Aires, 1978. 31 p.

326. Asociación Argentina de Críticos de Arte (Buenos Aires, Argentina). *Jornadas de la crítica; simposium Latinoamericano, Arte Argentino 78, la joven generación, premios a la crítica, Buenos Aires, noviembre 13-19, 1978.* Buenos Aires, 1978. 56 p.

327. Avellaneda (Argentina). Municipalidad. *Salón de Artes Plásticas 1954: homenaje a Eva Perón, 8-31 mayo 1954.* Avellaneda: Dirección de Cultura, 1954. 32 p.

328. Banco de la Ciudad de Buenos Aires (Buenos Aires, Argentina). *100 años de pintura y escultura en la Argentina, 1878-1978.* {Buenos Aires, 1978?}. 94 p.

 Catalog of an exhibition held June 22-July 2, 1978, and July 5-16, 1978.

329. Banco de la Provincia de Córdoba (Córdoba, Argentina). *Ochenta años de arte plástico cordobés, 1860-1940.* Córdoba, 1969. 1 v.

330. Bank of Ireland (Dublin, Ireland). *Jacques Bedel, Luis Benedit, Jorge Glusberg...CAYC Group at the Bank of Ireland.* Dublin, 1980? 47 p.

331. Basel (Switzerland). Kunsthalle. *Argentinische Kunst der Gegenwart.* Basel, 1971. 1 v.

 Catalog of an exhibition, June 12-July 25, 1971.

332. Bértola, Elena de. *Realismos en la Argentina {exposición}, 8 de agosto al 2 de setiembre 1977.* Buenos Aires, Argentina: Asociación Argentina de Críticos de Arte, 1977. 8 p.

333. Bienal Argentina de Arte Sagrado Moderno (1st : 1954 : Buenos Aires, Argentina). *Bienal Argentina de Arte Sagrado Moderno, 1954- .* Buenos Aires: Museo Histórico de la Iglesia, 1954- .

334. Bienal Argentina de Arte Sagrado Moderno (2nd : 1956 : Buenos Aires, Argentina). *Segunda Bienal Argentina de Arte Sagrado Moderno; escultura y pintura, octubre de 1956.* Buenos Aires: Museo Histórico de la Iglesia, 1956. 46 p.

Exhibition catalog.

335. Bienal de São Paulo (6th : 1961 : São Paulo, Brazil). *Arte argentino 1961: VI Bienal, Museo de Arte Moderno de São Paulo, Brasil, septiembre-diciembre 1961.* São Paulo: Museo de Arte Moderno, 1961. ca. 100 p.

336. Bienal de São Paulo (7th : 1963 : São Paulo, Brazil). *VII Bienal Museo de Arte Moderno de São Paulo, Brasil, septiembre 1963.* Buenos Aires, Argentina: Ministerio de Relaciones Exteriores y Culto, 1963. 1 v.

337. Biennale di Venezia (31st : 1962 : Venice, Italy). *XXXI Bienal Internacional de Arte, Venecia, Argentina, 1962.* Buenos Aires, 1962? 42 p.

Text in Italian and Spanish.

338. Blanca de Morán, Rosa. *Plumas y pinceles de la pampa.* Buenos Aires, Argentina: Editorial Dinámica Gráfica, 1955.

339. Bonino, Galería (Buenos Aires, Argentina). *Catálogos, temporado, 1960-* . Buenos Aires, 1960- .

340. Bonino, Galería (Buenos Aires, Argentina). *Exposición Arte Madí Internacional.* Buenos Aires, 1956. 8 p.

341. Brughetti, Romualdo. *El arte en la Argentina.* Mexico City, Mexico: Editorial Pormaca, n.d.

342. Brughetti, Romualdo. *Crítica de arte.* Buenos Aires, Argentina: Asociación Argentina de Críticos de Arte, 1963.

343. Brughetti, Romualdo. *Geografía plástica argentina.* Buenos Aires, Argentina: Editorial Nova, 1958.

344. Brughetti, Romualdo. *Historia del arte en Argentina.* Mexico City, Mexico: Editorial Pormaca, 1965. 223 p.

345. Brughetti, Romualdo. *Introducción al estudio de la escuela pictórica argentina.* Buenos Aires, Argentina: Edición del Ministerio de Relaciones Exteriores, 1964.

346. Brughetti, Romualdo. *Italia y el arte argentina; itinerario de una emulación plástico-cultural.* Buenos Aires, Argentina: Asociación Dante Alighieri, 1952. 81 p.

347. Brughetti, Romualdo. *Nuestro tiempo y el arte.* Buenos Aires, Argentina: Editorial Poseidón, 1945. 246 p.

348. Bucich, Antonio J. *Noticia sobre el arte de los boquenses.* Buenos Aires, Argentina: Maggiolo, 1949. 12 p.

349. Bucich, Antonio J. *Tres figuras del arte boquense; Francisco Parodi, Francisco Cafferata, Américo Bonettí.* Buenos Aires, Argentina: Congreso de la Nación, 1950. 15 p.

350. Buenos Aires (Argentina). Administración de Subterráneos de Buenos Aires. *Arte bajo la ciudad = Art beneath the city.* Buenos Aires, 1978. 275 p.

 Edited by Manrique Zago.

351. Buenos Aires (Argentina). Instituto Torcuato Di Tella. Centro de Artes Visuales. *Arte nuevo de la Argentina = New art of Argentina; exposición del 18 de febrero al 8 de marzo de 1964.* Buenos Aires, 1964. 4 p.

 Checklist of the works of 30 young Argentinian artists sent later in 1964 to be exhibited in the U.S. at the Walker Art Center, Minneapolis, Minnesota, and other U.S. art museums.

352. Buenos Aires (Argentina). Instituto Torcuato Di Tella. Centro de Artes Visuales. *Mas allá de la geometría, extensión del lenguaje artístico-visual en nuestros días.* Buenos Aires, 1968.

353. Buenos Aires (Argentina). Instituto Torcuato Di Tella. Centro de Artes Visuales. *Un movimiento de vanguardia en Buenos Aires.* Buenos Aires, 1967.

354. Buenos Aires (Argentina). Intendencia Municipal. *Blaszko, Kurchan, Melé, Ungar; arquitectura, proy. de urbanismo, esculturas y pinturas; {exposición}, del 7 al 31 de julio de 1953.* Buenos Aires, 1953. 16 p.

355. *Buenos Aires 1936; 4o. Centenario de su fundación.* Buenos Aires, Argentina: Atlántida, 1937. 226 p.

356. Buenos Aires (Argentina). Municipalidad. Centro Permanente de Exposiciones. *1a. Exposición de artistas visuales del interior del país, 12 al 29 de mayo de 1977.* Buenos Aires, 1972. 34 p.

357. Buenos Aires (Argentina). Museo de Arte Hispano-Americano. *Exposición conmemorando los 350 años de la provincia franciscana en el Rio de La Plata, 1612-1962.* Buenos Aires: Secretaría de Cultura de la Municipalidad de la Ciudad, 1962. 50 p.

358. Buenos Aires (Argentina). Museo de Arte Moderno. *Arte de sistemas; {exposición, julio 1977}.* Buenos Aires: CAYC, 1977. 212 p.

 Organized by Jorge Glusberg of the Centro de Arte y Comunicación, Buenos Aires, Argentina.

359. Buenos Aires (Argentina). Museo de Arte Moderno. *Artistas con acrílicopaolini: cuatro salón premio, del 3 al 21 de agosto de 1973.* Buenos Aires, 1973. 24 p.

360. Buenos Aires (Argentina). Museo de Arte Moderno. *Grupo Galaxia, {exposición, del 6 al 31 de agosto de 1974}.* Buenos Aires, 1974. 8 p.

361. Buenos Aires (Argentina). Museo de Arte Moderno. *Los primeros 15 años de Arte Madí, {exposición, noviembre 1961}.* Buenos Aires, 1961. 12 p.

362. Buenos Aires (Argentina). Museo de Arte Moderno. *Rosario 67, {exposición}, septiembre 1967.* Buenos Aires, 1967. 24 p.

363. Buenos Aires (Argentina). Museo de Artes Plásticas Eduardo Sívori. *El Grupo Informalista Argentino.* Buenos Aires, {1978}. {40} p.

 Catalog of an exhibition, July 12, 1978.

364. Buenos Aires (Argentina). Museo de Artes Plásticas Eduardo Sívori. *Vanguardias de la década del 40: Arte Concreto-Invención, Arte Madí, Perceptismo: {exposición}, octubre de 1980.* Buenos Aires, 1980. 50 p.

365. Buenos Aires (Argentina). Museo de Artes Plásticas Eduardo Sívori. *Visiones plásticas de Buenos Aires, {exposición, del 11 al 30 de noviembre 1970}.* Buenos Aires, 1970. 24 p.

366. Buenos Aires (Argentina). Museo Municipal de Bellas Artes. *Cuatro artistas del Litoral: Julio Vanzo, Israel Hoffmann, Enrique Estrada Bello, Ludovico Paganini.* Santa Fé, Argentina: Colmegna, 1945. 35 p.

367. Buenos Aires (Argentina). Museo Municipal de Bellas Artes. *Obras del arte argentino desde Pueyrredón hasta nuestros días; {exposición}, Academia Provincial de Bellas Artes, Mendoza, 1940.* Buenos Aires, 1940. 12 p.

368. Buenos Aires (Argentina). Museo Nacional de Bellas Artes. *150 años de arte argentino.* Buenos Aires, 1961. 548 p.

369. Buenos Aires (Argentina). Museo Nacional de Bellas Artes. *El desnudo: siglos XIX-XX: {exposición}, del 11 de agosto al 11 de setiembre de 1972.* Buenos Aires, 1972. 56 p.

370. Buenos Aires (Argentina). Museo Nacional de Bellas Artes. *Encuentros y coincidencias en el arte, {exposición}, agosto-setiembre 1967.* Buenos Aires, 1967. 112 p.

371. Buenos Aires (Argentina). Museo Nacional de Bellas Artes. *Exposición de un siglo de arte en la Argentina.* Buenos Aires, 1936.

372. Buenos Aires (Argentina). Museo Nacional de Bellas Artes. *Exposición de la pintura y la escultura argentinas de este siglo.* Buenos Aires, 1952. 54 p.

373. Buenos Aires (Argentina). Museo Nacional de Bellas Artes. *F-Muro, Grillo, Ocampo, Sakai, Testa; {catálogo}.* Buenos Aires, 1960. 1 v.

Text by Jorge Romero Brest.

374. Buenos Aires (Argentina). Museo Nacional de Bellas Artes. *Materiales; nuevas técnicas, nuevas expresiones: {exposición, del 20 de septiembre al 30 de octubre 1968}.* Buenos Aires, 1968. 65 p.

375. Buenos Aires (Argentina). Museo Nacional de Bellas Artes. *1960-1963, obras de artistas argentinos maduros.* Buenos Aires, 1963? 36 p.

376. Buenos Aires (Argentina). Museo Nacional de Bellas Artes. *La pintura y la escultura argentinas de este siglo, 1952-53.* Buenos Aires, 1952? 70 p.

377. Butler, Horacio. *Las personas y los años.* Buenos Aires, Argentina: Editorial Emecé, 1973.

378. Carrillo, Galería (Rosario, Argentina). *Rosario: siglo XX, historia de la evolución plástica en la ciudad, {exposición}, 1-26 de agosto de 1967.* Rosario,1967. 26 p.

379. Centro de Arte y Comunicación (Buenos Aires, Argentina). *Argentina inter-medios = Argentine intermedia.* Buenos Aires, 1964. 26 p.

Documentation of a performance.

380. Centro de Arte y Comunicación (Buenos Aires, Argentina). *Arte y cibernética; {exposición, junio 1970}.* Buenos Aires, 1970. 20 p.

381. Centro de Arte y Comunicación (Buenos Aires, Argentina). *2.972.453; {una exposición... diciembre 4, 1970}.* Buenos Aires, 1970. 86 leaves.

 Text in Spanish and English.

382. Centro de Arte y Comunicación (Buenos Aires, Argentina). *Hacia un perfil del arte latinoamericano, muestra del Grupo de Los Trece e invitados {Encuentro Internacional de Arte en Pamplona, España, 26 de junio al 3 de julio de 1972}.* Buenos Aires, 1972. 54 p.

383. Centro de Arte y Comunicación (Buenos Aires, Argentina). *Jacques Bedel, Luis Benedit, Víctor Grippo, Vicente Marotta, Alfredo Portillos, Clorindo Testa (integrantes del Grupo CAYC), {exposición, julio 1979}.* Buenos Aires, 1979. 20 p.

384. Centro de Arte y Comunicación (Buenos Aires, Argentina). *21 artistas argentinos en el Museo Universitario de Ciencias y Arte, Ciudad Universitaria, México, D.F., noviembre 1977.* Buenos Aires, 1977. 40 p.

 385. Centro de Estudios de Arte y Comunicación (Buenos Aires, Argentina). *Primera muestra del Centro de Estudios de Arte y Comunicación = First exhibition of the Centre of Studies on Art and Communication, agosto-setiembre 1969.* Buenos Aires, 1969. 28 p.

386. Certamen Trienal: Valores Plásticos del Interior (1970 : Buenos Aires, Argentina). *Certamen Trienal: Valores Plásticos del Interior, 1970- .* Buenos Aires: Ministério de Cultura y Educación, 1970- .

387. Chiabra Acosta, Alfredo (Atalaya). *Alfredo (Atalaya) Chiabra Acosta, 1920-1932; críticas de arte argentino.* Buenos Aires, Argentina: M. Gleizer, 1934. 399 p.

388. Chile. Sociedad Nacional de Bellas Artes. *Homenaje de la Sociedad Nacional de Bellas Artes a los artistas argentinos, {exposición}, veinticinco de mayo 1953.* Santiago, 1953. 48 p.

389. Colón, Antonio. *Contribución al estudio de la plástica santafesina.* Santa Fé, Argentina: Castellvi, 1959. 67 p.

390. Colón, Antonio. *Cuatro artistas del Litoral.* Santa Fé, Argentina: Ediciones Colemegna, 1974. 89 p.

 Ludovico Paganini, Enrique Estrada Bello, Julio Andriano Lammertyn, and Jacinto M. Castillo.

391. Colón, Antonio. *La plástica en Santa Fé.* Santa Fé, Argentina: Editorial Oficial, 1973.

392. Continental, Galería (Lima, Perú). *CAYC, Centro de Arte y Comunicación, Buenos Aires; 20 artistas argentinos, {exposición}, mayo 1977.* Lima, 1977. 12 p.

393. Córdoba (Argentina). Museo Provincial de Bellas Arte. *De la figuración al arte de sistemas; muestra organizada por el CAYC; obras y documentación, Luis Fernando Benedit, Nicolás García Uriburu, Edgardo Antonio Vigo {14 al 31 de agosto 1970}.* Córdoba, 1970. 24 p.

Text by Jorge Glusberg.

394. Córdova Iturburu. *De la prehistoria al op-art.* 2a. ed. Buenos Aires, Argentina: Editorial Atlántida, 1971.

395. Córdova Iturburu. *La revolución martinfierrista.* Buenos Aires, Argentina: Ediciones Culturales Argentinas, 1962.

396. Dellepiane, Antonio. *Arte y historia.* Buenos Aires, Argentina: Porter, 1940. 149 p.

397. Fèvre, Fermín. *La crisis de las vanguardias.* Buenos Aires, Argentina: Centro Editor de América Latina, 1975.

398. Foglia, Carlos A. *Arte y mistificación.* 2a ed. Buenos Aires, Argentina: Bartolomé U. Chiesino, 1958. 123 p.

399. Foglia, Carlos A. *La simulación en el arte contemporáneo.* Buenos Aires, Argentina: Ediciones Aureas, 1963. 184 p.

400. Freyre, María. *Geometricos argentinos.* Uruguay? n.d.

401. Gabriel, José. *Vindicación de las artes.* Buenos Aires, Argentina: Mercatali, 1926. 235 p.

402. Gesualdo, Vicente. *Cómo fueron las artes en la argentina.* Buenos Aires, Argentina: Editorial Plus Ultra, 1973. 11 p.

403. Gudiño Kramer, Luis. *Escritores y plásticos del Litoral.* Santa Fé, Argentina: Castellvi, 1955. 171 p.

Literary appreciations of young Argentine painters.

404. Los Independientes, Galería (Buenos Aires, Argentina). *Exposición Arte Madí: 10.* Buenos Aires, n.d. 4 p.

405. Instituto Frances de Estudios Superiores (Buenos Aires, Argentina). *Madí: la. exposición, días 3,4,5,6 de agosto de 1946.* Buenos Aires, 1946. 8 p.

406. Kogan, Jacobo. *El lenguage del arte psicología y sociología del arte.* Buenos Aires, Argentina: Editorial Paidós, 1965. 220 p.

407. Kosice, Gyula. *Arte y arquitectura del agua.* Caracas, Venezuela: Monte Avila, c1974. 148 p.

408. Lo Celso, Angel T. *50 años de arte plástico en Córdoba, desde el año 1920 al 1970, con un apéndice por los años 1971 y 1972.* Córdoba, Argentina: Banco de la Provincia de Córdoba, 1973. 881 p.

409. London (England). Camden Arts Centre. *CAYC; from figuration art to systems art in Argentina in Camden Arts Centre: {exhibition}, February 23, 1971.* London, 1971. 4 p.

Organized by Jorge Glusberg.

410. Lozano Mouján, José María. *Apuntes para la historia de la pintura y la escultura argentinas.* n.p., 1922.

411. Lozano Mouján, José María. *Figuras del arte argentino.* Buenos Aires, Argentina: A. García Santos, 1928. 186 p.

Includes information on nineteen Argentine artists.

412. Manet, Xavier. *Contra el arte moderno.* Buenos Aires, Argentina: Galerna, 1978. 170 p.

413. Mantovani, Juan. *La cultura, el arte y el estado.* Santa Fé, Argentina: Ministerio de Insturcción Pública y Fomento, 1939. 59 p.

414. Mexico City (Mexico). Museo de Arte Moderno. *Arte argentino contemporáneo; pintores, Carlos Aguero...{et al.}; escultores, Libero Badii...{et al.}; {exposición}, Museo de Arte Moderno, abril-mayo de 1975.* Mexico City, {1975}. {96} p.

415. Mexico. Embajada. (Argentina). *Síntesis histórica del arte argentino.* Mexico City, Mexico: Embajada Argentina, n.d. 52 p.

416. Minnespolis (Minnesota). Walker Art Center. *New art of Argentina; an exhibition organized by the Walker Art Center, Minneapolis, and the Visual Arts Center, Instituto Torcuato Di Tella, Buenos Aires, {Sept. 9-Oct. 11, 1964}.* Minneapolis, 1964. 82 p.

417. Mújica Láinez, Manuel. *Argentina.* Washington, D.C.: Pan American Union, 1961. 74 p.

418. Negri, Tomás Alva. *Arte argentino y crítica europea*. Buenos Aires, Argentina: Editorial Bonino, 1975.

419. Nessi, Angel Osvaldo. *El Atelier Pettoruti; un taller de dibujo, pintura y composición abstracta en Buenos Aires, 1947-1952*. Buenos Aires, Argentina: Dirección General de Cultura, Ministerio de Educación y Justicia, Ediciones Culturales Argentinas, 1963. 139 p.

 Bibliography: p. 75-90.

420. New York World's Fair (1939). Argentina National Committee. *Fine arts in Argentina*. Buenos Aires, Argentina: Argentina National Committee, 1940. 105 plates.

421. Noé, Luis Felipe. *Antiestética*. Buenos Aires, Argentina: Ediciones Van Riel, 1965. 213 p.

422. Numero, Galleria (Florence, Italy). *Arte Madí: 10 artisti, disegni, tempere, progetti, {Bay, Biedma, Darie, Eitler, Fonseco, Kasak, Kosice, Laañ, Presta, Rothfuss, dal 20 gennaio al 2 febbraio 1955.*

423. Pagano, José León. *El arte de los Argentinos*. Buenos Aires, Argentina: Edición del Autor, 1937-40. 3 v.

 V. l; Desde los aborigenes hasta el período de los organizadores; v. 2; Desde las acción inovadora del 'Nexus' hasta las expresiones más recientes--pintura, escultura, grabado.

424. Pagano, José Lewón. *Historia del arte argentino desde los aborigenes hasta el momento actual*. Buenos Aires, Argentina: L'Amateur, 1944.

425. Palomar, Francisco. *Primeros salones de arte de Buenos Aires*. Buenos Aires, Argentina: Editorial de la Municipalidad, 1962.

426. Paris (France). Musée National d'Art Moderne. *L'art argentin actuel*. Paris, 1964. {95} p.

 Catalog of an exhibition, Dec. 1963-Feb. 1964.

427. Pellegrini, Aldo, {et al.}. *Artistas abstractos de la Argentina*. Buenos Aires, Argentina: Cercle International d'Art, 1955.

428. Pellegrini, Aldo. *New tendencies in art*. New York, N.Y.: Crown, 1965.

429. Pepsi-Cola Company (New York, N.Y.). *Buenos Aires 64; {exhibition}*. New York, 1964? 24 p.

430. Premio de Honor Ver y Estimar (1963 : Buenos Aires, Argentina). *Premio de Honor Ver y Estimar, 1963.* Buenos Aires: Museo Nacional de Bellas Artes, 1963. 1 v.

 52 contemporary Argentine artists.

431. Premio de Honor Ver y Estimar (1964 : Buenos Aires, Argentina). *Premio de Honor Ver y Estimar, 1964.* Buenos Aires: Museo Nacional de Bellas Artes, 1964. 34 p.

432. Premio de Honor Ver y Estimar (1969 : Buenos Aires, Argentina). *Premio de Honor Ver y Estimar, 1969, {exposición del 30 de abril al 19 de mayo de 1968}.* Buenos Aires, 1968. 20 p.

433. Premio Georges Braque (1964 : Buenos Aires, Argentina). *Premio Georges Braque.* Buenos Aires: Museo Nacional de Bellas Artes, 1964. 24 p.

 Sponsored by the French Embassy, Buenos Aires, Argentina.

434. Premio Georges Braque (1966 : Buenos Aires, Argentina). *Premio G. Braque, 1966: {exposición, 12 al 30 de julio de 1966}.* Buenos Aires: Museo Nacional de Bellas Artes, 1966. 32 p.

435. Premio Marcelo de Ridder (1973 : Buenos Aires, Argentina). *Premio Marcelo de Ridder, 1973: {exposición}, agosto 1973.* Buenos Aires: Museo Nacional de Bellas Artes, 1973. 31 p.

436. Premio Marcelo de Ridder (1974 : Buenos Aires, Argentina). *Premio Marcelo de Ridder, 1974: {exposición}, julio/agosto 1974.* Buenos Aires: Museo Nacional de Bellas Artes, 1974. 38 p.

437. Premio Marcelo de Ridder (1975 : Buenos Aires, Argentina). *Premio Marcelo de Ridder, 1975: {exposición, pintura y grabado}.* Buenos Aires: Museo Nacional de Bellas Artes, 1975. 30 p.

438. Premio Nacional e Internacional Instituto Torcuato Di Tella (1964 : Buenos Aires, Argentina). *Premio Nacional e Internacional Instituto Torcuato Di Tella, 1964- .* Buenos Aires: Instituto Torcuato Di Tella, Centro de Artes Visuales, 1964- .

439. Premio Nacional e Internacional Instituto Torcuato Di Tella (1964 : Buenos Aires, Argentina). *Premio Nacional e Internacional Instituto Torcuato Di Tella 1964: expoosición del 7 octubre al 1 de noviembre de 1964.* Buenos Aires: Instituto Torcuato Di Tella, Centro de Artes Visuales, 1964. 73 p.

440. Premio Nacional e Internacional Instituto Torcuato Di Tella (1965 : Buenos Aires, Argentina). *Premio Nacional e Internacional Instituto Torcuato Di Tella, 1965: {exposición}, 1-23 de setiembre de 1965.* Buenos Aires: Instituto Torcuato Di Tella, Centro de Artes Visuales, 1965. 77 p.

441. Premio Nacional Instituto Torcuato Di Tella (1966 : Buenos Aires, Argentina). *Premio Nacional Instituto Torcuato Di Tella, 1966- .* Buenos Aires: Instituto Torcuato Di Tella, Centro de Artes Visuales, 1966- .

442. Premio Nacional Instituto Torcuato Di Tella (1966 : Buenos Aires, Argentina). *Premio Nacional Instituto Torcuato Di Tella, 1966: {exposición}, 29 de setiembre-30 de octubre de 1966.* Buenos Aires: Instituto Torcuato Di Tella, Centro de Artes Visuales, c1965. 55 p.

443. Premio Palanza (1st : 1947 : Buenos Aires, Argentina). *Premio Palanza, 1947- .* Buenos Aires: Academia Nacional de Bellas Artes, 1947- .

444. Premio Palanza (1951 : Buenos Aires, Argentina). *El Premio Palanza, 1947-1950; catálogo general ilustrado de las obras presentadas en las cuatro primeras exposiciones del concurso.* Buenos Aires: Academia Nacional de Bellas Artes, 1951. 202 p.

445. Presta, Salvador. *Arte argentino actual.* Buenos Aires, Argentina: Lacio, 1960.

446. Ratti, Ricardo. *Por los nuevos caminos del arte.* Buenos Aires, Argentina: Edición del autor, 1950.

447. Richmond (Virginia). Virginia Museum of Fine Arts. *A comprehensive exhibition of the contemporary art of Argentina.* Richmond, 1940.

448. Ripamonte, Carlos P. *Janus: consideraciones y reflexiones artísticas.* Buenos Aires, Argentina: M. Gleizer, 1926. 207 p.

449. Rivera, Jorge B. *Madí y la vanguardia argentina.* Buenos Aires, Argentina: Paidós, 1976. 86 p.

 Bibliography.

450. Rocha, Augusto da. *Un siglo de arte en la Argentina.* Buenos Aires, Argentina: Dirección Nacional de Bellas Artes, 1936.

451. Romero Brest, Jorge. *Arte en la Argentina: últimas décadas.* Buenos Aires, Argentina: Paidós, 1969. 110 p.

452. Romero Brest, Jorge. *Pintores y grabadores rioplatenses.* Buenos Aires, Argentina: Argos, 1951. 300 p.

Short articles orgininally published in magazines.

453. Ron, Badin. *Plástica argentina; reportaje a los años 70.* Buenos Aires, Argentina: Corregidor, 1978. 228 p.

454. Salón Anual de Artes Plásticas (1st : 1910 : Buenos Aires, Argentina). *Salón Anual de Artes Plásticas, 1910- . Buenos Aires: Comisión Nacional de Bellas Artes, 1910-* .

455. *Salón Anual de Santa Fé: Pintura, Escultura, Grabado y Dibujo (1st : 1923? : Santa Fé, Argentina). Salón Anual de Santa Fé: Pintura, Escultura, Grabado y Dibujo, 1923?- . Santa Fé: Museo Rosa Galisteo de Rodríguez, 1923?-* .

456. Salón Anual de Santa Fé: Pintura, Escultura, Grabado y Dibujo (7th : 1930 : Santa Fé, Argentina). *VII Salón Anual.* Santa Fé, 1930. 138 p.

457. Salón Anual de Santa Fé: Pintura, Escultura, Grabado y Dibujo (25th : 1948 : Santa Fé, Argentina). *XXV Salón Anual de Santa Fé: Pintura, Escultura, Grabado y Dibujo: {exposición}, 25 de mayo de 1948.* Santa Fé: Museo Rosa Galisteo de Rodríguez, 1948. 68 p.

458. Salón Anual de Santa Fé: Pintura, Escultura, Grabado y Dibujo (26th : 1949 : Santa Fé, Argentina). *XXVI Salón Anual de Santa Fé.* Santa Fé, 1949. 37 p.

459. Salón Anual de Santa Fé: Pintura, Escultura, Grabado y Dibujo (1956 : Santa Fé, Argentina). *Exposición de los premeros premios de pintura, escultura, dibujo y grabado de los XXXIII salones anuales de Santa Fé e invitados de honor, 1922-1956.* Santa fé: Museo Provincial de Bellas Artes Rosa Galisteo de Rodróguez, 1956.

460. Salón Anual de Santa Fé: Pintura, Escultura, Grabado y Dibujo (35th : 1958 : Santa Fé, Argentina). *XXXV Salón Anual de Santa Fé: Pintura, Escultura, Dibujo y Grabado, 25 de mayo de 1958.* Santa Fé: Museo Provincial de Bellas Artes Rosa Galisteo de Rodríguez, 1958. 118 p.

461. Salón Anual de Santa Fé: Pintura, Escultura, Grabado y Dibujo (36th : 1959 : Santa Fé, Argentina). *XXXVI Salón Anual de Santa Fé.* Santa Fé: Museo Provincial de Bellas Artes Rosa Galisteo de Rodríguez, 1959. 1 v.

462. Salón Anual de Santa Fé: Pintura, Escultura, Grabado y Dibujo (40th : 1963 : Santa Fé, Argentina).*40 Salón Anual: {exposición}, 25 de mayo 1963.* Santa Fé, 1963. 44 p.

463. Salón de Arte de Bahia Blanca (1st : 1945 : Bahia Blanca, Argentina). *Salón de Arte de Bahia Blanca, 1945-* . Bahia Blanca: Palacio Municipal, 1945- .

464. Salón de Arte de Bahia Blanca (1st : 1945 : Bahia Blanca, Argentina). *I Salón de Arte de Bahia Blanca, desde el 9 al 31 de julio 1945.* Bahia Blanca: Palacio Municipal, 1945. 17 p.

465. Salón de Arte de Buenos Aires (1st : 1936? : Buenos Aires, Argentina). *Salón de Arte de Buenos Aires, 1936?-* . Buenos Aires, 1936?- .

466. Salón de Arte de Buenos Aires (8th : 1944 : Buenos Aires, Argentina). *VIII Salón de Arte de Buenos Aires: {exposición}, 18 noviembre-31 diciembre 1944.* La Plata, 1944. 42 p.

467. Salón de Arte de Junín (1st : 1944? : Junín, Argentina). *Salón de Arte de Junín, 1944?-* . *Junín, 1944?-* .

468. *Salón de Arte de Junín (3rd : 1947 : Junín, Argentina). III Salón de Arte de Junín; {exposición}, del 4 de setiembre al 3 de octubre 1947.* Junín: Museo de Bellas Artes, 1947. 14 p.

469. Salón de Arte de La Plata (1st : 1932? : La Plata, Argentina).*Salón de Arte de La Plata, 1932?-* . La Plata: Comisión Provincial de Bellas Artes, 1932?- .

470. Salón de Arte de La Plata (7th : 1939 : La Plata, Argentina). *Séptimo Salón de Arte de La Plata; catálogo general ilustrado; pintura, escultura, dibujo, grabado.* La Plata: Comisión Provincial de Bellas Arte, 1939. 405 p.

471. Salón de Arte de La Plata (8th : 1940 : La Plata, Argentina). *Octavo Salón de Arte de La Plata; catálogo general ilustrado; pintura, escultura, dibujo, grabado; {exposición}, junio-julio 1940.* La Plata: Comisión Provincial de Bellas Artes, 1940. 397 p.

472. Salón de Arte de La Plata (9th : 1941 : La Plata, Argentina). *Noveno Salón de Arte de La Plata; catálogo general ilustrado; pintura, escultura, dibujo, grabado; {exposición}, junio-julio 1941.* La Plata: Comisión Provincial de Bellas Artes, 1941. 440 p.

473. Salón de Arte de La Plata (15th : 1947 : La Plata, Argentina). *XV Salón de Arte de La Plata, {exposición}, 23 mayo-23 junio 1947; {reglamento}.* La Plata: Pasaje Dardo Rocha, 1947. 5 p.

474. Salón de Arte de Mar del Plata (1st : 1942 : Mar del Plata, Argentina). *Salón de Arte de Mar del Plata, 1942-* . Mar del Plata, 1942- .

475. Salón de Arte de Mar del Plata (1st : 1942 : Mar del Plata, Argentina). *Primer Salón de Arte de Mar del Plata; catálogo general ilustrado; pintura, escultura, dibujo, grabado; {exposición}, 14 marzo-13 abril 1942.* Mar del Plata: Comisión Provincial de Bellas Artes, 1942. 486 p.

476. Salón de Arte de Mar del Plata (2nd : 1943 : Mar del Plata, Argentina). *Segundo Salón de Arte de Mar del Plata; catálogo general ilustrado; pintura, escultura, dibujo, grabado.* Mar del Plata: Comisión Provincial de Bellas Artes, 1943. 723 p.

477. Salón de Arte de Mar del Plata (3rd : 1944 : Mar del Plata, Argentina). *Tercer Salón de Arte de Mar del Plata; catálogo general ilustrado; pintura, escultura, dibujo, grabado.* Mar del Plata: Dirección de Bellas Artes, 1944. 455 p.

478. Salón de Arte de Mar del Plata (4th : 1945 : Mar del Plata, Argentina). *IV Salón de Arte de Mar del Plata; {exposición}, 9 febrero-20 marzo 1945.* Mar del Plata, 1945. 30 p.

479. Salón de Arte de Mar del Plata (6th : 1947 : Mar del Plata, Argentina). *VI Salón de Arte de Mar del Plata, {exposición}, 1 febrero-15 marzo 1947.* Mar del Plata: Palacio del Casino, 1947. 51 p.

480. Salón de Arte de Mar del Plata (14th : 1955 : Mar del Plata, Argentina). *XIV Salón de Arte de Mar del Plata, 1955.* Buenos Aires, 1955.

481. Salón de Arte de Pergamino (1st : 1936? : Pergamino, Argentina). *Salón de Arte de Pergamino, 1936?-* . Pergamino, 1936?- .

482. Salón de arte de Pergamino (9th : 1945 : Pergamino, Argentina). *IX Salón de Arte de Pergamino; {exposición}, desde el 9 al 31 de julio 1945.* Pergamino: Palacio Municipal, 1945. 15 p.

483. Salón de Arte de Pergamino (11th : 1947 : Pergamino, Argentina). *XI Salón de Arte de Pergamino; {exposición}, desde el 12 al 31 de julio 1947.* Pergamino: Palacio Municipal, 1947. 13 p.

484. Salón de Arte Sagrado y Retrospectivo (1st : 1940 : Santa Fé, Argentina). *Salón de Arte Sagrado y Retrospectivo, 1940-* . Santa Fé, 1940- .

485. Salón de Arte Sagrado y Retrospectivo (1st : 1940 : Santa Fé, Argentina). *Primer Salón de Arte Sagrado y Retrospectivo.* Santa Fé: Museo Provincial de Bellas Artes 'Rosa Galisteo de Rodríguez,' 1940. 20 p.

486. Salón de Otoño de la Sociedad Argentina de Artistas Plásticos (1st : 1934 : Buenos Aires, Argentina). *Salón de Otoño de la Sociedad Argentina de Artistas Plásticos, 1934-* . Buenos Aires, 1934- .

487. Salón de Otoño de la Sociedad Argentina de Artistas Plásticos (2nd : 1935 : Buenos Aires, Argentina). *Catálogo ilustrado del II Salón de Otoño de la Sociedad Argentina de Artistas Plásticos.* Buenos Aires: Botu, 1935. 158 p.

 Exhibition held May, 1935.

488. Salón de Rosario (1st : 1921? : Rosario, Argentina). *Salón de Rosario, 1921?-* . Rosario, 1921?- .

489. Salón de Rosario (21st : 1942 : Rosario, Argentina). *Catálogo del XXI Salón de Rosario.* Rosario: Museo Municipal de Bellas Artes 'Juan B. Castagnino', 1942.

 Catalog of an exhibition held July 9-31, 1942.

492. Salón del Litoral (1st : 1941? : Santa Fé, Argentina). *Salón del Litorial, 1941?-* . Santa Fé, 1941?- .

493. Salón del Litoral (3rd : 1944 : Santa Fé, Argentina). *Tercer Salón del Litoral (Cuatro Salón Anual) del 30 de septiembre al 21 de octubre 1944.* Santa Fé: Museo Municipal de Bellas Artes, 1944. 16 p.

494. Salón Juvenil de Artes Plásticas de Córdoba (1st : 1965? : Córdoba, Argentina). *Salón Juvenil de Artes Plásticas de Córdoba, 1965?-* . Córdoba, 1965- .

495. Salón Juvenil de Artes Plásticas de Córdoba (4th : 1969 : Córdoba, Argentina). *Córdoba; escultura, dibujo actual; exposición de artistas premiados y menciones de honor del IV Salón Juvenil de Artes Plásticas de Córdoba, 26 de septiembre al 14 de octubre de 1969.* Buenos Aires, 1969. 8 p.

496. Salón Municipal de Artes Plásticas 'Manuel Belgrano' (1959 : Buenos Aires, Argentina). *Salón Municipal de Artes Plásticas 'Manuel Belgrano.'* Buenos Aires, 1959. 23 p.

497. Salón Municipal de Artes Plásticas 'Manuel Belgrano' (1970 : Buenos Aires, Argentina). *Salón Municipal de Artes Plásticas 'Manuel Belgrano', 1970.* Buenos Aires, 1970. 32 p.

498. Salón Municipal de Artes Plásticas 'Manuel Belgrano' (1971 : Buenos Aires, Argentina). *Salón Municipal de Artes Plásticas 'Manuel Belgrano', 1971.* Buenos Aires: Museo de Artes Plásticas Eduardo Sivori, 1971. 32 p.

499. Salón Municipal de Artes Plásticas 'Manuel Belgrano' (1973 : Buenos Aires, Argentina). *Salón Municipal de Artes Plásticas Manuel Belgrano, 1973.* Buenos Aires: Museo de Artes Plásticas Eduardo Sivori, 1973. 36 p.

500. Salón Municipal de Artes Plásticas 'Manuel Belgrano' (1979 : Buenos Aires, Argentina). *Salón Municipal de Artes Plásticas Manuel Belgrano, 1979.* Buenos Aires: Museo de Artes Plásticas Eduardo Sívori, 1979. 32 p.

501. Salón Municipal de Otoño de Artes Plásticas (1st : 1945 : Buenos Aires, Argentina). *Salón Municipal de Otoño de Artes Plásticas, 1945- .* Buenos Aires, 1945- .

502. Salón Municipal de Otoño de Artes Plásticas (2nd : 1946 : Buenos Aires, Argentina). *II Salón Municipal de Otoño de Artes Plásticas.* Buenos Aires: Municipalidad de la Ciudad, 1946. 28 p.

503. Salón Nacional de Artes Plásticas (1st : 1911 : Buenos Aires, Argentina). *Salón Nacional de Artes Plásticas, 1911- .* Buenos Aires: Ministerio de Justicia e Instrucción Pública, 1911- .

504. Salón Nacional de Artes Plásticas (35th : 1945? : Buenos Aires, Argentina). *Salón Nacional de Artes Plásticas, 35.* Buenos Aires: Ministerio de Justicia e Insturcción Pública, 1945? 327 p.

505. Salón Nacional de Artes Plásticas (58th : 1969 : Buenos Aires, Argentina). *Salón Nacional de Artes Plásticas, LVIII, Buenos Aires, 1969; catálogo ilustrado y documental.* Buenos Aires: Ministerio de Cultura y Educación, 1969. 231 p.

506. Salón Nacional de Artes Plásticas (60th : 1971 : Buenos Aires, Argentina). *Salón Nacional de Artes Plásticas, LX, Buenos Aires, 1971; catálogo ilustrado y documental.* Buenos Aires: Ministerio de Cultura y Educación, 1971. 171 p.

507. Salón Nacional de Bellas Artes (1944 : Buenos Aires, Argentina). *Salón Nacional de Bellas Artes, 1944- .* Buenos Aires, 1944- .

Before 1944, sponsored by the Comisión Nacional de Bellas Artes.

508. Salón Nacional de Pintura y Escultura (1st : 1950? : Buenos Aires, Argentina). *Salón Nacional de Pintura y Escultura, 1950?- .* Buenos Aires, 1950- .

509. Salón Nacional de Pintura y Escultura (11th : 1959 : Buenos Aires, Argentina). *IX Salón Nacional de Pintura y Escultura, {exposición}, 8 al 30 de julio 1959.* San Miguel de Tucumán, Argentina: Museo Provincial de Artes Visuales, 1959. 36 p.

510. Santa Fé (Argentina). Museo Provincial de Bellas Artes 'Rosa Galisteo de Rodríguez'. *Exposición Boa-Phases; confrontación internacional de arte experimental, del 4 al 20 de junio de 1959.* Santa Fé, 1959. 40 p.

511. Santa Fé (Argentina). Universidad Nacional del Litoral. Instituto Social. *Primera reunión de arte contemporáneo, 1957.* Santa Fé, 1958. 174 p.

512. Schiaffino, Eduardo. *La pintura y la escultura en Argentina, 1783-1894.* Buenos Aires, Argentina: Edición del Autor, 1933.

513. Segni, Franco di. *Hacia la pintura; psicoanálisis aplicado al arte.* Buenos Aires, Argentina: Ediciones del Movimiento NOA, c1960. 119 p.

514. Segni, Franco di. *Muerte y destrucción de un cuadro de Sameer Makarius (psicoanálisis aplicado al arte).* Buenos Aires, Argentina: Ediciones del Movimiento NOA, 1960. 71 p.

515. Segni, Franco di. *Un nuevo método para la comprensión del arte; relato de una experiencia grupal.* Buenos Aires, Argentina: Ediciones del Movimiento NOA, 1959. 31 p.

516. Slullitel, Isidoro. *Cronología del arte en Rosario.* Buenos Aires, Argentina: Editorial Biblioteca, 1968.

517. Sociedad de Acuarelistas y Grabadores (Buenos Aires, Argentina). *25 Aniversario.* Buenos Aires, 1939. 23 p., 97 plates.

518. Sociedad Española de Amigos del Arte (Madrid, Spain). *Plásticos argentinos en España: Audivert, Brie, Cocca Ventura, Cortés, Cheridi, Di Mauro, {et al.}, {27 mayo al 2 junio 1968}.* Madrid, 1968. 36 p.

519. Squirru, Rafael. *Arte de América; 25 años de crítica.* Buenos Aires, Argentina: Gaglianone, 1979. 506 p.

520. Squirru, Rafael. *Claves del arte actual.* Buenos Aires, Argentina: Troquel, 1976.

521. Storni, Eduardo Raúl, and Colón, Antonio. *Santa Fé en la plástica.* Santa Fé, Argentina: Castellví, 1954. 103 p.

522. *Las tareas rurales en la iconografía argentina.* Buenos Aires, Argentina: Sociedad Rural Argentina, 1972. 1 v.

 Depictions of rural working life in the 19th century.

523. UNESCO. *Cultural policy in Argentina.* Paris, France: UNESCO, 1979. 92 p.

524. United Nations (New York, N.Y.). *10 artistas argentinos en las Naciones Unidas: {exposición}.* New York, n.d. 26 p.

 Text in Spanish and English.

525. Uribe, Basilio. *La mujer argentina en las artes visuales de hoy.* Buenos Aires, Argentina: Ministerio de Cultura y Educación, 1972.

526. Van Riel, Galería (Buenos Aires, Argentina). *7AM; siete artistas argentinos Madí; dibujo, pintura, escultura, arquitectura.* {Buenos Aires, 1957}.

 Catalog of an exhibition held December 1957.

527. *Veinte pintores y escultores.* Buenos Aires, Argentina: Ediciones Culturales Argentinas, {1963?}. {54} p.

528. Viau Galería de Arte (Buenos Aires, Argentina). *Grupo de artistas modernas de la Argentina: pinturas, esculturas, dibujos: Aebi, Fernández-Muro, Girola, Sarah Grilo, Hlito, Iommi, Maldonado, Ocampo, Lidy Prati.* {Buenos Aires, 1952}.

 Exhibition catalog.

529. Viña del Mar (Chile). Museo Municipal de Bellas Artes. *Obras del arte argentino desde Pueyrredón hasta nuestros días, VIII Salón de Verano, 1940.* Viña del Mar, 1940. 12 p.

530. Washington World Gallery (Washington, D.C.). *Recent Argentine art, {exhibition, March 1979}.* Washington, D.C., 1979. 24 p.

ARGENTINA—GENERAL—BIBLIOGRAPHIES

531. *Anuario plástico.* Buenos Aires, Argentina: Editorial Plástica, 1938?- .

 Reviews of the most important exhibitions in Argentina.

532. *Bibliografía argentina de arte y letras.* no. 1 (enero-marzo 1959)- .
 Buenos Aires, Argentina: Fondo Nacional de las Artes, 1959- .

533. Buschiazzo, Mario José. *Bibliografía de arte colonial argentino.* Buenos Aires, Argentina: Universidad de Buenos Aires, Instituto de Arte Americano e Investigaciones Estéticas, 1947. 150 p.

 Classified bibliography of books, periodical articles and documents; short annotations.

534. Sabor, Josefa, and Revello, Lydia H. *Bibliografía básica de obras de referencia de artes y letras para la Argentina.* Buenos Aires, Argentina: Fondo Nacional de las Artes, 1969. 82 p.

 Bibliografía argentina de artes y letras; compilaciones especiales, no. 36.

ARGENTINA—GENERAL—COLLECTIONS

535. Argentina. Academia Nacional de Bellas Artes. *Conmemoración del XXV aniversario de su creación, julio 1 de 1936-1961.* Buenos Aires, 1961. 27 p.

536. Argentina. Academia Nacional de Bellas Artes. *Memoria 1948.* Buenos Aires: Peuser, 1948. 18 p.

537. Argentina. Fondo Nacional de las Artes. *Los 15 años del Fondo Nacional de las Artes.* Buenos Aires, 1973. 238 p.

538. Avellaneda (Argentina). Museo de Arte. *Museo de Arte de Avellaneda.* Avellaneda, 1956.

539. Buenos Aires (Argentina). Instituto Torcuato Di Tella. Centro de Artes Visuales. *Colección Torcuato Di Tella.* Buenos Aires, 1965. 90 p.

 Text by Lionello Venturi and Jorge Romero Brest.

540. Buenos Aires (Argentina). Instituto Torcuato Di Tella. Centro de Artes Visuales. *Colección Torcuato Di Tella; {exposición}, del 20 de setiembre al 27 de octubre de 1963.* Buenos Aires, 1963. 18 p.

541. Buenos Aires (Argentina). Instituto Torcuato Di Tella. *Memoria, 1963.* Buenos Aires, 1964. lv.

542. Buenos Aires (Argentina). Instituto Torcuato Di Tella. *Memoria y balance, 1967.* Buenos Aires, c1968. 72 p.

 Annual report and the years activities.

543. Buenos Aires (Argentina). Museo de Arte Moderno. *Anuario del Museo de Arte Moderno de Buenos Aires, 1960.* Buenos Aires, 1960. 65 p.

 Summation of the year's activities.

544. Buenos Aires (Argentina). Museo de Arte Moderno. *MAM 10 años, 1956-1967.* Buenos Aires, 1967? 32 p.

545. Buenos Aires (Argentina). Museo Municipal de Bellas Artes y Anexo de Artes Comparadas. *Catálogo general del Museo Municipal de Bellas Artes y Anexo de Artes Comparadas.* Buenos Aires: Intendencia Municipal de la Ciudad, 1946. 300 p.

546. Buenos Aires (Argentina). Museo Nacional de Arte Decorativo. *Catálogo del Museo Nacional de Arte Decorativo.* Buenos Aires: Comisión Nacional de Cultura, 1947.

547. Buenos Aires (Argentina). Museo Nacional de Bellas Artes. *Colección Alfredo González Garaño; iconografía argentina/sudamericana siglo XIX; {exposición, septiembre 1979}.* Buenos Aires, 1979. 24 p.

 Bibliography.

548. Buenos Aires (Argentina). Museo Nacional de Bellas Artes. *Colección Scheimberg; {exposición, setiembre 1977}.* Buenos Aires, 1977. 16 p.

 Collection of Dr. Simón Scheimberg.

549. Buenos Aires (Argentina). Museo Nacional de Bellas Artes. *Inauguración de la nueva sede del Museo Nacional de Bellas Artes...* Buenos Aires, 1933.

550. Centro de Arte y Comunicación (Buenos Aires, Argentina). *What is the Center of Art and Communication of Buenos Aires?* Buenos Aires: CAYC, 197? 8 p.

551. González Garaño, Alejo B. *Homenaje de la Academia Nacional de Bellas Artes a González Garaño; catálogo de la muestra de obras representativas de su colección realizada en la Asociación Amigos del Libro.* Buenos Aire: Kraft, 1968. 23 p.

552. Lujan (Argentina). Museo Colonial e Historico de Lujan. *Catálogo del Museo Colonial e Historico de Lujan, (1933-1934).* La Plata: Imprenta Oficiales, 1934. 261 p.

553. Paraná (Argentina). Museo Provincial de Bellas Artes Dr. Pedro E. Martínez. *Catálogo general de obras.* Paraná, 1968. 33 p.

554. Santa Fé (Argentina). Museo Provincial de Bellas Artes Rosa Galisteo de Rodríguez. *La donación Luis León de Los Santos, 1942-1952.* Santa Fé, 1952. 59 p.

555. Santa Fé (Argentina). Museo Provincial de Bella Artes Rosa Galisteo de Rodríguez. *Museo Provincial Rosa Galisteo de Rodríguez.* Santa Fé: Imprenta de la Provincia, 1948. 79 p.

 Painting and sculpture.

556. Santa Fé (Argentina). Museo Provincial de Bellas Artes Rosa Galisteo de Rodríguez. *Museo Rosa Galisteo de Rodríguez, 1922-1947; guía general de obras.* Santa Fé: Imprenta de la Provincia, {1947}. 107 p.

ARGENTINA—GENERAL—DICTIONARIES, ETC.

557. Merlino, Adrián. *Diccionario de artistas plásticas de la Argentina, siglos XVII-XIX-XX.* Buenos Aires, 1954. 433 p.

558. *A; publicación de arte.* no. 1 (March 1956?)- . Buenos Aires, Argentina? 1956?- .

559. *A partir de cero.* no. 1 (November 1952)- . Buenos Aires, Argentina? 1952- .

 Surrealist periodical directed by Enrique Molina.

560. *La Actualidad en el arte.* v. 4, no. 18 (May 1980)- . Buenos Aires, Argentina, 197?- .

561. *Anales del Instituto de Arte Americano e Investigaciones Estéticas.* no. 1 (1948)- . Buneos Aires, Argentina: Universidad de Buenos Aires, Facultad de Arquitectura y Urbanismo, 1948- .

562. *Anuario de la crítica de arte de la Asociación Argentina de Críticos de Arte.* 196-?- . Buenos Aires, Argentina: Asociación Argentina de Críticos de Arte, 196-?- .

563. *Argentina; periódico de arte y crítica.* v. 1, no 1-3 (November 1930-August 1931). Buenos Aires, 1930-31.

564. *Argentina en el arte.* v. 1 (1966)- . Buenos Aires, Argentina: Viscontea Editora, 1966- .

565. *Ars; revista de arte.* v. 1 (1941)- . Buenos Aires, Argentina, 1941- .

566. *Arte concreto.* no. 1 (August 1946)- . Buenos Aires, Argentina, 1946- .

567. Arte Concreto-Invención. 1945- . Buenos Aires, Argentina, 1945- .

568. *Arte informa.* v. 3 (1972)- . Buenos Aires, Argentina, 1970?- .

569. *Arte Madí.* no. 1-8 (1947?-June 1954). Buenos Aires, Argentina, 1947?-1954.

 Title also appears as Arte Madí Universal; ceased publication with no. 7/8 (June 1954).

570. *Arte nuevo.* no. 1 (1956)- . Buenos Aires, Argentina, 1956- .

 Semiannual?

571. *Artemúltiple.* v. 1, no. 1 (1977?)- . Buenos Aires, Argentina, 1977?-

572. *Artes y letras argentinas.* v. 1-8, no. 1-31 (Oct./Dec. 1958-May/Dec. 1966). Buenos Aires, Argentina: Fondo Nacional de las Artes, 1958-66.

Title varies: Boletín del Fondo Nacional de las Artes.

573. *Artinf; arte informa.* no. 1-17 (1970-June 15-July 15, 1973). Buenos Aires, Argentina, 1970-73.

Second series: no. 19 {May 1980}- .

574. *Artiempo.* v. 1 (1968?)- . Buenos Aires, Argentina, 1968?- .

575. *Arturo; revista de artes abstractos.* no. 1 (Summer 1944). Buenos Aires, Argentina, 1944.

576. *Augusta; revista de arte.* v. 1-5, no 1-31 (June 1918-December 1920). Buenos Aires, Argentina, 1918-1920.

Monthly

577. *Boa.* no. 1-3 (May 1958-July 1960). Buenos Aires, Argentina? 1958-1960.

Surrealist magazine.

578. *Cabalgata; revista mensual de letras y artes.* v. 1, no. 1 (October 1946)- . Buenos Aires, Argentina, 1946- .

579. *Ciclo; arte, literatura, y pensamiento moderno.* no. 1-2 (Nov./Dec. 1948-March/April 1949). Buenos Aires, Argentina, 1948-49.

580. *Correo de arte.* 1977?- . Buenos Aires, 1977?- .

581. *Crónica de arte.* v. 1, no. 1-2 (June-Sept. 1931). La Plata, Argentina, 1931.

Published by the Museo de La Plata, Argentina.

582. *Cuadernos de arte nuevo; publicación bimestral.* v. 1, no 1 (March/June 1977)- . Buenos Aires, Argentina: Ediciones Arte Nuevo, 1977- .

583. *Diagonal cero.* no. 1 (1962?)- . La Plata, Argentina, 1962?-

Three times a year.

584. *Guía quincenal de la actividad intelectual y artistica argentina.* v. 1, no. 1 (April 1947)- . Buenos Aires, Argentina: Comisión Nacional de Cultura, 1947- .

585. *Horizontes; revista de arte.* v. 1, no. 1 (Sept. 1978)- . Buenos Aires, Argentina, 1978- .

586. *Letra y línea; revista de cultura contemporánea, artes plásticas, literatura, teatro, cine música, crítica.* 1953?- . Buenos Aires, Argentina, 1953?- .

　　　Directed by Aldo Pelligrini.

587. *Martín Fierro; periódico quincenal de arte y crítica libre.* v. 1-4, no. 1-44 (Feb. 1924-Aug./Nov. 1927?). Buenos Aires, Argentina, 1924-27?

588. *Ojo; revista de arte contemporáneo.* no. 1 (1976)- . Buenos Aires, Argentina, 1976- .

589. *Perceptismo; téorico y polémico.* no. 1 (Oct. 1950)- . Buenos Aires, Argentina, 1950- .

590. *Plástica.* v. 1-2, no. 1-10 (June 1935-Oct. 1936; new series, 1939-1948). Buenos Aires, Argentina, 1935-48.

　　　Monthly, 1935-36; annual 1939-48; suspended Nov. 1936-38.

591. *Pluma y pincel.* v. 1 (1976?)- . Buenos Aires, Argentina, 1976?- .

　　　Bimonthly.

592. *Qué.* no. 1-2 (1928-1930). Buenos Aires, Argentina, 1928-1930.

　　　Surrealist magazine.

593. *Ver y estimar.* 1948-1955. Buenos Aires, Argentina, 1948-1955.

ARGENTINA—GENERAL—PERIODICALS—INDEXES

594. Kahan, Nélida. *Bibliografía argentina de arte y letras (compilaciones especiales correspondiente al no. 24; las artes plásticas en revistas argentinas).* Buenos Aires, Argentina: Fondo Nacional de las Artes, 1966. 120 p.

　　　Indexes to the journals *Augusta; revista de arte,* and *Plástica.*

595. *Arquitectura bonaerense.* Buenos Aires, Argentina: Leonardo Preiss, 1912? 50 plates.

596. *Arquitectura en la Argentina.* Buenos Aires, Argentina: Eudeba, 1980. 3 v. (10 fasicules; no. 1, 17 p.).

597. Bullfinch, Francisco. *Arquitectura argentina contemporánea; panorama de la arquitectura argentina, 1950-63.* Buenos Aires, Argentina: Ediciones Nueva Visión, c1963. 164 p.

598. Buschiazzo, Mario J. *La arquitectura en la República Argentina, 1810-1930.* Buenos Aires, Argentina: Artes Gráficas B.U. Chiesino, 1966. 41 p.

 Another edition: Buenos Aires, Argentina: Jorman, 1971. 2 v. {56, 31 p.}

599. Glusberg, Jorge. *Arquitectos de Buenos Aires.* Buenos Aires, Argentina: Espacio, 1979. 141 p.

600. Glusberg, Jorge. *Hacia una crítica de la arquitectura.* Buenos Aires, Argentina: Espacio, 1980. 219 p.

601. Guido, Angel. *Arqueologia y estética de la arquitectura criolla.* Buenos Aires, Argentina: Cles, 1932. 32 p.

602. Gutiérrez, Ramón, and Viñuales, Graciela María. *Evolución de la arquitectura en Rosario, 1850-1930.* Resistencia, Argentina: Universidad Nacional del Nordeste, Facultad de Ingeniería, Vivienda y Planeamiento, Departamento de Historia de la Arquitectura, 1969. 1 v.

603. Matamoro, Blas. *La casa porteña.* Buenos Aires, Argentina: Centro Editor de América Latina, 1971. 114 p.

604. Viñales, Graciela María. *Evolución de la arquitectura de la provincia de Salta.* Resistencia, Argentina: Universidad Nacional del Nordeste, Facultad de Ingeniería, Vivienda y Planeamiento, Departamento de Historia de la Arquitectura, 1969. 35 p.

605. *Viviendas argentinas; selección de casas individuales modernas, rústicas, californianas, etc., proyectadas por conocidos arquitectos.* Buenos Aires, Argentina: Editorial Contemora, n.d. 135 p.

ARGENTINA—ARCHITECTURE—DICTIONARIES, ETC.

606. Sociedad Central de Arquitectos (Buenos Aires, Argentina). *Anuario, 1943-* . Buenos Aires, 1943- .

 Annual yearbook of publications, list of members, competitions, etc.

ARGENTINA—ARCHITECTURE—PERIODICALS

607. *Revista de arquitectura.* no. 1 (1913)- . Buenos Aires, Argentina, 1913- .

608. *Summa; revista de arquitectura, tecnología y diseño.* 196-?- . Buenos Aires, 196?- .

ARGENTINA—DESIGN

609. Buenos Aires (Argentina). Centro de Investigación del Diseño Industrial. *Muestra de disen ñ o industrial; CIDI 71, 7 al 27 de junio {1971}.* Buenos Aires: Museo de Arte Moderno, 1971. 70 p.

 Exhibition held at the Museo de Arte Moderno, Buenos Aires, Argentina.

610. Buenos Aires (Argentina). Museo de Arte Moderno. *Objetos útiles e inútiles con acrílicopaolini, {exposición, del 9 de noviembre al 9 de diciembre de 1970}.* Buenos Aires, 1970. 24 p.

ARGENTINA—GRAPHIC ARTS

611. Antonio, Juan. *Xilografías porteñas.* Buenos Aires, Argentina: Municipalidad de la Ciudad de Buenos Aires, 1947. {29} p.

612. Bróccoli, Alberto, and Trillo, Carlos. *Las historietas.* Buenos Aires, Argentina: Centro Editor de América Latina, 1972. 107 p.

 Art of the comic strip.

613. Buenos Aires (Argentina). Biblioteca Nacional. *Exposición el grabado en las ediciones argentinas, octubre 1967.* Buenos Aires, 1967. 32 p.

 Exhibition also shown at the Museo del Grabado, Buenos Aires, Argentina.

614. Buenos Aires (Argentina). Escuela Superior de Bellas Artes de la Nacion 'Ernesto de la Carcova'. *Exposición del taller de grabado, 1932-1943, del 8 al 20 de noviembre, Galería Muller.* {Buenos Aires: Ministerio de Justicia e Instrucción Pública, Dirección Nacional de Artes Plásticas, 1943}. {16} p.

615. Buenos Aires (Argentina). Museo de Arte Moderno. *Panorama nacional del grabado, {exposición, del 11 al 30 de diciembre de 1973}.* Buenos Aires, 1973. 8 p.

616. Buenos Aires (Argentina). Museo de Arte Moderno. *Premio dibujo 25 años MAM.* Buenos Aires, {1981}. {24} p.

Catalog of an exhibition, Sept. 1981.

617. Buenos Aires (Argentina). Museo del Grabado. *G; contribución al mayor conocimiento del grabado como obra de arte, {exposición}, octubre 1963.* Buenos Aires, 1963. 12 p.

618. Buenos Aires (Argentina). Museo Nacional de Bellas Artes. *Dibujos de Badii, Casariego, Heredia, Sinclair, Wells... {exposición}, a partir del 7 de julio hasta el 6 de noviembre de 1966.* Buenos Aires, 1966. 14 p.

619. Buenos Aires (Argentina). Museo Nacional de Bellas Artes. *Grabados argentinos: {exposición}, 28 de abril-29 de mayo 1967.* Buenos Aires, 1967. ca 40 p.

620. Centro de Arte y Comunicación (Buenos Aires, Argentina). *El dibujo en la Argentina; muestra circulante.* Buenos Aires, 197? 8 p.

621. Córdoba (Argentina). Universidad Nacional de Córdoba. *Grabados de alumnos de la Escuela de Artes, Universidad Nacional de Córdoba.* Córdoba, 1963. portfolio.

622. Hernández, José. *Martín Fierro/72; con la aportación literaria de treinta y dos escritores y las realizaciones originales de cincuenta y ocho artistas plásticos: homenaje.* Buenos Aires, Argentina: Instituto Salesiano de Artes Gráficas, 1972. 256 p.

623. López Anaya, Fernando. *El grabado argentino en el siglo XX; principales instituciones promotoras.* Buenos Aires, Argentina: Ediciones Culturales Argentinas, 1963. 51 p.

624. Moores, Guillermo H. *Estampas y vistas de la Ciudad de Buenos Aires, 1599-1895.* Buenos Aires, Argentina: Municipalidad de Buenos Aires, 1945. 189 p.

Second edition, 1960. 197 p.

625. Pecora, Oscar C. *Sesenta y cinco grabados en madera; la xilografía en el Rio de La Plata...* Buenos Aires, Argentina: Ediciones Plásticas, 1943. 32 p.

626. Premio Benson & Hedges al Nuevo Grabado y Dibujo en Argentina (1978 : Buenos Aires, Argentina). *Premio Benson & Hedges al Nuevo Grabado y Dibujo en Argentina.* {Buenos Aires}, 1978. {68} p.

 Exhibition catalog.

627. Rosario (Argentina). Museo Municipal de Bellas Artes 'Juan B. Castagnino'. *El grabado en la Argentina, 1705-1942.* Rosario: Taller de Tambirini, 1942. 55 p.

 Catalog of an exhibition held, October 25-November 22, 1942.

628. Salón de la Tradición Argentina de Grabado, Dibujo e Ilustración (1st : 1955? : Avellaneda, Argentina). *Salón de la Tradición Argentina de Grabado, Dibujo e Ilustración, 1955-* . Avellaneda, 1955- .

629. Salón de la Tradición Argentina de Grabado, Dibujo e Ilustración (2nd : 1956 : Avellaneda, Argentina). *II Salón de la Tradición Argentina de Grabado, Dibujo e Ilustración; {exposición}, Museo de Arte de Avellaneda del 9 al 30 de noviembre 1956.* Avellaneda: Dirección General de Cultura, 1956. 21 p.

630. Salón Nacional de Dibujo y Grabado (1st : 1951 : Buenos Aires, Argentina). *Salón Nacional de Dibujo y Grabado, 1951-* . Buenos Aires: Dirección General de Cultura, 1951- .

631. Salón Nacional de Dibujo y Grabado (1st : 1951 : Buenos Aires, Argentina). *Primer Salón Nacional de Dibujo y Grabado, 1951.* Buenos Aires: Dirección General de Cultura, 1951. 52 p.

632. Salón Nacional de Dibujo y Grabado (6th : 1970 : Buenos Aires, Argentina). *Salón Nacional de Grabado y Dibujo, VI, Buenos Aires, 1970; catálogo ilustrado y documental.* Buenos Aires: Ministerio de Cultura y Educación, 1970. 72 p.

633. Salón Swift de Grabado (1st : 1968 : Buenos Aires, Argentina). *Salón Swift de Grabado, 1968-* . Buenos Aires, 1968- .

634. Salón Swift de Grabado (1st : 1968 : Buenos Aires, Argentina). *Primer Salón Swift de Grabado, 1968; {exposición, del 4 al 20 de octubre de 1968}.* Buenos Aires: Museo de Arte Moderno, 1968. 8 p.

635. Salón Swift de Grabado (2nd : 1969 : Buenos Aires, Argentina). *Segundo Salón Swift de Grabado, 1969, {exposición, Museo de Arte Moderno, del 1 al 19 de octubre de 1969}.* Buenos Aires, 1969. 8 p.

636. Santa Fé (Argentina). Museo Provincial de Bellas Artes 'Rosa Galisteo de Rodríguez.' *Exposición de litografías, estampas y grabados de asuntos argentinos y americanos, siglo XIX, Museo Rosa Galisteo de Rodríguez.* Santa Fé, 1947. 59 p.

637. Washington (D.C.). Corcoran Gallery of Art. *Modern Argentine drawings; {exhibition}.* {Washington, D.C., c1975}. {24} p.

 Organized jointly with the Museo de Bellas Artes, Buenos Aires, Argentina.

ARGENTINA—PAINTING

638. Altamira, Luis Roberto. *Córdoba, sus pintores y sus pinturas (siglos XVII y XVIII).* Córdoba, Argentina: Universidad Nacional de Córdoba, 1954. 455 p.

639. Amsterdam (Netherlands). Stedelijk Museum. *Acht argentijnse abstracten.* Amsterdam, {1953}. {10} p.

 Exhibition catalog.

640. Argentina. Ministerio de Cultura y Educación. *Algunos maestros de la pintura argentina.* Salta, 1949. 20 p.

641. Argentina. Ministerio de Cultura y Educación. *Pintura argentina, 1923-1969.* Buenos Aires, 1970. 24 p.

642. Argentina. Secretaria de Educación, Subsecretaría de Cultura. *Algunos maestros de la pintura argentina.* Buenos Aires, 1948. 54 p.

643. Argentina. Secretaria de Educación, Subsecretaría de cultura. *Algunos maestros de la pintura argentina; jornadas previas del Tren Cultura, 18-20 de junio.* Buenos Aires, 1949. 19 p.

644. Argul, José Pedro. *Exposiciones de pintura*. Buenos Aires, Argentina: Argos, 1951.

645. Avellaneda (Argentina). Museo de Arte. *Diez años a través de treinta pintores argentinos*. Avellaneda, 1957. 30 p.

646. Bandin, Ron. *Plástica argentina; reportaje a los años 70*. Buenos Aires, Argentina: Corregidor, c1978. 228 p.

647. Bedel, Rene. *Letras para la pintura*. Buenos Aires, Argentina: Francisco A. Colombia, 1980. 106 p.

648. Bienal de Pintura Actual Pipino y Marquez (1st : 1958 : Buenos Aires, Argentina). *Bienal de Pintura Actual Pipino y Marquez, 1958- *. Buenos Aires, 1958- .

649. Bienal de Pintura Actual Pipino y Marquez (2nd : 1960 : Buenos Aires, Argentina). *2a. Bienal de Pintura Actual Pipino y Marquez; {exposición}, Córdoba, 13 de junio 1960; Buenos Aires, 4 de julio 1960, Galería Van Riel*. Buenos Aires, 1960. 48 p.

650. Bienal de São Paulo (6th : 1961 : São Paulo, Brazil). *Arte argentino, 1961; VIa. Bienal, Museo de Arte Moderno de São Paulo, Brasil: {exposición}, setiembre-diciembre 1961*. São Paulo, 1961? 120 p.

651. Biennale di Venezia (32nd : 1964 : Venice, Italy). *Argentina, XXXII Bienal de Venecia, 1964*. Buenos Aires, Argentina: Dirección General de Relaciones Culturales, 1964. 40 p.

652. Bogotá (Colombia.) Museo de Arte Moderno. *EDPA; exposición de pintura argentina, noviembre 1963*. Bogotá, 1963. 75 p.

653. Bonino, Galería (New York, N.Y.). *Four new Argentinian artists; {Brizzi, Mac-Entyre, Polesello, Vidal}*. {New York, 1968}. 12 p.

 Exhibition catalog.

654. Brughetti, Romualdo. *De la joven pintura rioplatense*. Buenos Aires, Argentina: Ediciones Plástica, 1942. {43} p.

655. Brughetti, Romualdo. *Geografía plástica argentina; planteo nacional por un arte universal*. Buenos Aires, Argentina: Nova, 1958. 126 p.

656. Brughetti, Romualdo. *Introducción al estudio de la escuela pictórica argentina*. Buenos Aires, Argentina, 1964.

657. Brughetti, Romualdo. *Pintura argentina joven (1930-1947); nuevas señales para una teoría sobre arte nacional.* Buenos Aires, Argentina: Ollantay, 1947. 78 p.

658. Brughetti, Romualdo. *Pintura joven.* Buenos Aires, Argentina: Ollantay, 1947.

659. Buenos Aires (Argentina). Instituto Torcuato Di Tella. *Surrealismo en la Argentina; exposición no. 46, del 9 al 29 de junio de 1967.* Buenos Aires, 1967. 61 p.

660. Buenos Aires (Argentina). Municipalidad. *Nuevas generaciones en la pintura argentina.* Buenos Aires, 1958? 116 p.

661. Buenos Aires (Argentina). Museo de Arte Moderno. *El paisaje en la Argentina a través de sus pintores en el siglo XX; {exposición}, junio/julio de 1980, año del IV Centenario de la fundación de Buenos Aires.* Buenos Aires, 1980. ca. 100 p.

662. Buenos Aires (Argentina). Museo de Arte Moderno. *Pintura argentina; {exposición}.* Buenos Aires, 1959. {38} p.

Text in Spanish and English.

663. Buenos Aires (Argentina). Museo de Artes Plásticas Eduardo Sívori. *El Taller de Spilimbergo en Tucumán; {exposición, 5 de julio de 1979}.* Buenos Aires, 1979. 36 p.

664. Buenos Aires (Argentina). Museo Nacional de Bellas Artes. *Deira, Macció, Noé, de la Vega; {exposición}, del 15 de junio al 7 de julio 1963...* Buenos Aires, 1963. 32 p.

665. Buenos Aires (Argentina). Museo Nacional de Bellas Artes. *F-Muro, Grilo, Ocampo, Sakai, Testa; {exposición}, julio de 1960.* Buenos Aires, 1960. 34 p.

666. Buenos Aires (Argentina). Museo Nacional de Bellas Artes. *Pintura argentina actual; dos tendencias; geometría, surrealismo.* Buenos Aires, 1976. 34 p.

Catalog of an exhibition held Sept.-Oct., 1976.

667. Butler, Horacio. *La pintura de mi tiempo.* Buenos Aires, Argentina: Sudamericana, 1966.

668. Carrasquilla-Mallarino, E. *Pintores y paisajes argentinos.* Buenos Aires, Argentina: Banco Municipal, 1939. 41 p.

669. *Certamen Nacional de Investigaciones Visuales.* Buenos Aires, Argentina: Ministerio de Cultura y Educación, Subsecretaría de Cultura, 1970. 37 p.

670. Clayton, Salón (Buenos Aires, Argentina). *Exposición de pintura argentina, julio de 1932.* Buenos Aires: Platie, 1932. {30} p.

671. Colón, Antonio. *Una época de la pintura santafesina.* Santa Fé, Argentina: Castellví, 1951. 78 p.

 Essays on late Romantic painters of Argentina.

672. Córdova Iturburu. *80 años de pintura argentina, del pre-impresionismo a la novísima figuración.* Buenos Aires, Argentina: Ediciones Librería La Ciudad, c1978. 243 p.

 Bibliography: p. 221-222.

673. Córdova Iturburu. *La pintura argentina del siglo XX.* Buenos Aires, Argentina: Atlántida, 1958. 272 p.

674. *Cuentistas y pintores.* Buenos Aires, Argentina: Editorial Universitaria de Buenos Aires, 1963. 76 p.

675. D'Arcy Galleries (New York, N.Y.). *10 Argentine painters; {exhibition, April 12-May 7, 1966}.* New York, 1966. 28 p.

676. *Diez pintores: Carlos Alonso...{et al.}.* Buenos Aires, Argentina: EUDEBA, 1963. 20 plates.

677. D'Onofrio, Armindo. *La época y el arte de Prilidiano Pueyrredón.* Buenos Aires, Argentina: Sudamericana, 1944. 115 p.

678. Fundación Lorenzutti (Buenos Aires, Argentina). *Panorama de la pintura argentina, 2; exposición del 15 al 30 de abril de 1969.* Buenos Aires, 1969. 179 p.

679. Fundación Lorenzutti (Buenos Aires, Argentina). *Pintura argentina; promoción internacional; 10 al 30 de julio de 1970 = Argentine painting; international promotion; 10 to 30 of July, 1970.* Buenos Aires: Museo Nacional de Bellas Artes, 1970. 1 v.

680. Fundación San Telmo (Buenos Aires, Argentina). *Otra figuración-- viente años despues.* Buenos Aires, {1981}. 12 p.

 Catalog of an exhibition, July 13-Sept. 1, 1981.

681. Galería del Buen Ayre (Buenos Aires, Argentina). *Exposición inaugural de la Galería del Buen Ayre, agosto-setiembre 1980.* Buenos Aires, 1980. 16 p.

682. Haber, Abraham {et al.}. *La pintura argentina.* Buenos Aires, Argentina: Centro Editora de América Latina, 1975. 96 p.

683. Junquet, Ana María. *Los precursores de nuestra pintura.* Buenos Aires, Argentina: Francisco A. Colombia, 1967. 68 p.

684. Lanuza, José Luis. *Pintores del viejo Buenos Aires.* Buenos Aires, Argentina: Ediciones Culturales Argentinas, 1961. 59 p.

685. Lima (Peru). Museo de Arte. *Un siglo de pintura en la Argentina; {exposición, 12-30 de noviembre de 1959}.* Lima, 1959. 20 p.

686. Mújica Lainez, Manuel. *Pintores argentinos; Orlando Pierri, Roberto Rossi, Raúl Russo, Marcos Tiglio.* Buenos Aires, Argentina: Editorial Pampa, 1953. ca. 50 p.

 Text in English and Spanish.

687. Nessi, Angel Osvaldo. *El Atelier de Pettoruti.* Buenos Aires, Argentina: Ediciones Culturales Argentinas, 1963.

688. Nessi, Angel Osvaldo. *Situación de la pintura argentina.* Buenos Aires, Argentina, 1956. 196 p.

689. Palomar, Francisco A. *Primeros salones de arte en Buenos Aires; reseña histórica de algunas exposiciones desde 1829.* Buenos Aires, Argentina: Secretaría de Cultura y Acción Social, 1962. 151 p.

690. *Panorama de la pintura argentina joven.* Buenos Aires, Argentina, 1972. 80 p.

 Catalog of an exhibition held at the Museo de Arte Moderno de Buenos Aires and the Museo de Artes Plásticas Eduardo Sívori, Buenos Aires, July 4-23, 1972.

691. Paris (France). Musée d'Art Moderne de la Ville de Paris. *Projection et dynamisme; six peintres argentins; {exposition}, mars-mai, 1973.* Paris, 1973. 32 p.

692. Payró, Julio E. *Veintidos pintores; facetas del arte argentina.* Buenos Aires, Argentina: Poseidon, 1944. 266 p.

693. Payró, Julio E. *23 pintores de la Argentina, 1810-1900.* Buenos Aires, Argentina: Universitaria, 1962. 62 p.

694. Pepsi-Cola Exhibition Gallery (New York, N.Y.). *Buenos Aires 64.* New York, 1964. 24 p.

695. Pellegrini, Aldo. *Panorama de la pintura argentina contemporánea.* Buenos Aires, Argentina: Paidós, 1967. 214 p.

696. Pellegrini, Aldo. *Pintura argentina.* Buenos Aires, Argentina: Paidós, 1968.

697. Perón, Juan Domingo. *El presidente de la Nacion, General Juan Perón, habla a los artistas pintores en el Salón Blanco de la Casa del Gobierno, Buenos Aires, 27 de noviembre de 1947.* Buenos Aires, 1947.

698. *Pintores argentinos.* Buenos Aires, Argentina: Pampa, 1952-54. 4 v.

Text in Spanish and English.

699. *Pintores argentinos del siglo XX.* Buenos Aires, Argentina: Centro Editor de América Latina, c1980- .

700. *Pintores de Rosario: Benvenuto, Cochet, Musto, Ouvrard, Schiavoni, Vanzo.* Rosario, Argentina: Krass Artes Plásticas, 1974. 1 v.

701. Premio Anual Dr. Genaro Pérez (1st : 1956 : Córdoba, Argentina). *Premio Anual Dr. Genaro Pérez, 1956- .* Córdoba, 1956- .

702. Premio Anual Dr. Genaro Pérez (1st : 1956 : Córdoba, Argentina). *Premio Anual Dr. Genaro Pérez, l; {exposición, 4 de julio de 1956}.* Córdoba: Museo Municipal, 1956? 20 p.

703. Premio Banco de Acuerdo (1980 : Buenos Aires, Argentina). *Premio Banco de Acuerdo; Museo Nacional de Bellas Artes, 1980.* Buenos Aires, 1980. {42} p.

704. Premio Benson & Hedges a la Nueva Pintura Argentina (1977 : Buenos Aires, Argentina). *Premio Benson & Hedges a la Nueva Pintura Argentina.* {Buenos Aires}, 1977. {56} p.

Exhibition catalog.

705. Premio de Pintura Instituto Torcuato Di Tella (1961 : Buenos Aires, Argentina). *Premio de Pintura Instituto Torcuato Di Tella, 1961- .* Buenos Aires, 1961- .

706. Premio Nacional de Pintura Instituto Torcuato Di Tella (1960 : Buenos Aires, Argentina). *Premio Nacional de Pintura Instituto Torcuato Di Tella, 1960-* . Buenos Aires, 1960- .

707. Premio Nacional e Internacional de Pintura Instituto Torcuato Di Tella (1963 : Buenos Aires, Argentina). *Premio Nacional e Internacional de Pintura Instituto Torcuato Di Tella, 1963-* . Buenos Aires, 1963- .

708. Premio Nacional e Internacional de Pintura Instituto Torcuato Di Tella (1963 : Buenos Aires, Argentina). *Premio Nacional e Internacional de Pintura Instituto Torcuato Di Tella, 1963; exposición 12 de agosto-8 de setiembre.* Buenos Aires, 1963. 64 p.

709. Rosario (Argentina). Museo Municipal de Bellas Artes 'Juan B. Castagnino'. *La postfiguración; Alvaro, Burton, Dowek, Gómez, Heredia, Soibelman; {exposición}, noviembre 1979.* Rosario, 1979. {32} p.

710. Salón IKA: Pintura (4th : 1961 : Córdoba, Argentina). *Salón de Artes Visuales Contemporáneas; IV Salón IKA: Pintura; catálogo.* Córdoba: Industrias Kaiser Argentina, 1961. 28 p.

711. Salón Italo (1st : 1968 : Buenos Aires, Argentina). *Salón Italo, 1968-* . Buenos Aires, 1968- .

712. Salón Italo (3rd : 1971 : Buenos Aires, Argentina). *Tercer Salón Italo: La energía de las artes visuales.* Buenos Aires: Museo Municipal de Arte Moderno, 1971. 34 p.

Organized by the Compañía Italo Argentina de Electricidad.

713. Salón Italo (4th : 1973 : Buenos Aires, Argentina). *Cuarto Salón Italo; homenaje al Profesor Julio E. Payró: {exposición, 24 de agosto al 9 de setiembre de 1973}.* Buenos Aires: Museo de Arte Moderno, 1973. 40 p.

714. Salón Nacional de Pintura (1961 : San Miguel de Tucumán, Argentina). *VI Salón Nacional de Pintura; {exposición}, 8 al 30 de julio 1961.* San Miguel de Tucumán: Museo Provincial de Artes Visuales, 1961. 18 p.

715. Salón Peuser (Buenos Aires, Argentina). *Salón Peuser; conferencias, concierto, exposición de artistas plásticos, exposición del libro; exposición inaugural.* Buenos Aires, 1944. 115 p.

716. Salón San Martiniano de Artes Plásticas (1950 : Buenos Aires, Argentina). *Salón San Martiniano de Artes Plásticas, 10 al 31 de oct. de 1950.* Buenos Aires: Comisión Nacional Homenaje al Libertador General San Martín, 1950. 49 plates.

717. San Martín, María Laura. *Pintura argentina contemporánea.* Buenos Aires, Argentina: La Mandrágora, 1961. 265 p.

718. Santa Fé (Argentina). Museo Municipal de Bellas Artes. *Cuatro artistas del Litoral.* Santa Fé, {1945}. {51} p.

719. Santa Fé (Argentina). Museo Provincial de Bellas Artes 'Rosa Galisteo de Rodríguez'. *Exposición de diez pintores rosarinos fallecidos en este siglo.* Santa Fé, 1955.

720. Santa Fé (Argentina). Museo Rosa Galisteo de Rodríguez. *100 Años de pintura santafesina; {exposición}, julio de 1945.* Santa Fé, 1945. 59 p.

721. Santiago (Chile). Museo de Bellas Artes. *Pintura argentina-promoción internacional; {exposición 1972?}.* Buenos Aires, Argentina: Ministerio de Relaciones Exteriores y Culto, 1972? 63 p.

722. Santiago (Chile). Universidad de Chile. Museo de Arte Contemporáneo. *EDPA; exposición de pintura argentina; agosto 1963.* Santiago, 1963? 76 p.

723. Sarfatti, Margarita G. *Espejo de la pintura actual.* Buenos Aires, Argentina: Argos, 1947.

724. Slullitel, Isidoro. *Pintores de Rosario en lo que va del siglo.* Santa Fé, Argentina: Tipografía El Orden, 1964.

 Catalog of an exhibition held at the Museo Municipal de Bellas Artes Juan B. Castignino, 1964.

725. Squirru, Rafael. *Pintura, pintura; siete valores argentinos en el arte actual.* Buenos Aires, Argentina: Ediciones Arte y Crítica, 1975. 101 p.

726. Taverna Yrigoyen, Jorge. *Constantes americanas en la pintura argentina.* Santa Fé, Argentina: Universidad Nacional del Litoral, 1970.

727. Trostiné, Rodolfo. *La pintura en las provincias argentinas; siglo XIX.* Santa Fé, Argentina: Universidad Nacional del Litoral, 1950. 53 p.

728. Washington (D.C.). National Gallery of Art. *A century and a half of painting in Argentina.* Washington, D.C., 1956. 14 p.

 Exhibition catalog.

729. Wildenstein & Co. (London, England). *Art in the Argentine; contemporary trends, [exhibition], May 1975.* London, 1975. 36 p.

730. Witcomb, Galerías (Santa Fé, Argentina). *Exposición de pintura; siglo XIX, del 12 de junio al 1 de julio 1944.* Santa Fé, 1944. 60 p.

731. Zabatta, Gioconda de. *16 pintores de Avellaneda.* Avellaneda, Argentina: Municipalidad de Avellaneda, 1969. 139 p.

ARGENTINA—PAINTING—COLLECTIONS

732. Acquarone, Ignacio. *Pintura argentina; colección Acquarone.* Buenos Aires, Argentina: Aleph, 1955. {118} p.

 Text in Spanish and French.

733. *Pintura actual Rosario; obras de la colección Dr. Isidoro Slullitel.* Rosario, Argentina: Gráfico Martín Fierro, n.d. 54 p.

734. Santiago (Chile). Museo de Bellas Artes. *Pintura argentina del siglo XIX; obras de propiedad del Museo Nacional de Bellas Artes de Buenos Aires, [exposición].* Santiago, n.d. 16 p.

ARGENTINA—PHOTOGRAPHY

735. Buenos Aires (Argentina). Museo de Arte Moderno. *Un arte de avanzada; 1843, cien años de fotografía argentina, 1943; [exposición], octubre-noviembre de 1967.* Buenos Aires, 1967. 44 p.

736. Pessano, Carlos Alberto. *Fotografías argentinas.* Buenos Aires, Argentina, 1939.

ARGENTINA—PHOTOGRAPHY

737. Riobó, Julio F. *La daguerrotipia y los daguerrotipos en Buenos Aires.* Buenos Aires, 1949.

739. Witcomb, Galería (Buenos Aires, Argentina). *Exposición de daguerrotipos y fotografías en vidrio.* Buenos Aires, 1944. 60 p.

ARGENTINA—SCULPTURE

740. Argentina. Dirección General de Cultura. *Exposición de esculturas premiadas en el Salón Nacional, 1911-1961.* Buenos Aires: Asociación Amigos del Salón Nacional, 1963. 44 p.

741. Arias, Abelardo. *Ubicación de la escultura argentina en el siglo XX.* Buenos Aires, Argentina: Ediciones Culturales Argentinas, 1962. 74 p.

742. Benzacar, Ruth, Galería (Buenos Aires, Argentina). *Once espacios; {exposición, octubre/noviembre 1977}.* Buenos Aires, 1977. 16 p.

743. Buenos Aires (Argentina). Museo de Arte Moderno. *18 esculturas para la ciudad; Semana de Buenos Aires, 1978.* Buenos Aires, 1978. 20 p.

744. Buenos Aires (Argentina). Museo de Arte Moderno. *8 escultores; {exposición, julio 22 al 14 de agosto de 1965}.* Buenos Aires, 1965. 24 p.

745. Buenos Aires (Argentina). Museo Nacional de Bellas Artes. *Esculturas en hierro.* Buenos Aires, 1969. 1 v.

Exhibition catalog.

746. Buenos Aires (Argentina). Museo Nacional de Bellas Artes. *Materials; nuevas técnicas, nuevas expresiones.* Buenos Aires, 1968. 65 p.

747. Buenos Aires (Argentina). Museo Nacional de Bellas Artes. *Panorama de la escultura argentina actual; {exposición, del 4 al 31 de agosto de 1971}.* Buenos Aires, 1971. 79 p.

748. Buenos Aires (Argentina). Museo Nacional de Bellas Artes. *Plástica con plásticos; {exposición}, setiembre de 1966.* Buenos Aires, 1966. 98 p.

749. Buenos Aires (Argentina). Museo Nacional de Bellas Artes. *Visión elemental; las formas no ilusionistas; César Ambrosini, Gabriel Mesil, César Paternosto...{et al.}; {exposición del 26 de septiembre al 17 de octubre de 1967}.* Buenos Aires, 1967. 20 p.

750. Buenos Aires (Argentina). Teatro Municipal General San Martín. *Doce escultores en la Argentina; {exposición, agosto 1979}.* Buenos Aires, 1979. 24 p.

751. *Buenos Aires y sus esculturas.* Buenos Aires, Argentina: Manrique Zago, 1981. 214 p.

752. Massini Correas, Carlos. *Consagración escultórica de los próceres argentinos en el siglo XIX; San Martín y Belgrano.* Mendoza, Argentina: Universidad Nacional de Cuyo, 1962? 34 p.

 Conference held at the Universidad Nacional de Cuyo, Mendoza, Argentina, May 2, 1962.

753. Premio Nacional e Internacional de Escultura Instituto Torcuato Di Tella (1962 : Buenos Aires, Argentina). *Premio Nacional e Internacional de Escultura Instituto Torcuato Di Tella, 1962- .* Buenos Aires, 1962- .

754. Sociedad Hebraica Argentina (Buenos Aires, Argentina). *Estructuras primarias II; {exposición}, 27 de setiembre al 21 de octubre de 1967.* Buenos Aires, 1967. 56 p.

 Text in Spanish, French and English.

755. Tosto, Pablo. *Antografía escultórica, 1914-1964.* Buenos Aires, Argentina: Librería Hachette, 1966. 235 p.

756. Taverna Irigoyen, Jorge. *Aproximación a la escultura argentina de este siglo.* Santa Fé, Argentina: Editorial Colmegna, 1967. 68 p.

757. Yumar, Galería (Buenos Aires, Argentina). *Cuatro escultores Madí; {Stimm, Sabelli, Linenberg, Kosice}.* {Buenos Aires, 1960}.

 Catalog of an exhibition, September 1960.

Barbados

758. Washington (D.C.). Museum of Modern Art of Latin America. *Art of today in Barbados: {exhibition, December 5, 1980-January 4, 1981}.* Washington, D.C., 1980. 8 p.

Bolivia

759. Asociación Boliviana de Artístas Plásticos (La Paz, Bolivia). *Primera exposición de arte boliviano contemporáneo, 1974, 24 de julio al 17 de agosto, {Casa Municipal de la Cultura Franz Tamayo}.* {La Paz, 1974}. {40} p.

760. Encuentro Nacional de Profesionales y Artístas Bolivianos. (1st : 1967 : Potosí, Bolivia). *Primer Encuentro Nacional de Profesionales y Artístas Bolivianos.* Potosí: Universidad Mayor y Autónoma 'Tomás Frías', 1967. 264 p.

761. Tapia Claure, Osvaldo. *Los estudios de arte en Bolivia: (intento de bibliografía crítica).* La Paz, Bolivia: Instituto de Investigaciones Estéticas, 1966. {126} p.

 Bibliography: p. 113-119.

762. UNESCO. *Cultural policy in Bolivia.* Paris, France: UNESCO, 1979. 81 p.

763. Villarroel Claure, Rigoberto. *Arte contemporáneo: pintores, escultores y grabadores bolivianos; desarrollo de las artes y la estética; de la caricatura, Academia Nacional.* La Paz, Bolivia: {Ministerio de Educación y Bellas Artes}, 1952. 131 p.

 Bibliography.

BOLIVIA—GENERAL—DICTIONARIES, ETC.

764. Mesa, José de, and Gisbert, Teresa. *Museos de Bolivia: Nacional, Moneda, Charcas, Catedral de Sucre, Murillo, Pintura.* La Paz, Bolivia: Fondo Nacional de Cultura y Turismo, 1969.

BOLIVIA—GENERAL—PERIODICALS

765. *Arte; revista del Consejo Nacional de Arte.* v. 1, no. 1 (Jan.-April 1961)- . La Paz, Bolivia, 1961- .

BOLIVIA—GRAPHIC ARTS

766. Ibáñez, Genaro. *Estampas de Bolivia: 10 grabados en madera.* La Paz, Bolivia: E. Burillo, 1958. 8 p., (10 plates).

767. Iturralde de Chinel, Luis de. *Paisajes y voces de la estampa boliviana.* Lima, Peru: Enrique Bustamante y Ballivián, 1940. 158 p.

BOLIVIA—PAINTING

768. Bienal de Arte (1st : 1975 : La Paz, Bolivia). *I Bienal de Arte: pintores bolivianos contemporáneos, 1975.* La Paz, 1975. 60 p.

Exhibition catalog.

769. Bienal de Arte (2nd : 1977 : La Paz, Bolivia). *II Bienal de Arte: pintores bolivianos contemporáneos, 1977.* La Paz, 1977. 54 p.

Exhibition catalog.

770. Bolivia. Embajada (Germany). *Pintura boliviana actual: Alemania, 1974, {exposición}.* La Paz, 1973? 25 p.

771. Bolivia. Embajada (U.S.S.R.). *Pintura boliviana actual: {exposición, Embajada boliviana, Moscú}, 9-19 de febrero 1971.* La Paz, 1971? 32 p.

772. Chacón T., Marío. *Pintores del siglo XIX.* La Paz, Bolivia: Dirección Nacional de Informaciones de la Presidencia de la República, 1963.

773. Mesa, José de, and Gisbert, Teresa. *Pintura contemporánea (1952-1962).* La Paz, Bolivia: Dirección Nacional de Informaciones, 1962. 50 p.

774. Villarroel Claure, Rigoberto. *Bolivia.* Washington, D.C.: Pan American Union, 1963. 86 p.

 Bibliography.

BOLIVIA—PAINTING—COLLECTIONS

775. La Paz (Bolivia). Museo Nacional de Arte. *Museo Nacional de Arte, {la pintura en el Museo Nacional de Arte, catálogo de las colecciones}.* La Paz, n.d. 24 p.

776. Mesa, José de, and Gisbert, Teresa. *Pinacoteca Nacional.* La Paz, Bolivia: Dirección Nacional de Informaciones de la Presidencia de la República, 1961.

Brazil

BRAZIL—GENERAL

777. Acquerone, F. *Historia da arte no Brasil.* Rio de Janeiro, Brazil: O. Mano, 1939. 276 p.

778. Almeida, Paulo Mendes de. *De Anita ao Museu.* São Paulo, Brazil: Conselho Estadual de Cultura, Comissão de Literatura, 1961. 74 p.

779. Amaral, Aracy A. *Artes plásticas no Semana de 22; subsídios para uma história da renovação das artes no Brasil.* São Paulo, Brazil: Editôra Perspectiva, 1970. 323 p.

Bibliography: p. 311-321.

780. Andrade, Mario de. *Aspectos das artes plásticas no Brasil.* São Paulo, Brazil: Martins, 1965. 96 p.

2nd edition, São Paulo, Brazil: Martins, 1975, 96 p.

781. Andrade, Rodrigo M.F. de. *As artes plásticas no Brasil.* Rio de Janeiro, Brazil: Ouro, 1968. 7 v.

782. *Art and artists.* London, England, 1976.

Special issue on Brazil, v. 11, no. 1 {April 1976}.

783. Arte Global, Galeria (São Paulo, Brazil). *Estojo contendo coleção de catálogos da temporada de 1974, que apresentou artistas nacionais e estrangeiros.* São Paulo, 1975. unpaged.

784. *Arte y arquitectura del modernismo brasileño (1917-1930).* Caracas, Venezuela: Biblioteca Ayacucho, 1978. 236 p.

Bibliography: p. 235-236; compiled by Aracy A. Amaral; translated by Marta Traba.

785. Assumpção, Clovis. *Arte do Grupo de Bagé; história.* Canoas, Brazil: Tipografia e Editora La Salle, 1975. 68 p.

Painters, printmakers and illustrators from Rio Grande do Sul, 1940 to mid 1950.

786. *Atlas cultural do Brasil.* Rio de Janeiro, Brazil: Ministério da Educação e Cultura, Conselho Federal de Cultura, 1972. 376 p.

787. *Aujourd'hui; art et architecture.* Paris, France, 1964.

Special issue devoted to the arts of Brazil; no. 46 {July 1964}.

788. Ayala, Walmir. *A criação plástica em questão.* Petrópolis, Brazil: Editôra Vozes, 1970. 283 p.

Responses to a questionaire submitted to 30 Brazilian artists.

789. Banco de Desenvolvimento do Paraná (Curitiba, Brazil). *Discípulos de Andersen & artistas independentes; {exposição, de 17 de agôsto a 5 de setembro de 1976, Salão de Exposições do BADEP}.* Curitiba, Brazil: BADEP, {1976}. 28 p.

790. Banco do Brasil (Caracas, Venezuela). *Cuatro artistas brasileños; {exposición}, julio 1978.* Caracas, 1978. 12 p.

791. Bardi, Pietro Mario. *História da arte brasileira; pintura, escultura, arquitetura, outras artes.* São Paulo, Brazil: Edições Melhoramentos, 1975. 228 p.

792. Bardi, Pietro Mario. *O modernismo no Brasil.* São Paulo, Brazil: SUDAMERIS, Banco Francês e Italiano para a América do Sul, 1978. 186 p.

793. Bardi, Pietro Mario. *New Brazilian art.* New York, N.Y.: Praeger, 1970. 160 p.

794. Bardi, Pietro Mario. *Profile of the new Brazilian art.* Rio de Janeiro, Brazil: Livraria Kosmos Editôra, c1970. 160 p.

795. Belo Horizonte (Brazil). Museu de Arte. *Mestres das artes em Minas Gerais: {exposição}, 9-8-1968.* Belo Horizonte, 1968. 44 p.

796. Bienal de São Paulo (1st : 1951 : São Paulo, Brazil). *Bienal de São Paulo, 1951- .* São Paulo, 1951-

797. Bienal de São Paulo (16th : 1981 : São Paulo, Brazil). *Catálogo de arte postal, v. 2, {XVI Bienal de São Paulo, 16 de outubro a 20 de dezembro de 1981}.* São Paulo, 1981. 136 p.

798. Bienal de São Paulo (16th : 1981 : São Paulo, Brazil). *Catálogo de arte incomun, v. 3, {XVI Bienal de São Paulo, 16 de outubro a 20 de dezembro de 1981}.* São Paulo, 1981. 113 p.

799. Bienal Nacional (1972 : São Paulo, Brazil). *Mostra de Arte Sesquicentenário da Independência: Brasil, plástica, 72: {exposição}, 1972; catálogo..* São Paulo: Fundação Bienal de São Paulo, 1972. 103 p.

800. Bienal Nacional (1974 : São Paulo, Brazil). *Bienal Nacional-74: {exposição}, novembro-dezembro.* São Paulo: Funcação Bienal de São Paulo, 1974. 103 p.

801. Bienal Nacional (1976 : São Paulo, Brazil). *Bienal Nacional-76: {exposição}, octubre-novembro.* São Paulo: Fundação Bienal de São Paulo, 1976. 192 p.

802. Bienal Nacional de Artes Plásticas (1st : 1966 : Salvador, Brazil). *Catálogo.* Salvador: Imprensa Oficial, 1967. unpaged.

803. Biennale di Venezia (31st : 1962 : Venice, Italy). *Brasile/XXXI Biennale.* Rio de Janeiro, Brazil: Departamento Cultural e de Informações do Ministério das Relações Exteriores, 1962. 23 p.

804. Birmingham (Alabama). Museum of Art. *Birmingham Festival of the Arts, 1975.* Birmingham, 1975. 36 p.

 Issue honoring Brazil.

805. Brazil. Biblioteca Nacional. *Movimientos de vanguardia na Europa e modernismo brasileiro (1900-1924); catálogo da exposição organizada pela Seção de Exposições e inaugurada em março de 1976.* Rio de Janeiro, 1976. 83 p.

806. Brazil. Biblioteca Nacional. Seção de Iconografia. *Imagens e documentos, iconografia; catálogo da exposição...dezembro de 1976.* Rio de Janeiro, 1976. 26 p.

807. Brazil. Ministério da Educação e Cultura. Departamento de Assuntos Culturais. *Arte gaucho/74; exposição.* Rio de Janeiro, 1974? 97 p.

 Text by Walmir Ayala.

808. Brazil. Ministério das Relações Exteriores. *Brazilian Art.* {São Paulo?}, 1976. 128 p.

 Translated from Portuguese; Spanish edition also published 1976.

809. Brito, Mario da Silva. *História do modernismo brasileiro; antecedentes da Semana de Arte Moderna.* São Paulo, Brazil: Edição Saraiva, 1958. 287 p.

> Second edition, revised; Rio de Janeiro: Editôra Civilização Brasileira, 1964, 322 p.; 4th edition: Rio de Janeiro: Civilização Brasileira, 1974, 322 p.; contains bibliography.

810. Buenos Aires (Argentina). Museo de Arte Moderno. *Artistas brasileños contemporáneos: {exposición}, 22 de abril-21 de mayo de 1966.* Buenos Aires, 1966. 42 p.

811. Buenos Aires (Argentina). Museo Nacional de Bellas Artes. *Arte moderno en Brasil.* Buenos Aires, 1957. 46 p.

> Exhibition organized by the Museu de Arte Moderna, Rio de Janeiro, Brazil.

812. Carneiro, Newton. *As artes e o artesanato no Paraná.* Curitiba, Brazil, 1955.

813. Carneiro, Newton. *Iconografía paranaense.* Curitiba, Brazil, 1950? 40 p.

814. Castedo, Leopoldo. *The baroque prevalence in Brazilian art.* New York, N.Y.: C. Frank Publications, {c1964}. 151 p.

> Bibliography: p. 147-149.

815. Cavalcanti, Carlos. *Arte e sociedade.* Rio de Janeiro, Brazil: Ministério da Educação e Cultura, n.d. 98 p.

816. Celestino, Antonio. *Gente da terra.* São Paulo, Brazil: Martins, 1972. 180 p.

> Artists from Bahia, Brazil.

817. Centro de Arte y Comunicación (Buenos Aires, Argentina). *20 Brazilian artists; {exhibition}, August 76-September 76.* Buenos Aires, 1976. 24 p.

818. Chase Manhattan Bank (New York, N.Y.). *Brazilian art today; {exhibition}.* New York, 1966?

819. Cidade, Hernani. *Lições de cultura luso-brasileira; epocas e estílos na literatura e nas artes plásticas.* Rio de Janeiro, Brazil: Nunes, 1960. 349 p.

820. Corona, Fernando. *Caminhada nas artes (1940-1976)*. Porto Alegre, Brazil: Universidade Federal do Rio Grande do Sul, Instituto Estadual do Livro, 1977. 241 p.

821. Cunha, Luiz de Almeida. *Brazil*. Washington, D.C.: Pan American Union, 1960. 84 p.

822. Damasceno, Athos. *Artes plásticas no Rio Grande do Sul, 1755-1900*. Pôrto Alegre, Brazil: Editôra Globo, 1971. 520 p.

823. Duque-Estrada, L. Gonzaga. *A arte brasileira: pintura e escultura*. Rio de Janeiro, Brazil: Lombaerts, 1884. 254 p.

824. Duque-Estrada, L. Gonzaga. *Contemporâneos: pintores e escultores*. Rio de Janeiro, Brazil: Benedito de Souza, 1929.

825. Duque-Estrada, L. Gonzaga. *Graves e grívolos; por assuntos de arte*. Rio de Janeiro, Brazil: Teixeira, 1910.

826. Encontro Nacional de Artistas Plásticos Profissionais (1st : 1979 : Rio de Janeiro, Brazil). *Anais do primeiro Encontro Nacional de Artistas Plásticos Profissionais, Rio de Janeiro, 26-29 de novembro de 1979*. Rio de Janeiro, 1979. 87 p.

827. Eulalio, Alexandre. *A aventura brasileira de Blaise Cendrars; ensaio, cronologia, filme, depoimentos, antologia*. São Paulo, Brazil: Quíron; Brasília, Instituto Nacional do Livro, 1978. 301 p.

828. Ferreira, José Ribamar. *Cultura posta em questão*. Rio de Janeiro, Brazil: Editôra Civilização Brasileira, 1965. 126 p.

829. Ferreira, José Ribamar. *Vanguarda e subdesenvolvimento; ensaios sôbre arte*. Rio de Janeiro, Brazil: Editôra Civilização Brasileira, 1969. 132 p.

830. Fonseca, Jose Paulo Moreira da. *Exposição de arte; temas gerais e artes plásticas no Brasil*. Rio de Janeiro, Brazil: Edições Tempo Brasileiro, 1965. 84 p.

831. Freyre, Gilberto. *Arte, ciência e trópico; em tôrno de alguns problemas de sociologia da arte; conferências proferidas, umas no Museu de Arte de São Paulo, outras nas Universidades do Recife e da Bahia*. São Paulo, Brazil: Martins, 1962. 125 p.

832. Guido, Angelo. *As artes plásticas no Rio Grande do Sul*. Porto Alegre, Brazil, 1940.

833. Guimarães, Argeu de Segadas Machado. *História das artes plásticas no Brasil.* Rio de Janeiro, Brazil: Jornal do Comercio, 1918.

834. Instituto de Cultura Uruguayo-Brasileño (Montevideo, Uruguay). *20 artistas brasileños; catálogo de una exposición celebrada en el local de exposiciones de la Comisión Municipal de Cultura.* Montevideo, 1945.

835. Kassel (West Germany). Kunstverein. *Brasilianische Künstler der Gegenwart; Ausstellung im Kassler Kunstverein unter der Schirmherrschaft der Brasilianischen Botschaft, 1962.* Kassel, 1962. 28 p.

836. Kawall, Luiz Ernesto Machado. *Artes reportagem.* São Paulo, Brazil: Centro de Artes Novo Mundo, 1972. unpaged.

 Interviews with 45 contemporary Brazilian artists.

837. La Plata (Argentina). Museo Provincial de Bellas Artes. *20 artistas brasileños; {exposición}, del 2 al 19 de agosto 1945.* La Plata, 1945?

838. Leite, Jose Roberto Teixeira. *Gente nova, nova gente.* Rio de Janeiro, Brazil: Editôra Expressão e Cultura, 1967. 135 p.

839. Lombardi, Mary. *Women in the modern art movement in Brasil: Salon leaders, artists, and musicians, 1917-1930.* 193 p.

 Ph.D., University of California, Los Angeles, 1977.

840. Machado, Lourival Gomes. *Retrato da arte moderna do Brasil.* São Paulo, Brazil: Departamento de Cultura, 1948.

841. Manhattan Center (Brussels, Belgium). *Image du Brésil = Beeld van Brasilië = Image of Brazil; {exposition}, Bruxelles, November '73.* {São Paulo, Brazil: Brunner, 1973?}. {176} p.

 Organized by the Museu de Arte de São Paulo Assis Chateaubriand, São Paulo, Brazil.

842. Manuel-Gismondi, Pedro Caminada. *Tentativa de uma pequena história da arte no Brasil.* São Paulo, Brazil: Publicações Convivio, 1964. 55 p.

843. Martins, Luis. *Arte e polêmica.* São Paulo, Brazil: Guaíra, 1942? 67 p.

844. Mattos, Anibal. *Historia da arte brasileira.* Belo Horizonte, Brazil: Apollo Bibliotheca Mineira de Cultura, 1937. 2 v. (268, 310 p.).

 Contents: v. 1--Das origens da arte brasileira: v. 2--Arte colonial brasileira.

845. Mello Moraes, Alexandre Jose de. *Artistas do meu tempo, seguidos de um estudo sôbre Laurindo Rabello.* Rio de Janeiro, Brazil: Paris, France: Garnier, 1904.

846. Milliet, Sergio. *Ensaios.* São Paulo, Brazil, 1938. 251 p.

847. Milliet, Sergio. *Fora da forma, arte e literatura.* São Paulo, Brazil: Anchieta, 1942? 182 p.

848. Minneapolis (Minnesota). Walter Art Gallery. *New art of Brazil; an exhibition...{March 20-April 22, 1962}.* Minneapolis, 1962. 36 p.

849. Morais, Federico. *Artes plásticas; a crise da hora atual.* Rio de Janeiro, Brazil: Editora Paz e Terra, 1975. 120 p.

850. Mosquera, Joan Jose Moriño. *Psicologia da arte.* Porto Alegre, Brazil: Livraria Sulina Editora, 1973. 101 p.

 Bibliography.

851. Motta, Flávio. *Contribuição ao estudo do 'arte nouveau' no Brasil.* São Paulo, Brazil: Universidade de São Paulo, Faculdade de Arquitetura, 1957. 83 p.

852. Moura, Carlos Francisco. *As artes plásticas em Mato Grosso nos séculos XVIII e XIX.* {Cuiaba, Brazil?}: Fundação Cultural de Mato Grosso, 1976. 93 p.

 Bibliography: p. 43-45.

853. Munich (West Germany). Haus der Kunst. *Ausstellung brasilianischer Künstler: Juni bis September 1959.* Munich, 1959. 97 p.

 Organized by the Museu de Arte Moderna do Rio de Janeiro, Brazil.

854. Nashville (Tennessee). Tennessee Fine Arts Center at Cheek-wood. *The art of Brazil: {exhibition}, June 15-September 14, 1975.* Nashville, 1975. 24 p.

855. Navarra, Ruben. *Jornal de arte.* Campina Grande, Brazil: Edições da Comissão Cultural do Minicípio, Prefeitura Municipal de Campina Grande, Paraíba, 1966. 418 p.

856. *Navilouca; almanaque dos aqualoucos.* Rio de Janeiro, Brazil: Edições Gernasa e Artes Gráficas, n.d. unpaged.

 Works by Caetano, Veloso, Augusto de Campos, Lygia Clark, Oiticia, etc.

857. Neuchâtel (Switzerland). Musée d'Ethnographie de Neuchâtel. *Le Brésil; arts primitifs, indigène, afro-brésilien, populaire, arts modernes, architecture, peinture, sculpture, gravure et dessin, fotographie: {exposition}, Musée d'Ethnographie de Neuchâtel, du 19 novembre 1955 au 20 février 1956.* Neuchâtel, {1955?}.

858. New York World's Fair. Brazilian Pavillion. *Pavilhão do Brasil, Feira Mundial de Nova York de 1939.* New York, N.Y.: H. K. Pub. Co., 1938? 63 p.

859. *Panorama das artes plásticas em Mato Grosso.* {Cuiabá, Brazil}: Edições Universidade Federal de Mato Grosso, 1975. {64} p.

860. Panorama de Arte Atual Brasileira (1st : 1969 : São Paulo, Brazil). *Panorama de Arte Atual Brasileira, 1969- .* São Paulo: Museo de Arte Moderna de São Paulo, 1969- .

 Catalogs of exhibitions where the Prêmio Museu de Arte Moderna de São Paulo and the Prêmio Estímulo Caixa Econômica Federal are awarded. Each year a different medium is exhibited: painting, design-engraving, sculpture-objects, etc.

861. Paraíba (Brazil). Universidade Federal. Núcleo de Arte Contemporânea. *Almanac; setembro de 1978 a fevereido de 1980.* Paraíba, 1979/80. 140 p.

862. Pedrosa, Mário. *Arte brasileira hoje.* Rio de Janeiro, Brazil: Paz e Terra, 1973. 216 p.

863. Pedrosa, Mário. *Dimensões da arte.* Rio de Janeiro, Brazil: Ministério da Edcucação e Cultura, 1964. 231 p.

864. Pedroza, Raúl. *Synthèse de l'art brésilien.* Paris, France: Institut des Etudes Américaines, 1937?

865. Pignatari, Décio. *Informação, linguagem, comunicação.* São Paulo, Brazil: Editôra Perspectiva, 1968. 144 p.

866. Pontual, Roberto. *Brasil/arte/hoje: 50 anos depois.* São Paulo, Brazil: Edições Artes, 1973. 401 p.

 Catalog of an exhibition held at the Galeria Collectio, São Paulo, Brazil.

867. Pré-Bienal de São Paulo (1970 : São Paulo, Brazil). *Pré-Bienal de São Paulo: {exposição}, catálogo.* São Paulo: Fundação Bienal de São Paulo, 1970. 96 p.

868. *Quatro artistas brasileiros = Vier brasilianische Künstler: Douchez, Ianelli, Martins, Nicola: {exposição}, Bonn, Kultur Forum, Bonn Center, 28. April bis 5. Mai 1980...* São Paulo, {1980?}. {28} p.

Exhibition organized by Bayer do Brasil and the Museu de Arte Moderna, São Paulo, Brazil, and shown in nine European locations during 1980.

869. Querino, Manuel Raymundo. *Artistas bahianos (indiciações biográficas).* Bahia, Brazil: Oficinas da Empresa 'A Baia,' 1911.

870. Resende, Enrique de. *Pequena historia sentimental de Cataguases.* Belo Horizonte, Brazil: Itatiaia, 1969. 164 p.

Includes information on 20th century art.

871. Rio de Janeiro (Brazil). Museu de Arte Moderna. *Arte moderno brasileño.* Rio de Janeiro, 1960. unpaged.

Text in Spanish.

872. Rio de Janeiro (Brazil). Museu de Arte Moderna. *Exposição de artistas brasileiros; {exposição}, abril 1952.* {Rio de Janeiro, 1952.} 100 p.

873. Rio de Janeiro (Brazil). Museu de Arte Moderna. *Projeto construtivo brasileiro na arte (1950-1962).* Rio de Janeiro: Museu de Arte Moderna; São Paulo: Pinacoteca do Estado, 1977. 357 p.

Bibliography; exhibition organized by the Museu de Arte Moderna do Rio de Janeiro, Brazil, and the Pinacoteca do Estado de São Paulo, Brazil.

874. Rio de Janeiro (Brazil). Museu de Arte Moderna. *7 resumo de arte; Jornal do Brasil.* Rio de Janeiro: Editorial Sul Americana, 1969. unpaged.

875. Rio de Janeiro (Brazil). Museu Nacional de Belas Artes. *Exposição animalista (arte plástica).* Rio de Janeiro: Ministério da Educação e Saúde, 1942. 38 p.

876. Rio de Janeiro (Brazil). Museu Nacional de Belas Artes. *Reflexos do impressionismo no Museu Nacional de Belas-Artes: {exposição comemorativa de 1 centenário do impressionismo, 1874-1974.* Rio de Janeiro, 1974? {50} p.

Bibliography: p. {46}.

877. Rio Grande do Sul (Brazil). Universidade Federal. Instituto de Artes. *Nervo óptico: Carlos Asp, Clovis Dariano, Mara Alvares, Telmo Lanes, Vera C. Barcellos: {exposição}, 27 de setembro a 10 de outubro de 1978.* Rio Grande do Sul, 1978. 20 p.

878. Rodman, Selden. *Genius in the backlands; popular artists of Brazil.* Old Greenwich, Connecticut: Devin-Adair, c1977. 150 p.

879. Rodrigues, Maria Cristina de Lacerda. *Guia, histórica e crítica da arte: I, modernismo no Brasil.* Rio de Janeiro, Brazil: Museu de Arte Moderna, 1972. 16 p.

880. Romero Brest, Jorge. *El arte brasilero.* Mexico City, Mexico? Poseidón, 1945.

881. Rubens, Carlos. *Pequena historia das artes plásticas no Brasil.* São Paulo, Brazil: Companhia Editôra Nacional, 1941. 388 p.

882. Salão Bahiano de Belas Artes (1st : 1949 : Bahia, Brazil). *Salão Bahiano de Belas Artes, 1949-* . Bahia, 1949- .

883. Salão Bahiano de Belas Artes (2nd : 1950 : Bahia, Brazil). *Catálogo do Segundo Salão Bahiano de Belas Artes, 1950.* Bahia: Secretaria de Educação e Saúde, 1950? 44 p.

884. Salão de Arte Contemporânea de Campinas (10th : 1975 : Campinas, Brazil). *10 Salão de Arte Contemporânea de Campinas: arte no Brasil, documento/debate; {exposição}, 2-30 novembro 1975.* Campinas: Museu de Arte Contemporânea, 1975. 56 p.

885. Salão de Arte da Eletrobrás (1st : Brazil). *1 Salão de Arte da Eletrobrás; tema, luz e movimento.* n.p., n.d. 32 p.

886. Salão de Arte Global de Pernambuco (1st : 1974 : Recife, Brazil). *Salão de Arte Global de Pernambuco, 1974-* . Recife, 1974- .

887. Salão do Artista Jovem (3rd : 1971 : Campinas, Brazil). *3 Salão do Artista Jovem, Campinas, Brasil, 1971.* São Paulo: Universidade de São Paulo, Museu de Arte Contemporânea, 1971. 16 p.

888. Salão Global de Inverno (1st : 1973 : Belo Horizonte, Brazil). *Salão Global de Inverno, 1973-* . Belo Horizonte, 1973- .

889. Salão Global de Inverno (4th : 1977 : Belo Horizonte, Brazil). *4 Salão Global de Inverno: {exposição}, 26/6 a 18/7, Palacio das Artes, B.H.; 20 a 28/7, Casa dos Contos, Ouro Preto.* Belo Horizonte, 1977. 24 p.

890. Salão Municipal de Belas Artes (22nd : 1968 : Belo Horizonte, Brazil). *XXII Salão Municipal de Belas Artes, Museu de Arte da Prefeitura de Belo Horizonte, 12 dezembro 1967-5 fevereiro 1968.* Belo Horizonte, 1968. 36 p.

891. Salão Nacional de Arte Contemporânea de Belo Horizonte (lst : 1970 : Belo Horizonte, Brazil). *1 Salão Nacional de Arte Contemporânea de Belo Horizonte, {exposição, 12 de dezembro de 1969-5 de fevereiro de 1970}.* Belo Horizonte, 1968? 44 p.

892. Salão Nacional de Arte Moderna (17th : 1968 : Rio de Janeiro, Brazil?). *Catálogo, 1968.* Rio de Janeiro: Ministério da Educação e Cultura, 1968. 64 p.

893. Salão Nacional de Belas Artes (1st : 1894? Rio de Janeiro, Brazil). *Salão Nacional de Belas Artes, 1894?* . Rio de Janeiro, 1894?- .

894. Salão Nacional de Belas Artes (43rd : 1937 : Rio de Janeiro, Brazil). *Catálogo do XLIII Salão Nacional de Belas Artes; pintura, escultura, gravura, arquitetura, desenho e arte decorativa; {exposição}, inaugurado em 17 de setembro de 1937.* Rio de Janeiro, 1937.

895. Salão Nacional de Belas Artes (53rd : 1948 : Rio de Janeiro, Brazil). *Catálogo.* Rio de Janeiro: Ministério da Educação e Saúde, 1948. 141 p.

896. Salão Pan-Americano de Arte (1st : 1958 : Pôrto Alegre, Brazil). *Primeiro Salão Pan-Americano de Arte, abril-1958-maio.* Pôrto Alegre: Ministério da Educação e Cultura, Instituto de Belas Artes do Rio Grande do Sul, 1958. 62 p.

897. Salão Paranaense de Belas-Artes (24th : 1967 : Curitiba, Brazil). *24 Salão Paranaense de Belas-Artes; {exposição}, 1-19 de dezembro de 1967.* Curitiba: Departamento de Cultura, 1967. 40 p.

898. Salão Paulista de Arte Contemporânea (1st : 1969? : São Paulo, Brazil). *Salão Paulista de Arte Contemporânea, 1969?-* . São Paulo, 1969?- .

899. Salão Paulista de Arte Contemporânea (5th : 1974 : São Paulo, Brazil). *V Salão Paulista de Arte Contemporânea; Fundação Bienal de São Paulo, {exposição}, 25 de novembro-14 de dezembro 1974.* São Paulo, 1974. 40 p.

900. Salão Paulista de Arte Contemporânea (7th : 1977 : São Paulo, Brazil). *VII Salão Paulista de Arte Contemporânea, {exposição}, 14 de dezembro de 1976 a 30 de janeiro de 1977.* São Paulo, 1976. 48 p.

901. São Paulista de Belas Artes (7th : 1940? : São Paulo, Brazil). *Setimo Salão Paulista de Belas Artes e exposição retrospectiva; obras de maestres de pintura brasileira e seus discipulos.* São Paulo, 1940? 197 p.

 Includes section on 19th century Brazilian painters.

902. Salão Paulista de Belas Artes (10th : 1944 : São Paulo, Brazil). *Decimo Salão Paulista de Belas Artes, 1944; exposição...* São Paulo: Editora Galeria Prestes Maia, 1944? 42 p.

903. Santiago (Chile). Museo Nacional de Bellas Artes. *4 artistas de Brasil: homenaje al centenario del Museo Nacional de Bellas Artes de Chile, 1980.* Santiago, 1980. 12 p.

904. Santos, Reinaldo dos. *As artes plásticas no Brasil; antecedentes portuguêses e exóticos.* Rio de Janeiro, Brazil: Edições de Ouro, 1968. 84 p.

905. São Paulo (Brazil). Museu de Arte de São Paulo Assis Chateaubriand. *Paraná: memória e momento; {exposição}, 10 de junho a 9 de julho de 1980.* São Paulo, 1980. 24 p.

906. São Paulo (Brazil). Museu de Arte de São Paulo Assis Chateaubriand. *Semana de 22: antecedentes e consequências; exposição comemorativa do cinqüecentenário, 1972.* São Paulo, 1972. 150 p.

907. São Paulo (Brazil). Museu de Arte de São Paulo Assis Chateaubriand. *Tempo dos modernistas; {exposição}, Museu de Arte de São Paulo Assis Chateaubriand, agosto-setembro 1974.* São Paulo, 1974. 105 p.

908. São Paulo (Brazil). Paço das Artes. *Exposição 'novas tendências', setembro, 1975.* São Paulo, 1975. 32 p.

909. São Paulo (Brazil). Paço das Artes. *Temática brasileira.* São Paulo: Estado de São Paulo, Secretaria de Cultura, 1972. unpaged.

910. São Paulo (Brazil). Pinacoteca do Estado. *As artes no Brasil do século XIX; um ciclo de palestras, {exposição}, agosto-setembro de 1977.* São Paulo, 1977. 52 p.

 Bibliography.

911. São Paulo (Brazil). Universidade de São Paulo. Escola da Comunicações e Artes. *Multimedia internacional, {exposição}, 19 novembro-16 dezembro 1979.* São Paulo, 1979. 36 p.

912. São Paulo (Brazil). Universidade de São Paulo. Museu de Arte Contemporânea. *Artistas professores da Universidade de Brasília: {exposição}, 27 de novembro a 20 de dezembro de 1974.* São Paulo, 1974. 10 p.

913. São Paulo (Brazil). Universiedade de São Paulo. Museu de Arte Contemporânea. *Jovem arte contemporânea; 2. exposição, 19 de novembro a 20 de dezembro 1968.* São Paulo, 1968. unpaged.

914. São Paulo (Brazil). Universidade de São Paulo. Museu de Arte Contemporânea. *Prospectiva '74; {exposição}, 16 de agosto a 16 de setembro {1974}.* São Paulo, 1974. 48 p.

915. Schütz, Alfred. *O mundo artístico do Brasil = The artistic world of Brazil.* 1a. ed. Rio de Janeiro, Brazil: Pró-Arte, 1954. 402 p.

916. *7 brasileiros e seu universo; artes ofícios origens permanências.* Brasília, Brazil: Ministério da Educação e Cultura, 1974. 215 p.

917. Silva, H. Pereira da. *A função do inconsciente nas artes plásticas.* Rio de Janeiro, Brazil: A Noite, 1951? 232 p.

 Short essays on contemporary painters and sculptors.

918. Souza, Wladimir Alves de. *Arte brasileira.* Rio de Janeiro, Brazil: Delta, n.d. ca. 100 p.

 Offprint of the Enciclopedia Delta-Larousse.

919. Suassuna, Ariano. *O Movimento Armorial.* Recife, Brazil: Universidade Federal de Pernambuco, 1974. 73 p.

 Summaries in English and French.

920. Teixeira, Oswaldo. *Getulio Vargas e a arte no Brazil.* Rio de Janeiro, Brazil: DIP, 1940? 85 p.

921. Tornoto (Ontario, Canada). Art Gallery of Ontario. *10 Brazilian artists = 10 artistes brésiliens.* Toronto, c1975. {76} p.

 Catalog of an exhibition, April 5-27, 1975.

922. *UCLA Semana de Arte Moderna Symposium (February 7-12, 1972), {Los Angeles, California}; commemorating the 50th Anniversary of the Semana de Arte Moderna in São Paulo and the 150th Anniversary of Brazilian Independence, February 7-12, 1972.* Los Angeles, California: University of California, Latin American Studies Center, 1972. 271 p.

923. Valladares, Clarival do Prado. *7 brasileiros e seu universo; artes oficios, origens permanencias.* Brasília, Brazil: Ministério da Educação e Cultura, 1974. 215 p.

924. Valladares, José. *Artes maiores e menores; seleções de Crônicas de Arte, 1951-1956.* Salvador, Brazil: Universidade de Bahia, 1957. 176 p.

925. Valladares, José. *Dominicais; Crônicas de Arte.* Salvador, Brazil: Artes Gráficas, 1951. 197 p.

926. Vienna (Austria). Museum für angewandte Kunst. *Brasilianische Kunst heute; {Ausstellung}, 30. Septembre-30. Oktober 1965.* Vienna, 1965. 32 p.

927. *Visão da terra: arte agora; Antonio Henrique Amaral...{et al.}.* Rio de Janeiro, Brazil: Atelier de Arte Edições, 1977. 153 p.

Text by Ferreira Gullar; coordinated by Roberto Pontual.

BRAZIL—GENERAL—BIBLIOGRAPHIES

928. Basseches, Bruno. *A bibliography of Brazilian bibliographies = Uma bibliografia das bibliografias brasileiras.* Detroit, Michigan: Ethridge Books, {1978}. 185 p.

Text in Portuguese; summaries in English.

929. Bonino, Galeria (Rio de Janeiro, Brazil). *Exposições realizadas na Galeria Bonino, Rio de Janeiro é index, 1960-1979.* Rio de Janeiro, 1979/80. 11 p., typescript.

930. Placer, Xavier. *Modernismo brasileiro: bibliografia (1918-1971).* Rio de Janeiro, Brazil: Biblioteca Nacional, 1972.

931. Valladares, José. *Arte brasileira, publicações de 1943-1954.* Salvador, Brazil, 1955. 78 p.

 Annotated bibliography of 506 items.

932. Valladares, José. *Arte brasileira; publicações de 1954.* Bahia, Brazil: Porgresso, 1958. 41 p.

 Annotated bibliography of 151 items.

933. Valladares, José. *Artes maiores e menores; seleção de crónicas de arte, 1951-1956.* Salvador, Brazil, 1957.

934. Valladares, José. *Estudos de arte brasileira, publicações de 1943-1958; bibliografia seletiva e comentada.* Salvador, Brazil: Museu do Estado, 1960. 193 p.

 Contains 693 annotated items.

BRAZIL—GENERAL—COLLECTIONS

935. Bahia (Brazil). Museu de Arte Moderna da Bahia. *Acervo MAMB: pintura, escultura, cerâmica, tapeçaria, pastel.* Salvador: Governo do Estado da Bahia, Secretaria da Educação e Cultura, 1976. unpaged.

 Describes 200 works from the collection.

936. Bahia (Brazil). Museu de Arte Moderna da Bahia. *Arte brasileira: os anos 60/70; Coleção Gilberto Chateaubriand...* Brazil, 1976.

 Catalog of an exhibition held at the Museu de Arte Moderna da Bahia, Brazil, Dec. 10-31, 1976; the Casarão de João Alfredo, Recife, Brazil, Jan. 14-Feb. 13, 1977; and the Fundação Cultural do Distrito Federal, Brasília, Brazil, May 9-27, 1977.

937. Bahia (Brazil). Museu de Arte Moderna da Bahia. *Museu de Arte da Bahia: guia dos visitantes.* Salvador, Brazil: Secretaria da Educação e Cultura, Divisão de Museus e Patrimonio Cultural, 1970. unpaged.

 Text by Carlos Eduardo da Rocha.

938. Bahia (Brazil). Museu de Arte Sacra. *Museu de Arte Sacra da Bahia.* Rio de Janeiro: AGGS-Indústrias Gráficas, 1979? 28 p.

939. Bardi, Pietro Mario. *The arts in Brazil: a new museum at São Paulo.* Milano, Italy: Milione, 1956. 296 p.

History of the Museu de Arte de São Paulo.

940. Bardi, Pietro Mario. *Museu de Arte de São Paulo.* Buenos Aires, Argentina: Editorial Codex, 1967. 85 p.

Text in Spanish; Portuguese text also available, Rio de Janeiro, Brazil: Codex, {1968}, 86 p.

941. Berne (Switzerland). Kunstmuseum. *Meisterwerke des Museums Sao Paulo, {Ausstellung} 8. mai-7. juni 1954.* {Berne, 1954}. {147} p.

942. Brazil. Biblioteca Nacional (Rio de Janeiro). Divisão de Publicações e Divulgação. *Vinte e cinco anos de enriquecimento do acervo, 1950-1975.* Rio de Janeiro, 1975. 52 p.

Includes 403 annotated items.

943. Brazil. Fundação Nacional de Arte. *Museu de Arte de São Paulo.* Rio de Janeiro: FUNARTE, 1981. 193 p.

Bibliography: p. 192-193.

944. Brazil. Fundção Nacional de Arte. *Museu Nacional de Belas Artes.* Rio de Janeiro: FUNARTE, 1979. 193 p.

Bibliography: p. 191-193; typescript English translation: Rio de Janeiro, FUNARTE, 1979? 177 leaves.

945. Brazil. Ministério da Educação e Cultura. *Pinacoteca do Museu Imperial.* Petrópolis, Brazil, 1956. 317 p.

946. Brazil. Ministério das Relações Exteriores. *Museu de Arte de São Paulo Assis Chateaubriand em Brasília.* Brasília, 1973. {10} p.

Exhibition held at the Palácio do Itamaraty, Brasília, Brazil, Nov. 20-Dec. 9, 1973.

947. Curitiba (Brazil). Museu Coronel David Carneiro. *Catálogo: Museu Coronel David Carneiro, Curitiba, Paraná.* Rio de Janeiro: Ministério da Educação e Saude, 1940? 282 p.

Semi-private museum of Brazilian costumes, furniture, firearms, coins, paintings.

948. Dias, Antônio Caetano. *Catálogo das obras raras ou valiosas da biblioteca da Escola Nacional de Belas Artes.* Rio de Janeiro, Brazil: Imp. Nacional, 1945. 67 p.

949. Espaço NO (Porto Alegre, Brazil). *Artistas brasileiros contemporâneos dos anos 60 a 70 no Coleção Rubem Knijnik...* Porto Alegre, 1981. 6 p.

950. *O espírito criador do povo brasileiro, através da Coleção de Abelardo Rodrigues do Recife: {exposição}, Palácio do Itamaraty, Brasília, julho e agosto, 1972.* São Paulo? 1972? {64} p.

951. Grupo Sul América de Seguros (Rio de Janeiro, Brazil). *Acervo do Grupo Sul América de Seguros: artistas brasileiros.* Rio de Janeiro, 1975. 68 p.

 Text by Walmir Ayala; English edition also published.

952. Hollanda, Guy de. *Recursos educativos dos museus brasileiros.* Rio de Janeiro, Brazil, 1958. 271 p.

 Sponsored by the International Council of Museums of UNESCO.

953. London (England). Tate Gallery. *Masterpieces from the Sao Paulo Museum of Art at the Tate Gallery.* London: Arts Council of Great Britain, 1954. 47 p.

 Second edition; exhibition catalog.

954. Mendonça, Edgar Suessekind de. *A extensão cultural nos museus.* Rio de Janeiro, Brazil: Imp. Nacional, 1946. 72 p.

955. New York (N.Y.). Metropolitan Museum of Art. *Paintings from the Sao Paulo Museum.* New York, 1957.

956. Paris (France). Musée de L'Orangerie. *Chefs-d'oeuvre du Musée d'Art de Sao-Paulo.* Paris: Editions des Musées Nationaux, 1953. 132 p.

 Exhibition catalog, Oct. 1953-Jan. 1954.

957. Petrópolis (Brazil). Museu Imperial. *Museu Imperial de Petrópolis.* Rio de Janeiro: AGGS-Indústrias Gráficas, 1979? 28 p.

958. Pontual, Roberto. *Arte brasileira contemporânea: Coleção Gilberto Chateaubriand.* Rio de Janeiro, Brazil: Edições Jornal do Brasil, 1976. 478 p.

 Text in Portuguese and English; also contains Dicionário biográfico: p. 404-431.

959. Porto Alegre (Brazil). Museu de Arte do Rio Grande do Sul. *Catálogo geral das obras* Porto Alegre, 1978. 88 p.

960. Rio de Janeiro (Brazil). Museu da Chácara do Céu. *Museu da Chácara do Céu: catálogo.* 2a. ed. Rio de Janeiro: Funcação Raymundo Ottoni de Castro Maya, 1980. {53} p.

961. Rio de Janeiro (Brazil). Museu de Arte Moderna. *Crição de um Centro de Documentação; nov. 79 = {Création d'un Centre Documentaire; nov. 79}.* Rio de Janeiro, 1979. {54} p.

962. Rio de Janeiro (Brazil). Museu de Arte Moderna. *Do moderne ao contemporâneo, Coleção Gilberto Chateaubriand, {exposição}, junio-julho de 1981.* Rio de Janeiro, 1981. {72} p.

 Text in Portuguese and English.

963. Rio de Janeiro (Brazil). Museu de Arte Moderna. *Museu de Arte Moderna do Rio de Janeiro.* Rio de Janeiro, 1967. unpaged.

 Text in Portuguese, French and English.

964. Rio de Janeiro (Brazil). Museu de Arte Moderna. *Exposição permanente; catálogo.* Rio de Janeiro, 1953.

965. Rio de Janeiro (Brazil). Museu de Arte Moderna. *Séde definitiva do Museu de Arte Moderna do Rio de Janeiro, janeiro 1954.* Rio de Janeiro, 1954. {13} p.

 Descriptive booklet.

966. Rio de Janeiro (Brazil). Museu Nacional de Belas Artes. *Aquisições do Museu Nacional de Belas Artes, 1970-1976.* {Rio de Janeiro, 1977.}. {71} p.

967. Rio de Janeiro (Brazil). Museu Nacional de Belas Artes. *Galeria irmãos Bernardelli.* Rio de Janeiro: Ministério da Educação e Saúde, 1942? 28 p.

968. Rio de Janeiro (Brazil). Museu Nacional de Belas Artes. *Guia das galerias de artistas brasileiros.* Rio de Janeiro, 1966. 40 p.

969. Rio de Janeiro (Brazil). Museu Nacional de Belas Artes. *Guia das galerias de artistas estrangeiros.* Rio de Janeiro, 1966. 28 p.

970. Rio de Janeiro (Brazil). Museu Nacional de Belas Artes. *Guia do Museu Nacional de Belas Artes.* Rio de Janeiro, 1945. 206 p.

971. Rio de Janeiro (Brazil). Museu Nacional de Belas Artes. *Relatório sucinto das actividades do Museu Nacional de Belas Artes, 1937-1946.* Rio de Janeiro: Imprensa Nacional, 1948. 74 p.

972. São Paulo (Brazil). Museu de Arte de São Paulo Assis Chateaubriand. *Catálogo das pinturas, esculturas e tapeçarias.* São Paulo, 1963. 312 p.

 Sections on Brasiliana--Brasileiros.

973. São Paulo (Brazil). Museu de Arte de São Paulo Assis Chateaubriand. *MASP Assis Chateaubriand; ano 30.* São Paulo, 1979. 110 p.

974. São Paulo (Brazil). Museu Lasar Segall. *Museu Lasar Segall, 1970-1980.* São Paulo, 1980. {8} p.

975. São Paulo (Brazil). Pinacoteca do Estado. *Catálogo.* São Paulo, 1954. 174 p.

976. São Paulo (Brazil). Pinacoteca do Estado. *Catálogo.* São Paulo, 1965. 200 p.

977. São Paulo (Brazil). Universidade de São Paulo. Museu de Arte Contemporânea. *Anteprojeto do edifício do Museo de Arte Contemporânea no campus da Universidade de São Paulo.* São Paulo, 1975. 25 p.

 Text by Walter Zanini and Jorge Wilheim.

978. São Paulo (Brazil). Universidade de São Paulo. Museu de Arte Contemporânea. *Catálogo geral das obras.* São Paulo, 1973. 462 p.

979. São Paulo (Brazil). Universidade de São Paulo. Museu de Arte Contemporânea. *Coleção Theon Spanudis: doação para o acervo do Museu de Arte Contemporânea da Universidade de São Paulo: {exposição}, dezembro de 1979-marzo de 1980.* São Paulo, 1979? 36 p.

980. São Paulo (Brazil). Universidade de São Paulo. Museu de Arte Contemporânea. *II Exposição circulante de obras do acervo do Museu de Arte Contemporânea da Universidade de São Paulo (meio século de arte nova): 1966.* São Paulo, 1966. 32 p.

981. São Paulo (Brazil). Universidade de São Paulo. Museu de Arte Contemporânea. *Museu de Arte Contemporânea da Universidade de São Paulo: doações e aquisições recentes: {exposição},27 de setembro a 20 de outubro de 1974.* São Paulo, 1974. 8 p.

982. Alves, Marieta. *Dicionário de artistas e artífices na Bahia.* Salvador, Brazil: Universidade Federal da Bahia, 1976. 210 p.

983. *Dicionário brasileiro de artes plásticos.* Brasília, Brazil: Instituto Nacional do Livro, 1973- . 4 v.

> Volume 1 and 2 edited by Carlos Cavalcanti; volume 3 edited by Walmir Ayala.

984. *Dicionário de artistas e artífices dos séculos XVIII e XIX em Minas Gerais.* Rio de Janeiro, Brazil: Instituto do Patrimônio Histórico e Artístico Nacional, 1974. 2 v.

> Bibliography: p. {323}-335; v. 2 edited by Judith Martina.

985. Fekete, Joan. *Dicionário universal de artistas plásticos.* Rio de Janeiro, Brazil: Editora Companhia Brasileira de Artes Gráficas, 1979. 377 p.

986. Fernandes, Neusa, and Pereira, Sonia Gomes. *Musées de Rio = Museums of Rio.* Rio de Janeiro, Brazil: Livraria Francisco Alves, 1973. 203 p.

987. *Guia dos museus do Brasil.* Rio de Janeiro, Brazil: Expressão e Cultura, 1972. 317 p.

> Text by Fernanda de Camargo E. Almeida; 2nd edition, Rio de Janeiro, Brazil: Expressão e Cultura, 1978, 167 p., edited by Maria Elisa Carrazzoni.

988. Pontual, Roberto. *Dicionário das artes plásticas no Brasil.* Rio de Janeiro, Brazil: Editôra Civilização Brasileira, 1969. {621} p.

989. Torres, Heloisa Alberto. *Museums of Brazil.* Rio de Janeiro, Brazil: Ministry of Foreign Affairs, 1955? 82 p.

> Translated from Portuguese.

990. Schütz, Alfred. *O mundo artístico do Brasil; enciclopédia biográfica sobre todos os setores da arte brasileira.* Rio de Janeiro, Brazil: Editôra Pró-Arte, 1954.

991. *ABC Côlor; orgão oficial de Imprensa da Cooperativa de Artistas Plásticos.* no. 1 (May 1980)- . São Paulo, 1980- .

992. *Acropole.* no. 1 (May 1938)- . São Paulo, 1938- .

993. *Arte em Revista.* v. 1, no. 1 (Jan.-March 1979)- . São Paulo, Brazil: Centro de Estudios de Arte Contemporâneo, 1979- .

994. *Arte em São Paulo.* no. 1 (1981)- . São Paulo, Brazil, 1981- .

 Edited by Luiz Paulo Baravelli.

995. *Arte hoje.* 1977- . Rio de Janeiro, Brazil, 1977- .

996. *Crítica de arte.* no. 1 (1975?)- . Rio de Janeiro, Brazil: Associação Brasileira de Críticos de Arte, 1975?-

997. *Cultura.* no. 1 (1971)- . Brasília, Brazil: Ministério da Educação e Cultura, Directoria de Documentação e Divulgação, 1971- .

998. *Fon Fon.* no. 1-10 (1907-Sept. 1916?). Rio de Janeiro, Brazil, 1907-1916?

999. *GAM; Galeria de Arte Moderna/Jornal Mensal de Artes Visuais.* 197-?- . Rio de Janeiro, Brzil, 197-?- .

1000. *Klaxon.* April 1922-Jan. 1923. Brazil, 1922-1923.

1001. *Malasartes.* no. 1 (Sept./Oct./Nov. 1975)- . Rio de Janeiro, Brazil, 1975- .

1002. *Nervo optico.* 197-?- . Porto Alegre, Brazil, 197-?- .

1003. *Número um.* no. 1 (May 1980)- . Rio de Janeiro, Brazil, 1980- .

1004. *Panóplia.* São Paulo, Brazil, 1917-1918.

1005. *A Parte do fogo.* no. 1 (1980)- . São Paulo, Brazil?, 1980- .

1006. *A Phala; revista do movimento surrealista.* no. 1 (1967)- . São Paulo, Brazil, 1967- .

1007. *Qorpo estranho; revista de criação intersemiótica.* no. 1 (May-Aug. 1976)- . São Paulo, Brazil?, 1976- .

1008. *RASM; revista anual do Salão de Maio.* no. 1 (1939)- . São Paulo, Brazil, 1939- .

1009. *Revista da Escola de Belas Artes de Pernambuco.* no. 1 (1957)- .
Recife, Brazil: Universidade de Recife, 1957- .

1010. *Revista goiana de artes.* no. 1 (Jan.-June 1980)- . Goiâna, Brazil:
Editora da Universidade Federal de Goiâna, 1980- .

1011. Rio de Janeiro (Brazil). Museu Nacional de Belas Arte. *Anuário,
1938-* . Rio de Janeiro, 1938?- .

1012. *Terra de soi; revista de arte e pensamento.* no. 1-4 (Jan.-Dec. 1924).
Rio de Janeiro, Brazil, 1924.

1013. *Terra roxa e outras terras.* no. 1-7 (1926). São Paulo, Brazil: Livraria
Martins, 1977.

Reprint edition.

1014. *Vida das artes.* no. 0 (May 1975)- . Rio de Janeiro, Brazil,
1975- .

BRAZIL—ARCHITECTURE

1015. Ante-Projeto. *Arquitetura contemporânea no Brasil...* Rio de Janeiro,
Brazil: Ante-Projeto, 1947-48. 2 v.

Organized by the magazine Ante-Projeto; text in Portuguese,
English and Spanish.

1016. Architectural Forum. *Brazil.* New York, 1947.

Special issue devoted to Brazilian architecture; v. 87, no. 5 (Nov.
1947, p. 65-112).

1017. Architecture Aujourd'hui. *Brésil.* Paris, France, 1952.

Special issue devoted to Brazilian architecture; v. 23 (Aug. 1952).

1018. Aures, N. *Symbolik in moderner Architektur: eine Deutung brasilianis-
chen Bauens.* Essen, West Germany: Ferrostaal, 1962. 18 leaves.

1019. Bahia (Brazil). Departamento Estadual de Estatística. *Monumentos
históricos.* Bahia, 1948. 21 p.

List of 19th and 20th century monuments.

1020. Belo Horizonte (Brazil). Universidade de Minas Gerais. Escola da Arquitetura. *Inquérito nacional de arquitetura*. Belo Horizonte, 1963. 236 p.

 Bibliography.

1021. Bienal de Arquitetura (1st : 1973 : São Paulo, Brazil). *Bienal de Arquitetura: {exposição}, 18 de junho a 15 de julho de 1973.* São Paulo, 1973. 84 p.

 Text in Portuguese and English.

1022. *Brasília: história, urbanismo, arquitetura, construção = {Brasília}: history, city planning, architecture, building.* 2a. ed. São Paulo, Brazil, 1960. 132 p.

 Translated by Gregorio Zolko and Alfredo Wiesenthal.

1023. *Brasília, plano piloto; relatoria justificativo 11-3-57; construtecnica S/A.* São Paulo, Brazil: Habitat, 1957. 50 p.

1024. Bruand, Yves. *Arquitetura contemporânea no Brasil.* São Paulo, Brazil: Perspectiva, 1981. 387 p.

 Translated from the French by Ana M. Goldberger.

1025. Caravlho, Benjamin da A. *Duas arquiteturas no Brasil.* Rio de Janeiro, Brazil: Editôra Civilização Brasileira, 1961. 179 p.

1026. Costa, Lúcio. *Sôbre arquitetura.* Pôrto Alegre, Brazil: Centro dos Estudantes Universitários de Arquitetura, 1962. 359 p.

1027. Debenedetti, Emma, and Salmoni, Anita. *Architettura italiana a San Paolo.* São Paulo, Brazil: Instituto Cultural Italo-Brasileiro, 1953. 106 p.

1028. Edmundo, Luiz. *O Rio de Janeiro do meu tempo.* Rio de Janeiro, Brazil: Imprensa Nacional, 1938. 3 v.

1029. Evenson, Norma. *Two Brazilian capitals; architecture and urbanism in Rio de Janeiro and Brasília.* New Haven, Conn.: Yale University Press, 1973. 225 p.

1030. Ferraz, Geraldo. *Warchavchik e a introdução da nova arquitetura no Brasil, 1925-1940.* São Paulo, Brazil: Museu de Arte, 1965. 277 p.

 Preface by P.M. Bardi.

1031. Fonsêca, Ivan de Aquino. *Análise da arquitetura moderna.* Recife, Brazil: Universidade Federal de Pernambuco, 1966. 164 p.

1032. Giuria, Juan. *La riqueza arquitectónica de algunas ciudades del Brasil.* Montevideo, Uruguay, 1937.

1033. Guardia, B., Fernando. *Brasília.* Cochabamba, Bolivia: Universidad Mayor de San Simón, Facultad de Arquitectura, 1963. 73 p.

1034. Lemos, Carlos Alberto Cerqueira. *Arquitetura brasileira.* São Paulo, Brazil: Melhoramentos, Editora da Universidade de São Paulo, 1979. 158 p.

1035. Lima (Peru). Museo de Arte. *Arquitectura brasileña: {exposición}, marzo de 1961.* Lima, 1961. 36 p.

Exhibition held in various cities of South America.

1036. Mello, Eduardo Kneese de. *A herança mourisca da arquitetura no Brasil.* São Paulo, Brazil: Universidade de São Paulo, Faculdade de Arquitetura e Urbanismo, 1974? 85 p.

Bibliography.

1037. Mindlin, Henrique E. *Modern architecture in Brazil.* New York, N.Y.: Reinhold, 1956. 256 p.

1038. New York (N.Y.). Museum of Modern Art. *Brazil builds; architecture new and old, 1652-1942.* New York, 1943. 198 p.

Exhibition held Jan. 12-Feb. 28, 1943; text by Philip L. Goodwin, photographs by G.E. Kidder Smith.

1039. Orico, Osvaldo. *Brasil; capital Brasília.* Rio de Janeiro, Brazil: Instituto Brasileiro de Geografia e Estatística, 1958. 257 p.

Text in Portuguese, French and English.

1040. São Paulo (Brazil). Museu de Arte de São Paulo Assis Chateaubriand. *Warchavchik e as origens da arquitetura moderna no Brasil: {exposição}, agosto 1971.* São Paulo, 1971. {72} p.

1041. Stäubli, Willy. *Brasília.* New York, N.Y.: Universe Books, 1966. 199 p.

Text in English; German edition also available: Stuttgart, West Germany: Koch, c1965, 200 p.

1042. Telles, Augusto Carlos da Silva. *Atlas dos monumentos históricos e artísticos do Brasil.* Rio de Janeiro, Brazil: Ministério da Educação e Cultura, 1975. 347 p.

BRAZIL—ARCHITECTURE—BIBLIOGRAPHIES

1043. São Paulo (Brazil). Universidade de São Paulo. Faculdade de Arquitetura e Urbanismo. Biblioteca. *Indice de arquitetura brasileira, 1950/70.* São Paulo, 1974. 661 p.

1044. São Paulo (Brazil). Universidade de São Paulo. Faculdade de Arquitetura e Urbanismo. Biblioteca. *Indice de arquitetura brasileira, 1967/69; Biblioteca.* São Paulo, 1970. 168 leaves.

BRAZIL—ARCHITECTURE—DICTIONARIES, ETC.

1045. Carona, Eduardo, and Lemos, Carlos A.C. *Dicionário da arquitetura brasileira.* {São Paulo, Brazil}: Edart-São Paulo, 1972. 472 p.

Dictionary of Portuguese terms relative to the architecture of Brasil; individual architects are not listed.

BRAZIL—ARCHITECTURE—PERIODICALS

1046. *Brasil constroi.* 1949- . Rio de Janeiro, Brazil, 1949- .

1047. *Habitat; arquitetura e artes no Brasil.* no. 1 (oct./dez. 1950)- . São Paulo, 1950- .

1048. *Módulo; revista de arquitetura e artes plásticas.* no. 1 (1955)- . Rio de Janeiro, Brazil, 1955- .

Irregular; text in Portuguese and English; tranlsations in German and French inserted.

BRAZIL—DESIGN

1049. *Desenho industrial; aspectos sociais, históricos, culturais e econômicos.* São Paulo, Brazil: Forum Roberto Simonsen, 1964. 112 p.

1050. Gonçalves, Vergniaud Calazans. *Automóvel no Brasil, 1893-1966.* São Paulo, Brazil: Editôra do Automóvel, 1966. 79 p.

1051. Rodrigues, José Wasth. *As artes plásticas no Brasil; mobiliário.* Rio de Janeiro, Brazil: Edições de Ouro, 1968. 101 p.

 Bibliography.

1052. Salão Contemporânea de Campinas (9th : 1974 : Campinas, Brazil). *Desenho brasileiro 74.* Campinas, 1974. 52 p.

1053. São Paulo (Brazil). Museu de Arte de São Paulo Assis Chateaubriand. *Mobiliário brasileiro, premissas e realidade; {exposição}, novembro-dezembro 1971.* São Paulo, 1971. {74} p.

1054. São Paulo (Brazil). Museu Lasar Segall. *Os papa-níquels, um desenho industrial precursor do Pop-Art; {exposição}, 12 de abril-13 de maio 1979.* São Paulo, 1979. 24 p.

BRAZIL—GRAPHIC ARTS

1055. Aele, Galería (Madrid, Spain). *Grabados populares del Noreste de Brasil: {exposición}, 14 de febrero al 4 de marzo 1975.* Madrid, 1975. 22 p.

1056. Bercowitz, Marc. *El grabado en el Brasil.* Santiago, Chile: Embajada del Brasil, 1963. 36 p.

1057. Berne (Switzerland). Kunstmuseum. *Graveurs brésiliens...{exposition}, mai-juin 1954.* {Berne, 1954}. {31} p.

1058. Bienal de São Paulo (12th : 1974 : São Paulo, Brazil). *Mostra da gravura brasileira: Fundação Bienal de São Paulo, novembro-dezembro de 1954.* São Paulo, 1974. 144 p.

1059. Brazil. Biblioteca Nacional (Rio de Janeiro). *Exposição comemorativa do centenário do Diário Oficial, 1862-1962.* Rio de Janeiro, 1962. 17 p.

 Nineteenth century graphic arts in Brazil.

1060. Brazil. Biblioteca Nacional (Rio de Janeiro). *A moderna gravura brasileira; catálogo da exposição.* Rio de Janeiro, 1974. 20 p.

1061. Brazil. Biblioteca Nacional (Rio de Janeiro). *O Rio da caricatura; exposição organizada pela Seção de Exposições da Biblioteca Nacional e patrocinada pelo Jornal do Brasil, como contribuição aos festejos do 4. Centenário da Cidade.* Rio de Janeiro, 1965.

1062. Brussels (Belgium). Palais des Beaux-Arts. *Quatre graveurs brésiliens; {exposition}, février 1975.* Brussels, 1975. 24 p.

1063. Carneiro, Newton. *As artes gráficas em Curitiba.* Curitiba, Brazil: Edições Paiol, 1976. 73 p.

History of the printed image in 19th century Curitiba.

1064. Center for Inter-American Relations (New York, N.Y.). *Gravadores brasileiros: {exhibition}, September 25-November 2, 1969.* New York, N.Y., 1969. 16 p.

1065. *Clube de Ilustradores do Brasil: {exposição}, julho 1978.* São Paulo, Brazil: Museo de Arte de São Paulo Assis Chateaubriand, 1978. 68 p.

1066. Clube dos Diretores de Arte do Brasil (Rio de Janeiro, Brazil). *Anuário de arte visual do Brasil, 67.* Rio de Janeiro, 1967? 124 p.

1067. Crespo, Angel. *Grabados populares del nordeste del Brasil.* Madrid, Spain: Servicio de Propaganda y Expansión Comercial de la Embajada del Brasil, 1963. 66 p.

1068. *Destaques Hilton de gravura; {exposição}, São Paulo, Museu de Arte Moderna, 22 a 30 de setembre de 1981...* São Paulo? 1981. {35} p.

Catalog of an exhibition circulated to nine Brazilian art institutions during 1981-82; 10 contemporary Brazilian printmakers are respresented.

1069. D'Horta, Arnaldo Pedroso and Almeida, Paulo Mendes de. *Grupo do Santa Helena; album de oito águas-fortes originais assinadas.* São Paulo, Brazil, 1971. unpaged.

1070. *Doze gravadores populares do Nordeste.* Recife, Brazil: Guariba Editora de Arte, 1974. unpaged.

1071. Ferreira, Orlando da Costa. *Imagem e letra; introdução à bibliologia brasileira; imagem gravada.* São Paulo, Brazil: Edições Melhoramentos, 1976. 279 p.

Nineteenth and 20th century Brazilian prints and drawings.

1072. Franco, Maria Eugenia. *Via Sacra; mestre nosa, xilogravuras populares.* São Paulo, Brazil: J. Pacello, {1979}. 19 leaves.

Text in Portuguese and English.

1073. Fundação Calouste Gulbenkian (Lisbon, Portugal). *Arte gráfica brasileira de hoje; Galeria de exposições temporárias—Lisoba—julho de 1975.* Lisbon, {1975}. {67} p.

1074. *Gravuras gaúchas, 1950-52.* Rio de Janeiro, Brazil: Editora Estampa, 1952.

Works of eleven artists from Rio Grande do Sul.

1075. Leite, José Costa. *Xilogravura popular do Nordeste.* Recife, Brazil, 1968. 9 p.

1076. Leite, José Roberto Teixeira. *A gravura brasileira contemporânea.* Rio de Janeiro, Brazil: Artes Gráficas Gomes de Souza, c1965. 70 p.

1077. Lima, Herman. *História da caricatura no Brasil.* Rio de Janeiro, Brazil: Livraria José Olympio Editôra, 1963. 4 v.

Bibliography.

1078. Neistein, José. *The original and its reproduction: a Melhoramentos project.* São Paulo, 1977. 16 p.

Works of twelve Brazilian artists assembled to travel in the United States.

1079. Oldenburg (West Germany). Landesmuseum. *Brasilianische Graphik der Gegenwart; Ausstellung im Landesmuseum Oldenburg, Schloss, Studio für zeitgenössische Kunst unter der Schirmherrschaft der Brasilianischen Botschaft, 2. Juni-5. Juli 1964.* Oldenburg, 1964. 8 leaves.

1080. Panorama de Arte Atual Brasileira: Desenho, Gravura (1971 : São Paulo, Brazil). *Panorama de Arte Atual Brasileira: Desenho, Gravura; catálogo de exposição...* São Paulo: Museu de Arte Moderna de São Paulo, 1971. 115 p.

1081. Panorama de Arte Atual Brasileira: Desenho, Gravura (1980 : São Paulo, Brazil). *Panorama 80; desenho e gravura, {exposição, outubro 1980?}.* São Paulo: Museu de Arte Moderna de São Paulo, 1980. 120 p.

1082. Paris (France). Musée Galliera. *Art graphique brésilien.* Paris, 1975. 36 p.

Text by José Roberto Teixeira Leite.

1083. Pereira, João Camacho. *Coleção de gravuras portuguêses: reproduções, pt. 2, Brasiliada.* Lisbon, Portugal, 1972. portfolio.

1084. Proença, M. Cavalcanti. *Gravuras.* Rio de Janeiro, Brazil: Gavião Editôra, 1962. 8 p.

 Seventeen woodcuts from the Brazilian Northeast.

1085. Projecta, Galeria de Arte (São Paulo, Brazil). *3 gravadores técnicas: xilogravura, litografía, metal...{exposição}, 23 de maio de 1978.* São Paulo, 1978. 16 p.

1086. Rubbers, Galería (Buenos Aires, Argentina). *Dibujantes y grabadores brasileños; {exposición}, octubre 1972.* Buenos Aires, 1972. 12 p.

1087. Salão de Arte Contemporânea de São Caetano du Sul (8th : 1975 : São Caetano do Sul, Brazil). *8 Salão de Arte Contemporânea de São Caetano do Sul, gravura; catálogo, Sala Especial, Oswaldo Goeldi, gravuras.* São Caetano do Sul: Fundação das Artes de São Caetano do Sul, 1975. 121 p.

1088. Santiago (Chile). Museo Nacional de Bellas Artes. *25 grabadores brasileños: {exposición}, Museo Nacional de Bellas Artes, 26 de junio al 13 de julio de 1980.* Santiago, 1980. 12 p.

1089. Santos, José Martins dos {et al.}. *Xilogravuras populares alagoanas.* Alagoas, Brazil: Universidade Federal de Alagoas, 1975. 50 plates.

1090. São Paulo (Brazil). Paço das Artes. *Caricaturistas, {exposição}.* São Paulo, 1971. 59 p.

 Works by 35 Brazilian artists.

1091. São Paulo (Brazil). Paço das Artes. *A gravura brasileira.* São Paulo, 1970. 21 p.

 Exhibition catalog; text by Wolfgang Pfeiffer, Walmir Ayala, and Geraldo Ferraz.

1092. São Paulo (Brazil). Pinacoteca do Estado. *O desenho jovem nos anos 40: {exposição}, 11 de novembro de 1976.* São Paulo, 1976. 16 p.

1093. São Paulo (Brazil). Pinacoteca do Estado. *A imprensa negra em São Paulo, 1918-1965; {exposição}, 31 de maio a 26 de junho de 1977.* São Paulo, 1977. {30} p.

1094. São Paulo (Brazil). Universidade de São Paulo. Museu de Arte Contemporânea. *O cartaz do cinema brasileiro (1923-1972); {exposição}, 25 de julho-12 de agosto 1973.* São Paulo, 1973. 8 p.

1095. São Paulo (Brazil). Universidade de São Paulo. Museu de Arte Contemporânea. *Novos e novíssimos gravadores nacionais: {exposição}, 22 de maio a 22 junho de 1975.* São Paulo, 1975. 8 p.

1096. São Paulo (Brazil). Universidade de São Paulo. Museu de Arte Contemporânea. *II Exposição da jovem gravura nacional: 18 novembro-11 dezembro 1966.* São Paulo, 1966. 24 p.

1097. Silva, Orlando da. *A arte maior da gravura.* São Paulo, Brazil: Edição Espade, 1976. 125 p.

Bibliography: p. 113-117.

1098. *Xilografos nordestinos.* Rio de Janeiro, Brazil: Fundação Casa de Rui Barbosa, 1977. 218 p.

Woodcuts of contemporary Brazilian artists.

BRAZIL—GRAPHIC ARTS—COLLECTIONS

1099. Rio de Janeiro (Brazil). Museu Nacional de Belas Artes. *A gravura brasileira no século XX; exposição de gravuras do acervo do Museu Nacional de Belas Artes, julho de 1973.* Rio de Janeiro, 1973. 76 p.

BRAZIL—PAINTING

1100. São Paulo (Brazil). Universidade da São Paulo. Museu de Arte Contemporânea. *70 gravadores brasileiros; obras pertencentes ao acervo do Museu de Arte Contemporânea da Universidade de São Paulo: {exposição}, 12 de outubro-9 de dezembro 1979.* São Paulo, 1979. 2 p.

1101. Acquarone, Francisco. *Mestres da pintura no Brasil.* Rio de Janeiro, Brazil: Paulo de Azevedo, 1950? 253 p.

All periods of Brazilian painting.

1102. Acquarone, Francisco, and Vieira, A. de Queiroz. *Primores da pintura no Brasil com uma introdução historica e textos explicativos.* Rio de Janeiro, Brazil: {Edição del Autores, 1942}. 2 v.

 Survey of 19th century painting in Brazil.

1103. Andrade, Geraldo Edson de. *Aspectos da pintura brasileira = Aspects of Brazilian painting.* São Paulo, Brazil? Spala Editora, 1975? 159 p.

1104. *Arte moderna.* Belo Horizonte, Brazil: Imprensa Oficial, 1944? 97 p.

 Contains works by 43 modern Brazilian painters.

1105. Atelier de Arte Colorama (Rio de Janeiro, Brazil). *Expoentes da pintura brasileira.* Rio de Janeiro: Clube de Arte, 1973. unpaged.

 Text by Antônio Bento.

1106. Bahia (Brazil). Museu de Arte Moderna da Bahia. *150 anos de pintura no Bahia.* Salvador: Artes Gráficas, 1973. unpaged.

 From the end of the Colonial period to World War II.

1107. Belo Horizonte (Brazil). Universidade de Minas Gerais. *Três séculos e meio de pintura no Brasil.* Belo Horizonte: Universidade de Minas Gerais, Edição da Reitoria, 1962. unpaged.

1108. Braga, Rubem. *Três primitivos.* Rio de Janeiro, Brazil: Ministério da Educação, 1953. 19 p.

 The three artists represented are: José Bernardo Cardoso, Jr., Heitor dos Prazeres, Paulista Antônio da Silva.

1109. Braga, Theodor. *Para a posteridade; artistas pintores no Brasil.* São Paulo, Brazil, 1942. 251 p.

 List of Brazilian painters with bibliography for each.

1110. Ferraz, Geraldo. *19 pintores.* São Paulo, Brazil: Galeria Prestes Maia, 1948.

1111. França, Acácio. *A pintura na Bahia.* Bahia, Brazil: Secretaria de Educação e Saúde, 1944. 72 p.

1112. Freire, Laudelino. *Galeria histórica dos pintores no Brasil.* Rio de Janeiro, Brazil: Oficinas Gráficas da Tipografia Marítima Brasileira, 1914.

1113. Freire, Laudelino. *Um século de pintura: apontamentos para a história da paisagem no Brasil, 1816-1916*. Rio de Janeiro, Brazil: Tipografia Röhe, 1916.

1114. Freyre, Gilberto. *Vida, forma e côr*. Rio de Janeiro, Brazil: J. Olympio, 1962. 396 p.

 Essays on Northeast Brazilian painting.

1115. Jorge, Fernando. *Vidas de grandes pintores do Brasil (incluindo as principais caricaturistas)*. São Paulo, Brazil: Martins, 1954. 308 p.

 Bibliography.

1116. Junior, Peregrino. *Interpretação biotipólogica das artes plásticas*. Rio de Janeiro, Brazil, 1936.

1117. Laemmert, Regina L. *Tendências da pintura brasileiro contemporânea*. Rio de Janeiro, Brazil: Museu Nacional de Belas Artes, 1969.

1118. La Plata (Argentina). Museo Provincial de Bellas Artes. *Artistas brasilêos: {exposición}, 1945 del 2 al 19 de agosto*. La Plata, 1945. 46 p.

 Text by Marques Rebêlo.

1119. Linhares, Mario. *Nova orientação da pintura brasileira*. Rio de Janeiro, Brazil: Vila Boas, 1926.

1120. London (England). Royal Academy of Arts. *Exhibition of modern Brazilian paintings*. London, 1944. 35 p.

1121. Martins, Luis. *A evolução social da pintura*. São Paulo, Brazil, 1942. 109 p.

1122. Martins, Luis. *A pintura moderna no Brasil*. Rio de Janeiro, Brazil: Schmidt, 1937.

1123. Milliet, Sérgio. *Marginalidade da pintura moderna*. São Paulo, Brazil: Gráfica da Prefeitura, 1942. 84 p.

1124. Milliet, Sérgio. *Pintores e pintura*. São Paulo, Brazil: Martins, 1940. 198 p.

 Collection of essays.

1125. Milliet, Sérgio. *Pintura quase sempre*. Pôrto Alegre, Brazil: Livraria do Globo, 1944. 260 p.

1126. Negro, Carlos del. *Contribução ao estudo da pintura mineira.* Rio de Janeiro, Brazil, 1958. 160 p.

1127. Oliveira, Carlota Paulina de Fegueirdo Cardoso de. *A pintura no Brasil; em homenagem ao IV Centenário da mui leal e heróica cidade de São Sebastião do Rio de Janeiro.* Rio de Janeiro, Brazil: Editôra Melso, 1963. 152 p.

1128. Panorama de Arte Atual Brasileira: Pintura (1973 : São Paulo, Brazil). *Panorama de Arte Atual Brasileira: Pintura, 1973-* . São Paulo: Museu de Arte Moderna da São Paulo, 1973- .

1129. Pinheiro, João Ribeiro. *Historia da pintura brasileira.* Rio de Janeiro, Brazil: Casa Leuzinger, 1931.

1130. Pontual, Roberto. *5 mestres brasileiros: pintores construtivistas: Tarsila, Volpi, Dacosta, Ferrari, Valentim.* Rio de Janeiro, Brazil: Livraria Kosmos Editora, c1977. 174 p.

Text in Portuguese and English.

1131. *Primores da pintura no Brasil, com una introdução histórica e textos explicativos.* Rio de Janeiro, {1942}. 1 v.

Edited by A. de Queiroz Vieira and F. Acquarone.

1132. Reis, José Maria dos. *História da pintura no Brasil.* São Paulo, Brazil: Editôra LEIA, 1944. 409 p.

Bibliography: p. {391}-397; a general history of Brazilian painting.

1133. Rio de Janeiro (Brazil). Museu de Arte Moderna. *Brasil/Cuiabá: pintura cabocla.* Rio de Janeiro, 1981. {32} p.

Catalog of an exhibition, Jan. 27-March 22, 1981.

1134. Rio de Janeiro (Brazil). Museu Nacional de Belas Artes. *Aspectos de Paris por pintores brasileiros.* Rio de Janeiro, 1945. 10 p.

Exhibition catalog.

1135. Rio de Janeiro (Brazil). Museu Nacional de Belas Artes. *Catálogo da exposição da paisagem brasileira.* Rio de Janeiro, 1944.

1136. Rio de Janeiro (Brazil). Museu Nacional de Belas Artes. *Exposição aspectos do Rio.* Rio de Janeiro, 1948. 41 p.

Rio de Janeiro in paintings by forty contemporary artists.

1137. Rio de Janeiro (Brazil). Museu Nacional de Belas Artes. *Exposição da missão artistica francesa de 1816.* Rio de Janeiro, 1940.

Catalog of an exhibition held Nov.-Dec., 1940; works by artists born in France who worked in Brazil.

1138. Rio de Janeiro (Brazil). Museu Nacional de Belas Artes. *Reflexos do impressionismo no Museu Nacional de Belas Artes; {exposição comemorativa do 1 Centenário do impressionismo, 1874-1974}.* Rio de Janeiro, 1974. {50} p.

Bibliography: p. 49.

1139. Rio de Janeiro (Brazil). Museu Nacional de Belas Artes. *Um século da pintura brasileira (1850-1950).* Rio de Janeiro, n.d.

Exhibition catalog.

1140. Romero Brest, Jorge. *La pintura brasileña contemporánea.* Buenos Aires, Argentina: Poseidon, {c1945}. 112 p.

1141. Rubens, Carlos. *História da pintura no Brasil.* Rio de Janeiro, Brazil: Ministério das Relações Exteriores, 1939. 32 p.

Bibliography: p. 32; mimeographed; English edition published in 1943, Rio de Janeiro: Imprensa Nacional, 47 p.; Spanish edition published in 1943, Rio de Janeiro: Imprensa Nacional, 46 p., translated by Alarcon Fernández.

1142. São Paulo (Brazil). Museu de Arte Moderna de São Paulo. *Arte transcendente; exposição de pintura, março-abril 1981.* São Paulo, 1981. {38} p.

1143. São Paulo (Brazil). Museu de Arte Moderna de São Paulo. *'19 pintores', agosto/setembro 1978, {exposição}.* São Paulo, 1978. 62 p.

1144. São Paulo (Brazil). Museu Lasar Segall. *As bienais e a abstração; a década de '50; {exposição}, abril-junho 1978.*

1145. São Paulo (Brazil). Museu Lasar Segall. *O Museu Lasar Segall apresenta ciclo de exposições da pintura brasileira contemporânea, 2a. fase-O Modernismo-1917/30...de 8 de maio à 1 de junho de 1975.* São Paulo, 1975. 12 p.

Bibliography: p. 11.

1146. São Paulo (Brazil). Universidade de São Paulo. Museu de Arte Contemporânea. *Exposição-homenagem a Francisco Matarazzo Sobrinho (1898-1977), 23 de junho a 31 de julho de 1977.* São Paulo, 1977. 22 p.

1147. Scliar, Salomão, and Michellozo, Francisco. *Seis pintores brasileiros contemporâneos, (Portinari, Segal, di Cavalcanti, Guignard, Pancetti, Djanira).* São Paulo, Brazil: Cidady Editôra, 1963. unpaged.

1148. *Um século da pintura brasileira.* Rio de Janeiro, Brazil: Ministério da Educação e Saúde, 1950? 72 p.

1149. Serviço Social do Comercio (São Paulo, Brazil?). *Matrizes, filiais & companhias: Flávio L. Motta, Flávio Império, Claudio Tozzi, Renina Katz: SESC, 14 a 30 de dezembro 1979.* São Paulo? 1979. 56 p.

1150. Silva, H. Pereira da. *Belas Artes.* Rio de Janeiro, Brazil: Sociedade dos Artistas Nacionais, 1948. 172 p.

Collection of newspaper criticism dealing with academic Brazilian painters.

1151. Uirapuru Galeria de Arte (São Paulo, Brazil). *8 pintores do Grupo Santa Helena; {exposição, março 1973}.* São Paulo, 1973. 58 p.

1152. UNESCO. *Pintura brasileira.* Paris, France, 1952? unpaged.

1153. Vasconcellos, Sylvio de. *Arquitetura no Brasil; pintura mineira e outros temas.* Belo Horizonte, Brazil: Universidade de Minas Gerais, 1959. 96 p.

1154. *20 pintores brasileños: exposición...* São Paulo, Brazil: Museo de Arte de São Paulo Assis Chateaubriand, 1980. 44 p.

Exhibition held in Chile, 1980. Organized by the Ministério de Relaciones Exteriores de la República Federativa de Brasil to honor the visit of His Excellency, João Baptista Figueiredo, to the Republic of Chile.

1155. Vitureira, Cipriano Santiago. *Sentido humanista de la pintura brasileña contemporânea.* Montevideo, Uruguay: Central, 1947. 46 p.

1156. Braga, Theodoro. *Artistas pintores no Brasil.* São Paulo, Brazil: Editôra Limitada, 1942. 251 p.

BRAZIL—PAINTING—COLLECTIONS

1157. Rio de Janeiro (Brazil). Museu Nacional de Belas Artes. *Primores da pintura no Brasil.* Rio de Janeiro, 1941? 15 v.

Text by Francisco Acquarone and A. de Queiroz Vieira; color reproductions of Brazilian 19th century paintings in the collection of the museum.

1158. Rio de Janeiro (Brazil). Museu Nacional de Belas Artes. *Sintese da pintura no Brasil (no acervo de MNBA): {exposição, 1973}.* Rio de Janeiro, 1973. 64 p.

1159. Toledo (Ohio). Museum of Art. *One hundred paintings from the São Paulo Museum of Art.* Toledo, {1957}. {14} p.

Exhibition catalog, Oct. 8-Nov. 17, 1957.

1160. São Paulo (Brazil). Pinacoteca do Estado. *A paisagem no coleção da Pinacoteca; {exposição}, dezembro de 1978.* São Paulo, 1978. 40 p.

1161. São Paulo (Brazil). Pinacoteca do Estado. *O retrato na coleção da Pinacoteca; {exposição}, 26 de agosto a 26 de setembro de 1976.* São Paulo, 1976. 24 p.

BRAZIL—PHOTOGRAPHY

1162. Caracas (Venezuela). Museo de Bellas Artes. *11 fotógrafos brasileros; {exposición}.* Caracas, 1980.

1163. Center for Inter-American Relations (New York, N.Y.). *Pioneer photographers of Brazil, 1840-1920.* New York, 1976.

Text by Gilberto Ferrez and Watson J. Naef.

1164. Fuss, Peter. *Brasilien.* Berlin, Germany: Atlantis Verlag, 1937.

255 photographs of Brazil.

1165. Kossoy, Boris. *Origines e expansão fotografía no Brasil; século XIX.* Rio de Janeiro, Brazil, 1980.

1166. *Mostra da fotografía, Revolução de 30.* Rio de Janeiro, 1980.

Exhibition catalog.

1167. Rio de Janeiro (Brazil). Museu de Arte Moderna. *Foto linguagem: Museu de Arte Moderna do Rio de Janeiro, {exposição }, agosto 2 a 26 1973.* Rio de Janeiro, 1973. 32 p.

1168. São Paulo (Brazil). Museu de Arte de São Paulo Assis Chateaubriand. *GSP/76; um panorama da Grande São Paulo em todos as aspectos existenciais; {exposição}, março-abril-maio 1976.* São Paulo, 1976. 48 p.

1169. São Paulo (Brazil). Museu de Arte de São Paulo Assis Chateaubriand. *'O homen brasileiro e suas raízes culturais'; {exposição}, 02-30 de setembro de 1980.* São Paulo, 1980. 21 leaves.

1170. São Paulo (Brazil). Museu Lasar Segall. *O lambe-lambe hoje; (o fotógrafo de jardim; {exposição}, 10 de maio a 08 de junho de 1980.* São Paulo, 1980. 36 p.

1171. São Paulo (Brazil). Universidade de São Paulo. Museu de Arte Contemporânea. *Fotógrafos de São Paulo: {exposição}, 12 de maio a 13 de junho de 1971.* São Paulo, 1971. unpaged.

1172. São Paulo (Brazil). Universidade de São Paulo. Museu de Arte Contemporânea. *O fotógrafo desconhecido; {exposição}, 23 de novembro-20 de dezembro 1972.* São Paulo, 1972. 28 p.

1173. Trienal de Fotografia do Museu de Arte Moderna de São Paulo (1st : 1980 : São Paulo, Brazil). *Trienal de Fotografia do Museu de Arte Moderna de São Paulo, 1980-* São Paulo, 1980-

BRAZIL—SCULPTURE

1174. Centro Campestra SESC 'Brasilio Machado Neto' (São Paulo, Brazil). *Panorama da escultura brasileira no século XX; {exposição}, 13 de janeiro a 10 de fevereiro de 1980.* São Paulo, {1980}. portfolio (36 p.).

BRAZIL—SCULPTURE

1175. Saia, Luiz. *Escultura popular brasileira.* São Paulo, Brazil: Editôra Gaveta, 1944. 62 p.

BRAZIL—TAPESTRY

1176. Trienal da Tapeçaria (1st : 1976 : São Paulo, Brazil). *I Trienal da Tapeçaria: {exposição}, Museu de Arte Moderna de São Paulo, outubro-novembro 1976.* São Paulo, 1976. 74 p.

BRAZIL—TYPOGRAPHY

1177. São Paulo (Brazil). Museu de Arte de São Paulo Assis Chateaubriand. *História da tipografia no Brasil.* São Paulo, 1979. 277 p.

Bibliography: p. 266-268; exhibition catalog.

BRAZIL—VIDEO

1178. *Expo-projeção 73; som, audio-visual, Super 8, 16 mm; São Paulo, junho, 1973.* São Paulo? Centro de Artes Novo Mundo, 1973? 96 p.

Text in Portuguese and English.

Chile

1179. Bienal Arte Universitario (2nd : 1981 : Santiago, Chile). *2a. Bienal Arte Universitario: dibujo, pintura, escultura, grabado: Pontificia Universidad Católica de Chile, {exposición}, Museo Nacional de Bellas Artes, octubre '81.* Santiago, Chile: Pontificia Universidad Católica de Chile, Facultad de Bellas Artes, Corporación de Extensión Artística, Escuela de Arte, 1981. 1 folded sheet.

1180. Bienal de São Paulo (7th : 1963 : São Paulo, Brazil). *Chile en la VII Bienal de Sao Paulo, 1963.* Santiago, Chile: Universidad de Chile, 1963.

1181. Bienal de São Paulo (15th : 1979 : São Paulo, Brazil). *Chile: XV Bienal Internacional de Arte de São Paulo, Brasil, 1979.* Santiago, Chile: Ministerio de Relaciones Exteriores, 1979?

1182. Bienal Latino Americana de São Paulo (1st : 1978 : São Paulo, Brazil). *Chile: 1978, Primera Bienal Latinoamericana de São Paulo, Brasil.* Santiago, Chile: Ministerio de Relaciones Exteriores, 1978?

1183. Biennale di Venezia (Italy). Chilean Pavilion. *Liberta al Chile = Libertad para Chile.* Venice, Italy, 1974. portfolio.

 Catalog of an exhibition, October-November, 1974.

1184. Buenos Aires (Argentina). Museo de Arte Moderno. *Chile en la novena Bienal de San Pablo.* Buenos Aires, 1968. 40 p.

 Exhibition catalog.

1185. Buenos Aires (Argentina). Museo Nacional de Bellas Artes. *Chile: dibujos-pinturas: {exposición, septiembre 1969}.* Buenos Aires, 1969. 23 p.

1186. Central de Arte, Galería (Santiago, Chile). *Galería Central de Arte: Aldunate, Antúnez, Balmes, Barreda, Barríos, Bonati, Bru, Carreño, Castro Cid, Couve, {et al.}: {exposición}.* Santiago, n.d. 28 p.

1187. Corporación Cultural (Santiago, Chile). Departamento de Artes Plásticas. *I. {i.e., Ilustre} Municipalidad de Santiago y la Corporación Cultural presentan con la colaboración de su Departamento de Artes Plásticas la exposición de pintura y escultura 'Los Premios Nacionales de Arte' en la sala 'La Capilla' del Teatro Municipal, 5 mayo 1976, Santiago de Chile.* {Santiago, 1976?}. 61 p.

1188. Estellé Méndez, Patricio and Hurtado Zañartu, Juan Agustín. *Album de las mujeres chilenas: 10 láminas de los siglos XVIII y XIX.* Santiago, Chile: Editorial Universitaria, 1974. portfolio.

1189. Exposición Anual de Bellas Artes (13th : 1946 : Santiago, Chile). *Catálogo de la XIII Exposición Anual de Bellas Artes.* Santiago, 1946. 40 p.

1190. Exposición Anual de Bellas Artes (20th, 21st : 1953, 1954 : Santiago, Chile). *XX-XXI Exposición Anual de Bellas Artes: Salón Nacional, 1953-54.* Santiago, 1954. 50 p.

1191. Gonzalez Echeñique, Jávier. *Arte colonial en Chile.* Santiago, Chile: Departamento de Extensión Cultural del Ministerio de Educación, c1978. 58 p.

1192. Grez, Vicente. *Les beaux-arts au Chili.* Paris, France: A. Roger et R. Chernoviz Editeurs, 1880. 76 p.

1193. Güemes, Miguel M. *Reglamento para la Escuela de Artes: I Oficios, dictado por el Supremo Gobierno el 22 de enero de 1864.* Santiago, Chile: Nacional, 1864. 29 p.

1194. Guerra, Gregório. *Interpretación marxista del arte.* Santiago, Chile: Smirnow, n.d. 153 p.

1195. Kunzle, David. *Art of new Chile.* Venice, California: Environmental Communications, 1975. 33 slides.

1196. Las Condes (Chile). Instituto Cultural de Las Condes. *Pintura y escultura de hoy: {exposición}, septiembre-octubre 1976.* Las Condes, 1976. 77 p.

1197. Los Angeles (California). University of California. *Contemporary Chilean art by artists associated with the University of Chile: an exhibition...* Santiago, Chile: Editorial Universitaria, 1966. 39 p.

Organized by the University of California-University of Chile, Cooperative Program with the support of the Ford Foundation, 1966-67.

1198. Mackenna Subercaseaux, Alberto. *Luchas por el arte.* Santiago, Chile: Imprenta Barcelona, 1915. 103 p.

1199. Maldonado, Carlos. *El arte moderno y la teoría marxista del arte.* Santiago, Chile: Universidad Técnica del Estado, 1971. 183 p.

1200. Marinovic, M., and Jadresic, V. *Sociología del Chileno: estudio exploratório de la 'personalidad nacional' realizado a través del arte.* Santiago, Chile: Ediciones Aconcagua, 1978. 138 p.

1201. Melcherts, Enrique. *El arte en la vida colonial chilena.* Valparaíso, Chile: Parera, 1966.

1202. Montecino, Sergio. *Pintores y escultores de Chile.* Santiago, Chile, 1970. 110 p.

1203. Ovalle Castillo, Darío. *Apuntes de platería colonial en Chile y notas sobre arte chileno.* Melipilla, Chile: Imprenta 'La Moderna', 1945.

1204. Pereira Salas, Eugenio. *Historia del arte en el Reino de Chile.* Santiago, Chile: Universidad de Chile, 1965. 497 p.

1205. *Programa de las fiestas del 2 Centenario de San Felipe: y catálogo de la exposición de arte que se inaugura con el mismo motivo.* Santiago, Chile: Cervantes, 1940. 30 p.

1206. Rio de Janeiro (Brazil). Ministério da Educação e Saúde. Salão. *Arte chilena contemporánea: exposição apresentada pela Faculdade de Belas Artes da Universidade do Chile e patrocinada no Rio de Janeiro pela Divisão de Cooperação Intelectual do Ministério de Relações Exteriores, 30 de setembro a 14 de outubro de 1944.* Rio de Janeiro: Gráfico Mundo Espírita, 1944?

1207. Riquelme Figueroa, Luis. *El desarrollo histórico del arte pictórico en Chile.* Santiago, Chile: Imprenta Escuela Nacional de Artes Gráficas, 1942.

CHILE—GENERAL

1208. Rojas Mix, M.A. *La imagen artística de Chile.* Santiago, Chile: Universitaria, c1970. 152 p.

1209. Romera, Antonio R. *Chile.* Washington, D.C.: Pan American Union, 1963. 76 p.

Bibiligraphy: p. 74-76.

1209a. Salón de Verano (1st : 1931 : Viña del Mar, Chile). *Salón de Verano, 1931-* . Viña del Mar, 1931- .

1209b. Salón de Verano (10th : 1942 : Viña del Mar, Chile). *Salón de Verano: {exposición}, febrero 14 a marzo 15 de 1942.* Viña del Mar: Palacio de Bellas Artes, 1942. 32 p.

1210. Salón de Verano (12th : 1945 : Viña del Mar, Chile). *XII Salón de Verano: exposición de artes plásticas: 25 enero al 3 de marzo de 1945.* Viña del Mar, 1945. 44 p.

Exhibition held at the Palacio de Bellas Artes, Viña del Mar, Chile.

1211. Salón de Verano (20th : 1956 : Viña del Mar, Chile). *XX Salón de Verano 1956.* Viña del Mar, 1956. 24 p.

Exhibition held at the Palacio de Bellas Artes, Viña del Mar, Chile.

1212. Salón Oficial del Estado (49th : 1937 : Santiago, Chile). *XLIX Salón Oficial del Estado, 1937.* Santiago, 1937. 49 p.

Exhibition catalog.

1213. Salón Oficial del Estado (52nd, 53rd : 1940, 1941 : Santiago, Chile). *Salón Oficial del Estado, 52 y 53: IV Centenario de la Fundación de Santiago, 1941, Santiago, Museo de Bellas Artes, del 31 de octubre al 14 de diciembre 1941.* Santiago: Universidad de Chile, Facultad de Bellas Artes, 1941. 68 p.

1214. Salón Oficial del Estado (65th : 1954 : Santiago, Chile). *LXV Salón Oficial 1954: Museo Nacional de Bellas Artes, oct.-nov.* Santiago: Universitaria, 1954. 30 p.

Exhibition catalog.

1215. Salón Oficial del Estado (66th : 1955 : Santiago, Chile). *LXVI Salón Oficial 1955: Museo de Arte Contemporáneo: quinta normal, oct.-nov.* Santiago: Universitaria, 1955. 25 p.

1216. Santiago (Chile). Museo de Bellas Artes. *La mujer en el arte: {exposición: pintura, escultura, dibujo, grabado: septiembre 1975}*. Santiago, 1975. 68 p.

1217. Santiago (Chile). Universidad de Chile. Museo de Arte Contemporáneo. *Panorama del arte contemporáneo en Chile: en honor a las Delegaciones Extranjeras concurrentes a la VI Asamblea de la OEA.* Santiago, 1976. 52 p.

 Exhibition catalog.

1218. The Studio Magazine, v. 139, #686 (May, 1950). *The art of Chile.*

 Entire issue devoted to the art of Chile.

1219. Toledo (Ohio). Museum of Art. *Chilean contemporary arts; an exhibition...* Toledo, 1942. 169 p.

 Sponsored by the Ministry of Education of the Republic of Chile and the Faculty of Fine Arts of the University of Chile; organized by the Toledo Museum of Art in collaboration with the Office of the Coordinator of Inter-American Affairs. Also exhibited at the Pasadena (California) Art Institute, July 1942?

CHILE—GENERAL—BIBLIOGRAPHIES

1220. Santiago (Chile). Museo Nacional de Bellas Artes. Biblioteca. *Bibliografía arte chileno (no se incluyen catálogos).* Santiago, 1979. 6 p., typescript.

CHILE—GENERAL—COLLECTIONS

1221. Balmaceda F., Lissette. *El Museo Nacional de Bellas Artes.* Santiago, Chile: Facultad de Bellas Artes, Universidad de Chile, 1978. 152 p.

 Thesis; Universidad de Chile, 1978.

1222. Cruz, Isabel. *Museo Colonial de San Francisco.* Santiago, Chile: Ministerio de Educación, Departamento de Extensión Cultural, 1978. unpaged.

1223. Santiago (Chile). Universidad de Chile. Museo de Bellas Artes. *El Museo de Bellas Artes, 1880-1930.* Santiago: Universidad de Chile, Departamento de Extensión Cultural y Artística, 1930. 107 p.

CHILE—GENERAL—DICTIONARIES, ETC.

1224. Asociación Chilena de Pintores y Escultores (Chile). *Pintores y escultores de Chile.* Santiago: Editorial Universitaria, 1941. 161 p.

1225. Ossandón Guzmán, Carlos. *Guía de Santiago: cosas de interés artístico, histórico o pintoresco que pueden verse en lugares públicos o de fácil acceso.* Santiago, Chile: Zig-Zag, 1962. 169 p.

CHILE—GENERAL—PERIODICALS

1226. *Atenea; revista mensual de ciencias, letras y bellas artes.* no. 1 (April 1924)- . Concepción, Chile: Universidad de Concepción, 1924-
.

1227. *Babel; revista de arte y crítica.* no. 1 (May 1939)- . Santiago, Chile, 1939- .

1228. *La Bicicleta; revista chilena de la actividad artística.* no. 2 (Dec. 1978)- . Santiago, Chile, 1978?- .

1229. *CAL; coordinación artística latinoamericana; arte, expresiones culturales.* v. 1 (June 1979)- . Santiago, Chile, 1979- .

1230. *Coral; revista de turismo, arte y cultura.* 1965-1971? Santiago, Chile, 1965-71?

1231. *Forma; revista de arte.* v. 1, no. 1-v. 2, no. 13 (June 1941-June 1943). Santiago, Chile, 1941-1943.

1232. *Portal; revista de las letras y las artes.* no. 1 (Dec. 1965)- . Santiago, Chile, 1954- .

 Monthly.

1233. *Revista de arte.* no. 1-22 (June 1934-1939). Santiago, Chile: Universidad de Chile, Facultad de Bellas Artes, 1934-39.

 Superceded by Revista de Arte; boletín menusal.

1234. *Revista de arte.* v. 1, no. 1-5 (Nov. 1939-May 1940); series 2, no. 1 (July/Aug. 1955)- . Santiago, Chile: Facultad de Bellas Artes, Universidad de Chile, 1939-1940, 1955- .

 Supercedes another publication of the same title issued 1934-1939, (Nov. 1939-May 1940), by the Facultad de Bellas Artes of the Universidad de Chile; July/Aug., 1955, by the faculty's Instituto de Extensión de Artes Plásticas.

1235. *Revista de arte del Museo de Arte Contemporáneo.* 1936?- . Santiago, Chile: Universidad de Chile, Instituto de Extensión de Artes Plásticas, Museo de Arte Contemporáneo, 1936?- .

1236. *Revista de artes y letras.* no. 1-18 (July 15, 1884-90?). Santiago, Chile, 1884-1890?

1237. *Selecta; revista difusora del arte y la cultura.* n.d.

CHILE—ARCHITECTURE

1238. Benavides C., Juan {et al.}. *Arquitectura del altiplano: caseríos y villorrios ariqueños.* Santiago, Chile: Universidad de Chile, 1977. 109 p.

 Photos, plans, and maps of small northern Chilean communities.

1239. Bienal de Arquitectura (3rd : 1981 : Santiago, Chile). *3a. Bienal de Arquitectura: Vivienda; Colegio de Arquitectos de Chile, Museo Nacional de Bellas Artes, Museo de Arte Contemporáneo, {exposición}, 6 al 28 de agosto de 1981/Chile.* Santiago, 1981. 1 folded sheet.

1240. Cuadra, Gabriel. *Arquitectura rural en el valle central de Chile.* Santiago, Chile: Instituto de Historia, 1969.

CHILE—ARCHITECTURE

1241. Dávila, Roberto. *Apuntes sobre arquitectura colonial chilena.* Santiago, Chile: Universidad de Chile, 1978. 273 p.

1242. Montecinos B., Hernán {et al.}. *Arquitectura de Chiloé: estudio realizado en Chiloé durante el mes de febrero de 1976: {informe preliminar}.* Santiago, Chile: Facultad de Arquitectura y Urbanismo, Universidad de Chile, {1976}. 68 p.

CHILE—ARCHITECTURE—DICTIONARIES, ETC.

1243. Ortega, Oscar {et al.}. *Guía de la arquitectura en Santiago.* Santiago, Chile: Facultad de Arquitectura y Urbanismo, Universidad de Chile, 1976. 203 p.

CHILE—ARCHITECTURE—PERIODICALS

1244. *Arquitectura y construcción.* no. 1 (Dec. 1945)- . Santiago, Chile, 1945-

1245. *Revista de arquitectura.* v. 1, no. 1-5 (June 1913-May 1915). Santiago, Chile: Sociedad Central de Arquitectos de Chile, 1913-1915.

CHILE—COSTUMES AND NATIVE DRESS

1246. Corporación Cultural (Santiago, Chile). Departamento de Artes Plásticas. *I. {i.e., Ilustre} Municipalidad de Santiago y su Corporación Cultural presentan con la colaboración de su Departamento de Artes Plásticas la exposición de pintura Fiestas y costumbres de nuestro pueblo en la Sala 'La Capilla' del Teatro Municipal, septiembre de 1975, Santiago de Chile.* Santiago, 1975 or 1976. 22 p.

1247. Ruiz Aldea, Pedro. *Tipos y costumbres de Chile.* Santiago, Chile: Zig-Zag, 1947. 227 p.

Prologue and notes by Juan Uribe Echevarría.

CHILE—DESIGN

1248. Encuentro Arte-Industria (1st : 1980 : Santiago, Chile). *Primer Encuentro Arte-Industria 1980.* {Santiago, Chile: Sociedad de Fomento Fabril, 1980}. 32 p.

Catalog of an exhibition held at the Museo Nacional de Bellas Artes, Santiago, Chile, Dec. 18., 1980-Jan. 18, 1981.

CHILE—GRAPHIC ARTS

1249. Avila Martel, Alamiro de. *Los grabados populares chilenos.* Santiago, Chile: Editorial Universitaria, 1973. 22 p.

1250. Berlin (West Germany). Neue Gesellschaft für Bildende Kunst. *100 {i.e., Hundert} chilenische Plakate aus der Regierung Allende: {Ausstellung}, Sept./Okt. 1976.* Münster, Germany: Vereinigung zur Förderung der Demokratischen Kultur Chiles, {1976}. 114 p.

Text partly in Spanish.

1251. Exposición Anual de Bellas Artes (7th : 1940 :Santiago, Chile). *Exposición Anual de Bellas Artes: (artes del dibujo): Salón Nacional 1940.* Santiago: Sociedad Nacional de Bellas Artes, 1940. 77 p.

1252. *Grabado chileno contemporáneo = Contemporary Chilean printmaking: Agenda, 1978, {calendar, 1978}.* Santiago, Chile: Editorial Lord Cochrane, 1978. 180 p.

1253. Lima (Peru). Museo de Arte. *Muestra del grabado chileno presentado por la Escuela Nacional de Bellas Artes del Perú, del 8 al 22 de julio de 1960.* Lima, 1960. 8 p.

CHILE—PAINTING

1254. Alvarez Urquieta, Luis. *La pintura en Chile durante el período colonial.* Santiago, Chile: Academia Chilena de la Historia, 1933. 26 p.

1255. Bindis, Ricardo. *Panorama de la pintura chilena.* Santiago, Chile: Editorial Lord Cochrane, 1974. 20 p.

Offprint of the Revista Diplomacia, no. 4, Sept.-Dec. 1974.

1256. Buenos Aires (Argentina). Museo Nacional de Bellas Artes. *150 años de pintura chilena: {exposición}, 20 setiembre-22 octubre 1972.* Buenos Aires, 1972. 31 p.

1257. Carvacho Herrera, Víctor. *Pintura chilena contemporánea: segunda exposición itinerante.* Santiago, Chile: Departamento de Extensión Cultural del Ministerio de Educación, {1978?}. {62} p.

1258. Carvecho Herrera, Víctor. *Veinte pintores contemporáneos de Chile.* Santiago, Chile: Departamento de Extensión Cultural del Ministerio de Educación, 1978. 78 p.

1259. Comité Chileno del Congreso por la Libertad de la Cultura (Chile). *La pintura informalista.* Santiago, Chile: Orbe, 1964. 172 p.

1260. Compañía de Acero del Pacífico (Santiago, Chile). *Visión de la pintura chilena.* Santiago: Ladrón de Guevara y Ceitelis, 1963. 48 p.

Calendar for the year 1963.

1261. Cromo, Galería (Santiago, Chile). *Cinco expresiones de la figuración en Chile: 1, Dávila; 2, Lira; 3, Yrarrázabal; 4, Bru; 5, Smythe: {exposición, julio-agosto 1977}.* Santiago, 1977. 28 p.

1262. Epoca, Galería (Santiago, Chile). *Ricardo Yrarrázaval, Lily Garafulic, Rodolfo Opazo, Raúl Valdivieso, Gonzalo Díaz, Rosa Vicuña: {exposición}.* Santiago, 197-?

1263. Estudio Actual (Caracas, Venezuela). *Cuatro artistas chilenos: Atúnez, Opazo, Vilches, Yrarrázaval.* Caracas,{1971}. {12} p.

1264. *Forma y Espacio: 16 años {1955-1971}.* Santiago, Chile: Ediciones Cultura y Publicaciones, Ministerio de Educación, 1971? 52 p.

1265. Galaz, Gaspar, and Ivelic, Milan. *La pintura en Chile: desde José Gil de Castro hasta Juan Francisco González.* Santiago, Chile: Ediciones Extensión Universitaria, Universidad de Chile, 1975. 233 p.

Bibliography.

1266. Helfant, Ana. *Los pintores del medio siglo en Chile.* Santiago, Chile: Departamento de Extensión Cultural del Ministerio de Educación, 1978. 66 p.

1267. Helfant, Ana. *Pintura chilena contemporánea, segunda exposición itinerante.* Santiago, Chile: Departamento de Extensión Cultural del Ministerio de Educación, {1978?}. {67} p.

1268. Las Condes (Chile). Instituto Cultural de Las Condes. *Los arquitectos pintores: {exposición, septiembre 1979}.* Las Condes, 1979. 25 p.

1269. Las Condes (Chile). Instituto Cultural de Las Condes. *Exposición pintura colonial en los monasterios de Santiago: mayo-junio 1978.* Santiago, Chile, 1978. 33 p.

1270. Las Condes (Chile). Instituto Cultural de Las Condes. *Movimiento Forma y Espacio, 1955-1979: {exposición, octubre 1979?}.* Las Condes, 1979. 31 p.

1271. Las Condes (Chile). Instituto Cultural de Las Condes. *Pintores primitivos e ingenuos (latinoamericanos y chilenos): {exposición, mayo-junio 1979}.* Las Condes, 1979. 27 p.

1272. Las Condes (Chile). Instituto Cultural de Las Condes. *Seis valores jovenes: Benito Rojo, Robinson Mora, Alvaro Donoso, Rafael Edwards, Francisco de la Puente, y Sergio Castillo A.* Santiago, Chile: Editorial Gabriela Mistral, 1978. 32 p.

 Exhibition catalog.

1273. Otta, Francisco. *Guía de la pintura moderna: un panorama de los estilos con 10 ilustraciones didácticas del mismo autor.* 3a. ed., revisada y aumentada. Santiago, Chile: Editorial Universitaria, 1959. 105 p.

1274. Pollner, Edith. *Veinte jovenes pintores chilenos = Twenty young Chilean painters.* Santiago, Chile: Sociedad de Arte Contemporáneo y la Editorial Universitaria de Chile, c1968. 52 p.

1275. Robles Rivera, Armando. *La pintura en Chile.* Santiago, Chile: Imprenta Universo, 1921.

1276. Rocuant, Miguel Luis. *Tierras y cromos, pintura chilena.* Madrid, Spain: El Autor, 193-?

1277. Romera, Antonio R. *Asedio a la pintura chilena; desde el mulato Gil a los bodegones literarios de Luis Durand.* Santiago, Chile: Nascimiento, 1969. 186 p.

1278. Romera, Antonio R. *Historia de la pintura chilena.* {la. ed.}. Santiago, Chile: Editorial del Pacífico, 1951. 223 p.

 Bibliography; 2a. ed., Santiago, Chile: Zig-Zag, 1960, 157 p.; 3a. ed., corregida y aumentada, Santiago, Chile: Zig-Zag, 1968, 230 p.; 4a. ed., Santiago, Chile: Editorial Andrés Bello, 1976, 224 p.

1279. Romera, Antonio R. *Razón y poesia de la pintura.* Santiago, Chile: Nuevo Extremo, 1950. 160 p.

1280. Santiago (Chile). Museo Nacional de Bellas Artes. *El arte y la banca: exposición homenaje de las instituciones financieras en el Centenario del Museo Nacional de Bellas Artes, {Museo Nacional de Bellas Artes, Sala Matta, 28 agosto-21 septiembre 1980}.* Santiago, 1980. 20 p.

1281. Santiago (Chile). Museo Nacional de Bellas Artes. *La historia de Chile en la pintura: {exposición}, 1-26 de julio 1981.* Santiago, 1981. 32 p.

1282. Santiago (Chile). Museo Nacional de Bellas Artes. *Pintura chilena: {exposición}.* Santiago, 1977. 86 p.

1283. Santiago (Chile). Museo Nacional de Bellas Artes. *Pintura chilena.* Santiago, 1980. 20 p.

Exhibition catalog, Oct., 1980?

1284. Santiago (Chile). Universidad de Chile. Museo de Arte Contemporáneo. *Forma y Espacio: pintura: 1 muestra internacional: {17 julio-5 agosto 1962}.* Santiago: Universidad de Chile, 1962. 68 p.

1285. Saúl, Ernesto. *Pintura social en Chile.* Santiago, Chile: Quimantú, 1972. 96 p.

Bibliography.

1286. Solanich S., Enrique. *Precursores de la pintura chilena.* Santiago, Chile: Departamento de Extensión Cultural del Ministerio de Educación, 1978. 58 p.

1287. Vila, Waldo. *Una capitanía de pintores.* Santiago, Chile: Editorial del Pacífico, 1966. 197 p.

1288. Vila, Waldo. *Pintura joven: la década emergente.* Santiago, Chile: Editorial del Pacífico, 1973. 109 p.

1289. *Visión de la pintura chilena.* Santiago, Chile? Cap, 1963.

CHILE—PAINTING—COLLECTIONS

1290. Alvarez Urquieta, Luis. *Breve historia de la pintura en Chile; algunos juicios críticos y nómina de los cuadros de la colección Luis Alvarez Urquieta.* Santiago, Chile, 1938. 30 p.

1291. Alvarez Urquieta, Luis. *La pintura en Chile: colección Luis Alvarez Urquieta.* Santiago, Chile, 1928. 54 p.

CHILE—PAINTING—DICTIONARIES, ETC.

1292. Lira, Pedro. *Diccionario biográfico de pintores.* Santiago, Chile: Esmeralda, 1902. 552 p.

CHILE—PHOTOGRAPHY

1293. Salón de Verano de la Fotografía (2nd : 1980 : Santiago, Chile). *2 Salón de Verano de la Fotografía, Museo Nacional de Bellas Artes, Sala Matta, 19 de diciembre 1979/27 de enero 1980.* Santiago, 1979? 12 p.

1294. Salón de Verano de la Fotografía (3rd : 1981 : Santiago, Chile). *Tercer Salón de Verano de la Fotografía, Sala Matta, 16 diciembre 1980-31 enero 1981.* Santiago: Museo Nacional de Bellas Artes de Chile, 1980? 12 p.

CHILE—SCULPTURE

1295. Compañía de Acero del Pacífico (Chile). *Agenda CAP 1964: la escultura en Chile.* Santiago, 1964. 50 p.

Desk calendar for 1964.

1296. Las Condes (Chile). Instituto Cultural de Las Condes. *Escultura chilena de hoy: {exposición, 9-30 mayo 1968}.* Las Condes, 1968. 16 p.

1297. Ivelic, Milan. *La escultura chilena.* Santiago, Chile: Departamento de Extensión Cultural del Ministerio de Educación, c1978. 92 p.

1298. Rojas Mix, Miguel. *La imagen del hombre: muestras de esculturas neofigurativas chilenas.* Santiago, Chile: Instituto de Arte Latinoamericano, Universidad de Chile, 1971.

1299. Santiago (Chile). Museo Nacional de Bellas Artes. *23 escultores chilenos presentan sus obras para el 'Concurso Escultura Banco Concepción': abril 24-mayo 8 de 1980.* Santiago, 1980. 12 p.

Colombia

COLOMBIA—GENERAL

1300. Abril, Julio. *La sumisión del arte colombiano: voces protesta de un escultor.* Tunja, Colombia, 1973. 134 p.

1301. Academia Colombiana de Bellas Artes (Bogotá, Colombia). *Iniciación de una guía de arte colombiano.* Bogotá: Imprenta Nacional, 1934.

1302. Angel, Félix. *Nosotros: un trabajo sobre los artistas antioqueños.* Medellín, Colombia: Museo del Castillo, 1976. 220 p.

1303. Arboleda, Sergio. *Las letras, las ciencias, y las bellas artes en Colombia.* Bogotá, Colombia: Ministerio de Educación Nacional, 1936. 164 p.

1304. *Arte colombiano.* Bogotá, Colombia, 196-? {62} p.

 Supplement of the Revista Lámpara; text in Spanish and English; edited by Marta Traba.

1305. Barney Cabrera, Eugenio. *Geografía del arte en Colombia, 1960.* Bogotá, Colombia: Ministerio de Educación Nacional, 1963. 289 p.

1306. Barney Cabrera, Eugenio. *Temas para la historia del arte en Colombia.* Bogotá, Colombia: Universidad Nacional de Colombia, 1970.

 Bibliography.

1307. Barney Cabrera, Eugenio. *La trasculturación en el arte colombiano.* Bogotá, Colombia: Escuela de Bellas Artes, Universidad Nacional de Colombia, 1962.

 Bibliography.

1308. Bogotá (Colombia). Biblioteca Luis Angel Arango. *Colombia: arte de hoy: {exposición, junio-julio 1979}.* Bogotá, 1979. 44 p.

1309. Bogotá (Colombia). Biblioteca Luis Angel Arango. *Pintura, escultura y tapiceria de Colombia: {exposición, 19-30 abril 1968}.* Bogotá, 1968. 24 p.

1310. Bogotá (Colombia). Museo de Arte Moderno. *32 artistas colombianos de hoy: {exposición}, abril 1973.* Bogotá, 1973. 48 p.

1311. Buenos Aires (Argentina). Museo de Arte Moderno. *Colombia '71: pintura y escultura; exposición organizada por el Museo de Arte Moderno de Bogotá, septiembre-octubre, 1971.* Buenos Aires, 1971. 56 p.

1312. Cali (Colombia). Museo de Arte Moderno La Tertulia. *Arte de los años 80; {exposición}, marzo 21 de 1980.* Cali, 1980. 36 p.

1313. Cali (Colombia). Museo de Arte Moderno La Tertulia. *Cali a la vanguardia; {exposición}, junio 1974.* Cali, 1974. 44 p.

1314. Cali (Colombia). Museo de Arte Moderno La Tertulia. *Pintura y escultura de los años '30; {exposición}.* Cali, 1978? 32 p.

1315. Caracas (Venezuela). Museo de Arte Contemporáneo. *Los novísimos colombianos; {exposición}, junio 1977.* Caracas, 1977. 62 p.

1316. Colombia. Instituto Colombiano de Cultura. *25 años de plástica en Colombia.* Bogotá: Espiral, 1969. 90 p.

1317. Díaz, Hérnan, and Traba, Marta. *Seis artistas contemporáneos colombianos.* Bogotá, Colombia: Antares, 1963? 89 p.

1318. Exposición Nacional (1944 : Medellín, Colombia). *Catálogo; exposición de los artistas independientes; recuerdo de la Exposición Nacional.* Medellín, 1944. 42 p.

1319. Fundación Eugenio Mendoza (Caracas, Venezuela). Sala de Exposiciones. *Arte colombiano de hoy; {exposición}, junio-julio 1974.* Caracas, 1974. 50 p.

1320. Giraldo Jaramillo, Gabriel. *El arte en Colombia.* Mexico City, Mexico: Fondo de Cultura Económica, 1948. 248 p.

1321. Giraldo Jaramillo, Gabriel. *Notas y documentos sobre el arte en Colombia.* Bogotá, Colombia: Editorial ABC, 1954.

1322. Gostautas, Estanislao. *Arte colombiano.* Bogotá, Colombia: Editorial Iqueima, 1960.

1323. Havana (Cuba). Casa de las Américas. Galería Latinoamericana. *La plástica colombiana de este siglo; {exposición, desde mayo 26 de 1977}.* Havana, 1977.

1324. *Historia del arte colombiano.* v. 1- . Bogotá, Colombia: Salvat Editores Colombiana, 1976?- .

1325. Jiménez Gallo, Herbert. *14 artistas de Antioquia.* Medellín, Colombia: Editorial Bedout, 1945.

1326. Medellín (Colombia). Museo de Arte Moderno. *El arte en Antioquia y la década de los setentas; {exposición}, abril de 1980.* Medellín, 1980. 70 p.

1327. Medina, Alvaro. *Procesos del arte en Colombia.* Bogotá, Colombia: Instituto Colombiano de Cultura, 1978.

1328. Panesso, Fausto. *Los intocables: Botero, Grau, Negret, Obregón, Ramírez V.* Bogotá, Colombia: Ediciones Alcaraván, 1975. 120 p.

1329. Rendón G., Guillermo. *Teorética del arte.* Bogotá, Colombia: Editorial Presencia, 1974. 248 p.

1330. Rivero, Mario. *Introducción a la historia del arte en Colombia.* Bogotá, Colombia: Compañía Central de Seguros, 1972.

1331. Ruiz, Jorge Eliécer. *La política cultural en Colombia.* Paris, France: UNESCO, 1976. 93 p.

 Also published in English.

1332. Salón Anual de Artistas Colombianos (1st : 1940 : Bogotá, Colombia). *Salón Anual de Artistas Colombianos, 1940- .* Bogotá, Colombia, 1940- .

1333. Salón Atenas (1st : 1975 : Bogotá, Colombia). *Salón Atenas: {exposición}, 1975- .* Bogotá, Colombia: Museo de Arte Moderno, 1975- .

 Annual.

1334. Salón Intercol de Artistas Jovenes (1st : 1964 : Bogotá, Colombia). *Primer Salón Intercol de Artistas Jovenes: {exposición, 1964}.* Bogotá, Colombia: Museo de Arte Moderno, 1964. 24 p.

1335. Salón Nacional de Artes Plásticas Jorge Tadeo Lozano (1st : 1972 : Bogotá, Colombia). *Primer Salón Nacional de Artes Plásticas Jorge Tadeo Lozano, Bogotá, Colombia: {exposición}, octubre 1972.* Bogotá: Universidad Jorge Tadeo Lozano, 1972. 6 p.

1336. Salón Nacional de Artes Visuales (27th : 1978 : Bogotá, Colombia). *XXVII Salón Nacional de Artes Visuales, 1978: II Salones Regionales, Zona Suroccidental, Zona Central, Zona Norte, Zona Nororiental, Zona Noroccidental, Zona Central del Sur; {exposición}, noviembre 1978-enero 1979.* Bogotá, 1978-79. 48 p.

1337. Serrano, Eduardo. *Un lustro visual; ensayos sobre arte contemporáneo colombiano.* Bogotá, Colombia: Museo de Arte Moderno; Ediciones Tercer Mundo, 1976. 282 p.

1338. Sociedad de Mejoras y Ornato (Bogotá, Colombia). *Bogotá, publicación de la Sociedad de Mejoras y Ornato con motivo de la conmemoración del cuarto centenario de la fundación de la ciudad.* Bogotá, 1938. 102 plates.

1339. Traba, Marta. *Colombia.* Washington, D.C.: Pan American Union, 1959. 18 p.

1340. Traba, Marta. *Historia abierta del arte colombiano.* Cali, Colombia: Ediciones Museo La Tertulia, 1971? 250 p.

1341. Traba, Marta. *Mirar en Bogotá.* Bogotá, Colombia: Instituto Colombiano de Cultura, 1976. 415 p.

1342. UNESCO. *Cultural policy in Colombia.* Paris, France? UNESCO, 1977. 93 p.

1343. Vidales, Luis. *La circunstancia social en el arte.* Bogotá, Colombia: Instituto Colombiano de Cultura, 1973. 269 p.

1344. Zalamea, Jorge. *Nueve artistas colombianos.* Bogotá, Colombia: Litografía Colombia, 1941. 65 p.

1345. Zea de Uribe, Gloria. *Hacia una nueva cultura colombiana.* Bogotá, Colombia: Instituto Colombiano de Cultura, c1978. 140 p.

COLOMBIA—GENERAL—BIBLIOGRAPHIES

1346. Giraldo Jaramillo, Gabriel. *Bibliografía selecta del arte en Colombia.* Bogotá, Colombia: Editorial ABC, 1956. 147 p.

1347. Giraldo Jaramillo, Gabriel. *Notas y documentos sobre el arte en Colombia*. Bogotá, Colombia: Editorial ABC, 1954.

COLOMBIA—GENERAL—COLLECTIONS

1348. Cali (Colombia). Museo de Arte Moderno La Tertulia. *La mujer en las artes visuales; colección Museo de Arte Moderno La Tertulia; {exposición}, febrero 1980*. Cali, 1980. 16 p.

1349. Banco Cafetero (Bogotá, Colombia). Colección Banco Cafetero; {exposición}, Museo de Arte Moderno, 1976. Bogotá, 1976. 40 p.

1350. Bogotá (Colombia). Biblioteca Luis Angel Arango. *24 obras de arte de la Colección de la Biblioteca Luis-Angel Arango del Banco de la República; {exposición, julio de 1972, Cúcuta, Colombia}*. Cúcuta, Colombia, 1972.

1351. Bogotá (Colombia). Biblioteca Luis Angel Arango. *21 obras de la Colección de la Biblioteca Luis-Angel Arango del Banco de la República, Bogotá, Colombia; {exposición, abril 1971, Popayán, Colombia}*. Popayán, Colombia? 1971?

1352. Bogotá (Colombia). Museo de Arte Contemporáneo. *Guía oficial, Museo de Arte Contemporáneo de Bogotá, Colombia, 'El Minuto de Dios.'* Bogotá, 1969. 16 p.

Text in Spanish and English.

1353. Bogotá (Colombia). Museo Nacional. *Catálogo del Museo Nacional*. 2a. ed. Bogotá: Ministerio de Educación Nacional, 1968. 381 p.

1354. Cali (Colombia). Museo de Arte Moderno La Tertulia. *Museo La Tertulia, Cali, junio 20 de 1968*. Cali, 1968. 28 p.

Descriptive booklet.

1355. Havana (Cuba). Casa de las Américas. Galería Latinoamericana. *Exposición de arte colombiano; colección de la Biblioteca 'Luis Angel Arango', del Banco de la República de Colombia; desde diciembre de 1978*. Havana, 1978. 20 p.

1356. Medellín (Colombia). Museo de Arte de Medellín Fco. Antonio Zea. *Museo de Arte de Medellín Fco. Antonio Zea.* Cali, Colombia: Biblioteca Banco Popular, 1977. 125 p.

 Catalog of the collection.

1357. Panama City (Panama). Instituto Panameño de Arte. *De la colección de arte de la Biblioteca Luis-Angel Arango: Abularach...{et al.}.* Panama City, {1973}. {18} p.

1358. Serrano, Eduardo. *El Museo de Arte Moderno de Bogotá: recuento de un esfuerzo conjunto.* Bogotá, Colombia: Museo de Arte Moderno, 1979? 143 p.

 Text in Spanish and English.

1359. Taller de Artes (Medellín, Colombia). *Actividades desarrolladas por el Taller de Artes, Medellín durante sus tres años de funcionamiento {1977-1980}.* Medellín, 1977. 6 p.

 Typescript.

COLOMBIA—GENERAL—DICTIONARIES, ETC.

1360. Acuña, Luis Alberto. *Diccionario biográfico de artistas que trabajaron en el nuevo reino de Granada.* Bogotá, Colombia: Instituto Colombiano de Cultura Hispánica, 1964. 71 p.

 Bibliography: p. {69}-71; painters, sculptors, architects, and artisans working during the colonial period.

1361. Ortega Ricuarte, Carmen. *Diccionario de artistas en Colombia.* Bogotá, Colombia: Ediciones Tercer Mundo, c1965. 448 p.

1362. Ortega Ricuarte, Carmen. *Diccionario de artistas en Colombia; pintores, escultores, arquitectos (s. XVI-s. XIX), ingenieros militares (s. XVI-s. XVIII), grabadores, dibujantes, caricaturistas, ceramistas, orfebres, plateros.* 2a. ed., corregida y aumentada. Bogotá, Colombia: Plaza & Janés, Editores Colombia Ltda., c1979. 542 p.

COLOMBIA—GENERAL—PERIODICALS

1363. *Arte en Colombia.* v. 1, no. 1 (July 1976)- . Bogotá, Colombia, 1976- .

 Monthly.

1364. *Plástica.* no. 1-12 (April 1956-July/Dec. 1958?). Bogotá, Colombia, 1956-1958?

Bimonthly, 1957; quarterly, 1958.

1365. *Re-Vista.* v. 1, no. 1 (April-June 1978)- . Medellín, Colombia, 1978- .

Monthly.

COLOMBIA—ARCHITECTURE

1366. Aragón, Víctor, and Espinosa, José. *Lo mejor del urbanismo y de la arquitectura en Colombia.* Bogotá, Colombia: Librería Colombiana, 1966? unpaged.

1367. Arango, Jorge, and Martínez, Carlos. *Arquitectura en Colombia; arquitectura colonial, 1538-1810; arquitectura contemporánea en cinco años, 1946-1951.* Bogotá, Colombia: Ediciones Proa, 1951. 136 p.

Text in Spanish, English and French.

1368. Hernández de Alba, Guillermo. *Historia de la casa colonial.* Bogotá, Colombia: Instituto Gráfico Limitada, 1942. 12 p.

1369. Martínez, Carlos. *Arquitectura en Colombia.* Bogotá, Colombia: Ediciones Proa, 1963. 221 p.

Architecture since 1951 in the largest cities of Colombia.

1370. *Moderna Bogotá arquitectónica, 1960.* Bogotá, Colombia: Suramericana Editores, 1960. 307 p.

1371. *Puertos de Colombia: el folclor en los puertos colombianos.* Bogotá, Colombia: Fondo de Publicaciones, 1977. 79 p.

1372. Sociedad Colombiana de Arquitectos (Bogotá, Colombia). *El arquitecto y la nacionalidad.* Bogotá, c1975. 290 p.

Text by Jaime Coronel Arroyo {et al.}.

1373. Téllez, German. *Crítica & imagen.* Bogotá, Colombia: Escala, 1977 or 1978. 328 p.

COLOMBIA—COSTUMES AND NATIVE DRESS

1374. Torres Méndez, Ramón. *Costumbres nacionales.* Bogotá, Colombia: Italgraf, 1978. 94 p.

COLOMBIA—DESIGN

1375. Medellín (Colombia). Museo de Arte Moderno. *Primera muestra del mueble colombiano, 1980; 4-30 de junio.* Medellín, 1980. 31 p.

1376. Medellín (Colombia). Universidad Pontificia Bolivariana. Biblioteca Central. *Muestra colectiva de los profesores de la Facultad de Diseño, U.P.B., Biblioteca Central, noviembre 1979.* Medellín, 1979. {32} p.

COLOMBIA—GRAPHIC ARTS

1377. Austin (Texas). University of Texas. Art Museum. *Colombian figurative graphics; {exhibition}, February 1-March 28, 1976.* Austin, c1976. 47 p.

1378. Bogotá (Colombia). Biblioteca Luis Angel Arango. *Grabadores y dibujantes de Colombia, 1971; {exposición, del 27 de julio al 18 de agosto de 1971}.* Bogotá, 1971. 8 p.

1379. Bogotá (Colombia). Biblioteca Luis Angel Arango. *Grabadores y dibujantes de Colombia: {exposición}, 14 de marzo al 2 de abril de 1973.* Bogotá, 1973. 28 p.

1380. Bogotá (Colombia). Biblioteca Luis Angel Arango. *Dibujantes y grabadores, 1978: {exposición, diciembre 1978-febrero 1979}.* Bogotá, 1978. 28 p.

1381. Bogotá (Colombia). Museo de Arte Moderno. *5 dibujantes: Astudillo, Caballero, Guerrero, Jaramillo, Truss; {exposición}, octubre 1975.* Bogotá, 1975. 26 p.

1382. Giraldo Jaramillo, Gabriel. *El grabado en Colombia.* Bogotá, Colombia: Editorial ABC, 1959. 224 p.

COLOMBIA—GRAPHIC ARTS

1383. Havana (Cuba). Casa de las Américas. Galería Latinoamericana. *Graficário de la lucha popular en Colombia; testimonio gráfico de 32 artistas nacionales; {exposición}.* Havana, 1977? 16 p.

1384. Ortega Ricuarte, Carmen. *Dibujantes y grabadores del Papel Periódico Ilustrado y Colombia Ilustrada.* Bogotá, Colombia: Instituto Colombiano de Cultura, 1973. 224 p.

COLOMBIA—GRAPHIC ARTS—COLLECTIONS

1385. Cartón de Colombia (Bogotá, Colombia). *Grabados 74; serie internacional, colección Cartón de Colombia.* Bogotá? 1974. 16 p.

COLOMBIA—GRAPHIC ARTS—PERIODICALS

1386. *Papel Periódico Ilustrado.* 1881-1887. Bogotá, Colombia: Banco de la República, 1968. 405 p.

Reproductions of woodcuts which originally appeared in el Papel Periódico Ilustrado.

COLOMBIA—PAINTING

1387. Belarca, Galería (Bogotá, Colombia). *Al fin pintura! {exposición, julio 1976}.* Bogotá, 1978. 30 p.

1388. Bienal de São Paulo (15th : 1979 : São Paulo, Brazil). *Colombia: XV Bienal Internacional de São Paulo, oct. 3-dic. 9, 1979; Montoya, Marín, Sanín, Vellojín: {exposición}.* Bogotá, Colombia: Instituto Colombiano de Cultura, 1979. 16 p.

1389. Bogotá (Colombia). Museo de Arte Moderno. *Paisaje: 1900-1975; {exposición, 1975}.* Bogotá: Museo de Arte Moderno; Salvat Editores Colombiana, 1975. 190 p.

Text by Eduardo Serrano.

1390. Buchholz, Galería (Bogotá, Colombia). *Nueve obras de la pintura contemporánea colombiana; {exposición}, 27 junio-22 julio 1969.* Bogotá, 1969. 24 p.

1391. Cali (Colombia). Museo de Arte Moderno La Tertulia. *10 años de arte colombiano: {exposición, octubre 29-noviembre 29 {1961?}}.* Cali, 1961? 66 p.

1392. Congreso Interamericano de Estadística (Bogotá, Colombia). *Catálogo de las exposiciones de pintura colombiana; pintura contemporánea; carteles para los censos de 1950.* Bogotá: Contraloría General de la República, Dirección Nacional de Censos, 1950? unpaged.

1393. Giraldo Jaramillo, Gabriel. *La pintura en Colombia.* Mexico City, Mexico: Fondo de Cultura Económica, 1948. 184 p.

Bibliography: p. 182-184.

1394. Lucena, Clemencia. *Anotaciones políticas sobre pintura colombiana.* Bogotá, Colombia: Editorial Bandera Roja, 1975. 117 p.

1395. Medellín (Colombia). Universidad de Antioquia. *Emisora cultural, 1933-1958; algunos pintores antioqueños de todos las tendencias; publicación especial con motivo de los 25 años de labores.* Medellín, 1958. 20 p.

COLOMBIA—PAINTING—COLLECTIONS

1396. Bogotá (Colombia). Biblioteca Luis Angel Arango. *Veinte pinturas; colección de la Biblioteca Luis-Angel Arango del Banco de la República, Bogotá; {exposición, Salón Cultural del Banco de la República, Barranquilla, julio de 1967.}* Barranquilla, 1967? 34 p.

COLOMBIA—PAINTING—DICTIONARIES, ETC.

1397. Giraldo Jaramillo, Gabriel. *Pinacotecas bogotanas.* Bogotá, Colombia: Editorial Santafé, 1956.

Bibliography.

COLOMBIA—PHOTOGRAPHY

1398. Bogotá (Colombia). Museo de Arte Moderno. *Paisaje colombiano: 14 fotografías.* Bogotá, 1979. 14 postcards.

1399. Cali (Colombia). Museo de Arte Moderno La Tertulia. *Fotografía colombiana; {exposición}, diciembre 1978.* Cali, 1978. 34 p.

1400. *Fotografía colombiana contemporánea.* Bogotá, Colombia: Ediciones Taller La Huella, 1978? 170 p.

COLOMBIA—PHOTOGRAPHY—PERIODICALS

1401. *Fotografía contemporánea.* no. 1 (oct.-nov. 1979)- . Bogotá, Colombia, 1979- .

COLOMBIA—SCULPTURE

1402. Cali (Colombia). Museo de Arte Moderno La Tertulia. *Escultura colombiana.* Cali, 1978? 19 p.

Costa Rica

COSTA RICA—GENERAL

1403. Costa Rica. Secretaría de Educación Pública. *El arte en Costa Rica; exposición celebrada en el Teatro Nacional, {1941?}.* San José: Imprenta Nacional, 1941.

1404. Echeverría, Carlos Francisco. *Ocho artistas costarricenses y una tradición.* San José, Costa Rica: Ministerio de Cultura, Juventud y Deportes, Departamento de Publicaciones, 1977.

1405. Echeverría Loria, Arturo. *De artes y de letras; opiniones y comentarios.* San José, Costa Rica: Don Quijote, 1967.

1406. Havana (Cuba). Casa de las Américas. Galería Latinoamericana. *Plástica contemporánea de Costa Rica; {exposición, desde febrero 28 de 1978}.* Havana, 1978. 20 p.

1407. Pan American Union (Washington, D.C.). *Modern artists of Costa Rica; an exhibition of paintings and sculptures assembled by the Group 8 of San José, {January 8 to 28, 1964}.* Washington, D.C., 1964. 20 p.

1408. UNESCO. *Cultural policy in Costa Rica.* Paris, France? UNESCO, 1977. 61 p.

COSTA RICA—GENERAL—COLLECTIONS

1409. Lawrence (Kansas). University of Kansas. Museum of Art. *The Stouse Collection: the arts of Costa Rica.* Lawrence, 1974.

Exhibition catalog, Aug. 15-Oct. 6, 1974; text by James K. Ballinger and Ann Hornbaker.

COSTA RICA—PAINTING

1410. Ulloa Barrenechea, Ricardo. *Pintores de Costa Rica.* San José, Costa Rica: Editorial Costa Rica, 1975. 217 p.

COSTA RICA—SCULPTURE

1411. Ferrero, Luis. *La escultura en Costa Rica.* San José, Costa Rica: Editorial Costa Rica, 1973. 272 p.

Cuba

1412. Alfonso, Manuel F., and Valero Martínez, T. *Cuba before the world: {Panama-Pacific International Exposition, San Francisco, 1915}.* Havana, Cuba: Souvenir Guide of Cuba Co., 1915. 223 p.

1413. Arcos, Juan. *Un ciclo de la pintura cubana.* Mexico City, Mexico, 1940.

1414. Asociación de Pintores y Escultores (Havana, Cuba). *1927: primera exposición de arte nuevo, mayo de 1927.* Havana: Revista de Avance, 1927.

1415. Cali (Colombia). Museo de Arte Modereno La Tertulia. *Exposición de la plástica actual: Museo de Arte Moderno La Tertulia, Cali, Colombia, noviembre 1976.* Cali: Ediciones Museo de Arte Moderno La Tertulia, 1976. {36} p.

 Organized by the Consejo Nacional de Cultura de la República de Cuba.

1416. Caravia Montenegro, Enrique, and Bertot, Teresita. *Los museos y la comunidad.* Havana, Cuba: Comité Nacional Cubano de Museos con la colaboración del Centro Regional de la UNESCO en el Hemisferio Occidental, Seminario Nacional Cubano, 1958. 83 p.

1417. Carbonell, José Manuel. *Las bellas artes en Cuba.* Havana, Cuba: Imprenta El Siglo XX, 1928.

1418. Castro, Marta de. *El arte en Cuba.* Miami, Florida: Ediciones Universal, 1970. 151 p.

 Bibliography: p. 135-144.

1419. Congreso de Arte Cubano (1st : 1939 : Santiago, Cuba). *Primer Congreso de Arte Cubano, Santiago de Cuba, 8 al 13 de enero de 1939: trabajos...del Consejo Corporación de Educación, Sanidad y Beneficencia.* Havana: P. Fernández, 1939. 46 p.

Text by F. de Ibarzabal?

1420. Cuba. Academia Nacional de Artes y Letras. *Estatutos.* Havana: El Siglo XX, 1922. 25 p.

1421. Cuba. Consejo Nacional de Cultura. Dirección Nacional de Museos y Monumentos. *Los niños y los jovenes en la plástica, {exposición, abril 1976}.* Havana, 1976. 28 p.

1422. Cuba. Dirección General de Relaciones Culturales. *Anuario cultural de Cuba.* Havana, 1943- .

1423. Cuba. Ministerio de Cultura. *Perfiles culturales, Cuba, 1977.* Havana: Editorial Orbe, 1978. 148 p.

1424. Dragon, Galerie du (Paris, France). *Art cubain contemporain: 14 artistes choisis et présentés par Robert Altmann: {exposición}.* Paris, 1961. 22 p.

1425. Festival Universitario de Arte (1st : 1954 : Havana, Cuba). *Primer Festival Universitario de Arte, mayo 20-junio 4, 1954.* Havana: Federación Estudiantil Universitaria, 1954.

1426. Havana (Cuba). Casa de las Américas. *Imágenes de Cuba, 1953/73: pasado y presente; tránsito hacia un presente definitivo, {exposición, junio/julio 1973}.* Havana, 1973. 36 p.

1427. Havana (Cuba). Casa de las Américas. Galería Latinoamericana. *Pintores y guerrillas: el deber de todo revolucionario es hacer la revolución: Mariano Rodríguez, {et al.; exposición julio 18, 1967}.* Havana, 1967. 1 folded sheet.

1428. Havana (Cuba). Instituto Nacional de Artes Plásticas. *Exposición de arte en la Universidad de La Habana; 300 años de arte en Cuba.* Havana, 1970. 70 p.

1429. Havana (Cuba). Municipio. *Primera exposición de arte moderno; pintura y escultura.* Havana, 1937. 71 p.

1430. Havana (Cuba). Museo Nacional. *160 aniversario de la Escuela San Alejandro: {exposición, 1978}.* Havana, 1978. 24 p.

1431. Havana (Cuba). Museo Nacional. *50 ãos de la Revista de Avance: colección patrimonio, {exposición 1978}.* Havana: Editorial Orba, 1978. 61 p.

1432. Havana (Cuba). Museo Nacional. *Didáctica 2: {exposición 1979}.* Havana: Ministerio de Cultura, 1979. 75 p.

1433. Havana (Cuba). Palacio Muinicipal. *Exposición de arte moderno y clásico: la pintura y la escultura contemporánea en Cuba.* Havana, 1941-42.

1434. Havana (Cuba). Universidad de La Habana. *El arte en Cuba: su evolución en la obra de algunos artistas, catálogo de la exposición, {1940}.* Havana, 1940.

1435. Juan, Adelaida de, and Rojas Mix, M.A. *Dos ensayos sobre plástica cubana.* Santiago, Chile: Editorial Andrés Bello, 1972. 30 p.

1436. Juan, Adelaida de. *En La Galería Latinoamericana.* Havana, Cuba: Casa de las Américas, 1979. 203 p.

1437. Juan, Adelaida de, and Rojas Mix, M.A. *Encuentro Chile/Cuba.* Santiago, Chile: Editorial Andrés Bello, 1973. 32 p.

1438. Juan, Adelaida de. *Introducción a Cuba; las artes plásticas.* Havana, Cuba: Instituto del Libro, 1968. 107 p.

1439. Kunzle, David. *Public art of revolutionary Cuba: vallas, sculpture, and environment.* Venice, California: Environmental Communications, 1975. 42 color slides.

1440. Las Villas (Cuba). Universidad Central de Las Villas. *Pintores y dibujantes populares de Las Villas.* Santa Clara, Cuba, 1962. 111 p.

1441. Lund (Sweden). Konsthall. *Konst från Cuba; 7-27/8, 1969.* Lund, 1968. 12 p.

1442. Madrid (Spain). Museo Español de Arte Contemporáneo. *Pintura y gráfica cubanas: {exposición, abril 1978}.* Madrid, 1978. 51 p.

 Text by Alejo Carpentier.

1443. *Malarstwo i grafika Kuby: wystawa zorgizowana z. okazji Dni Kultury Kubanskiej w Polsce, 22 VI-2 V 1976, Centraine Biuro Wystaw Artystycznych, Warszawa 'Azcheta': {katalog}.* Warsaw, Poland: CBWA, 1976. 28 p.

1444. Mexico City (Mexico). Museo de Arte Moderno. *Panorama del arte cubano de la colonia a nuestros días: pinturas, grabados y carteles: {exposición, abril-mayo 1975}*. Mexico City, 1975. 36 p.

1445. Paris (France). Musée National d'Art Moderne. *Art cubain contemporain: {exposition}, février-mars 1951*. Paris, 1951. 20 p.

1446. Pérez Cisneros, Guy. *Pintura y escultura en 1943*. Havana, Cuba: Editorial Ucar García, 1944. 72 p.

1447. Phillips, Ewan, Gallery (London, England). *Cuba! first London exhibition of contemporary Cuban art*. London, {1967}. 18 p.

1448. Portuondo, José Antonio. *Estética y revolución*. Havana, Cuba: Unión de Escritores y Artistas de Cuba, 1963. 103 p.

1449. Retiro Odontológico (Havana, Cuba). *Pintura, escultura, cerámica: {exposición}, 18 de julio al 2 de agosto de 1953*. Havana, 1953. 20 p.

1450. Rigol, Jorge. *Apuntes sobre el grabado y la pintura en Cuba*. {Havana, Cuba}: Consejo Nacional de Cultura, {1971?}. {51} p.

1451. Rodríguez, Carlos Rafael. *Problemas del arte en la revolución*. Havana, Cuba: Letras Cubanas, 1979. 79 p.

1452. Salón de Primavera (1945 : Havana, Cuba). *Salón de Primavera, 1945: catálogo de pintura y escultura*. Havana: Talleres Tipográficos Ucar García, 1945.

1453. Sarasota (Florida). John and Mable Ringling Museum of Art. *Two centuries of Cuban art, 1759-1959, from the Cuban Foundation Collection of the Museum of Arts and Sciences, Daytona Beach, Florida, and additional works from the Solomon R. Guggenheim Museum, New York, The Museum of Modern Art, New York, and the Museum of Modern Art of Latin America, Washington, D.C., {exhibition, 1980}*. Daytona Beach, Florida: Museum of Arts and Sciences, 1980. 30 p.

1454. Suarée, Octavio de la. *Adras: 12 críticas de arte*. Havana, Cuba: Alonso y Gómez, 1958.

1455. Torriente, Loló de la. *Estudio de las artes plásticas en Cuba: Premio Nacional del Ministerio de Educación, República de Cuba (1950)*. Havana, Cuba: Impresores Ucar García, 1954. 230 p.

Bibliography: p. 213-224.

1456. Valderrama y Peña, Esteban. *La pintura y la escultura en Cuba = Painting and sculpture in Cuba = La Peinture et la sculpture à Cuba.* Havana, Cuba, 1952 or 1953. 35l p.

1457. Westbeth Gallery (New York, N.Y.). *10 young artists from today's Cuba: {exhibition} November 3-November 22, 1981/Westbeth Gallery, New York.* New York, N.Y., {1981}. 31 p.

 On title page: A Center for Cuban Studies Project.

CUBA—GENERAL—COLLECTIONS

1458. Havana (Cuba). Casa de las Américas. *Casa de las Américas.* Havana, n.d. 45 p.

 Descriptive booklet.

1459. Havana (Cuba). Museo Nacional. *Guía de la galería de arte del Museo Nacional de Cuba.* Havana: P. Fernández, 1955. 110 p.

1460. Havana (Cuba). Palacio de Bellas Artes. *Sala permanente de artes plásticas de Cuba.* Havana: Instituto Nacional de Cultura, 1965? 16 p.

CUBA—GENERAL—PERIODICALS

1461. *Arte, ciencia y trabajo.* no. 1 (1937-Jan. 1938)- . Havana, Cuba: Escuela Superior de Artes y Oficios, 1937/38- .

1462. *Arte y decoración.* v. 1-2, no. 5 (agosto 1931-mayo 1932). Havana, Cuba, 1931-1932.

1463. *Artes plásticas.* no. 1 (1960)- . Havana, Cuba: Dirección General de Cultura, Ministerio de Educación, 1960- .

1464. *Cuadernos de arte.* no. 1 (1950)- . Havana, Cuba: Dirección de Cultura, Ministerio de Educación, 1950- .

1465. *Galería.* (no. 17-18, año III, ago.-oct. 1959)- . Santiago, Cuba: Galería de Artes Plásticas de Santiago de Cuba, 195-?- .

1466. *Mensuario de arte, literatura, historia y crítica.* no. 1 (dec. 1949)- . Havana, Cuba: Dirección de Cultura, 1949- .

1467. *Noticias de arte.* v. 1, no. 1-11 (sept. 1952-oct./nov. 1953). Havana, Cuba, 1952-53.

1468. *Revista; Instituto Nacional de Cultura.* v. 1 (dec., 1955)- . Havana, Cuba, 1955- .

1469. *Revista de avance.* v. 1-5, no. 1-50 (March 15, 1927-Sept. 30, 1930?). Havana, Cuba, 1927-1930.

1470. *Revista de bellas artes.* no. 1-4 (enero-dic., 1918). Havana, Cuba, 1918.

1471. *Revista Lyceum.* no. 1 (1936)- . Havana, Cuba, 1936- .

1472. *Revolución y cultura.* 196-?- . Havana, Cuba, 196-?- .

1473. *La Veronica, que aparece los lunes.* v. 1 (1942)- . Havana, Cuba, 1942- .

CUBA—ARCHITECTURE

1474. Acotta, Maruja, and Hardoy, Jorge Enrique. *Reforma urbana en Cuba revolucionaria.* Caracas, Venezuela: Síntesis Dosmil, 1971. 149 p.

1475. Congress of the International Union of Architects (7th : 1963 : Havana, Cuba). *Cuba.* Havana, Cuba, 1963. 118 p.

1476. Cuba. Junta Nacional de Planificación. *Plan piloto de La Habana: directivas generales; diseños preliminares, soluciones tipo; Town Planning Associates, Paul Lester Wiener, José Luis Sert, Paul Schulz.* Havana, 1959. 53 p.

1477. Havana (Cuba). Universidad de La Habana. *Ensayos sobre arquitectura e ideología en Cuba revolucionaria.* Havana: Centro de Información Científica y Técnica, Universidad de La Habana, 1970. 155 p.

1478. Kelly, John J. *Arquitrectura religiosa de La Habana en el siglo veinte.* Havana, Cuba: Imprenta Ucar García, 1955. 155 p.

1479. Rallo, Joaquín. *Sombrigramas para La Habana*. Havana, Cuba, 1964? 63 p.

1480. Rodríguez Castell, Esteban. *La arquitectura en Cuba*. Barcelona, Spain: Salvat, 1936.

1481. Rumania. Consiliul Culturii si Educatiei Socialiste. *Monumente din Cuba: decembrie 1972-ianuarie 1973*. Bucharest, 1972. 20 p.

1482. Serge, Roberto. *La arquitectura de la revolución cubana*. Montevideo, Uruguay: Universidad de la República, 1968. 28 p.

1483. Serge, Roberto. *Cuba: l'architecttura della rivoluzione*. Padova, Italy: Marsilio Editori, 1970. 203 p.

 2. ed., rivista e aggiornata, Vencie, Italy: Marsilio Editori, 1977, 214 p.; Spanish edition entitled 'Cuba: arquitectura de la revolución,' Barcelona, Spain: Gustavo Gili, 1970, 221 p.

1484. Serge, Roberto. *Diez años de arquitectura en Cuba revolucionaria*. Havana, Cuba: Ediciones Unión, 1970. 225 p.

1485. Weiss y Sánchez, Joaquín. *Arquitectura cubana contemporánea: colección de fotografías de los más recientes y característicos edificios erigidos en Cuba*. Havana, Cuba: Editorial Cultural, 1947. 122 p.

1486. Weiss y Sánchez, Joaquín. *La arquitectura cubana del siglo XIX*. Havana, Cuba: Junta Nacional de Arqueología y Etnología, 1960. 48 p.

1487. Weiss y Sánchez, Joaquín. *Resumen de la historia de la arquitectura*. Havana, Cuba: Editorial Cultural, 1944.

CUBA—ARCHITECTURE—PERIODICALS

1488. *Album de Cuba*. v. 1 (1950)- . Havana, Cuba, 1950- .

1489. *Arquitecto; revista mensual*. no. 1-4 (abril 1926-junio/julio 1929). Havana, Cuba, 1926-29.

1490. *Arquitectura*. no. 1 (julio 1917)- . Havana, Cuba, 1917- .

1491. *Arquitectura*. no. 1 (1933)- . Havana, Cuba: Colegio Nacional de
Arquitectura, 1933- .

1492. *Arquitectura/Cuba*. 196-?- . Havana, Cuba: Instituto Cubano del
Libro, 196-?- .

CUBA—GRAPHIC ARTS

1493. Amsterdam (Netherlands). Stedelijk Museum. *Cubaanse affiches: {7
mei tot en met 6 juni 1971}*. Amsterdam, 1971. 80 p.

Text, in English and Dutch, by Edmundo Desnoes.

1494. Asociación de Caricaturistas Cubanos en el Exilio (Miami, Florida).
Exposición de caricaturas cubanas. Miami, n.d. 16 p.

1495. Asociación de Grabadores de Cuba (Havana, Cuba). *Xilografías*.
Havana, Cuba: Ediciones de Arte Buril, 1955. 8 p.

1496. Beltrán, Félix. *Acerca del diseño*. Havana, Cuba: Ediciones Unión,
1975. 86 p.

1497. Beltán, Félix. *Letragrafía*. Havana, Cuba, n.d.

1498. Cuba. Consejo Nacional de Cultura. *El dibujo político en Cuba, 1868-
1959, en saludo al Primer Congreso del Partido Comunista de Cuba*.
Havana, {1975}? {40} p.

Text by Adelaida de Juan.

1499. Cuba. Ministerio de Educación. Dirección de Cultura. *Xilografías
cubanas: {exposición, diciembre 23 al 29, 1949}*. Havana, 1949. 27 p.

1500. *Dibujos '67*. Havana, Cuba, 1967? 32 p.

1501. La Habana, Galería (Havana, Cuba). *Grabados cubanos: {exposición},
en saludo al 26 de julio y a la 1ra. conferencia de la OLAS, julio 1967*.
Havana, 1967. 12 p.

1502. Havana (Cuba). Casa de las Américas. Galería Latinoamericana.
*Exposición de La Habana: premios y menciones colección de grabados,
Casa de las Américas*. Havana, 197-? 66 p.

1503. Havana (Cuba). Museo Nacional. *Exposición gráfica cubana, 1977.* Havana, 1977. 12 p.

1504. Kunzle, David. *Public art of revolutionary Cuba; posters.* Venice, California: Environmental Communications, 1975. 35 color slides.

1505. Nuez, René de la. *Allí fumé: el dibujo antiburocrático.* Havana, Cuba: Unión Nacional de Escritores y Artistas de Cuba, 1966.

1506. Paris (France). Centre National d'Art et de Culture Georges Pompidou. Centre de Création Industrielle. *Culture et révolution: l'affiche cubaine contemporaine.* Paris, 1977. 26 p.

1507. Pommeranz-Liedtke, Gerhard. *Kubanische revolutionäre Graphik.* Dresden, East Germany: Veb Verlag der Kunst, 1962. 29 p.

1508. Sánchez, Juan. *El grabado en Cuba.* Havana, Cuba: Imprenta Mundial, 1955. 104 p.

1509. Stermer, Dugald. *The art of revolution: Castro's Cuba, 1959-1970.* New York, N.Y.: McGraw-Hill, 1970.

1510. Taller Experimental de Gráfica (Havana, Cuba). *Litografías, 1963.* Havana, Cuba: Consejo Nacional de Cultura, Coordinación Provincial de La Habana, 1963.

CUBA—PAINTING

1511. Argentina. Dirección General de Cultura. *11 pintores cubanos; Salas Nacionales de Exposición, del 3 al 10 de agosto de 1946.* Buenos Aires, 1946. 23 p.

1512. Bologna (Italy). Palazzo Re Enzo. Sala del Trecento. *Pittura cubana contemporanea.* Bologna, 1966.

Exhibition held at the gallery Due Mondi, Rome, Italy, Nov. 5-25, 1966, and at the Palazzo Re Enzo, Bologna, Italy, Dec. 13-28, 1966; text by Enrico Crispolti and Adelaida de Juan.

1513. Caracas (Venezuela). Museo de Bellas Artes. *Pintura contemporánea en Cuba: {exposición}, julio 10, 1960.* Caracas, 1960. 36 p.

Organized by Casa de las Américas, Havana, Cuba.

1514. Center for Inter-American Relations (New York, N.Y.). *6 Cuban painters working in New York: {exhibition}, January 15-February 23, 1975.* New York, 1975. 24 p.

1515. Cuba. Corporación Nacional del Turismo. *La pintura colonial en Cuba: exposición en el Capitolio Nacional, marzo 4 a abril 4 de 1950.* Havana, 1950. 21 p.

1516. *Cuban painters, 1952-1962, 10 years of Cuban painting = Peintres cubains, 1952-1962, 10 ans de peinture cubaine.* Havana, Cuba? 1962? 24 p.

 English text translated by José Rodríguez Feo.

1517. de Aenlle, Roland, Gallery (New York, N.Y.). *Recent paintings from Cuba: {exhibition}, October 5 to October 25, 1955?* New York, 1955? folder.

1518. Gómez Sicre, José. *Pintura cubana de hoy = Cuban painting of today.* Havana, Cuba: María Luisa Gómez Mena, 1944. 205 p.

1519. Guatemala. Academia Nacional de Bellas Artes. *Exposición de pintura cubana moderna, octubre de 1945.* Guatemala City, 1945. 4 p.

1520. Havana (Cuba). Museo Nacional. *Pintura contemporánea cubana: {exposición}, diciembre, 1-9, 1967.* Havana, Cuba: Casa de las Américas, 1967. folder.

1521. Jähner, Horst. *Kubanische Malerei.* Leipzig, East Germany: E.A. Seemann, 1975. 27 p.

1522. Jamaica. Embassy (Cuba). *Cuba: line and colour: {exhibition, June, 1974}.* Havana, Cuba: Casa de las Américas, 1974. 4 p.

1523. Juan, Adelaida de. *Pintura cubana: temas y variaciones.* la.ed. Havana, Cuba: Unión de Escritores y Artístas de Cuba, 1978. 207 p., {72} p. of plates.

1524. Juan, Adelaida de. *Los temas en la pintura cubana.* Havana, Cuba? 1972.

1525. La Plata (Argentina). Museo de Bellas Artes. *11 pintores cubanos: {exposición}, 1946, del 2 al 25 de julio.* La Plata: Dirección General de Cultura, 1946. 31 p.

1526. Maribona, Armando. *La pintura en Cuba.* Barcelona, Spain: Editorial González Porto, Salvat Editorial, 1936.

1527. Marinello Vidaurreta, Juan. *Conversación con nuestros pintores abstractos.* Havana, Cuba: Imprenta Nacional de Cuba, 1961. 111 p.

1528. Martí, José. *Cuba: letras, educación y pintura.* Havana, Cuba: Editorial Trópico, 1938. 2 v.

1529. Mexico City (Mexico). Palacio de Bellas Artes. *Exposición de pintura cubana moderna, junio de 1946.* Mexico City, 1946. 7 p.

1530. Mexico City (Mexico). Universidad Nacional Autónoma de México. Museo Universitario de Ciencias y Arte. *Pintura cubana contemporánea: {exposición}, febrero-marzo 1968.* Mexico City, 1968. 52 p.

1531. New York (New York). Museum of Modern Art. *Modern Cuban painters: {exhibition}, March 17-May 7, 1944.* New York, 1944. 14 p.

 IN: Museum of Modern Art Bulletin, April, 1944, v. XI, no. 5.

1532. Paris (France). Musée d'Art Moderne de la Ville de Paris. *Cuba: peintres d'aujourd'hui; {exposition, 18 novembre 1977-15 janvier 1978}.* Paris, 1978. 30 p.

1533. Pérez Cisneros, Guy. *Características de la evolución de la pintura en Cuba: siglos XVI, XVII, XVIII y primera mitad del XIX.* Havana, Cuba: Dirección General de Cultura, Ministerio de Educación, 1959. 96 p.

1534. *Pintores cubanos.* Havana, Cuba: Ediciones R, 1962. 255 p.

 Another edition?, Havana, Cuba: Letras Cubanas, 1978.

1535. Pogolotti, Graziella. *Examen de conciencia.* Havana, Cuba: Unión Nacional de Escritores y Artístas de Cuba, 1965. 154 p.

1536. Rumania. Consiliul Culturii si Educatiei Socialiste. *Expozitia de pictura contemporana din Cuba: {julie-august 1973}.* Bucharest, 1973. 22 p.

1537. *Siete pintores cubanos = Sept peintres cubains.* Paris, France: UNESCO, Misión Permanente de Cuba, 1972. unpaged.

1538. Signs Gallery (New York, N.Y.). *Cuban art: a retrospective, 1930-1980: Rene Portocarrero: a retrospective, 1940-1980: Los novísimos cubanos, Grupo Volumen I, {exhibition}, The Signs Gallery, New York, January-May, 1982: Contemporary Art Museum, Panamá, INAC, Panamá, Sala Arteconsult, Panamá, May-June, 1982.* New York, 1982. 48 p.

 Text in English and Spanish.

1539. Soto y Sagarra, Luis de. *Esquema para una indagación estilística de la pintura moderna cubana.* Havana, Cuba, 1943. 46 p.

1540. Stockholm (Sweden). Liljevalchs Konsthall. *Kubanska Malare: {exhibition, 1949}.* Stockholm, 1949. 24 p.

1541. Vich Adell, Mercedes, editor. *Pintores cubanos.* Havana, Cuba: Editorial Gente Nueva, Instituto Cubano del Libro, 1974. 68 p.

CUBA—PAINTING—COLLECTIONS

1542. Daytona Beach (Florida). Museum of Arts and Sciences. *Cuban painting from the Collection of General Fulgencio Batista.* Daytona Beach, 1977. 48 p.

1543. Havana (Cuba). Museo Nacional. *Museo Nacional de Cuba: pintura; retratos de Fayum; pintura europea; pintura cubana.* Havana, Cuba: Editorial Cubanas; Leningrad, USSR: Editorial de Arte Aurora, 1978. 145 p.

 English edition; *The National Museum of Cuba: painting; the Fayum portrait; Western European painting; Cuban painting.* Havana, Cuba: Letras Cubanas; Leningrad, USSR: Aurora Art Publishers, 1978. 145 p.

1544. Rio Piedras (Puerto Rico). Universidad de Puerto Rico. Museo. *Exposición pintores cubanos: Colección Nicolas Quintana: 19 de diciembre 1961-5 de enero 1962.* Rio Piedras, 1961-62? 4 p.

CUBA—PHOTOGRAPHY

1545. Havana (Cuba). Archivo Nacional de Cuba. *Catálogo de la exposición fotográfica vida de Martí en el cincuentenario de su muerte, 19-26 de mayo de 1945.* Havana, 1945. 60 p.

1546. Havana (Cuba). Casa de las Américas. *1959-1979, 20 aniversario Casa de las Américas; obra gráfica, historia de la fotogrtafía cubana.* Havana, 1979.

 Exhibition catalog.

1547. Lauderman Ortiz, Gladys. *Factores estilísticos de la escultura cubana contemporánea.* Havana, Cuba, 1951. 149 p.

1548. Soto y Sagarra, Luis de. *La escultura cubana contemporánea.* Havana, Cuba, 1945.

Dominican Republic

DOMINICAN REPUBLIC—GENERAL

1549. Banco Central de la República Dominicana. *Las artes plásticas en la República Dominicana; una selección; {exposición, 17-24 mayo 1975}.* Santo Domingo, Dominican Republic, 1975. 56 p.

1550. Bienal de Artes Plásticas (1st : 1942 : Santo Domingo, Dominican Republic). *Bienal de Artes Plásticas, 1942-* . Santo Domingo, Dominican Republic, 1942- .

 Also called Bienal Nacional de Artes Plásticas.

1551. Bienal de Artes Plásticas (11th : 1963 : Santo Domingo, Dominican Republic). *Exposición Bienal de Artes Plásticas, XI, 1963; {catálogo}.* Santo Domingo: Ministerio de Educación, Bellas Artes y Cultos, Dirección General de Bellas Artes, 1963. 40 p.

 Exhibition held at the Palacio de Bellas Artes, Santo Domingo, Dominican Republic.

1552. Exposición de Pintores y Escultores Dominicanos (1st : 1977 : Santo Domingo, Dominican Republic). *Exposición de Pintores y Escultores Dominicanos, 1977-* . Santo Domingo: Chase Manhattan Bank, 1977- .

1553. Exposición de Pintores y Escultores Dominicanos (3rd : 1979 : Santo Domingo, Dominican Republic). *3ra. Exposición de Pintores y Escultores Dominicanos en el Chase, noviembre 1979.* Santo Domingo: Chase Manhattan Bank, 1979. 36 p.

1554. Exposición de Pintores y Escultores Dominicanos (4th : 1980 : Santo Domingo, Dominican Republic). *IV Exposición de Pintores y Escultores Dominicanos; {noviembre 1980?}.* Santo Domingo: Chase Manhattan Bank, 1980. 44 p.

1555. Rodríguez Demorizi, Emilio. *Pintura y escultura en Santo Domingo.* Santo Domingo, Dominican Republic: Hispaniola, 1972. 264 p.

1556. Santo Domingo (Dominican Republic). Museo del Hombre Dominicano. *Exposición de santos de palo dominicanos: catálogo.* Santo Domingo, 1978. 17 p.

1557. Santo Domingo (Dominican Republic). Museo del Hombre Dominicano. *Exposición temporal; mascáras de carnaval dominicanas.* Santo Domingo, 1978. 28 p.

1558. Signs Gallery (New York, N.Y.). *Arte dominicano contemporáneo = Contemporary Dominican art; {exhibition}, October 6/November 6, 1981.* New York, N.Y., 1981. 27 p.

Guest curator, Jeannette Miller.

1559. Suro Darío. *Arte dominicano (monografía de las artes plásticas dominicanas).* {Santo Domingo, Dominican Republic, 1969}. 165 p.

Bibliography: p. 163-165.

1560. Valldeperes, Manuel. *El arte de nuestro tiempo.* Ciudad Trujillo, Dominican Republic: Librería Dominicana, 1957. 181 p.

A section is devoted to the modern art of the Dominican Republic.

DOMINICAN REPUBLIC—GENERAL—COLLECTIONS

1561. Dominican Republic. Secretaría de Educación y Bellas Artes. *Galería Nacional de Bellas Artes; catálogo general.* Santo Domingo: Edición Brigadas Dominicanas, 1964.

Introduction and notes by Aída Cartagena Portalatín.

1562. Santo Domingo (Dominican Republic). Galería de Arte Moderno. *Recuerdo de la inauguración de la Galería de Arte Moderno, Plaza de la Cultura 'Juan Pablo Duarte', año de Duarte, 17 de diciembre de 1976, Santo Domingo de Guzmán, República Dominicana.* Santo Domingo: Ediciones Mundo Diplomático Internacional, 1980? 47 p.

1563. Santo Domingo (Dominican Republic). Museo del Hombre Dominicano. *Legislación dominicana sobre museos y proteción del patrimonio cultural, 1870-1977.* Santo Domingo, 1978. 136 p.

Compiled by Plinio Piña.

DOMINICAN REPUBLIC—ARCHITECTURE

1564. Gazón Bona, Henry. *La arquitectura dominicana en la era de Trujillo.* Ciudad Trujillo, Dominican Republic: Impresora Dominicana, 1949. 84 p.

1565. Rozas Aristy, Eduardo. *Hacia un nuevo enfoque del diseño arquitectónico.* Santiago, Dominican Republic: Universidad Católica Madre y Maestra, Departamento de Publicaciones, 1979. 187 p.

DOMINICAN REPUBLIC—GRAPHIC ARTS

1566. Rodríguez Demorizi, Emilio. *Caricatura y dibujo en Santo Domingo.* Santo Domingo, Dominican Republic, 1977. 224 p.

DOMINICAN REPUBLIC—PAINTING

1567. Miller, Jeannette. *Historia de la pintura dominicana.* 2a ed. Santo Domingo, Dominican Republic: the author, 1979. 112 p.

1568. Santos, Danilo de los. *Los pintores de Santiago.* Santiago, Dominican Republic: Universidad Católica Madre y Maestra, 1970.

1569. Santo, Danilo de los. *La pintura en la sociedad dominicana.* Santiago, Dominican Republic: Universidad Católica Madre y Maestra, 1979. 606 p.

DOMINICAN REPUBLIC—PHOTOGRAPHY

1570. Grupo Fotográfico Jueves 68. *10 años de fotografía dominicana.* la. ed. {Dominican Republic}: E. León Jiménez, 1978. {166} p.

Includes partial text in English.

Ecuador

ECUADOR—GENERAL

1571. *Arte de Ecuador (siglos XVIII-XIX).* Quito, Ecuador: Salvat Editores Ecuatoriano, 1977. 236 p.

1572. *Arte ecuatoriano.* Quito, Ecuador: Salvat Editores Ecuatoriano, 1976. 2 v. (226, 296 p.).

1573. *Artistas ecuatorianos.* Quito, Ecuador: Ediciones Paralelo Cero, 1976-

 Irregular; text in Spanish and English.

1574. Concurso Nacional de Artes Plásticas (3rd : 1979 : Quito, Ecuador). *Tercer Concurso Nacional de Artes Plásticas, {Museo del Banco Central del Ecuador, Quito, diciembre 1979}.* Quito: Museo del Banco Central del Ecuador, {1979}. {47} p.

1575. Guayaquil (Ecuador). Casa de la Cultura Ecuatoriana. *Testimonio plástico; {exposición, 22 diciembre 1966-4 enero 1967}.* Guayaquil, 1967? 60 p.

1576. Lasso, Ignacio. *Ensayo y poesía.* Quito, Ecuador: Casa de la Cultura Ecuatoriana, 1957. 105 p.

 Short appraisals of five modern artists of Ecuador.

1577. Lima (Peru). Museo de Arte. *Exposición de arte colonial y contemporáneo del Ecuador.* Lima, 1958. 26 p.

1578. Navarro, José Gabriel. *El arte en la provincia de Quito.* Mexico City, Mexico: Instituto Panamericano de Geografía e Historia, 1960. 98 p.

1579. Navarro, José Gabriel. *Artes plásticas ecuatorianas.* Mexico City, Mexico: Fondo de Cultura Económica, 1945. 263 p.

 Bibliography: p. 263-264.

1580. Siglo XX, Galería (Quito, Ecuador). *Arte actual ecuatoriano; {exposición, 1965?}.* Quito, 1965? 24 p.

1581. UNESCO. *Cultural policy in Ecuador.* Paris, France: UNESCO, 1979. 94 p.

1582. Vaquero Dávila, Jesús. *Síntesis histórica de la cultura intelectual y artística del Ecuador.* Quito, Ecuador: Fr. Jodoco Ricke, 1947. 370 p.

1583. Vargas, José María. *El arte ecuatoriano.* Puebla, Mexico: J. M. Cajica, Jr., 1959.

1584. Vargas, José María. *Historia del arte ecuatoriano.* Quito, Ecuador: Editorial Santo Domingo, 1964. 284 p.

1585. Vargas, José María. *Los maestros del arte ecuatoriano.* Quito, Ecuador: Municipal, 1955. 161 p.

1586. Vargas, José María. *Patrimonio artístico ecuatoriano.* Quito, Ecuador: Editorial Santo Domingo, 1972. 473 p.

ECUADOR—GENERAL—BIBLIOGRAPHIES

1587. Chaves, Alfredo. *Primer registro bibliográfico sobre artes plásticas en el Ecuador.*

 IN: Llerna, José Alfredo. *La pintura ecuatoriana del siglo XX.* Quito, Ecuador: Imprenta de la Universidad, 1942. 116 p.

1588. Cordero Iñíguez, Juan. *Bibliografía ecuatoriana de artesanías y artes populares.* Cuenca, Ecuador: Centro Interamericano de Artes Populares, 1980. 373 p.

ECUADOR—GENERAL—DICTIONARIES, ETC.

1589. Navarro, José Gabriel. *Guía artística de Quito.* Quito, Ecuador: La Prensa Católica, 1961.

1590. Astudillo Ortega, José María. *Escoplos, cinceles y pinceles.* Cuenca, Ecuador: Casa de la Cultura Ecuatoriana, 1955. 75 p.

Fragmentary resume of painting in Ecuador.

1591. Center for Inter-American Relations (New York, N.Y.). *Abstract currents in Ecuadorian art; Araceli, Maldonado, Molinari, Rendón, Tábara, Villacis.* New York, N.Y., c1977. 48 p.

Exhibition curated by Jacqueline Barnitz.

1592. Diez, Jorge A. *La pintura moderna en el Ecuador; conferencia dictada en el Salón Máximo de la Universidad Central el día 27 de junio de 1938, para clausurar el 2 ciclo del curso de capacitación del personel del Museo y Archivo.* Quito, Ecuador: Talleres Gráficos de Educación, 1938. 28 p.

1593. Fulling, Kay Painter. *The cradle of American art; Ecuador, its contemporary artists.* New York, N.Y.: North River Press, 1948. 77 p.

1594. Llerena, José Alfredo. *La pintura ecuatoriana del siglo XX: Alfredo Chaves: primer registro bibliográfico sobre artes plásticas en el Ecuador.* Quito, Ecuador: Imprenta de la Universidad Central, 1942. 116 p.

1595. Vargas José María. *Los pintores quiteños del siglo XIX.* Quito, Ecuador: Editorial Santo Domingo, 1971. 67 p.

ECUADOR—PHOTOGRAPHY

1596. Carrión, Alejandro A. *Imagenes de la vida política del Ecuador.* Quito, Ecuador: Banco Central del Ecuador, 1980.

1597. Quito (Ecuador). Museo del Banco Central del Ecuador. *Imagen de la ciudad; Quito, testimónio fotográfico, 1860-1930, {exposición}, noviembre 1978.* Quito, 1978. 28 p.

El Salvador

EL SALVADOR—GENERAL

598. López, Matilde Elena. *Interpretación social del arte: sociología del arte.* 2a ed. San Salvador, El Salvador: Ministerio de Educación, 1974. 708 p.

EL SALVADOR—GENERAL—PERIODICALS

1599. *Ars.* no. 1 (oct./dic. 1951)- . San Salvador, El Salvador: Dirección General de Bellas Artes, 1951-

EL SALVADOR—ARCHITECTURE

1600. Monedero, Oscar Manuel. *Historia de la arquitectura contemporánea en El Salvador.* San Salvador, El Salvador: Editorial Universitaria, 1970. 157 p.

Guatemala

GUATEMALA—GENERAL

1601. Alonso de Rodríguez, Josefina {et al}. *Arte contemporáneo, Occidente, Guatemala.* Guatemala City, Guatemala: Universidad de San Carlos, Facultad de Humanidades, 1966.

1602. Alvarado, Huberto. *Por un arte nacional democrático y realista.* Guatemala City, Guatemala: Ediciones Sakeriti, 1953.

1603. Alvarado Rubio, Marío, and Galeotti Torres, Rudolfo. *Indice de pintura y escultura = Index of Guatemalan painting and sculpture.* Guatemala City, Guatemala: Ministerio de Educación Pública, 1946. 95 p.

1604. Chinchilla Guilar, Ernesto. *Historia del arte en Guatemala, 1524-1962; arquitectura, pintura y escultura.* Guatemala City, Guatemala: Ministerio de Educación Pública, 1963. 229 p.

Second edition, 1965, 261 p.

1605. Diaz, Víctor Miguel. *Las bellas artes en Guatemala.* Guatemala City, Guatemala: Tipografía Nacional, 1934. 600 p.

1606. Méndez Dávila, Lionel. *Arte vanguardia; Guatemala.* Guatemala City, Guatemala: Universidad de San Carlos, 1969. 19 p.

1607. Méndez Dávila, Lionel. *Guatemala.* Washington, D.C.: Pan American Union, 1966. 110 p.

Bibliography.

1608. Mobil, José A. *Historia del arte guatemalteco.* 3a ed. Guatemala City, Guatemala: Serviprensa Centroamericana, 1977. 416 p.

1609. *Revista Saker-ti.* no. 1 (1947)- . Guatemala City, Guatemala, 1947- .

Magazine of the Group Saker-ti.

GUATEMALA—ARCHITECTURE

1610. Markman, Sidney David. *Colonial architecture of antigua Guatemala.* Philadelphia, Pennsylvania: American Philosophical Society, 1966. 335 p.

GUATEMELA—PAINTING

1611. Cifuentes, José Luis. *Algunos pintores contemporáneos de Guatemala.* Guatemala City, Guatemala: Editorial del Ministerio de Educación Pública, 1956. 106 p.

1612. Guatemala. Ministerio de Educación Pública. Dirección General de Cultura y Bellas Artes. *Pintores de Guatemala.* Guatemala City, 1967-68. 2 v.

GUATEMALA—PAINTING—COLLECTIONS

1613. Guatemala City (Guatemala). Palacio Nacional. *Colección nacional de artes plásticas; exposición.* Guatemala City: Tipografía Nacional, 1951? 24 p.

Presentada por el Ministerio de Educación Pública y la Escuela Nacional de Artes Plásticas en el pasaje del Palacio Nacional, del 10 de marzo al 10 de abril 1951.

1614. Cifuentes, José Luis. *Algunos escultores contemporáneos de Guatemala*. Guatemala City, Guatemala: Ministerio de Educación Pública, 1956. 94 p.

Guyana

GUYANA—GENERAL

1615. *Guyana; colonial art to revolutionary art, 1966-1976.* Georgetown, Guyana: Guyana National Service Publishing Centre, 1976? 12 p.

1616. UNESCO. *Cultural policy in Guyana.* Paris, France: UNESCO, 1977. 68 p.

Haiti

1617. Brooklyn (New York). Museum. *Haitian art; [catalogue of exhibition, Sept. 2-Nov. 5, 1978].* Brooklyn, c1978. 176 p.

> Bibliography; text by Ute Stebich, et al.; also shown at the Milwaukee Art Center, Milwaukee, Wisconsin, Dec. 22, 1978-Feb. 4, 1979; and the New Orleans Museum of Art, New Orleans, Louisiana, Sept. 15-Oct. 28, 1979.

1618. Center for Inter-American Relations (New York, N.Y.). *Artists of the Western Hemisphere; art of Haiti and Jamaica.* New York, 1968.

> Text by Selden Rodman and DeWitt C. Peters.

1619. Christensen, Eleanor Ingalls. *The art of Haiti.* New York, N.Y.: Barnes, 1975. 76 p.

> Bibliography: p. 73-74; chronology of the Centre d'Arte, Port-au-Prince, Haiti, and brief biographies of more than one hundred 20th century Haitian artists.

1620. Fernández Méndez, Eugenio. *Le primitivisme haïtien = The Haitian primitivism = El primitivismo haitiano.* Barcelona, Spain? Galerie Georges S. Nader, 1972. 95 p.

1621. Joukhadar Gallery (New York, N.Y.). *Haitian art, past and present.* New York, 197? 8 p.

1622. Nader, Georges S., Galerie (Port-au-Prince, Haiti). *Contemporary Haitian art = Art haïtien contemporain.* Port-au-Prince, 1971? 107 p.

1623. Pallière, Madeleine. *Collection histoire de l'art.* Port-au-Prince, Haiti: La Societé des Amis du Musée d'Art Haitien du College St. Pierre, 1975. 22 p.

> Text based on interviews with Héctor Hyppolite and Lucien Price.

HAITI—GENERAL

1624. Rodman, Selden. *The miracle of Haitian art.* {1st ed.}. Garden City, N.Y.: Doubleday, 1974. 95 p.

1625. South Orange (New Jersey). Seton Hall University. Student Art Gallery. *Religion in the art of Haiti; {exhibition, March 17-April 10, 1968}.* South Orange, N.J., 1968. 43 p.

1626. Thoby-Marcelin, Philippe. *Haiti.* Washington, D.C.: Pan American Union, 1959.

1627. Williams, Sheldon. *Voodoo and the art of Haiti.* Nottingham, England: Morland Lee Ltd., 1969.

HAITI—GENERAL—COLLECTIONS

1628. Dortmund (West Germany). Museum am Ostwall. *Kunst aus Haiti: Sammlung Kurt Bachmann, New York; 30. November 1969-ll. January 1970.* Dortmund, 1970. 39 p.

1629. Milwaukee (Wisconsin). Art Center. *The naive tradition; Haiti; the Flagg Tanning Corporation Collection.* Milwaukee, 1974. 120 p.

Introduction by Selden Rodman.

1630. Rodman, Selden. *Haitian art; the third generation, with an overlook at the first and second; 1979 Mind Collection; {exhibition, 1979}.* N. p., n.d. 32 p.

1631. Society of the Four Arts (Palm Beach, Florida). *Naive art from Haiti lent by the Smithsonian Institution.* Palm Beach, 1967.

HAITI—GENERAL—PERIODICALS

1632. *Haitian Art Newsletter.* v. 1, no. 1 (1979)- . Silver Springs, Maryland, 1979- .

1633. *Studio No. 3; bulletin mensuel du Centre d'Art.* v. 1, no 1-5 (Nov. 1945-Dec. 1946). Port-au-Prince, Haiti: Centre d'Art, 1945-46.

Irregular; edited by Philippe Thoby-Marcelin.

1634. *10 gravures originales signées par les peintres populaires d'Haiti.* Port-au-Prince, Haiti: Editions du Centre d'Art, {1947?}. portfolio.

HAITI—PAINTING

1635. American British Art Center (New York, N.Y.). *Haitian popular paintings presented by Le Centre d'Art, Port-au-Prince, Haiti.* New York, 1947.

Foreward by Selden Rodman.

1636. American Federation of the Arts (New York, N.Y.). *Haitian painting; the naive tradition; an exhibition.* New York, c1973. 64 p.

Bibliography: p. 58-63; selected by Pierre Apraxine, Assistant Curator of Painting and Sculpture, The Museum of Modern Art, New York; organized and circulated the The American Federation of the Arts.

1637. Amsterdam (Netherlands). Stedelijk Museum. *19 schilders uit Haiti.* Amsterdam, 1950. 8 p.

Exhibition catalog.

1638. Arts Council of Great Britain (London, England). *Popular paintings from Haiti, 1968-1969.* London, England, 1968?

Exhibition catalog.

1639. Carlebach (New York, N.Y.). *Popular artists of Haiti: Haitian Art Center of New York: {exhibition}, October 9-23, {1951?}.* New York, 1951? folder.

1640. Davenport (Iowa). Municipal Art Gallery. *The art of Haiti; {exhibition, 1969?}.* Davenport, 1969? 20 p.

1641. Mexico City (Mexico). Museo de Arte Moderno. *Pintura primitiva y moderna haitiana: {exposición}, diciembre de 1975/enero de 1976.* Mexico City, 1975? {33} p.

1642. Rodman, Selden. *Renaissance in Haiti; popular painters in the Black Republic.* New York, N.Y.: Pellegrini and Cudahy, 1948. 134 p.

HAITI—PAINTING

1643. Washington (D.C.). United National Club. *Haitian popular paintings.* Washington, D.C., 1945.

Exhibition catalog.

HAITI—PAINTING—COLLECTIONS

1644. American British Art Center (New York, N.Y.). *Paintings from Le Centre d'Art, Port-au-Prince, Haiti.* New York, 1946.

Foreward by René d'Harnoncourt.

1645. London (England). Hayward Gallery. *Popular paintings from Haiti from the Collection of Kurt Bachmann.* London, 1969.

Exhibition catalog.

HAITI—PAINTING—SALES

1646. Parke-Bernet Galleries (New York, N.Y). *Haitian paintings donated by Le Centre d'Art and private collectors; public sale, May 22, 1969.* New York, 1969.

1647. PB Eighty-Four (New York, N.Y.). *Haitian paintings and sculpture; property from the Collection of Kurt Bachmann, San José, Costa Rica, and various owners; public sale, April 12, 1977.* New York, 1977.

1648. PB Eighty-Four (New York, N.Y.). *Haitian paintings and sculpture; public sale, May 9, 1978.* New York, 1978.

1649. PB Eighty-Four (New York, N.Y.). *Haitian paintings; public auction, May 23, 1979; sale 691.* New York, 1979. 24 p.

1650. PB Eighty-Four (New York, N.Y.). *Haitian painting; public auction, May 6, 1980; sale 757.* New York, 1980. 64 p.

1651. Sotheby Parke-Bernet (New York, N.Y.). *Haitian paintings.* New York, 1975. {32} p.

Auction catalog, January 25, 1975.

Honduras

1652. Mariñas Otero, Luis. *La pintura en Honduras.* Tegucigalpa, Honduras: Universidad Nacional Autónoma de Honduras, Departamento de Extensión Universitaria, 1959. 21 p.

1653. *El arte contemporáneo en Honduras.* Tegucigalpa, Honduras: Servicio de Información de Los Estados Unidos de América, Instituto Hondureño de Cultura Interamericana, Escuela Nacional de Bellas Artes de Honduras, 1968. 40 p.

1654. Martínez Castillo, Marío Felipe. *La escultura en Honduras.* Tegucigalpa, Honduras: Instituto Hondureño de Cultura Hispánica, 1961.

Jamaica

JAMAICA—GENERAL

1655. Kappel, Philip. *Jamaica Gallery: a documentary of the island of Jamaica, West Indies.* Boston, Massachusetts: Little, Brown, 1961.

1656. Kingston (Jamaica). National Gallery. *Five centuries of art in Jamaica: {exhibition}, July 19-September 19, 1976.* Kingston, 1976. 36 p.

1657. Kingston (Jamaica). National Gallery. *The formative years; art in Jamaica, 1922-1940; {exhibition}, August 5-October 7, 1978.* Kingston, 1978. 20 p.

1658. National Exhibition of Painting, Drawing & Sculpture (1978 : Kingston, Jamaica). *The annual National Exhibition of Painting, Drawing & Sculpture, 1978.* Kingston: National Gallery, 1978. 36 p.

1659. Nettleford, Rex M. *Caribbean cultural identity: the case of Jamaica: an essay in cultural dynamics.* Kingston, Jamaica: Institute of Jamaica, 1978.

1660. UNESCO. *Cultural policy in Jamaica.* Paris, France: UNESCO, 1977. 53 p.

A study prepared by the Institute of Jamaica.

JAMAICA—GENERAL—COLLECTIONS

1661. Kingston (Jamaica). National Gallery. *The collectors: The Dorit Hutson Eldemire Collection at the National Gallery of Jamaica, Devon House, January 28 to March 10th, 1979.* Kingston, 1979. 6 p.

1662. Kingston (Jamaica). National Gallery. *New acquisitions, 1976; {exhibition}, June 15-July 10, 1976.* Kingston, 1976. 16 p.

JAMAICA—ARCHITECTURE

1663. *Buildings in Jamaica.* Kingston, Jamaica: Jamaica Information Service, 1970? 68 p.

Text by Vic Reid; photography by Quito Bryan and others.

JAMAICA—PAINTING

1664. Washington (D.C.). Museum of Modern Art of Latin America. *Four primitive painters from Jamaica; Everald Brown, Clinton Brown, Sidney McLaren, Kapo; {exhibition, August 7-September 8, 1978}.* Washington, D.C., 1978. 8 p.

JAMAICA—SCULPTURE

1665. London (England). Commonwealth Institute Art Gallery. *Ten Jamaican sculptors; {exhibition}, Commonwealth Institute Art Gallery, London, September 4-28, 1975.* London, 1975? 31 p.

Exhibition organized by the National Gallery of Jamaica, Kingston, Jamaica.

Martinique

1666. *Parallèlles.* Fort-de-France, Martinique, 196-?- .

Mexico

1667. Abreu Gómez, Ermilo. *Sala de retratos; intelectuales y artistas de mi época.* Mexico City, Mexico: Editorial Leyenda, 1946.

1668. Altamirano, Ignacio Manuel. *El Salón en 1879-1880; impresiones de un aficionado.* Mexico City, Mexico: Imprenta de F. Díaz de León, 1880.

1669. Amabilis, J. Manuel. *El Pabellón de México en la Exposición Iberoamericana de Sevilla.* Mexico City, Mexico: Taller Gráficos de la Nación, 1929.

1670. American Federation of Arts (Washington, D.C.). *Mexican arts.* Washington, D.C., {1930}.

 Exhibition circulated to the Metropolitan Museum of Art, New York; The Museum of Fine Arts, Boston, Massachusetts, and six other U.S. museums, 1930-31.

1671. Angeli, Jorge de. *Artistas plásticos.* Mexico City, Mexico: Ediciones Culturales, 1975. 192 p.

1672. Ann Arbor (Michigan). University of Michigan. *Mexican art, pre-Columbian to modern times.* Ann Arbor, 1958. 62 p.

 Exhibition catalog.

1673. Armand Hammer Foundation (Los Angeles, California). *Tesoros de México de los museos nacionales mexicanos = Treasures of Mexico from the Mexican National Museums.* Los Angeles, 1978. 206 p.

 Catalog of an exhibition organized by the Foundation and circulated to the Hirshhorn Museum and Sculpture Garden and elsewhere in Washington, D.C.; also shown at the Knoedler and Hammer Galleries in New York City; and the Museo de Monterrey, Monterrey, Mexico.

1674. *L'Art vivant au Mexique.* Paris, France: Larousse, 1930. 104 p.

Special issue devoted to all aspects of Mexican art; 6e année, no. 122, {15 fevrier 1930}.

1675. Arts Council of Great Britain (London, England). *Exhibition of Mexican art from pre-Columbian times to the present day: {The Tate Gallery, 4 March to 26 April 1953}.* London, 1953. 103 p.

Illustrated supplement to the catalog also published.

1676. Barocio, Alberto. *México y la cultura.* Mexico City, Mexico: Secretaría de Educación Pública, 1946. 995 p.

Includes many sections on Mexican art.

1677. Barrio, Raymond. *Mexico's art and Chicano artists.* Guerneville, California: Ventura Press, 1978. 70 p.

1678. Berlin (West Germany). Kunstlerhaus Bethanien. *Kunstlerinnen aus Mexico.* Berlin: Gesellschaft für Bildende Kunst, 1981. 110 p.

Exhibition catalog?

1679. Berlin (West Germany). Neue Gesellschaft für Bildende Kunst. *Kunst der mexikanischen Revolution: Legende und Wirklichkeit.* Berlin, c1974. 191 p.

Bibliography; exhibition held at Schloss Charlottenburg, West Berlin, Nov.-Dec., 1974.

1680. Best Maugard, Adolfo. *Manuale y tratados: método de dibujo: tradición, resurgimiento y evolución del arte mexicano.* Mexico City, Mexico: Secretaría de Educación, 1923. 133 p.

1681. Bienal de Febrero (1978 : Mexico City, Mexico). *Bienal de Febrero: nuevas tendencias: Salón 1977-78, {exposición}, marzo/abril 1978.* Mexico City, 1978. 106 p.

1682. Biennale de Paris (10th : 1977 : Paris, France). *Grupo Proceso Pentágono, Grupo Suma, Grupo Tetraedro, Taller de Arte e Ideología: presencia de México en la X Bienal de París, 1977; présence de Méxique à la X Biennale de Paris, 1977.* Mexico City, Mexico: Instituto Nacional de Bellas Artes, {1977?}. {60} p.

Exhibition held at the X Biennale de Paris, 1977, and the Universidad Nacional Autónoma de México, Museo Universitario de Ciencias y Arte, Mexico City, Mexico, 1977.

1683. Brenner, Anita. *Idols behind altars.* New York, N.Y.: Payson & Clarke, 1929. 359 p.

Bibliography.

1684. Brown, Thomas A. *La Academia de San Carlos de la Nueva España.* Mexico City, Mexico: Secretaría de Educación Pública, 1976. 2 v.

Translated from English.

1685. Burchwood, Katharine Tyler. *The origin and legacy of Mexican art.* South Brunswick, N.J.: Barnes, 1971. 159 p.

Bibliography.

1686. Cardona Pena, Alfredo. *Semblanzas mexicanas; artistas y escritores del México actual.* Mexico City, Mexico: Libro-Mex, 1955.

1687. Cardoza y Aragón, Luis. *Mexican art today.* Mexico City, Mexico: Fondo de Cultura Económica, 1966.

Spanish edition published in 1964.

1688. Centro Superior de Artes Aplicadas (Mexico City, Mexico). *Programas y reglamento.* Mexico City: Instituto Nacional de Bellas Artes, 1958. 124 p.

1689. Charlot, Jean. *Art from the Mayans to Diseny.* New York, N.Y.; London, England: Sheed & Ward, 1939. 285 p.

1690. Charlot, Jean. *Art-making from Mexico to China.* New York, N.Y.: Sheed & Ward, 1950. 308 p.

1691. Charlot, Jean. *An artists on art; collected essays.* Honolulu, Hawaii: University of Hawaii Press, c1972. 2 v.

Volume 2, *Mexican art.*

1692. Charlot, Jean. *Mexican art and the Academy of San Carlos, 1785-1915.* Austin, Texas: University of Texas Press, 1962. 177 p.

1693. Cologne (West Germany). Rautenstrauch-Joset-Museum der Stadt Köln. *Kunst der Mexikaner, 25. April bis 7. Juni 1959, {Ausstellung}.* Cologne: Druckhaus Deutz, 1959. 33 p.

Exhibition catalog.

1694. *Cuarenta siglos de plástica mexicana: arte moderno y contemporáneo.* Mexico City, Mexico: Editorial Herrero, 1971. 391 p.

 Texts by Edmundo O'Gorman, Justino Fernández, Luis Cardoza y Aragón, Ida Rodríguez Prampolini, Carlos G. Mijares Bracho; indexes and chronology by Xavier Moyssén.

1695. Darmstadt (West Germany). Kunsthalle. *Mexikanische Volkskunst; Ausstellung, 2 Dezember 1962 bis 27. Januar 1963 in der Kunsthalle am Steubenplatz.* Darmstadt: Kunstverein Darmstadt E.V., 1963. 24 p.

1696. *Del arte; homenaje a Justino Fernández.* Mexico City, Mexico: Universidad Nacional Autónoma de México, Instituto de Investigaciones Estéticas, 1977. 309 p.

 Festschrift, edited by Donald Robertson...{et al.}.

1697. Delphic Studios (New York, N.Y.). *Exhibition of works of Mexican artists and artists of the Mexican school: December 1, 1930-January 4, 1931.* New York, 1930? 6 p.

1698. Delphic Studios (New York, N.Y.). *Exhibit by contemporary Mexican artists of the Mexican school presented by Delphic Studios, New York City: Junior League, November 16-November 30, 1931.* New York, 1931. 4 p.

1699. D'Harnoncourt, Rene. *Mexicana; a book of pictures.* New York, N.Y.: Knopf, 1931.

1700. Díez Barroso, Francisco. *El arte en Nueva España.* Mexico City, Mexico: Mexicana de Artes Gráficas, 1921. 419 p.

1701. Doerner, Gerd. *Mexikanische Volkskunst.* Vienna, Austria: Wilhelm Andermann Metropol Bucher, 1962. 67 p.

1702. Downing, Todd. *The Mexican earth.* New York, N.Y.: Doubleday, Doran, 1940. 337 p.

1703. Essen (West Germany). Villa Hugel. *Kunst aus Mexiko: von den Anfangen bis zur Gegenwart.* Essen, 1974. 270 p.

 Exhibition catalog, May 8-August 18, 1974.

1704. Estrada, Genaro. *Algunos papeles para la historia de las bellas artes en México: documentos de la Academia de Bellas Artes de San Fernando, de Madrid, relativa a la Academia de Bellas Artes de San Carlos, de México.* Mexico City, 1935? 86 p.

1705. Estrada, Genaro. *El arte mexicano en España*. Mexico City, Mexico: Porrúa, 1937.

1706. *Exposición arte de Jalisco; de los tiempos prehispánicos a nuestros días; catálogo*. Mexico City, Mexico: Muñoz, 1963. ca. 100 p.

 Edited by Víctor M. Reyes and Adrián Villagómez.

1707. Exposición Nacional de Obras de Bellas Artes (25th : 1920 : Mexico City, Mexico). *Convocatoría para la XXV Exposición Nacional de Obras de Bellas Artes que se verificará en ésta escuela de 25 de diciembre de 1919 al 25 de enero de 1920*. Mexico City: Tipografía E. Rivera, 1919.

1708. Exposición Nacional de Obras de Bellas Artes (25th : 1920 : Mexico City, Mexico). *Catálogo de la XXV Exposición Nacional de Obras de Bellas Artes*. Mexico City: Escuela Nacional de Bellas Artes, Imprenta 'La McDerna' de José D. Rojas, 1920.

1709. Exposición de la Escuela Nacional de Bellas Artes (23rd : 1898? : Mexico City, Mexico). *Catálogo de las obras nacionales y extranjeras presentadas en la XXIII Exposición de la Escuela Nacional de Bellas Artes*. Mexico City: Tipografía de El Tiempo, 1898. 103 p.

1710. Fernández, Justino. *El arte del siglo XIX en México*. Mexico City, Mexico: Universidad Nacional Autónoma de México, Instituto de Investigaciones Estéticas, 1967. 256 p.

 Bibliography; first published in 1952 as part of *Arte moderno y contemporáneo de México*.

1711. Fernández, Justino. *Arte mexicano; de sus orígenes a nuestros días*. Mexico City, Mexico: Porrúa, 1958. 208 p.

 Bibliography; 2nd edition, 1961; 4th edition, 1975.

1712. Fernández, Justino. *El arte moderna en México; breve historia, siglos XIX y XX*. Mexico City, Mexico: Porrúa, 1937. 473 p.

 Bibliogrpahy.

1713. Fernández, Justino. *Arte moderno y contemporáneo de México*. Mexico City, Mexico: Universidad Nacional Autónoma de México, Instituto de Investigaciones Estéticas, 1952. 521 p.

 Bibliography: p. 505-512.

1714. Fernández, Justino. *A guide to Mexican art from its beginnings to the present.* Chicago, Illinois: University of Chicago Press, c1969. 398 p.

Bibliography: p. 194-196.

1715. Fernández, Justino. *Estética del arte mexicano; Coatlicue, El retablo de los reyes, El hombre.* Mexico City, Mexico: Universidad Nacional Autónoma de México, Instituto de Investigaciones Estéticas, 1972. 599 p.

Collection of three major works by Fernández, each previously published seperately.

1716. Fernández, Justino. *El hombre; estética del arte moderno y contemporáneo.* Mexico City, Mexico: Universidad Nacional Autónoma de México, Instituto de Investigaciones Estéticas, 1962. 362 p.

Bibliography: p. 337-348.

1717. Fernández, Justino. *Mexican art.* London, England: Spring Books, c1965. 43 p.

1718. Fernández, María Patricia. *El arte del pueblo mexicano.* Mexico City, Mexico: Universidad Nacional Autónoma de México, 1975. 42 p.

1719. García Maroto, Gabriel. *Acción plástica popular; educación y aprendizaje a escala nacional.* Mexico City, Mexico: Plástica Americana, 1945. 219 p.

1720. Gibbon, Eduardo A. *Reflecciones sobre arte nacional; la última exposición de bellas artes en la Academia de San Carlos.* Mexico City, Mexico: Tipografía de la Escuela Industrial de Huérfanos, 1893.

1721. Gloria, Laguna, Art Gallery (Austin, Texas). *Art from Mexico: {exhibition}, November 4 to 30, 1958.* Austin, 1958. unpaged.

1722. Goldman, Shifra Meyerowitz. *Nueva Presencia: the human image in contemporary Mexican art.* Ann Arbor, Michigan: University Microfilm, 1977? 587 p.

Ph.D., 1977, University of California, Los Angeles.

1723. Guadalajara (Mexico). Casa de la Cultura Jalisciense. *Panorama actual de las artes plásticas en Jalisco.* Guadalajara, 1959.

Exhibition catalog.

1724. Guzmán, Daniel de. *México épico: una nueva valoración estética del impacto de la Revolución entre 1910-1940, a través de las corrientes literarias y artísticas formativas de aquella época.* Mexico City, Mexico: B. Costa-Amic Editor, 1962.

1725. Hagerstown (Maryland). Washington County Museum of Fine Arts. *Mexican exhibition, May 1st to 29th, 1935.* Hagerstown, 1935. 6 p.

1726. *Historia general del arte mexicano.* Mexico City, Mexico: Hermes, {1962-1964}. 3 v.

> Volume 3: Epoca moderna y contemporánea, by Raquel Tibol, edited by Pedro Rojas; includes bibliography. Another edition, 1974-1976, 6 v.: v. 1, Epoca colonial; v. 2, Indumentaria tradicional indígena; v. 3, Epoca prehispánica; v. 4, Danzas y bailes populares; v. 5, Etno-artesanías; v. 6, Arte popular, also edited by Pedro Rojas {et al.}.

1727. Houston (Texas). Contemporary Arts Museum. *Mexican paintings and drawings: {exhibition}, September 13 through September 29, 1953.* Houston, 1953. 8 p.

1728. Leal, Fernando. *El derecho de la cultura; doce capitulares y dos composiciones grabadas en madero por Bulmaro Guzmá.* Mexico City, Mexico: Organización Cultural Mexicana, 1952. 170 p.

> Treats the social significance of Mexican art.

1729. London (England). Tate Gallery. *Exhibition of Mexican art from pre-Columbian times to the present day.* London, 1953.

> Exhibition catalog, March 4-April 16, 1953.

1730. Los Angeles (California). County Museum of Art. *Chicanismo en el arte; {exhibition}, May 6-25, 1975.* Los Angeles, 1975. 28 p.

1731. Los Angeles (California). County Museum of Art. *Master works of Mexican art from pre-Columbian times to the present.* Los Angeles, 1964. 296 p.

> Exhibition catalog, October 1963-January 1964.

1732. Luna Arroyo, Antonio. *Panorama de las artes plásticas mexicanas, 1910-1960; una interpretación social.* Mexico City, Mexico, 1962.

1733. Maples Arce, Manuel. *Modern Mexican art = El arte mexicano moderno.* London, England: A. Zwemmer, {1945?}. 41 p.

1734. Maples Arce, Manuel. *Peregrinación por el arte de México: ciudades, obras, monumentos.* Buenos Aires, Argentina: López, 1951. 161 p.

1735. Mariscal, Nicolás. *El arte en México: conferencia.* Mexico City, Mexico: Tipografía de la viuda de F. Díaz de León, 1911. 23 p.

1736. Maza, Francisco de la. *Paginas de arte y de historia.* Mexico City, Mexico: INAH, 1966. 102 p.

Another edition, 1971, 248 p.

1737. Mexico City (Mexico). Escuela Central de Artes Plásticas. *Plan de estudios y reglamentos.* Mexico City: Universidad Nacional Autónoma de México, 1932. 28 p.

1738. Mexico City (Mexico). Escuela Nacional de Bellas Artes. *Catálogo de las obras expuestas en la Escuela Nacional de Bellas Artes correspondiente al décimo de los grupos determinado en el Cap. 3o., Sec. 2a, del reglamento formado por la Comisión Mexicana de la Exposición Nacional e Internacional de Filadelfia, año de 1875.* Mexico City: Imprenta de Francisco Díaz de León, 1875.

1739. Mexico City (Mexico). Instituto Nacional de Bellas Artes. *Art mexicain contemporain: peinture et gravure.* Mexico City: {1958}. {32} p.

Exhibition circulated to Bordeaux, Paris, Lille, Lyon and Toulouse, France.

1740. Mexico City (Mexico). Instituto Nacional de Bellas Artes. *México en el arte; crónica de medio siglo, 1900-1950.* Mexico City: Taller Gráfico de la Nación, 1950. 238 p.

Special issue of the magazine *México en el arte,* no. 10-11, 1950.

1741. Mexico City (Mexico). Instituto Nacional de Bellas Artes. *Plástica bajacaliforniana: selección Bienal, 1977.* Mexico City, 1977. 24 p.

1742. Mexico City (Mexico). Ministerio de Relaciones Exteriores. Departamento de Publicidad. *Senas de escritores y artistas mexicanos.* 2a ed. Mexico City, 1931.

1743. Mexico City (Mexico). Museo de Arte Moderno. *El geometrismo mexicano; una tendencia actual: {exposición}, noviembre-diciembre 1976.* Mexico City, 1976. 24 p.

1744. Mexico City (Mexico). Museo de Arte Moderno. *Surrealismo y arte fantástico en México: {exposición}, noviembre 29-diciembre 15, 1971.* Mexico City, 1971. 16 p.

Text in Spanish, English, French and German.

1745. Mexico City (Mexico). Museo Nacional de Arte Moderno. *Arte de Jalisco de los tiempos pre-hispánicos a nuestros días: catálogo.* Mexico City: Instituto Nacional de Bellas Arte, 1963.

1746. Mexico City (Mexico). Museo Nacional de Artes Plásticas. *Breve historia de la plástica: iniciación a su conocimiento; exposición, noviembre de 1949, Palacio de Bellas Artes.* Mexico City: Instituto Nacional de Bellas Artes, 1949?

1747. Mexico City (Mexico). Museo Nacional de Artes Plásticas. *Exposición de arte mexicano: guía del visitante, 20 de noviembre de 1953.* Mexico City, 1953. 138 p.

1748. Mexico City (Mexico). Palacio de Bellas Artes. *Exposición de trabajos de los alumnos de la Escuela de Pintura y Escultura realizados durante el año de 1946: del 22 de abril al 9 de mayo 1947.* Mexico City, 1947. 32 p.

1749. Mexico City (Mexico). Sistema de Transporte Colectivo (Metro). *Paisaje de México; Pasaje Zocalo/Pino Suárez, México, D.F., {exposición}, del 18 de octubre al 30 de noviembre de 1972.* Mexico City, 1972. 154 p.

1750. Mexico City (Mexico). Universidad Nacional Autónoma de México. *Las artes plásticas: (Las Humanidades en el siglo XX).* Mexico City, 1977. 2 v. (227, 151 p.).

Edited by Ida Rodríguez Prampolini.

1751. Mexico City (Mexico). Universidad Nacional Autónoma de México. Galería Universitaria Aristos. *Rostros, máscaras y caretas; {exposición}, junio-julio 1971.* Mexico City, 1971. 24 p.

1752. Mexico City (Mexico). Universidad Nacional Autónoma de México. Museo Universitario de Ciencias y Arte. *La muerte: expresiones mexicanas de un enigma.* la ed. {Mexico City}, 1975. 148 p.

Exhibition catalog, Nov. 1974-April 1975.

1753. Mexico City (Mexico). Universidad Nacional Autónoma de México. Museo Universitario de Ciencias y Arte. *Tendencias del arte abstracto en México.* Mexico City, 1967. {48} p.

Text by Luis Cardoza y Aragón; exhibition held, Dec. 1967-Jan. 1968.

1754. Millan, Verna Carleton. *Mexico reborn.* Boston, Massachusetts: Houghton Mifflin, 1939. 312 p.

1755. Montenegro, Roberto. *Planos en el tiempo.* Mexico City, 1962.

1756. Monterrey (Mexico). Museo de Monterrey. *Pintura y escultura contemporánea.* Monterrey, 197? 8 p.

1757. Moreno Villa, José. *Lo mexicano en las artes plásticas.* Mexico City, Mexico: El Colegio de México, 1948. 174 p.

1758. Nelken, Margarita. *El expresionismo en la plástica mexicana de hoy.* Mexico City, Mexico: Instituto Nacional de Bellas Artes, 1964. 297 p.

1759. New York (N.Y.). Museum of Modern Art. *Twenty centuries of Mexican art = Veinte siglos de arte mexicano.* New York: The Museum of Modern Art, in collaboration with the Mexican government, 1940. 199 p.

Exhibition catalog, May 15-Sept. 30, 1940.

1760. Obelisco, Galería (Mexico City, Mexico). *Arte moderno: exposición de inauguración de obras de 8 pintores y 2 escultores contemporáneos: noviembre 10 de 1966.* Mexico City, 1966. 28 p.

1761. Olea Figueroa, Oscar. *Configuración de un modelo axiológico para una crítica de arte.* Mexico City, Mexico: Universidad Nacional Autónoma de México, 1977. 175 p.

1762. Olea Figueroa, Oscar. *Estructura del arte contemporáneo.* Mexico City, Mexico: Universidad Nacional Autónoma de México, 1979. 117 p.

1763. Organizing Committee of the Games of the XIX Olympiad. *The Cultural Olympiad: Mexico 68.* Mexico City, Mexico, c1969. 756 p.

Text in English and French.

1764. Palencia, Ceferino. *Arte contemporáneo de México.* Mexico City, Mexico: Editorial Patria, 1951. 127 p.

1765. Paris (France). Musée National d'Art Moderne. *Art mexicain du précolombien à nos jours: {exposition}, mai-juillet 1952.* Paris: Les Presses Artistiques, {1952}. 2 v.

Second volume treats 19th and 20th century Mexican art.

1766. Paris (France). Petit Palais des Beaux Arts de la Ville de Paris. *Chefs d'oeuvre de l'art mexicain.* Paris, 1962. 420 p.

Bibliography: p. 412-420; also exhibited at the Palazzo delle Esposizioni, Rome, Italy, Oct. 1962-Jan. 1963.

1767. Pérez Sanvicente, Guadalupe, and Arriaga Ochoa, Antonio. *Juárez en el arte: antología iconográfica del Benemerito de las Américas.* Mexico City, Mexico: Comisión Nacional para la Commemoración del Centenario del Fallecimiento de Don Benito Juárez, 1972. 72 p., plates.

1768. Philadelphia (Pennsylvania). Museum of Art. *Mexican art today.* Philadelphia, 1943. 104 p.

Exhibition catalog.

1769. Ramos Galicia, Yolanda. *Proyecto para la creación de museos locales en México.* Mexico City, Mexico: INAH, 1977. 49 p.

1770. *Retablo barroco; a la memoria de Francisco de la Masa.* Mexico City, Mexico: Universidad Nacional Autónoma de México, Instituto de Investigaciones Estéticas, 1974. 382 p.

Deals primarily with Colonial Mexican art.

1771. Revilla, Manuel G. *El arte en México.* Mexico City, Mexico, 1893.

Focus is on Colonial art; 2nd edition, Mexico City, Mexico: Porrúa, 1923.

1772. Reyes y Zavala, Ventura. *Apuntes para formar un catálogo de los artistas que, o han nacido en el estado, o han vivido en el; dejando obras de manos.* Guadalajara, Mexico: Tipografía de Valeriano C. Olague, 1882.

1773. Rivera, Diego. *Arte y política.* Mexico City, Mexico: Grijalbo, 1979. 460 p.

Edited by Raquel Tibol.

1774. Rodman, Seldon. *Mexican journal: the conquerors conquered.* New York, N.Y.: Devin-Adair, 1958. 298 p.

Inteviews with Goitia, Siqueiros, Barragán, Tamayo...{et al.}.

1775. Rodríguez Prampolini, Ida. *La crítica de arte en México en el siglo XIX.* Mexico City, Mexico: Universidad Nacional Autónoma de México, Instituto de Investigaciones Estéticas, 1964. 3 v.

Volume 1, Estudio y documentos, 1810-1858; v. 2, Documentos, 1858-1878; v. 3, Documentos 1879-1902.

1776. Rodríguez Prampolini, Ida. *El surrealismo y el arte fantástico de México.* Mexico City, Mexico: Universidad Nacional Autónoma de México, Instituto de Investigaciones Estéticas, 1969. 133 p.

Bibliography: p. 113-117.

1777. Rodríguez Prampolini, Ida. *Una década de crítica de arte.* Mexico City, Mexico: Secretaría de Educación Pública, 1974. 198 p.

1778. Rojas Garcidueñas, José. *Presencias de Don Quijote en las artes de México.* Mexico City, Mexico: Universidad Nacional Autónoma de México, 1968. 188 p.

1779. Rojas Rodríguez, Pedro Mario. *The art and architecture of Mexico: from 10,000 B.C. to the present day.* Feltham: Hamlyn, 1968.

Translated by J. M. Cohen.

1780. Romero de Terreros, Manuel. *Catálogo de las exposiciones de la antigua Academia de San Carlos de México (1850-1898).* Mexico City, Mexico: Universidad Nacional Autónoma de México, Instituto de Investigaciones Estéticas, 1963. 690 p.

1781. Rosa, Antonio María de la. *Historia de las bellas artes de la Puebla.* Mexico City, Mexico, 1953. 30 p.

1782. Rubín de la Borbolla, Daniel Fernando. *México: monumentos históricos y arqueológicos: libro segundo: México colonial y moderno.* Mexico City, Mexico: Instituto Panamericano de Geografía e Historia, 1953. 215 p.

Colonial architecture, contemporary painting and prominent museums.

1783. Salón Independiente (2nd : 1969 : Mexico City, Mexico). *II Salón Independiente, {1969}: {exposición}, otoño-invierno, {1969}.* Mexico City: Universidad Nacional Autónoma de México, Museo Universitario de Ciencias y Arte, 1969. 72 p.

1784. Sánchez Vázquez, Adolfo. *Sobre arte y revolución.* Mexico City, Mexico: Grijalbo, 1979. 75 p.

1785. Schneider, Luis Mario. *México y el surrealismo, (1925-1950).* Mexico City, Mexico: Artes y Libros, 1978. 246 p.

1786. Smith, Bradley. *Mexico, a history in art.* Garden City, N.Y.: Doubleday, 1968. 296 p.

Bibliography.

1787. Spilimbergo, J.E. *Diego Rivera e el arte en la revolución mejicana.* Buenos Aires, Argentina: Indoamericana, 1954. 58 p.

1788. Stewart, Virginia. *45 contemporary Mexican artists; a twentieth-century renaissance.* Stanford, California: Stanford University Press, 1951. 167 p.

Bibliography: p. 163-167.

1789. Tabalada, José Juan. *Historia del arte en México.* Mexico City, Mexico: Campañía Nacional Editora 'Aguilas', 1927. 255 p.

1790. Tibol, Raquel. *Documentación sobre el arte mexicano.* 1a ed. Mexico City, Mexico: Fondo de Cultura Económica, 1974. 135 p.

1791. Tibol, Raquel. *Historia general del arte mexicano: época moderna y contemporánea.* Mexico City, Mexico: Editorial Hermes, 1964. 248 p.

Bibliography.

1792. Tokyo (Japan). National Museum of Modern Art. *Contemporary Mexican art.* Tokyo, {1974}. 83 p.

Catalog organized by the National Museum of Modern Art, Tokyo, Japan, The National Museum of Modern Art, Koyto, Japan, and The Instituto Nacional de Bellas Artes y Literatura, Mexico City, Mexico. Exhibited at the National Museum of Modern Art, Tokyo, Sept. 22-Nov. 4, 1974; and at the National Museum of Modern Art, Kyoto, Japan, Nov. 26, 1974-Jan. 12, 1975.

1793. Toor, Frances. *A treasury of Mexican folkways.* New York, N.Y.: Crown, {1947}. 566 p.

Illustrated by Carlos Mérida.

1794. Toussaint, Manuel. *Arte colonial en México.* Mexico City, Mexico: Universidad Nacional Autónoma de México, Instituto de Investigaciones Estéticas, 1948. 501 p.

Second edition, 1962; 3rd edition, 1974.

1795. Velázquez Chávez, Agustín. *Contemporary Mexican artists.* New York, N.Y.: Covici-Friede, 1937. 304 p.

Bibliography.

1796. Westheim, Paul. *Arte de México.* Mexico City, Mexico: Fondo de Cultura Económica, {1950}.

1797. Zuno, José G. *Las artes plásticas en Jalisco: ensayo crítico-histórico.* Guadalajara, Mexico: Et Cétera, 1953. 180 p.

Pre-Columbian to contemporary art.

1798. Zuno, José G. *Historia de la ironía plástica en Jalisco.* Guadalajara, Mexico, 1958. 79 p.

1799. Zuno, José G. *Historia de las artes plásticas en la revolución mexicana.* Mexico City, Mexico: Taller Gráfica de la Nación, 1967.

1800. Zuno, José G. *Lecciones de historia del arte.* Guadalajara, Mexico, 1961. 2 v. (163, 183 p.).

1801. Zuno, José G. *Notas sobre la plástica mexicana.* Guadalajara, Mexico, 1955.

MEXICO—GENERAL—BIBLIOGRAPHIES

1802. *Bibliografía comentada sobre arte del siglo XIX.* Mexico City, Mexico: Dirección de Estudios Históricos, INAH, 1978. 210 p.

Thematic bibliography, giving location of works, by Esther Acevedo, Rosa Sasanova, et al.

1803. Fernández, Justino. *Catálogo de las exposiciones de arte, v. 1, no. 1 (1946)-* . Mexico City, Mexico: Universidad Nacional Autónoma de México, Instituto de Investigaciones Estéticas, 1946- .

Supplement to no. 14 of the Anales del Instituto de Investigaciones Estéticas. From 1937 to 1944, published as part of the Anales del Instituto. Beginning in 1946 until 1973, published as a supplement of the Anales.

1804. Fernández, Justino. *Dos décadas de trabajo del Instituto de Investigaciones Estéticas: catálogo de sus publicaciones, índice de sus Anales.* Mexico City, Mexico: Universidad Nacional Autónoma de México, Instituto de Investigaciones Estéticas, 1957. 64 p.

> Second supplement to no. 25 of the Anales del Instituto de Investigaciones Estéticas.

1805. Mantecón, José Ignacio. *Bibliografía de los investigadores {del Instituto de Investigaciones Estéticas}.* Mexico City, Mexico: Universidad Nacional Autónoma de México, Instituto de Investigaciones Estéticas, 1961. 235 p.

> Second supplement to no. 30 of the Anales del Instituto de Investigaciones Estéticas.

1806. Mantecón, José Ignacio. *Bibliografía de Manuel Toussaint.* Mexico City, Mexico: Universidad Nacional Autónoma de México, Instituto de Investigaciones Estéticas, 1957. 36 p.

> Supplement to no. 25 of the Anales del Instituto de Investigaciones Estéticas.

1807. Ocampo, María Luisa, and Médiz Bolio, María. *Apuntes para una bibliografía del arte en México.* Mexico City, Mexico: Secretaría de Educación Pública, 1957. 194 p.

> Classified bibliography on Mexican art; 1,031 entries.

1808. Ongay Muza, Danilo. *Bibliografía del Instituto de Investigaciones Estéticas, 1935-1965.* Mexico City, Mexico: Universidad Nacional Autónoma de México, Instituto de Investigaciones Estéticas, 1966. 150 p.

1809. Ongay Muza, Danilo. *Bibliografía del Instituto de Investigaciones Estéticas, 1966-1968.* Mexico City, Mexico: Universidad Nacional Autónoma de México, Instituto de Investigaciones Estéticas, 1969. 33 p.

> Second supplement to no. 38 of the Anales del Instituto de Investigaciones Estéticas.

1810. Argentina. Ministerio de Educación y Justicia. *Exposición de arte mexicano; obras y colecciones de Francisco Mújica Díez de Bonilla.* Buenos Aires, 1956. 48 p.

1811. Banco Nacional de México (Mexico City, Mexico). *Images of Mexico: an artistic perspective from the pre-Columbian era to modernism; selected works from the Banamex Collection.* Mexico City: Fomento Cultural Banamex, c1979. {62} p.

> Catalog of an exhibition held at the Union Carbide Exhibition Hall, New York City, Nov. 1979, and the San Jose Museum of Art, San Jose, California, Feb. 15-March 30, 1980.

1812. Carrillo y Gariel, Abelardo. *Las Galerías de San Carlos.* Mexico City, Mexico: Ediciones Mexicanas, 1950. 53 p.

> Guide to the galleries.

1813. Centro Cultural ALFA (Monterrey, Mexico). *Centro Cultural ALFA.* Monterrey, 197? 20 p.

> Descriptive booklet.

1814. Chilpancingo (Mexico). Universidad Autónoma de Guerrero. *Museo de Arte Contemporáneo de la U.A.G., 1969.* Chilpancingo, 1969. 140 p.

> Includes portrait photographs and biographies of the artists.

1815. Ciudad Juárez (Mexico). Museo de Arte e Historia. *Museo de Arte e Historia de Ciudad Juárez, Chihuahua = Museum of Arts and History.* Mexico City: Programa Nacional Fronterizo, {1964}. 128 p.

> Texts describing the Museum, the art collection and catalog of the collection.

1816. Fredericton (New Brunswick, Canada). Beaverbrook Art Gallery. *Mexican works from the Vaughan Collection: {exhibition, 1979?}.* Fredericton, c1979. 22 p.

1817. Mexico City (Mexico). Galería de Historia, La Lucha del Pueblo Mexicano por Su Libertad. *Gallery of History—The Struggle of the Mexican People for Their Freedom.* Mexico City: Comité Organizador de los Juegos de la XIX Olimpiada, 1970, c1968. 46 p.

1818. Mexico City (Mexico). Instituto Nacional de Bellas Artes. *Dos años del INBA.* Mexico City, 1950. 166 p.

1819. Mexico City (Mexico). Instituto Nacional de Bellas Artes. *Inauguración del Museo Nacional de Artes Plásticas.* Mexico City, 1947. 36 p.

 Speech given by the Director of the INBA celebrating the inauguration of the Museum.

1820. Mexico City (Mexico). Museo de las Culturas. *El Museo de las Culturas, 1865-1866, 1965-1966.* Mexico City: Instituto Nacional de Antropología e Historia, 1967.

1821. Mexico City (Mexico). Museo de San Carlos. *Museo de San Carlos.* Mexico City: Instituto Nacional de Bellas Artes, 1958. unpaged.

 Catalog of the collection.

1822. Mexico City (Mexico). Museo de San Carlos. *The San Carlos Museum.* Mexico City: Comité Organizador de los Juegos de la XIX Olimpiada, 1970, c1968. 71 p.

 Description of the Museum and its collection.

1823. Mexico City (Mexico). Museo Diego Rivera. *Diego Rivera Museum-Anahuacalli.* Mexico City, 1970. 108 p.

 Descriptive catalog of the collection; text in English.

1824. Mexico City (Mexico). Palacio de Bellas Artes. *25 años del Palacio de Bellas Artes.* Mexico City: Instituto Nacional de Bellas Artes, 1959. 69 p.

 History of the Palacio from 1934 to 1959.

1825. Mexico City (Mexico). Palacio de Bellas Artes. *Galería de artistas mexicanos contemporáneos.* Mexico City, n.d. 18 p.

 Preface by Luis Cardoza y Aragón; text by Carlos Mérida.

1826. Mexico City (Mexico). Universidad Nacional Autónoma de México. Galería de Arte. *Catálogo de la Galería de Arte de la Universidad Nacional de México.* Mexico City: Ediciones de la Universidad Nacional, {1938?}.

1827. Miami (Florida). Museum of Modern Art. *Mexican independence, 1810-1960.* Miami, 1960? 44 p.

 Mexican art exhibition featuring paintings, prints and drawings from permanent collections of Mexican art of the Philadelphia Museum of Art and supplemented by loans from other museums and private collections, 1960.

1828. New York (N.Y.). Hispanic Society of America. *Catalogue of Mexican Maiolica belonging to Mrs. Robert W. de Forest.* New York, 1911. 151 p.

Text by Edwit Atlee Barber; catalog of an exhibition held Feb. 18-March 19, 1911.

1829. New York (N.Y.). Museum of Modern Art. *Mexican art; selections from The Museum of Modern Art; checklist.* {New York, 1978}. {19} leaves.

Exhibition, March 16-July 2, 1978.

1830. Romano, Arturo. *Museo Nacional de Antropología, {Mexico}.* Tokyo, Japan: Kodansha, 1969. 184 p.

Text in Japanese; captions to the plates in Japanese and English.

MEXICO—GENERAL—DICTIONARIES, ETC.

1831. *Artistas plásticos, México 75.* Mexico City, Mexico: Ediciones Culturales GDA, 1975. 192 p.

A who's who of Mexican art.

1832. *Enciclopedia mexicana de arte.* Mexico City, Mexico: Ediciones Mexicanos, 1950-

1833. Mexico City (Mexico). Programa Cultural de la XIX Olimpíada. *Guía de exposiciones; julio {1968}.* Mexico City, 1968. 67 p.

1834. *Museos de la Ciudad de México: directório gráfico.* la. ed. Mexico City, Mexico: Universidad Nacional Autónoma de México, Centro de Investigación y Servicios Museológicos, 1980. 119 p.

Text in Spanish, English and French.

1835. Montes de Oca Sein, Daniel Emilio. *Materiales y servicios en bibliotecas pertenecientes a museos de arte.* Mexico City, Mexico: Universidad Nacional Autónoma de México, Facultad de Filosofía y Letras, 1967. 130 leaves.

1836. *Anales del Instituto de Investigaciones Estéticas.* v. 1, no. 1 (1937)- . Mexico City, Mexico: Universidad Nacional Autónoma de México, Instituto de Investigaciones Estéticas, 1937- .

Irregular; annual since 1958.

1837. *Arquitectura y lo demás.* v. 1, no. 1-9 (May 1945-April/August 1946). Mexico City, Mexico, 1945-46.

1838. *Ars; revista mensual.* v. 1, no. 1-5 (Jan. 1942-May 1943). Mexico City, Mexico, 1942-43.

Monthly.

1839. *Arte en México; revista menusal.* no. 1 (1939)- . Mexico City, Mexico? 1939- .

1840. *Arte pública; tribún de pintores, muralistas, escultores, grabadores y artistas de la estampa en general.* no. 1 (195-?)- . Mexico City, Mexico? 195-?- .

1841. *Arte, sociedad e ideología.* no. 1 (June-July 1977)- . Mexico City, Mexico? 1977- .

1842. *Artes de México.* v. 1 (Oct./Nov. 1953)- . Mexico City, Mexico, 1953- .

Frequency varies; includes summaries of texts in English.

1843. *Artes plásticas; raíces y frutos de la cultura.* no. 1-4 (Spring/Winter 1939). Mexico City, Mexico: Universidad Nacional Autónoma de México, Escuela de Artes Plásticas, 1939.

1844. *Artes visuales.* no. 1 (January 1973)- . Mexico City, Mexico: Museo de Arte Moderno, 1973- .

Quarterly; text in Spanish and English.

1845. *Boletín de arte.* no. 1 (June 1951)- . Mexico City, Mexico: Museo Nacional de Artes Plásticas, 1951- .

1846. *Buro Interamericano de Arte. Boletín.* no. 1 (1951)- . Mexico City, Mexico, 1951- .

1847. *Contemporáneos; revista mexicana de cultura.* 1928-1931. Mexico City, Mexico, 1928-1931.

Facsimile edition available, 1976.

1848. *Dyn; a review of art and literature.* no. 1-6 (April/May 1942-November 1944). Coyoacán, Mexico, 1942-44.

 Text in English and French.

1849. *Espacios; revista integral de arquitectura y artes plásticas.* no. 1 (Sept. 1948)- . Jalapa, Mexico, 1948- .

1850. *Forma; revista de artes plásticas.* v. 1 (1927?)- . Mexico City, Mexico, 1927?- .

1851. *Galería; revista de arte.* v. 1, no. 1 (May 1978)- . Mexico City, Mexico, 1978- .

1852. *Mexican art and life.* no. 1 (1938?)- . Mexico City, Mexico, 1938?- .

1853. *Mexican folkways; legends, festivals, art, archeology.* v. 1-8, (1925-1937). Mexico City, Mexico, 1925-37.

 Text in English and Spanish.

1854. Mexico City (Mexico). Universidad Nacional Autónoma de México. Museo Universitario de Ciencias y Arte. *Boletín.* no. 1 (197?)- . Mexico City, Mexico, 197?- .

1855. *Mexico en el arte.* no. 1-12 (1948-1952). Mexico City, Mexico, 1948-52.

1856. *Nueva Presencia: el hombre en el arte de nuestro tiempo.* no. 1-5, (August 1961-August/Sept. 1963). Mexico City, Mexico, 1961-63.

 Irregular.

1857. *Revista de Bellas Artes.* 1965- . Mexico City, Mexico: Palacio de Bellas Artes, 1965- .

1858. *Tiras de colores.* v. 1 (1943)- . Mexico City, Mexico, 1943- .

MEXICO—GENERAL—SALES

1859. Sotheby, Parke-Bernet (Los Angeles, California). *Important Mexican, Post-Impressionist and Modern paintings, drawings and sculpture.* Los Angeles, 1972. 93 p.

 Sale no. 39, May 5-8, 1972.

1860. Sotheby Parke-Bernet (New York, N.Y.). *Modern Mexican paintings, drawings, sculpture & prints.* New York, 1977. {170} p.

Sale, May 26, 1977.

1861. Sotheby Parke-Bernet (New York, N.Y.). *Modern Mexican paintings, drawings, sculpture, photographs & prints.* New York, 1978. {106} p.

Sale, April 5, 1978.

1862. Sotheby Parke-Bernet (New York, N.Y.). *Nineteenth and twentieth century Mexican paintings, drawings, sculpture and prints.* New York, 1979. {175} p.

Sale, May 11, 1979.

1863. Sotheby Parke-Bernet (New York, N.Y.). *19th and 20th century Mexican paintings, drawings, sculpture and prints.* New York, 1980. {175} p.

Sale no. 4373; Auction held May 9, 1980.

MEXICO—ARCHITECTURE

1864. Aldrich, Richard. *Style in Mexican architecture.* Coral Gables, Florida: University of Miami Press, 1968. 110 p.

1865. *L'Architecture d'aujourd'hui.* Paris, France, 1963.

Special issue devoted to Mexican architecture; no. 109, {Sept. 1963}.

1866. *Arquitectura contemporánea mexicana: obras y proyectos de Teodoro Gonzálex de León y Abraham Zablodovsky.* Mexico City, Mexico: Central de Publicaciones, 1969. 201 p.

Text in Spanish and English; 2nd edition, Central de Publicaciones, 1970.

1867. Born, Esther. *The new architecture in Mexico.* New York, N.Y.: Morrow, 1937. 159 p.

1868. Cervantes, Enrique A. *Puebla de Los Angeles en el año de mil novecientos treinta y tres.* Mexico City, Mexico: Estado de Puebla, 1935. {15 p., 50 plates}.

1869. Cervantes, Enrique A. *Santiago de Querétaro en el año de mil novecientos treinta y cuatro.* Mexico City, Mexico: Hacienda y Crédito Público, 1934. {15 p., 50 plates}.

1870. Cervantes, Luis de. *Crónica arquitectónica: prehispánica, colonial, contemporáneo.* Mexico City, Mexico, 1952. 110 p.

1871. Cetto, Max L. *Modern architecture in Mexico.* New York, N.Y.: Praeger, 1961.

 English and German edition; Teufen, Germany: Niggli, {1961}, 224 p.

1872. García Maroto, Gabriel, and Yáñez, Enrique. *Arquitectura popular de México.* Mexico City, Mexico: Instituto Nacional de Bellas Artes, 1954. 214 p.

1873. Heyer, Paul. *Mexican architecture: the work of Abraham Zabludovsky and Teodoro González de León.* New York, N.Y.: Walker, 1978. 141 p.

 Text in English and Spanish.

1874. Ituarte, Manuel M. *Arquitectura mexicana, 1521-1934.* Barcelona, Spain: González Porto, Salvat, 1936.

 Brief section on modern Mexican architecture.

1875. Katzman, Israel. *La arquitectura contemporánea mexicana; precedentes y desarrollo.* la. ed. Mexico City, Mexico: Instituto Nacional de Antropología e Historia, c1964. 205 p.

 Bibliography: p. 199-200.

1876. Katzman, Israel. *Arquitectura del siglo XIX en México.* Mexico City, Mexico: Universidad Nacional Autónoma de México, 1973. 323 p.

1877. Kirby, Rosina Greene. *Mexican landscape architecture; from the street and from within.* Tuscon, Arizona: University of Arizona Press, c1972. 167 p.

 Bibliography.

1879. Le Beaume, Louis, and Papin, William Booth. *The picturesque architecture of Mexico.* New York, N.Y.: Architectural Book Publishing, Wenzel and Krakow, 1915. 119 plates.

1880. MacGregor, Luis. *Arquitectura civil.* Mexico City, Mexico: Ediciones de Arte, 1948.

1881. Mariscal, Nicolás. *El desarrollo de la arquitectura en Mejico: discurso.* Mexico City, Mexico: Secretaría de Fomento, 1901. 31 p.

1882. Mexico City (Mexico). Escuela Nacional de Bellas Artes. *Programas y horario para los cursos de la sección de arquitectura e informes y decretos respecto al plan y al reglamento de estudios de la carrera de arquitecto.* Mexico City, 1911. unpaged.

1883. Mexico City (Mexico). Secretaría de Educación Pública. *Escuelas primarias, 1932; nueva arquitectura económica y sencilla.* Mexico City, 1933. 16 p., 89 plates.

1884. Murillo, Gerardo, et al. *Iglesias de México.* Mexico City, Mexico: Secretaría de Hacienda, 1924-27. 6 v.

1885. Myers, I.E. *Mexico's modern architecture.* New York, N.Y.: Architectural Book Publishing, {c1952}. 264 p.

　　　Bibliography: p. 251-255; text in English and Spanish.

1886. Neuvillate Ortiz, Alfonso de. *10 arquitectos mexicanos: Luis Barragán, P. Ramírez Vázquez, Francisco Artigas, J. Sordo Madaleno, E. de la Mora y Palomar, Mario Pani, Juan O'Gorman, Agustín Hernández, A. Zabludovsky y T. González de León.* Mexico City, Mexico: Ediciones Galería de Arte Misrachi, c1977. 61 p.

1887. Obregón Santacilia, Carlos. *Cincuenta años de arquitectura mexicana, 1900-1950.* Mexico City, Mexico: Patria, 1952. 121 p.

1888. Obregón Santacilia, Carlos. *El monumento a la revolución.* Mexico City, Mexico: Secretaría de Educación Pública, 1960. 74 p.

1889. Rodríguez, Antonio. *La Ciudad Universitaria.* Mexico City, Mexico: Editorial Espartaco, 1960.

1890. Romero de Terreros, Manuel. *Los acueductos de México en la historia y en el arte.* Mexico City, Mexico: Universidad Nacional Autónoma de México, 1949. 155 p.

1891. Sanford, Trent Elwood. *The story of architecture in Mexico: including the work of the Ancient Indian civilizations and that of the Spanish Colonial empire which succeeded them, together with an account of the background in Spain and a glimpse at the modern trend.* New York, N.Y.: Norton, 1947. 363 p.

1892. Shipway, Verna Cook, and Shipway, Warren. *Mexican homes of today.* New York, N.Y.: Hastings, 1964. 249 p.

MEXICO—ARCHITECTURE

1893. Smith, Clive Bamford. *Builders in the sun; five Mexican architects: {Juan O'Gorman, Luis Barragán, Félix Candela, Mathias Goeritz, Mario Pani.}* New York, N.Y.: Architectural Book Publishing, 1967. 224 p.

1894. Sociedad de Arquitectos Mexicanos (Mexico City, Mexico). *4000 años de arquitectura mexicana.* Mexico City: Libreros Mexicanos Unidos, 1956. 330 p.

Text in English, Spanish, French and German.

1895. Yáñez, Enrique. *18 residencias de arquitectos mexicanos = 18 homes of Mexican architects.* Mexico City, Mexico: Ediciones Mexicanas, 1951. 118 p.

MEXICO—ARCHITECTURE—BIBLIOGRAPHIES

1896. Torre Villar, Ernesto de la. *La arquitectura y sus libros: guía bibliográfica para la historia y desarrollo de la arquitectura y el urbanismo en México.* Mexico City, Mexico: Universidad Nacional Autónoma de México, Instituto de Investigaciones Estéticas, 1978. 39 p.

MEXICO—ARCHITECTURE—DICTIONARIES, ETC.

1897. Alvarez, Manuel Francisco. *Apuntes biográficos de arquitectos mexicanos.* Mexico City, Mexico: Editor Vargas Rea, 1955. 39 p.

MEXICO—ARCHITECTURE—PERIODICALS

1898. *Arquitecto.* v. 1, no. 1 (1977?)- . Mexico City, Mexico, 1977?-

Six times a year.

1899. *Arquitectura y decoración,* v. 1, no. 1 (August 1937)- . Mexico City, Mexico: Sociedad de Arquitectos Mexicanos, 1937- .

Monthly.

1900. Sociedad de Arquitectos Mexicanos. *Anuário, 1919-* . Mexico City, Mexico, 1919- .

MEXICO—BOOKBINDING

1901. Romero de Terreros, Manuel. *Encuadernaciones artísticas mexicanas.* 2a ed. Mexico City, Mexico: Biblioteca de la II Feria del Libro, 1943. 32 p.

MEXICO—COSTUMES AND NATIVE DRESS

1902. Cartón y Papel de México (Mexico City, Mexico). *El México de Guadalupe Victoria (1824-1829).* Mexico City: Empresa Editorial Cuauhtemoc, c1974. 112 p.

1903. Frias y Soto, Hilarion, {et al.}. *Los mexicanos pintados por sí mismos.* Mexico City, Mexico: Librería de Manuel Porrúa, 1975. 290 p.

Facsimile reproduction of the 1855 edition; descriptions of Mexican national costumes.

1904. Mapelli Mozzi, Carlota. *El traje indigena en México = Indian dress in Mexico: dibujos de Teresa Castello Yturbide.* Mexico City, Mexico, 1965-66. 3 v.

1905. Mérida, Carlos. *Trajes regionales mexicanos.* Mexico City, Mexico: Editorial Atlante, 1945. 16 p.

Portfolio of colored plates of regional Mexican costumes.

1906. Valdiosera, Ramón. *Mexican native costumes.* Mexico City, Mexico: Fishgrund, 1949. 16 p.

Translated by Ruth Poyo.

1907. Carrillo y Gariel, Abelardo. *Mueble mexicano.* Mexico City, Mexico: Ediciones de Arte, 1948. 64 p.

1908. Mexico City (Mexico). Instituto Nacional de Bellas Artes. *El arte en la vida diaria; exposición de objetos de buen diseño hechos en México.* Mexico City, 1952. 112 p.

1909. Mexico City (Mexico). Museo de Arte Moderno. *Diseño en México; retrospectiva y prospectiva; {exposición}, agosto-septiembre 1975.* Mexico City, 1975? 48 p.

MEXICO—GRAPHIC ARTS

1910. Ayala Echavarrí, Rafael. *La litografía en Querétaro.* Mexico City, Mexico, 1964. 16 p.

Examples of 19th century Mexican lithography.

1911. Carrasco Puente, Rafael. *La caricatura en México.* Mexico City, Mexico: Imprenta Universitaria, 1953.

1912. Cortés Juárez, Erasto. *El grabado contemporáneo, 1922-1950.* Mexico City, Mexico: Ediciones Mexicanas, 1951. 79 p.

Bibliography: p. 77-78.

1913. Espinosa Pitman, Alejandro. *Unos grabadores y una guadalupana.* San Luis Potosí, Mexico, 1975. 12 p.

Biblioteca de historia potosina.

1914. Fernández, Justino. *El grabado en lámina en la Academia de San Carlos durante el siglo XIX; reimpresión de 24 planchas originales tiradas a mano por Carlos Alvarado Lang.* Mexico City, Mexico: Universidad Nacional Autónoma de México, Instituto de Investigaciones Estéticas, 1938. 15 p.

Another edition: Havana, Cuba: Revista 'Universidad de La Habana', 1938, 45 p.

1915. Fernández, Justino. *Litográfos y grabadores mexicanos contemporáneos.* Mexico City, Mexico: Editorial Delfin, 1944. portfolio.

1916. Haab, Armin. *Mexican graphic art.* Teufen, Germany: Arthur Niggli, 1957. 126 p.

1917. Haifa (Israel). Museum of Modern Art. *Modern Mexican drawings and prints: {exhibition}, Oct./Nov. 1972.* Haifa, 1972. 32 p.

1918. Harvard Society for Contemporary Art (Cambridge, Massachusetts). *Exhibition of modern Mexican art, March 21 to April 12, 1930.* Cambridge, 1930. 6 p.

1919. Havana (Cuba). Instituto Interamericano de Historia Municipal e Institucional. *Exposición de grabados mexicanos contemporáneos, Palacio del Gobierno Provincial, abril 14, día de las Américas de 1943.* Havana, 1943. 11 p.

1920. Mexico City (Mexico). Instituto Nacional de Bellas Artes. *El dibujo mexicano de 1847 a nuestros días; {exposición}, marzo 1964.* Mexico City, 1964. 55 p.

1921. Mexico City (Mexico). Instituto Nacional de Bellas Artes. *Treinta estampas populares.* Mexico City, 1947. 30 plates.

Unknown 18th and 19th century Mexican engravers.

1922. Mexico City (Mexico). Museo de Arte Moderno. *Actualidad gráfica-panorama artístico; obra gráfica internacional, 1971-1979; {exposición}, noviembre-enero, 1979-1980, Museo de Arte Moderno, México.* Mexico City, 1979? 108 p.

1923. Mexico City (Mexico). Museo de Arte Moderno. *Seis artistas del Centro de Artes Plásticas, A.C.: {exposición}, febrero-marzo 1970.* Mexico City, 1970. 16 p.

1924. Mexico City (Mexico). Museo de Arte Moderno. *30 años del Taller de Gráfica Popular: {exposición}, diciembre 1966.* Mexico City, 1966. 32 p.

1925. Mexico City (Mexico). Palacio de Bellas Artes. *20 años de la Sociedad Mexicana de Grabadores: {exposición}, 1968.* Mexico City, 1968. 46 p.

1926. Navalón Sebastián. *El grabado en México.* Mexico City, Mexico: Museo Nacional, 1933. 15 p.

1927. O'Gorman, Edmundo. *Documentos para la historia de la litografía en México.* Mexico City, Mexico: Universidad Nacional Autónoma de México, Instituto de Investigaciones Estéticas, 1955. 110 p.

Includes essay by Justino Fernández.

1928. Orosa Diaz, Jaime. *El grabado contemporáneo en Yucatan.* Mérida, Mexico: Gobierno del Estado de Yucatan, 1948. 36 p.

1929. Pruneda, Salvador. *La caricatura como arma política.* Mexico City, Mexico, 1958. 455 p.

Nineteenth and 20th century essays on Mexican political cartoons.

1930. Quintana, José Miguel. *Las artes gráficas en Puebla.* Mexico City, Mexico: Antigua Librería Robredo, 1960. 166 p.

Bibliography.

1931. Ramírez y Ramírez, Enrique. *146 estampas de la lucha del pueblo de México; obra colectiva de los artistas del Taller de Gráfica Popular en México.* la ed. Mexico City, Mexico, 1960. 136 p.

1932. Romero de Terreros, Manuel. *Grabados y grabadores en la Nueva España.* Mexico City, Mexico, 1948. 575 p.

1933. Ruíz Meza, Víctor. *Apuntes para la historia de la litografía en Toluca en el siglo XIX.* Mexico City, Mexico: Junta Mexicana de Investigaciones Históricas, 1948. 22 p.

1934. St. Petersburg (Florida). Museum of Fine Arts. *Mexican watercolors and graphics: an exhibition...* St. Petersburg, 1972? {10} p.

Exhibition held, Feb. 1-27, 1972.

1935. Salón del Grabado (1st : 1941 : Mexico City, Mexico). *Salón del Grabado, 1941- .* Mexico City: Galería de Arte 'Decoración', 1941- .

1936. South Hadley (Massachusetts). Mount Holyoke College. *Grabados mexicanos: an historical exhibition of Mexican graphics, 1839-1974.* South Hadley, c1974. 67 p.

Bibliography; text in English and Spanish, organized and written by Art History Seminar 372 of Mexican Graphics, Joyce W. Bailey...

1937. Taller de Gráfica Popular (Mexico City, Mexico). *450 años de lucha; homenaje al pueblo mexicano.* Mexico City, 1960. portfolio (146 plates).

1938. Taller de Gráfica Popular (Mexico City, Mexico). *Estampas de la Revolución mexicana; 85 grabados de los artistas del Taller de Gráfica Popular.* Mexico City: Estampa Mexicana, 1947. 12 p., 85 plates.

1939. Taller de Gráfica Popular (Mexico City, Mexico). *Grabados del Taller de Gráfica Popular; 23 grabados y litografías de cada uno de los componentes del TGP.* Mexico City, 1956.

1940. Taller de Gráfica Popular (Mexico City, Mexico). *Mexican people: 12 original signed lithographs by artists of the Taller de Gráfica Popular, Mexico City.* New York, N.Y.: Associated American Artists, 1946? portfolio (12 plates).

1941. Taller de Gráfica Popular (Mexico City, Mexico). *TGP, México: el Taller de Gráfica Popular; doce años de obra artística colectiva.* Mexico City: Estampa Mexicana, 1948. 24 p., 167 plates.

Text in Spanish and English.

1942. Taller de Gráfica Popular (Mexico City, Mexico). *Diez grabados de los artistas del Taller de Gráfica Popular en México en homenaje al III Congreso General.* Mexico City, 1948.

1943. Toussaint, Manuel. *La litografía en México.* 2a ed. Mexico City, Mexico: Biblioteca Nacional, 1934. 60 plates.

1944. Toussaint, Manuel. *La litografía en México en el siglo XIX.* 4a ed. Mexico City, Mexico, 1934. 30 p.

1945. Western Association of Art Museums (San Francisco, California). *Contemporary Mexican prints: {exhibition}.* San Francisco: Rubicon Gallery, c1980. 8 p.

U.S. travelling exhibition.

1946. Zuno, José Guadalupe. *Historia de la caricatura en México.* Guadalajara, Mexico: Universidad de Guadalajara, 1961. 124 p.

1947. Zürich (Switzerland). Kunstgewerbemuseum. *Mexikanische druckgraphik: Die Werkstatt für graphische volkskunst in Mexico: El Taller de Gráfica Popular.* Zürich, 1951. {7} p.

MEXICO—GRAPHIC ARTS—COLLECTIONS

1948. Cortés Juárez, Erasto. *Grabados en madera: impresión de las maderas originales de la colección de Manuel Porrúa.* Mexico City, Mexico: Manuel Porrúa, 1971. 283 p.

1949. General Motors of Mexico (Mexico City, Mexico). *Image of Mexico: the General Motors of Mexico Collection of Mexican graphic art.* {Austin, Texas}: University of Texas Press, 1969. 2 v.

Comprises two volumes of the Texas Quarterly, {Autumn-Winter, 1969}, v. 12, no. 3-4; contents: v. 1, A-K; v. 2, L-Z.

MEXICO—GRAPHIC ARTS—PERIODICALS

1950. *Arte gráfico.* no. 1-19, 33-98 (1919-1923). Mexico City, Mexico: Asociación de Industrias de Artes Gráficas y Anexas del Distrito Federal, 1919-1923.

1951. *Estampa.* no. 1-11 (1954). Mexico City, Mexico, 1954.

Boletín de la Sociedad Mexicana de Grabadores.

MEXICO—PAINTING

1952. Akron (Ohio). Art Institute. *Modern Mexican masters; {exhibition}, 5 November-3 December 1972.* Akron, 1972. 16 p.

1953. Arrangóiz y Berzabal, Francisco de Paula de. *Historia de la pintura en Méjico.* Madrid, Spain: Casa Editorial de Medina, 1879.

1954. Arte Moderno, Galería (Mexico City, Mexico). *7 pintores modernos: {exposición}, inauguración 18 de febrero.* Mexico City, 1949. 16 p.

1955. Austin (Texas). University of Texas at Austin. Art Museum. *Mexico; the new generation: {exhibition}, 1967?* Austin, 1967? 32 p.

1956. Bienal de São Paulo (1959 : São Paulo, Brazil). *Mexico: {cuatro pintores exponen su obra}, septiembre 1959.* Mexico City, Mexico: Instituto Nacional de Bellas Artes, 1959. 24 p.

1957. Biennale di Venezia (29th : 1958 : Venice, Italy). *Pintura mexicana contemporánea: XXIX Bienal de Venecia, Italia, 1958: {seis pintores exponen su obra}.* Mexico City, Mexico: Instituto Nacional de Bellas Artes, 1958. 24 p.

1958. Birmingham (Alabama). Museum of Art. *Contemporary Mexican painting: {exhibition, April 23-May 18, 1965}.* Birmingham, 1965. 12 p.

1959. Boston (Massachusetts). Institute of Modern Art. *Modern Mexican painters; a loan exhibition of their works organized by the Institute of Modern Art, Boston.* Boston, 1941.

Introduction by McKinley Helm.

1960. Cabrera, Francisco. *Pintura, verdad y mito: conversaciones con Camps Ribera.* Mexico City, Mexico, 1971? 78 p.

1961. Cardoza y Aragón, Luis. *México, pintura activa.* Mexico City, Mexico: Ediciones ERA, 1961. 158 p.

Text in Spanish and English.

1962. Cardoza y Aragón, Luis. *México, pintura de hoy.* Mexico City, Mexico: Fondo de Cultura Económica, c1964. 158 p.

1963. Cardoza y Aragón, Luis. *La nube y el reloj: Agustín Lazo, Carlos Mérida, Rufino Tamayo, Julio Castellanos, David Alfaro Siqueiros, Diego Rivera, José Clemente Orozco.* Mexico City, Mexico: Universidad Nacional Autónoma de México, 1940. 138 p.

1964. Cardoza y Aragón, Luis. *Pintura contemporánea de México.* la ed. Mexico City, Mexico: Ediciones ERA, c1974. 324 p.

1965. Cardoza y Aragón, Luis. *Pintura mexicana contemporánea.* Mexico City, Mexico: Imprenta Universitaria, 1953. 311 p.

Revised edition published in 1940 under the title 'La nube y el reloj'.

1966. Carrillo y Gariel, Abelardo. *Técnica de la pintura de Nueva España.* Mexico City, Mexico: Imprenta Universitaria, 1946. 203 p.

1967. Catillo, Arturo César. *One thousand years of murals in Mexico.* Mexico City, Mexico: Pemex Travel Club, 1945.

1968. Catlin, Stanton Loomis. *Art moderne mexicain.* Paris, France: Braun, 1952. 14 p., plates.

1969. Center for Inter-American Relations (New York, N.Y.). *Young Mexicans: Corzas, Gironella, López-Loza, Rojo, Toledo: {exhibition}, October 22, 1970-January 3, 1971.* New York, c1970. 44 p.

1970. Centro Cultural ALFA (Monterrey, Mexico). *Primera exposición.* Monterrey, 197? 20 p.

Exhibition of Mexican painters.

1971. Charlot, Jean. *The Mexican mural renaissance, 1920-1925.* New Haven, Connecticut: Yale University Press, 1963. 328 p.

1972. Chillán (Chile). Escuela México. *México a Chile, 1939-1942.* Chillán, 1942. {64} p.

1973. Cossio del Pomar, Felip. *Nuevo arte; teorías de la pintura contemporánea.* 2a ed. Mexico City, Mexico: Editorial América, 1939. 232 p.

1974. Couto, José Bernardo. *Dialogo sobre la historia de la pintura en México.* Mexico City, Mexico: Oficina Tipografía de la Secretaría de Fomento, 1889. 105 p.

Another edition; Mexico City, Mexico: Fondo de Cultura Económica, 1947, footnoted and corrected.

1975. Covantes, Hugo. *Cinco pintores de la fantasía: Yolanda Quijano, Paul Antragne, Mario Rangel, Froylán Ojeada, Jorge Quiroz; ensayo en 5 tiempos sobre el arte fantástico.* Mexico City, Mexico: Arte Ediciones, 1974. 120 p.

Bibliography.

1976. Crespo de la Serna, J.J. *5 interpreters of Mexico City: Diego Rivera, Feliciano Peña, Gustavo Montoya, Amador Lugo, Raúl Anguiano.* Mexico City, Mexico: Ediciones Mexicanas, 1949. 44 p.

1977. Díaz y de Ovando, Clementina. *El Colegio Máximo de San Pedro y San Pablo.* Mexico City, Mexico: Universidad Nacional Autónoma de México, Instituto de Investigaciones Estéticas, 1951. 176 p.

Murals of Roberto Montenegro, Dr. Atl, and Xavier Guerrero in the Colegio Máximo.

1978. Edelman, Lily. *Mexican mural painters and their influence in the U.S.* New York, N.Y.: Service Bureau for Intercultural Education, 1938. 14 p.

1979. Edwards, Emily. *Painted walls of Mexico; from prehistoric times until today.* Austin, Texas: University of Texas Press, c1966. 306 p.

Bibliography: p. 277-291.

1980. *Las escuelas de pintura al aire libre.* Mexico City, Mexico: Editorial Cultura, 1926. 174 p.

1981. Eslava, Ernesto. *Pintura mural: Escuela México de Chillán.* Chile? 1943. 27 p.

1982. Fernández, Justino. *Orozco, Rivera y Siqueiros.* Mexico City, Mexico: Fischgrund, 1948. portfolio.

1983. Fernández, Justino. *La pintura moderna mexicana.* 1a ed. Mexico City, Mexico: Editorial Pormaca, 1964. 211 p.

Bibliography: p. {209}-211.

1984. Fernández, Justino. *Prometeo; ensayo sobre pintura contemporánea.* Mexico City, Mexico: Porrúa, 1945. 219 p.

Essays on Rivera and Orozco.

1985. Flores Guerrero, Raúl. *5 pintores mexicanos: Frida Kahlo, Guillermo Meza, Juan O'Gorman, Julio Castellanos, Jesus Reyes Ferreira.* Mexico City, Mexico: Universidad Nacional Autónoma de México, 1957. 157 p.

1986. Fort Worth (Texas). Art Center. *Contemporary Mexican painting: {exhibition}, June 1-June 28, 1959.* Fort Worth, 1959. 16 p.

1987. Franco Fernández, Roberto. *La pintura en Jalisco: investigación histórica y recopilación.* Guadalajara, Mexico: Casa de la Cultura Jalisciense, 1970. 119 p.

1988. García Ponce, Juan. *La aparición de lo invisible.* Mexico City, Mexico: Siglo XXI, 1968. 218 p.

1989. Gardía Ponce, Juan. *Nueve pintores mexicanos.* Mexico City, Mexico: ERA, 1968. 105 p.

Bibliography: p. 103-105.

1990. Goldman, Shifra Meyerowitz. *Contemporary Mexican painting in a time of change.* Austin, Texas: University of Texas Press, c1981. 229 p.

Bibliography: p. 209-217.

1991. Guadalajara (Mexico). Departamento de Bellas Artes. *Los Vitalistas: exposición pictórica colectiva {1978?}.* Guadalajara, 1978? 20 p.

Includes Los Vitalistas' manifesto.

1992. Guadalajara (Mexico). Universidad del Valle de Atemajac. *Gaudalajara, tres siglos de pinturas, XVII, XVIII y XIX: {exposición}.* Guadalajara, 1974? {48} p.

1993. Gual, Enrique F. *La pintura de cosas naturales.* Mexico City, Mexico: Secretaría de Educación Pública, Dirección General de Educación Audiovisual y Divulgación, 1973. 159 p.

1994. Guerrero Galván, Jesus. *A Mexican painter views modern Mexican painting.* Albuquerque, New Mexico: University of New Mexico Press, 1942. 9 p., plates.

1995. Guerrero Reyes, Angel. *La pintura mural y la revolución mexicana.* Guadalajara, Mexico: Instituto Jalisciense de Antropología e Historia, 1962.

1996. Haufe, Hans. *Funktion und Wandel christlicher Themen in der mexikanischen Malerei des 20. Jahrhunderts.* Berlin, West Germany: Colloquium Verlag, 1978. 227 p.

1997. Havana (Cuba). Casa de las Américas. *Exposición de pintura mexicana contemporánea: julio 1970.* Havana: Consejo Nacional de Cultura, Casa de las Américas, 1970. ca. 25 p.

1998. Havana (Cuba). Casa de las Américas. Galería Latinoamericana. *20 pintores contemporáneos mexicanos: {exposición}, mayo 1980.* Havana, 1980. 36 p.

1999. Havana (Cuba). Casa de las Américas. Galería Latinoamericana. *Presencia de México en Cuba: {exposición}, julio 1980.* Havana, 1980. 6 p.

2000. Helm, MacKinley. *Modern Mexican painters.* New York, N.Y.: Harper, 1941. 200 p.

2001. Islas García, Luis. *Las pinturas al fresco del Valle de Oaxaca.* Mexico City, Mexico: Clásica, 1946. 90 p.

2002. Knoedler, M. & Co. (New York, N.Y.). *Mexican painting: exhibition, November 6 to November 24, 1945, Knoedler Galleries.* New York, 1945. {29} p.

Portraits and biographies of 13 Mexican painters.

2003. Laguna Beach (California). Museum of Art. *Freedom and expression: the essence of Mexico through the language of three contemporary artists from Mexico City: {exhibition}, Laguna Beach Museum of Art, April 3rd to May 8th, 1979.* Mexico City, Mexico: Pedro Trevilla, 1979. 8 p.

2004. Lambron, Robert H. *Mexican painting and painters; a brief sketch of the development of the Spanish School of painting in Mexico.* New York, N.Y., 1891. 76 p.

2005. Landesio, Eugenio. *La pintura general o de paisaje y la perspectiva en el Academia Nacional de San Carlos.* Mexico City, Mexico: Imprenta de Lara, 1867.

2006. Marqués Rodiles, Ignacio. *El muralismo en la Ciudad de México.* Mexico City, Mexico: Departamento del Distrito Federal, Secretaría de Obras y Servicios, 1975. 103 p.

2007. Martínez, Ignacio. *Pintura mural, siglo XX.* Guadalajara, Mexico: Planeación y Promoción, 1960. 67 p.

Text in Spanish and English.

2008. Mérida, Carlos. *Frescoes in primary schools, by various artists: an interpretative guide.* Mexico City, Mexico: Frances Toor Studios, 1943. 28 p.

2009. Mérida, Carlos. *Modern Mexican artists.* Mexico City, Mexico: Frances Toor Studios, 1937. 191 p.

Includes a portrait of each painter.

2010. Mexico City (Mexico). Instituto Mexicano del Seguro Social. *Historia en los muros; cinco muralistas y la Seguridad Social Mexicana.* Mexico City, 1977. 90 p., plates.

Murals by González Camarena, Juan O'Gorman, Diego Rivera, Luis Nishizawa and David Alfaro Siqueiros.

2011. Mexico City (Mexico). Instituto Nacional de Bellas Artes. *La pintura mural de la revolución mexicana.* 2a ed. Mexico City: Fondo Editorial de la Plástica Mexicana, 1975. 316 p.

2012. Mexico City (Mexico). Museo de Arte Moderno. *Autorretrato y obra (a partir de la Revolución): Sala IV del Museo de Arte Moderno, del 24 de febrero al 24 de agosto 1966.* Mexico City, 1966. 8 p.

2013. Mexico City (Mexico). Museo de Arte Moderno. *El geometrismo mexicano: una tendencia actual: {exposición}, noviembre/diciembre 1976.* Mexico City, 1976? 24 p.

2014. Mexico City (Mexico). Museo de Arte Moderno. *La mujer como creadora y tema del arte: {exposición}, junio-agosto 1975.* Mexico City, 1975? 52 p.

2015. Mexico City (Mexico). Museo de Arte Moderno. *8 pintores jovenes oaxaqueños: {exposición}, octubre-noviembre de 1976.* Mexico City, 1976. {23} p.

2016. Mexico City (Mexico). Museo Nacional de Arte Moderno. *El retrato mexicano contemporáneo.* Mexico City, 1961. 116 p.

> Exhibition catalog; texts by Horacio Flores-Sánchez, Paul Westheim, and Justino Fernández.

2017. Mexico City (Mexico). Museo Nacional de Artes Plásticas. *45 autorretratos de pintores mexicanos, siglos XVII a XX... exposición del Museo Nacional de Artes Plásticas...* Mexico City: Instituto Nacional de Bellas Artes, 1947. 118 p.

2018. Mexico City (Mexico). Museo Nacional de Bellas Artes. *Pintura contemporánea de México: exposición, agosto de 1962.* Mexico City, 1962. unpaged.

2019. Mexico City (Mexico). Palacio de Bellas Artes. *7 pintores contemporáneos: Gilberto Aceves Navarro, Luis López Loza, Rodolfo Nieto, Brian Nissen, Tomás Parra, Vlady, Roger von Gunten: {exposición, junio/agosto 1977}.* Mexico City, 1977. 24 p.

2020. Mexico City (Mexico). Universidad Nacional Autónoma de México. Galería de Arte. *2a exposición: pintores mexicanos contemporáneos del 25 de febrero al 31 de marzo {1938}.* Mexico City, 1938. 46 p.

2021. Mexico City (Mexico). Universidad Nacional Autónoma de México. Galería Universitaria Aristos. *Surrealismo y arte fantástico en México: {exposición, 1967-68?}.* Mexico City, 1967? 20 p.

2022. Mexico City (Mexico). Universidad Nacional Autónoma de México. Instituto de Investigaciones Estéticas. *El geometrismo mexicano.* Mexico City, 1977. 180 p.

> Texts by Jorge Alberto Manrique, Ida Rodríguez Prampolini, Juan Acha, Xavier Moyssén, and Teresa del Conde.

2023. Minneapolis (Minnestoa). University of Minnesota. University Gallery. *Presenting three exhibitions...Oceanic art, six modern sculptors, contemporary Mexican painting.* Minneapolis, 1937. 22 p.

2024. Misrachi, Jack, Gallery (New York, N.Y.). *Arnold Belkin, Arnaldo Coen, José Luis Cuevas, Felipe Ehrenberg...{et al.}: inaugural exhibition, Sept. 22-Oct. 17, 197?* New York, 197? 24 p.

2025. *Moderne mexikanische Maler.* Leipzig, East Germany: E. A. Seeman, 1958. 53 p.

Includes works on 12 Mexican painters.

2026. Monclova (Mexico). Museo Biblioteca Pape. *El inicio del muralismo mexicano contemporáneo: exposición, 30 de septiembre 1978-21 de enero 1979.* Monclova, 1979. 34 p.

2027. Montenegro, Roberto. *Pintura mexicana (1800-1860).* Mexico City, Mexico: Taller Tipografía de la Secretaría de Relaciones Exteriores, 1933. 22 p., plates.

Text in Spanish and English; 2nd edition, 1934, 19 p.

2028. Montenegro, Roberto. *Retablos de México = Mexican votive paintings.* Mexico City, Mexico: Ediciones Mexicanas, 1950. 75 p.

2029. Mont-Orendáin, Galería (Puebla, Mexico). *Pintura mexicana contemporánea.* Puebla, 1948. 32 p.

2030. Myers, Bernard S. *Mexican painting in our time.* New York, N.Y.: Oxford University Press, 1956. 283 p.

Bibliography: p. 269-276.

2031. Neuvillate Ortiz, Alfonso de. *10 pintores mexicanos: Rufino Tamayo, David Alfaro Siqueiros, Carlos Mérida, Jesus Guerrero Galván, Carlos Orozco Romero, Ricardo Martínez, Guillermo Meza, Raymundo Martínez, Jaime Saldívar, Ernesto Icaza.* Mexico City, Mexico: Galería de Arte Misrachi, 1977. 60 p.

2032. Neuvillate Ortiz, Alfonso de. *Mexico, arte moderno: Francisco Zuñíga, Frida Kahlo, Juan O'Gorman, Juan Soriano, Pedro Coronel, Antonio Peláez, Gunther Gerzso, Angela Gurria, Francisco Corzas, Maria Izquierdo.* Mexico City, Mexico: Galería de Arte Misrachi, 1976. 60 p.

2033. Neuvillate Ortiz, Alfonso de. *Mexico, arte moderno II: Diego Rivera, José Luis Cuevas, Rafael Coronel, Francisco Toledo, Leonora Carrington, Pedro Friedeberg, Miguel Covarrubias, Leonardo Nierman, Tomás Parra, Ernesto Paulsen.* Mexico City, Mexico: Galería de Arte Misrachi, 1977. 62 p.

2034. Neuvillate Ortiz, Alfonso de. *8 pintores mexicanos, de Velasco a Best Maugard.* Mexico City, Mexico: Ministerio de Educación, 1967. 63 p.

2035. Neuvillate Ortiz, Alfonso de. *Pintura actual: México 66.* Mexico City, Mexico: Artes de México y del Mundo, c1966. 67 p.

 Text in Spanish and English.

2036. New York (N.Y.). Museum of Modern Art. *{Postcards of Mexican art.* New York, 1940}. {18} postcards.

2037. Olivares Iriarte, Bernardo. *Apuntes artísticos sobre la historia de la pintura en la ciudad de Puebla.* Mexico City, Mexico: Tipografía Escalerillas, 1874.

2038. Pan American Union (Washington, D.C.). *Mexican modern painters in Washington collections: a loan exhibition, September 4 to 30, 1947.* Washington, D.C., 1947? 8 p.

2039. Paz, Octavio. *La pintura mural de la revolución mexicana.* Mexico City, 1960.

2040. Pérez Salazar, Francisco. *Historia de la pintura en Puebla.* Mexico City, Mexico: Universidad Nacional Autónoma de México, 1963. 245 p.

2041. Philadelphia (Pennsylvania). Museum of Art. *Mexican art today.* Philadelphia, 1943. 104 p.

 Exhibition catalog organized by the Philadelphia Museum of Art with the collaboration of the Dirección General de Educación Extra-Escolar y Estética, Mexico; survey of contemporary Mexican painting.

2042. Phoenix (Arizona). Art Museum. *Fifteen of Mexico's artists: {exhibition}, November, 1973.* Phoenix, 1973. 40 p.

2043. *La pintura mural de la revolución mexicana, 1921-1960.* Mexico City, Mexico: Fondo Editorial de la Plástica Mexicana, Banco Nacional de Comercio Exterior, 1960. 292 p.

 Also published in English; 2nd edition, 1975, 316 p.

2044. Plenn, Virginia, and Plenn, Jaime. *A guide to modern Mexican murals.* Mexico City, Mexico: Ediciones Tolteca, 1963. 164 p.

2045. Puebla (Mexico). Galería del Centenario. *Pintura mexicana del siglo XX: celebración del Centenario de La Victoria del 5 de Mayo: {exposición}, 1962.* Puebla, 1962. 36 p.

2046. Reed, Alma. *The Mexican muralists.* New York, N.Y.: Crown, 1960. 191 p.

2047. Rodríguez, Antonio. *A history of Mexican mural painting.* New York, N.Y.: Putnam, 1969. 518 p.

Translated from Spanish.

2048. Rodríguez, Antonio. *Der Mensch in Flammen: Wandmalerei in Mexiko von den Anfängen bis zur Gegenwart.* Dresden, East Germany: VEB Verlag der Kunst, 1967. 257 p.

Translated from Spanish.

2049. Romero de Terreros, Manuel. *Catálogos de las exposiciones de la antigua Academia de San Carlos de México, 1850-1898.* Mexico City, Mexico: Universidad Nacional Autónoma de México, Instituto de Investigaciones Estéticas, 1963. 690 p.

2050. Romero de Terreros, Manuel. *Paisajistas mexicanos del siglo 19.* Mexico City, Mexico: Imprenta Universitaria, 1943. 28 p., plates.

2051. Ruben, Lotte. *Modern mexikanische Maler; 12 farbige Reproduktionen.* Leipzig, East Germany: Seeman, 1958. 53 p.

2052. Salón Anual de Artes Plásticas (1978 : Mexico City, Mexico). *Salón Nacional de Artes Plásticas: Sección Anual de Pintura, {1978}: {exposición}.* Mexico City: Palacio de Bellas Artes, 1978. 85 p.

2053. Salón de Octubre (1977 : Guadalajara, Mexico?). *Salón de Octubre 1977: {exposición}, Casa de la Cultura Jalisciense, septiembre 30-octubre 31, {1977}.* Guadalajara: Departamento de Bellas Artes, 1977. 48 p.

2054. Salón de Pintura (1st : 1940 : Mexico City, Mexico). *Salón, 1940-* Mexico City: Galería de Arte 'Decoración', 1940- .

2055. Schmeckebier, Laurence E. *Modern Mexican art.* Minneapolis, Minnesota: University of Minnesota Press, 1939. 190 p.

Another edition: Westport, Connecticut: Greenwood Press, 1971?

2056. *7 pintores mexicanos.* Mexico City, Mexico: Universidad Nacional Autónoma de México, 1952. 10 plates.

2057. Siqueiros, David Alfaro. *El arte de la pintura en la revolución mexicana.* Caracas, Venezuela: Librería Pensamiento Vivo, 1960?

2058. Siqueiros, David Alfaro. *Como se pinta un mural.* Mexico City, Mexico: Ediciones Mexicanas, 1951.

2059. Siqueiros, David Alfaro. *No hay mas ruta que la nuestra: importancia nacional e internacional de la pintura mexicana moderna: el primer brote de reforma profunda en las artes plásticas del mundo contemporáneo.* Mexico City, Mexico, 1945. 126 p.

2060. Siqueiros, David Alfaro. *Mi repuesta: la historia de una insidia: quienes son los traidores a la patria?* Mexico City, Mexico: Ediciones de 'Arte Público', 1960.

2061. Siqueiros, David Alfaro. *El muralismo de México.* Mexico City, Mexico: Ediciones Mexicanas, 1950. 34 p.

2062. Siqueiros, David Alfrao. *La pintura mural mexicana y su relación con la arquitectura.* Caracas, Venezuela: Librería 'Pensamiento Vivo', 1960?

2063. Siqueiros, David Alfaro. *Siqueiros through the road of a neo-realism, or modern social realistic painting in Mexico.* Mexico City, Mexico: Instituto Nacional de Bellas Artes, 1951.

2064. Somolinos Palencia, Juan. *El surrealismo en la pintura mexicana.* Mexico City, Mexico: Arte Ediciones, c1973. 109 p.

Bibliography: p. 99-109.

2065. *Three Mexican painters: Orozco, Rivera, Siqueiros.* Mexico City, Mexico: Fishgrund, 1947? {30} p.

2066. Tibol, Raquel. *Orozco, Rivera, Siqueiros, Tamayo.* Mexico City, Mexico: Fondo de Cultura Económica, 1974. 63 p.

2067. Tomassi López, Leopoldo. *El feísmo en la pintura contemporánea.* Mexico City, Mexico, 1936. 158 p.

2068. Toscano, Salvador. *Juan Cordero y la pintura mexicana en el siglo XIX.* Monterrery, Mexico: Universidad de Nuevo León, 1946.

2069. Toussaint, Manuel. *Pintura colonial en México.* Mexico City, Mexico: Universidad Nacional Autónoma de México, Instituto de Investigaciones Estéticas, 1965. 308 p.

Edited by Xavier Moyssén.

2070. Traba, Marta. *La zona del silencio: Ricardo Martínez, Gunther Gerzso, Luis García Guerrero.* Mexico City, Mexico: Fondo de Cultura Económica, c1975. 63 p.

2071. Velázquez Chávez, Agustín. *Indice de la pintura mexicana contemporánea = Index of contemporary Mexican painting.* Mexico City, Mexico: Ediciones Arte Mexicano, 1935. 225 p.

Bibliography: p. 221-222.

2072. Velázquez Chávez, Agustín. *La pintura mexicana.* Mexico City, Mexico: Ediciones Arte Mexicano, 1937. 27 p.

Catalog of an exhibition held at the Galería de Arte Mexicano, Mexico City, 1937?

2073. Villaurrutia, Xavier. *La pintura mexicana moderna.* Barcelona, Spain: González Porto, Salvat, 1936.

Mexican painting from 1920 to 1936.

2074. Washington (D.C.). Hirshhorn Museum and Sculpture Garden. *Orozco, Rivera, Siqueiros: a selection from Mexican national collections: {exhbition}, March 30-April 30, 1978.* Washington, D.C., 1978. 12 p.

2075. Zabludovsky, Jacobo. *Charlas con pintores: Dr. Atl, Siqueiros, Rivera, Tamayo, Cuevas, Dalí.* Mexico City, Mexico: B. Costa Amic, 1966. 135 p.

2076. Zhadova, L. *Monumental'naya zhivopis' Meksiki: {Monumental painting of Mexico}.* Moscow, U.S.S.R.: Iskusstvo, 1965. {234} p

Bibliography: p. 134-136; text in Russian.

MEXICO—PAINTING—COLLECTIONS

2077. Carrillo y Gariel, Abelardo. *Las galerías de pintura de la Academia de San Carlos.* Mexico City, Mexico: Universidad Nacional Autónoma de México, Instituto de Investigaciones Estéticas, 1944. 82 p.

2078. Cortés Alonso, Vicenta. *Pintura del governador, alcaldes y regidores de México.* Madrid, Spain: Ministerio de Educación y Ciencia, 1976. ca. 100 p.

2079. Mexico City (Mexico). Instituto Nacional de Bellas Artes. *Museo José Clemente Orozco.* Mexico City, 1958. 10 p.

Descriptive booklet.

2080. Mexico City (Mexico). Instituto Nacional de Bellas Artes. *Museo-Taller José Clemente Orozco en Guadalajara, Jalisco: la casa del artista convertida en museo en homenaje a la obra del gran pintor desaparecido.* Mexico City, 197? 22 p.

Descriptive booklet.

2081. Mexico City (Mexico). Museo de Arte Alvar y Carmen T. de Carrillo Gil. *Museo de Arte Alvar y Carmen T. de Carrillo Gil: Orozco, Rivera, Siqueiros, Paalen, Gerzso: {exposición, 30 agosto 1974...}.* Mexico City, 1974. 32 p.

2082. Mexico City (Mexico). Museo Frida Kahlo. *The Frida Kahlo Museum.* Mexico City: Comité Organizador de los Juegos de la XIX Olimpiada, 1970, c1968. 47 p.

Description of the Museum and its collection.

2083. Mexico City (Mexico). Museo Pinacoteca Virreinal de San Diego. *Museum of Colonial Painting.* Mexico City: Comité Organizador de los Juegos de la XIX Olimpiada, c1970, c1968. 55 p.

Description of the Museum and its collection.

2084. Paní, A.J. *La segunda colección 'Paní' de pinturas: catálogo descriptivo y comentado.* Mexico City, Mexico: Editorial 'Cultura', 1940. 106 p.

2085. Pérez de Salazar, Javier. *La pintura mexicana en colecciones particulares.* Mexico City, Mexico, 1966.

2086. Rivera, Agustín. *Pinturas que tiene Agustín Rivera colocadas en las paredes de su gabinete de estudio i de su alcoba: catálogo escrito i publicado por el mismo.* Lagos de Moreno, Mexico: Imprenta de A. López Arca, 1898.

2087. Báez Macías, Eduardo. *Guía del Archivo de la antigua Academia de San Carlos (1844-1867).* Mexico City, Mexico: Universidad Nacional Autónoma de México, Instituto de Investigaciones Estéticas, 1976. 438 p.

2088. Carrillo y Gariel, Abelardo. *Autógrafos de pintores coloniales.* Mexico City, Mexico: Universidad Nacional Autónoma de México, Instituto de Investigaciones Estéticas, 1953. 168 p.

 Second edition, 1972.

2089. *Diccionario biográfico enciclopedico de la pintura mexicana = Biographic encyclopedic dictionary of Mexican painting: siglo XX, arte contemporáneo.* Mexico City, Mexico: Quinientos Años, 1979- .

2090. Edwards, Emily. *Modern Mexican frescoes; a guide to all Mexican frescoes with a special map to frescoes in the center of Mexico City.* Mexico City, Mexico: Central News Co., 1934. 41 p.

 Frescoes painted by Mexican artists in the U.S.: p. 33-{38}.

2091. Farías, Ixca. *Biografía de pintores jaliscienses, 1882-1940.* Guadalajara, Mexico: Ricardo Delgado, 1940.

 Includes 70 entries.

2092. Jiménez, Guillermo. *Fichas para la historia de la pintura en México.* Mexico City, Mexico: Ediciones de la Universidad Nacional, 1937. 52 p.

 Bio-bibliographies of Mexican painters born between 1866 and 1912.

2093. Suárez, Orlando S. *Inventario del muralismo mexicano: siglo VII a. de c.-{1968}.* Mexico City, Mexico: Universidad Nacional Autónoma de México, c1972. 412 p.

 Bibliography: p. 399-409.

2094. Toor, Frances, Studios (Mexico City, Mexico). *Mexican art series.* Mexico City, 1937. 8 parts.

 A series of guides to all the Mexican frescoes.

MEXICO—PHOTOGRAPHY

2095. Casasola, Agustín V. *Historia gráfica de la revolución, 1900-1940.* Mexico City, Mexico: Casasola, n.d. v. 16-20 {483} p.

2096. Fernández Ledesma, Enrique. *La gracia de los retartos antiguos.* Mexico City, Mexico: Ediciones Mexicanas, 1950. 156 p.

Portraits from the daguerreotype and collodion eras.

2097. Havana (Cuba). Casa de las Américas. Galería Latinoamericana. *Muestra fotográfica mexicana contemporánea: {exhibición desde diciembre 19 de 1979}.* Havana, 1979. 8 p.

2098. Mexico City (Mexico). Museo Nacional de Historia e Antropología. *Imagen histórica de la fotografía en México.* Mexico City, 1978.

Exhibition catalog.

2099. Mexico City (Mexico). Universidad Nacional Autónoma de México. *7 portafolios mexicanos.* Mexico City, c1980. 126 p.

Catalog of a travelling exhibition held first at the gallery Centro Cultural de México, Paris, France, Spring 1980; text in Spanish, French and English.

2100. New York (N.Y.). Museo del Barrio. *Four young Mexican photographers.* New York, 1978? 6 p.

Catalog of an exhibition held at the Corcoran Gallery of Art, Washington, D.C., Sept. 30-Nov. 26, 1978, and El Museo del Barrio, New York City, N.Y., Dec. 8, 1978-Feb. 25, 1979.

2101. New York (N.Y.). Museo del Barrio. *Photographs of Mexico: Modotti/Strand/Weston.* New York, 1978? 6 p.

Catalog of an exhibition held at the Corcoran Gallery of Art, Washington, D.C., Sept. 30-Nov. 26, 1978, and El Museo del Barrio, New York City, N.Y., Dec. 8, 1978-Feb. 25, 1979.

MEXICO—PHOTOGRAPHY—COLLECTIONS

2102. Aultman, Otis A. *Photographs from the border: the Otis A. Aultman Collection.* {El Paso, Texas}: El Paso Public Library Association, 1977. {49} leaves.

2103. *Foto; boletín mexicano de fotografía.* no. 1 (noviembre 1935)-
Mexico City, Mexico, 1935- .

MEXICO—SCULPTURE

2104. Bienal Nacional de Escultura (1st : 1962 : Mexico City, Mexico).
Bienal Nacional de Escultura, 1962- . Mexico City, Mexico,
1962- .

2105. Bienal Nacional de Escultura (1st : 1962 : Mexico City, Mexico).
*Primera Bienal Nacional de Escultura: escultura libre y escultura
integrada a la arquitectura: {exposición}, abril-julio de 1962.* Mexico
City, Mexico, 1962. 36 p.

2106. Luna Arroyo, Antonio. *Panorama de la escultura mexicana contempor-
ánea: estudio precedido de un ensayo histórico-estético sobre la
escultura pre-hispánica, colonial y del México independiente.* Mexico
City, Mexico: Ediciones del Instituto Nacional de Bellas Artes, {1964}.
178 p.

Bibliography: p. 169-175.

2107. Mexico City (Mexico). Universidad Nacional Autónoma de México.
Centro del Espacio Escultórico. Mexico City, 1978. 36 p.

Text in Spanish and English.

2108. Mexico City (Mexico). Universidad Nacional Autónoma de México.
Museo Universitario de Ciencias y Arte. *El Espacio Escultórico:
{exposición}, diciembre de 1980.* Mexico City, 1980. 119 p.

Text in Spanish, French and English.

2109. Monteforte Toledo, Mario. *Las piedras vivas: escultura y sociedad en
México.* Mexico City, Mexico: Universidad Nacional Autónoma de
México, Instituto de Investigaciones Sociales, 1965. 230 p.

2110. Nelken, Margarita. *Escultura mexicana contemporánea.* Mexico City,
Mexico: Ediciones Mexicanas, 1951. 39 p.

2111. Weismann, Elizabeth Wilder. *Escultura mexicana, 1521-1821.* Cam-
bridge, Massachusetts: Harvard University y Editorial Atlante, 1950.
224 p.

2112. Mexico City (Mexico). Palacio de Bellas Artes. *Exposición nueva acuarela, {mayo/junio 1978}*. Mexico City, 1978. 24 p.

2113. Salón de la Acuarela (Mexico City, Mexico). *Salón de la Acuarela: {exposición}, Galería del Instituto de Arte de México, {1959?}*. Mexico City, 1959? 36 p.

Netherlands Antilles

NETHERLANDS ANTILLES—PAINTING

2114. Amsterdam (Netherlands). Stedelijk Museum. *Curaçao: schilderend en geschilderd; {tentoonstelling}, 1953.* Amsterdam, 1953. 28 p.

2115. Carifesta (1972 : Georgetown, Guyana). *Carifesta '72: painters of the Netherlands Antilles: Caribbean Festival of the Arts, {exhibition}, August 25-Sept. 15, 1972.* Curaçao, Netherlands Antilles: Department of Culture and Education, 1972. 8 p.

Nicaragua

2116. Arellano, Jorge Eduardo. *Pintura y escultura en Nicaragua.* Managua, Nicaragua: Banco Central, 1977. 214 p.

Boletín Nicaragüense de Bibliografía y Documentación, nov.-dic., 1977, no. 20.

Panama

2117. Exposición Nacional de Artes Plásticas (1948 : Panama City, Panama). *Exposición Nacional de Artes Plásticas, 1948- .* Panama City: Ministerio de Educación, Departamento de Cultura y Publicaciones, 1948- .

2118. UNESCO. *Cultural policy in the Republic of Panama.* Paris, France? UNESCO, 1978. 73 p.

PANAMA—GENERAL—COLLECTIONS

2119. Panama City (Panama). Museo de Arte Contemporáneo de Panarte. *!Al fin museo! Museo de Arte Contemporáneo, Panarte, 1981.* Panama City, {1981}. {20} p.

 Catalog of the collection.

PANAMA—GENERAL—DICTIONARIES, ETC.

2120. Horna, Jorge F. *Museo de Panamá.* Panama City, Panama: Instituto Nacional de Cultura de Panamá, Dirección Nacional de Patrimonio Histórico, 1980. 125 p.

2121. *Cilindrica: arte, grabado y arquitectura.* 197-?- . Panama City, Panama, 197?-

PANAMA—ARCHITECTURE

2122. Gutiérrez, Samuel A. *Arquitectura panameña; descripción e historia.* Panama City, Panama: Editorial Litográfia, 1966. 379 p.

PANAMA—PAINTING

2123. Signs Gallery (New York, N.Y.). *Contemporary art of Panama = Arte contemporáneo de Panamá; {exhibition}, Signs Gallery, New York, December '81-January '82.* New York, 1981. {28} p.

> Also exhibited at the Forma Gallery (Miami, Florida), February-March '82, and the Museum of Contemporary Art, Panama, May-June '82.

Paraguay

2124. Báez, Jorge. *Arte y artistas paraguayos; período renacentista.* Ascunción, Paraguay: Editorial El Liberal, 1941.

2125. Fernández, Miguel Angel. *Paraguay.* Washington, D.C.: Organization of American States, 1969. 18 p.

2126. Plá, Josefina. *Arte moderno del Paraguay; muestra retrospectiva.* Asunción, Paraguay: Misión Culturfal Brasileña con la colaboración del SEPRO, 1964. 20 p.

2127. Plá, Josefina. *Las artes plásticas en el Paraguay; breve esquema histórico.* Buenos Aires, Argentina: Universidad Nacional de Buenos Aires, Facultad de Arquitectura y Urbanismo, 1966. 22 p.

Offprint of Anales del Instituto de Arte Americano e Investigaciones Estéticas, Universidad Nacional de Buenos Aires, no. 19, 1966.

2128. Plá, Josefina, and Fernández, Miguel Angel. *Aspectos de la cultura Paraguay; literatura paraguaya en el siglo XX; la plástica paraguaya moderna.* Asunción, Paraguay? Cuadernos Americanos, 1962.

Offprint of Cuadernos Americanos, enero-febrero, 1962.

2129. Unión de Intelectuales y Artistas (Asunción, Paraguay). *Estatutos y declaración de principios de la Unión de Intelectuales y Artistas.* Asunción, 1936. 8 p.

2130. Plá, Josefina. *Historia y catálogo del Museo de Bellas Artes.* 2a ed., corregida y ampliada. Asunción, Paraguay: Casa América, 1975. 157 p.

2131. Solís, Servillano. *Rasgos biográficos de artistas paraguayos; la pintura, la caricatura, el folklore del Paraguay y otros ensayos.* Buenos Aires, Argentina: Lucania, 1975. 61 p.

PARAGUAY—ARCHITECTURE

2132. Giuria, Juan. *La arquitectura en el Paraguay.* Buenos Aires, Argentina: Instituto de Arte Americano e Investigaciones Estéticas, 1950. 137 p.

2133. Gutiérrez Z., Ramón. *Evolución urbanística y arquitectónica del Paraguay, 1537-1911.* Corrientes, Argentina: Departamento de Historia de la Arquitectura, Universidad Nacional del Nordeste, 1974? 412 p.

PARAGUAY—GRAPHIC ARTS

2134. Plá, Josefina. *El grabado en el Paraguay.* Asunción, Paraguay: Alcor, 1962. 39 p.

Peru

PERU—GENERAL

2135. Acha, Juan. *Peru.* Washington, D.C.: Pan American Union, 1961. 19 p.

2136. Angrand, Léonce. *Imagen del Perú en el siglo XIX.* Lima, Perú: Milla Batres, 1972. 285 p.

2137. Banco Continental (Lima, Peru). Galería. *Arte nouveau en Lima.* Lima, Perú, 1973. unpaged.

2138. Comisión Organizadora de la Exposición Peruana en París (Lima, Peru). *Exposición peruana en París; los tesoros del Perú; memoria que presenta...* Lima, 1958. 154 p.

 Report on the exhibition of Peruvian art in the Petit Palais, Paris, France, May 20-July 20, 1958.

2139. González Salazar, Manuel. *El Peru y el arte.* Lima, Perú: Ediciones San Julian, 197? 191 p.

2140. Lima (Peru). Museo de Arte. *Grupo Arte Nuevo; {exposición}, octubre y noviembre de 1966.* Lima, 1966. 16 p.

2141. Lima (Peru). Universidad Nacional Mayor de San Marcos. *Nuevas tendencias en la plástica peruana; muestra...del 3 al 20 de mayo de 1968.* Lima, 1968. 30 p.

2142. Meléndez, Concha. *Entrada en el Perú.* Havana, Cuba: Editorial Verónica, 1941. 179 p.

2143. Mexico City (Mexico). Museo Nacional de Artes Plásticas. *Exposición arte del Perú; prehispánico, colonial, siglo XIX, contemporáneo, popular.* Mexico City: Instituto Nacional de Bellas Artes, 1955. unpaged.

2144. Sabogal, José. *Del arte en el Perú y otros ensayos.* Lima, Perú: Instituto Nacional de Cultura, 1975. 159 p.

2145. UNESCO. *Cultural policy in Peru.* Paris, France? UNESCO, 1977. 70 p.

2146. Velarde, Héctor. *Arte y arquitectura.* 1a ed. Lima, Perú: F. Moncloa, 1966. 270 p.

2147. Ugarte Elespuru, Juan Manuel. *Pintura y escultura en el Perú contemporáneo.* Lima, Peru: Editorial Universitaria, 1970. 248 p.

Bibliography.

2148. Washington (D.C.). Corcoran Gallery of Art. *Contemporary Peruvian paintings and sculpture.* Washington, D.C., 1966. 40 p.

Catalog of an exhibition, October 28-Dec. 18, 1966, organized by the Corcoran Gallery of Art and the Escuela Nacional Superior de Bellas Artes del Perú... In 1967 the show was exhibited at the Museum of Philadelphia, Civic Center, Philadelphia, Pennsylvania, and the Des Moines Art Center, Des Moines, Iowa.

2149. Wethey, Harold E. *Colonial architecture and sculpture in Peru.* Cambridge, Massachusetts: Harvard University Press, 1949. 330 p.

PERU—GENERAL—COLLECTIONS

2150. Tello, Julio C., and Mejía Xesspe, Toribio. *Historia de los museos nacionales del Perú, 1822-1946.* Lima, Perú: Museo Nacional de Antropología y la Universidad Nacional de San Marcos, Instituto y Museo de Arqueología, 1967. 268 p.

PERU—GENERAL—PERIODICALS

2151. *Amauta; revista mensual de doctrina, literatura, arte, polémica.* v. 1-4, no. 1-32 (sept. 1926-agosto/sept. 1930). Lima, Perú, 1926-30.

Facsimile edition, Lima, Perú: Empresa Editora Amauta, 1976, 6 v.

PERU—GENERAL—PERIODICALS

2152. *Espacio.* no. 1-7 (mayo 1949-mayo 1951). Lima, Perú: Editora Peruana, 1949-1951.

2153. *Plástica.* no. 1 (enero 1951)- . Lima, Perú, 1951- .
Monthly.

PERU—ARCHITECTURE

2154. Bromley, Juan, and Barbagelata, José. *Evolución urbana en la ciudad de Lima.* Lima, Peru: Consejo Provincial de Lima, 1945. 130 p.

2155. Cassinelli, Catalina. *Lima, the historic capital of South America.* Lima, Peru, 1942. 84 p.

2156. Harth-Terré, Emilio, {et al.}. *La arquitectura peruana a través de los siglos; circulación internacional.* Lima, Peru: Publicaciones Emi, 1964. 176 p.

Text in Spanish and English.

2157. Velarde, Héctor. *Arquitectura peruana.* Mexico City, Mexico: Fondo de Cultura Económica, 1946. 182 p.

PERU—GRAPHIC ARTS

2158. Instituto Cultural Peruano Norteamericano (Lima, Peru). *Grabadores peruanos contemporáneos; {exposición}, 28 setiembre-8 octubre 1965.* Lima, 1965. 44 p.

PERU—PAINTING

2159. Acha, Juan. *Pintura peruana, 1938-1967: {exposición}, junio 1967.* Lima, Peru: Instituto Cultural Peruano Norteamericano, 1967? 18 p.

2160. Bienal de São Paulo (São Paulo, Brazil). *El Perú en la VI Bienal de São Paulo.* Lima, Peru: Escuela Nacional de Bellas Artes, 1963? unpaged.

Text by Juan Manuel Ugarte-Eléspuru.

2161. Fernández Prada, Luis. *5 años de la pintura en el Perú.* Lima, Peru: Imprenta Gráfica Stylo, 1942.

2162. Fernández Prada, Luis. *La pintura en el Perú (5 años de ambiente artístico).* Lima, Peru: Sociedad de Bellas Artes del Perú, 1942. 45 p.

2163. Jachamowitz, Alberto. *Pintores y pintores.* Lima, Peru: Torres Aguirre, 1949. 166 p.

2164. Lauer, Mirko. *Introducción a la pintura peruana del siglo XX.* Lima, Peru: Mosca Azul Editores, 1976. 214 p.

Bibliography.

2165. Lavalle, José Antonio, and Lang, Werner. *Arte y tesoros del Perú: pintura contemporánea, 1820-1960.* Lima, Peru: Banco de Crédito del Perú en la Cultura, 1975. 2 v. (196, 193 p.).

2166. Lavalle, José Antonio, and Lang, Werner. *Arte y tesoros del Perú; pintura virreynal.* Lima, Peru: Banco de Crédito del Perú, 1973. 199 p.

2167. Lima (Peru). Universidad Nacional Mayor de San Marcos. Museo de Arte y de Historia. *Exposición pintores y catedráticos; noviembre de 1975.* Lima, 1975. 85 p.

Text by Francisco Stastny.

2168. Mesa, José de, and Gisbert, Teresa. *Historia de la pintura cuzqueña.* Buenos Aires, Argentina: Instituto de Arte Americano e Investigaciones Estéticas, 1962.

2169. Rios, Juan E. *La pintura contemporeánea en el Perú.* Lima, Peru: Editorial Cultura Antártica, 1946. 80 p.

2170. San Francisco (California). Museum of Art. *An introduction to contemporary Peruvian painting: {exhibition, 1942}.* San Francisco, 1942? 27 p.

Text by Grace Louise Morley.

2171. Stastny, Francisco. *Breve historia del arte en el Perú; la pintura precolombina, colonial y republicana.* Lima, Peru, 1967. 57 p.

PERU—PAINTING

2172. Viña del Mar (Chile). *Exposición de la pintura peruana presentada por el Consejo Provincial de Lima, Viña del Mar, Chile.* Lima, Peru: Empresa Gráfica Scheuch, 1946? 96 p.

2173. Villacorta Paredes, Juan. *Pintores peruanos de la República.* Lima, Peru: Editorial Universo, n.d. 126 p.

PERU—PAINTING—COLLECTIONS

2174. Lima (Peru). Museo de Arte. *Colección Paul Grinsten de pintura peruana contemporánea; {exposición}, julio de 1968.* Lima, 1968. 20 p.

PERU—PHOTOGRAPHY

2175. McElroy, D. *The history of photography in Peru in the nineteenth century, 1839-1876.* Albuquerque, New Mexico: University of New Mexico, 1977.

Dissertation, 1977.

PERU—SCULPTURE

2176. Alliance Française (Lima, Peru). *Esculturas del Perú.* Lima, 1972? unpaged.

2177. Barra, Felipe de la. *Monumentos escultóricos en Lima metropolitana y Callao y los grandes ausentes.* Lima, Peru, 1963. 30 p.

2178. Cubillas Soriano, Margarita. *Lima monumental.* Lima, Peru: Imprenta Editorial Lumen, 1974. 210 p.

Puerto Rico

PUERTO RICO—GENERAL

2179. Delgado Mercado, Osiris. *Sinopsis histórica de las artes plásticas en Puerto Rico.* San Juan, Puerto Rico: Instituto de Cultura Puertorriqueña, 1972. 28 p.

2180. García Cisneros, Florencio. *Santos of Puerto Rico and the Americas = Santos de Puerto Rico y las Américas.* Detroit, Michigan: Blaine Ethridge, 1978? 122 p.

2181. Housing Investment Corporation (San Juan, Puerto Rico). *Puerto Rico, la nueva vida; a collection of works by Puerto Rican artists.* San Juan, 196? 12 p.

Text in Spanish and English.

2182. New York (N.Y.). Museo del Barrio. *Almanaque 1980 con datos históricos.* New York, 1980.

2183. New York (N.Y.). Museo del Barrio. *The art heritage of Puerto Rico, pre-Colombian to the present = La herencia artística de Puerto Rico, época pre-colombina al presente.* New York, 1974. 120 p.

Bibliography: p. 118-120; exhibition catalog, shown at the Museo del Barrio, New York, N.Y., April 30-July 1, 1973, and at The Metropolitan Museum of Art, New York, N.Y., July 25-September 16, 1973.

2184. New York (N.Y.). Museo del Barrio. *Comadres, a collective environmental exhibit by ten women artists at El Museo del Barrio, May 16, 1980...June 30, 1980.* New York, 1980. portfolio (25 p.).

2185. New York (N.Y.). Museo del Barrio. *Santos de palo; {exhibition, April 1979?}.* New York, 1979. 48 p.

PUERTO RICO—GENERAL

2186. New York (N.Y.). Riverside Museum. *The Riverside Museum presents the first comprehensive exhibition of contemporary Puerto Rican artists, January 6 to 27th, 1957.* New York, 1957. 16 p.

2187. Puerto Rican Art {Gallery} (New York, N.Y.). *Puertorican art; group show, March 1969.* New York, 1969. 10 p.

 Biographies of 18 Puerto Rican artists.

2188. Traba, Marta. *Propuesta polémica sobre el arte puertorriqueño.* Rio Piedras, Puerto Rico: Ediciones Librería Internacional, 1971.

PUERTO RICO—GENERAL—COLLECTIONS

2189. Alegría, Ricardo E. *El Instituto de Cultura Puertorriqueña; los primeros cinco años, 1955-1960.* San Juan, Puerto Rico: Instituto de Cultura Puertorriqueña, 1960. 99 p.

2190. Alegría, Ricardo E. *El Instituto de Cultura Puertorriqueña, 1955-1973; 18 años contribuyendo a fortalecer nuestra conciencia nacional.* San Juan, Puerto Rico: Instituto de Cultura Puertorriqueña, 1978. 266 p.

2191. New York (N.Y.). Museo del Barrio. *Recent acquisitions, Museo del Barrio: {exhibition}, October-November, 1978.* New York, 1978. 29 p.

2192. Rio Piedras (Puerto Rico). University of Puerto Rico. *Art in review; reprints of material dealing with art exhibitions directed by Walt Dehner and acquisitions in the University of Puerto Rico, 1929-1938.* Rio Piedras, {1937}. 196 p.

 Text in Spanish and English; published as the University of Puerto Rico Bulletin, series VIII, no. 2, December 1937.

PUERTO RICO—GENERAL—DICTIONARIES, ETC.

2193. *Encyclopedia de Puerto Rico.* San Juan, Puerto Rico, 1976. 8 v.

 Volume 8: Artes plásticas, text by Osiris Delgado Mercado.

2194. *Boletín de Arte.* 1966- . San Juan, Puerto Rico: UNESCO of Puerto Rico, 1966- .

2195. *Imagen.* no. 1 (Sept. 1979)- . San Juan, Puerto Rico, 1979- .

2196. *Plástica.* 1979?- . San Juan, Puerto Rico, 1979- .

2197. *Revista de arte.* no. 1 (June 1969)- . Mayagüez, Puerto Rico: University of Puerto Rico, 1969- .

 Puerto Rican contemporary art.

2198. *Revista del Museo de Antropología, Historia y Arte de la University of Puerto Rico.* no. 1 (July-Dec. 1979)- . Rio Piedras, Puerto Rico, 1979- .

PUERTO RICO—ARCHITECTURE

2199. Fernández, José Antonio. *Architecture in Puerto Rico.* New York, N.Y.: Architectural Book Publishing Co., 1965. 267 p.

PUERTO RICO—GRAPHIC ARTS

2200. Colibri, Galería (San Juan, Puerto Rico). *Exposición colectiva de grabados puertorriqueños, pequeña retrospectiva, 6 al 30 septiembre 1963.* San Juan, 1963. 16 p.

2201. New York (N.Y.). Museo del Barrio. *La historia del cartel puertorriqueño = The history of the Puerto Rican poster; {exposición, de agosto a noviembre 1973}.* New York, 1973. 20 p.

PUERTO RICAN—GRAPHIC ARTS—COLLECTIONS

2202. Havana (Cuba). Casa de las Américas. Galería Latinoamericana. *Gráfica de Puerto Rico; colección de grabados y carteles del Instituto de Cultura Puertorriqueña, {exposición} desde septiembre de 1975.* Havana, 1975.

2203. New York (N.Y.). Museo del Barrio. *Bridge between islands; retrospective works by six Puerto Rican artists in New York.* New York, 1978? 32 p.

> Catalog of an exhibition held at the Henry Street Settlement, Louis Abrons Arts for Living Center, New York, N.Y., Nov. 3-Dec. 1, 1978; The Bronx Museum of the Arts, New York, N.Y., Jan. 6-Feb. 18, 1979; Museo del Barrio, New York, N.Y., Feb. 27-April 1, 1979.

2204. *Pintores contemporáneos puertorriqueños.* San Juan, Puerto Rico: Ediciones de Puerto Rico, 1969.

2205. San Juan (Puerto Rico). Instituto de Cultura Puertorriqueña. *Cuatro pintores puertorriqueños: Campeche, Atiles, Oller, Pou.* San Juan, 1967. portfolio.

2206. San Juan (Puerto Rico). Instituto de Cultura Puertorriqueña. *FRENTE, movimiento de renovación social del arte; exposición de pinturas; Paul Camacho, Lope Max Díaz, Luis Hernández Cruz, Antonio Navio, 13 de febrero a 10 de marzo de 1978.* San Juan, 1978. 16 p.

2207. San Juan (Puerto Rico). Instituto de Cultura Puertorriqueña. Museo Rodante. *Dos siglos de pintura puertorriqueña* San Juan, 197? 14 p.

> Exhibition catalog.

PUERTO RICO—PAINTING—COLLECTIONS

2208. Ponce (Puerto Rico). Museo de Arte de Ponce. *Catalogue I, Paintings of the European and American schools.* Ponce, 1965. 333 p.

> Text by Julius Held.

PUERTO RICO—PAINTING—PERIODICALS

2209. *Revista de arte insular; la pintura en Puerto Rico.* v. 1, no. 1 (June 1941)- . San Juan, Puerto Rico, 1941- .

2210. Ponce (Puerto Rico). Museo de Arte de Ponce. *Expresiones en barro; exposición de esculturas del Grupo Manos.* Hato Rey, Puerto Rico: Chase Manhattan Bank, 1981. 37 p.

Exhibition held at the Museo de Arte de Ponce, Puerto Rico, March 27-May 18, 1981, and at the Chase Manhattan Bank, Puerto Rico, June 1-July 31, 1981.

Suriname

2211. *Hedendaagse kunst uit Suriname: {tentoonstelling}, 1 Juni, 1967.* n.p., 1967? 28 p.

Uruguay

2212. Alianza Cultural Uruguay EE.UU. (Montevideo, Uruguay). *25 artistas de hoy; {exposición}, setiembre 1974.* Montevideo, 1974. 44 p.

2213. Amigos del Arte (Montevideo, Uruguay). *El gaucho y su medio; exposición, 21 de mayo-10 de junio 1962.* Montevideo: Subte Municipal, 1962. unpaged.

2214. Argul, José Pedro. *Las artes plásticas del Uruguay: desde la época indígena al momento contemporáneo.* {lst ed.?} Montevideo, Uruguay: Barreiro y Ramos, 1958.

 Second edition: 1966, 283 p.; 3rd edition entitled *Proceso de las artes plásticas del Uruguay: desde la época indígena al momento contemporáneo,* 1975, 364 p.

2215. Argul, José Pedro. *Educación para la belleza y el arte: del ejercicio de la crítica de arte.* Montevideo, Uruguay: Impresiones Uruguaya, 1956.

2216. Argul, José Pedro. *Pintura y escultura del Uruguay: historia crítica.* Montevideo, Uruguay: Revista del Instituto Histórico y Geográfico del Uruguay, 1958. 244 p.

 Bibliography.

2217. *Artistas contemporáneos de América.* no. 1 (1967)- . Montevideo, Uruguay: Editorial Alfa, 1967?- . pamphlets.

 Information on Uruguayan artists only, despite the title.

2218. Asociación de Arte Constructivo (Montevideo, Uruguay). *Nueva escuela de arte del Uruguay = The new art school of Uruguay = Nouvelle école d'art de l'Uruguay.* Montevideo, 1946. 68 p.

 Introduction by Joaquín Torres-García.

2219. Asociación de Arte Constructivo (Montevideo, Uruguay). *Nueva escuela de arte del Uruguay: pintura y arte constructivo, contribución al arte de las tres Américas*. Montevideo, 1946. 15 p.

2220. Fernández Saldana, José M. *Pintores y escultores uruguayos*. Montevideo, Uruguay: S. Brignole, 1916.

2221. Figari, Pedro. *Arte, estética, ideal*. Montevideo, Uruguay: Ministerio de Instrucción y Previsión Social, 1960. 3 v. (204, 250, 221 p.).

2222. Figari, Pedro. *Arte, estética, ideal; ensayo filosófico encarado de un nuevo punto de vista*. Montevideo, Uruguay: Juan J. Dornaleche, 1921. 593 p.

2223. Foglia, Carlos A. *Arte y mistificación*. 2a ed. Buenos Aires, Argentina: Bartolomé U. Chiesino, 1958. 123 p.

2224. García Esteban, Fernando. *Artes plásticas del Uruguay en el siglo veinte*. Montevideo, Uruguay: Universidad de la República, 1968. 150 p.

2225. Haedo, Oscar F. *XVIII plásticos uruguayos, 1920-1945*. Buenos Aires, Argentina: Talleres Gráficos Porter, 1947.

2226. Laroche, Ernesto. *Algunos pintores y escultores*. {Montevideo, Uruguay}: Ministerio de Instrucción Pública y Previsión Social, 1939. 214 p.

 Contains information on approximately twenty 19th century Uruguayan artists.

2227. Laroche, Walter E. *Elementos contributivos a la historia del arte en el Uruguay*. Montevideo, Uruguay: Museo y Archivo Ernesto Laroche, 1952. 88 p.

 Comentarios, anotaciones, notas, referencias bibliográficas, de Walter E. Laroche sobre textos originales de Ernesto Laroche.

2228. Laroche, Walter E. *Los precursores y otras fuentes documentales para nuestra iconografía pictórica*. Montevideo, Uruguay: A. Monteverde, 1961. 212 p.

2229. Laroche, Walter E. *Presencia del arte plástico en el Uruguay*. Montevideo, Uruguay, 1975. 101 p.

 Apartado del prólogo de la obra, 'Plásticos Uruguayos', compilados hasta el año 1970 por la Biblioteca del Poder Legislativo.

2230. Montevideo (Uruguay). Consejo Departamental de Montevideo. *Iconografía de Montevideo.* Montevideo, 1955. 250 p.

2231. New School for Social Research (New York, N.Y.). *The New School presents Taller Torres-García; {exhibition, December 12, 1960-January 8, 1961}.* New York, 1960. 44 p.

2232. Punta del Este (Uruguay). *De Blanés a nuestros días; catálogo, agosto, 1961.* Montevideo, Uruguay: Ministerio de Instrucción Pública y Previsión Social, Comisión Nacional de Bellas Artes, 1961. 135 p.

2233. Punta del Este (Uruguay). *26 artistas uruguayos contemporáneos; {exposición}, enero-febrero 1962.* Montevideo, Uruguay: Comisión Nacional de Bellas Artes, 1962. 20 p.

2234. Romero Brest, Jorge. *El primer Salón Municipal de Artes Plásticas en Montevideo.* Montevideo, Uruguay: Comisión Municipal de Cultura, 1940? 30 p.

 Lecture on the works in the exhibition.

2235. Salón Anual de la Asociación de Artistas Plásticos del Uruguay (1st : 1942 : Montevideo, Uruguay). *Salón Anual de la Asociación de Artistas Plásticos del Uruguay, 1942- .* Montevideo: Asociación de Artistas Plásticos del Uruguay, 1942- .

2236. Salón Anual del Sindicato Libre de Pintores, Escultores y Grabadores del Uruguay (1st : 1955 : Montevideo, Uruguay). *Salón Anual del Sindicato Libre de Pintores, Escultores y Grabadores del Uruguay, 1955- .* Montevideo, 1955- .

2237. Salón Bienal de Artes Plásticas (1st : 1953 : Montevideo, Uruguay). *Salón Bienal de Artes Plásticas, 1953- .* Montevideo: Comisión Nacional de Bellas Artes, 1953- .

2238. Salón Municipal de Artes Plásticas (1st : 1940? : Montevideo, Uruguay). *Salón Municipal de Artes Plásticas, 1940?- .* Montevideo: Imprenta Enrique Miguez, 1940?- .

2239. Salón Nacional de Pintura y Escultura (1st : 1936? : Montevideo, Uruguay). *Salón Nacional de Pintura y Escultura, 1936?-* Montevideo: Comisión Nacional de Bellas Artes, 1936-

2240. Salón Nacional: Exposición Anual de Bellas Artes (1st : 1937 : Montevideo, Uruguay). *Salón Nacional: Exposición Anual de Bellas Artes, 1937- .* Montevideo: Comisión Nacional de Bellas Artes, 1937- .

2241. *6 artistas uruguayos.* {Madrid, Spain}: Publicaciones Españoles, {1977}. {18} p.

 Catalog of an exhibition held at the Ateneo de Madrid, Spain, Sala de Santa Catalina, November 1977.

2242. Uruguay. Comisión Nacional de Bellas Artes. *12 artistas uruguayos contemporáneos: {exposición, Montevideo, junio 1961}.* Montevideo, 1961. unpaged.

2243. Vitureira, Cipriano Santiago. *Arte simple.* Montevideo, Uruguay: Nueva América, 1937? 197 p.

 A section is devoted to the following Uruguayan artists: Rafael Barradas, Joaquín Torres-García, Pedro Figari, José Cúneo and Bernabé Michelena.

URUGUAY—GENERAL—COLLECTIONS

2244. Montevideo (Uruguay). Museo Nacional de Bellas Artes. *Catálogo descriptivo del Museo Nacional de Bellas Artes.* Montevideo, 1966. 483 p.

URUGUAY—GENERAL—PERIODICALS

2245. *Circulo y cuadrado.* no. 1-8/10 (mayo 1936-dic. 1943). Montevideo, Uruguay, 1936-43.

 Published by the Asociación de Arte Constructivo.

2246. *Clima; cuadernos de arte.* v. 1, no. 1-2/3 (julio-oct./dic. 1950)- Montevideo, 1950-

2247. *Escuela del sur.* 1951- Montevideo, Uruguay, 1951-

 Continuation of *Removedor; revista del Taller Torres-García.*

2248. *Ovum.* Montevideo, Uruguay, 19--

2249. *Removedor; revista del Taller Torres-García.* no. 1-27 (enero 1945-dic. 1950). Montevideo, Uruguay, 1945-50.

Irregular; continued by *Escuela del sur.*

URUGUAY—ARCHITECTURE

2250. Giuria, Juan. *La arquitectura en el Uruguay.* Montevideo, Uruguay, 1955-58. 2 v.

Volume 1: Epoca colonial, 181 p.; volume 2: En Montevideo de 1830-1900, 91 p.

2251. Payssé, Mario. *Donde estamos en arquitectura?* Montevideo, Uruguay: Facultad de Arquitectura, Sociedad de Arquitectos, 1968. 307 p.

Partial text in English and French.

URUGUAY—GRAPHIC ARTS

2252. Banco de la República Oriental del Uruguay (Montevideo, Uruguay). *Exposición Premio Blanés; grabado y dibujo, IV, 1964.* Montevideo, 1964. unpaged.

2253. Exposición Nacional de las Artes Gráficas (1st : 1945 : Montevideo, Uruguay). *Exposición Nacional de las Artes Gráficas, 1945-* . Montevideo: Asociación de Impresores y Anexos, 1945- .

2254. Havana (Cuba). Casa de las Américas. Biblioteca José A. Echeverría. *Muestra del libro y el grabado uruguayos; [exposición desde junio 20 de 1979].* Havana, 1979.

2255. Salón Nacional de Dibujo y Grabado (1st : 1937? : Montevideo, Uruguay). *Salón Nacional de Dibujo y Grabado, 1937?-* . Montevideo, 1937?- .

2256. Uruguay. Comisión Nacional de Bellas Artes. *Exposición de grabados del siglo XIX de la Colección Rosenwald.* Montevideo, 1945.

URUGUAY—PAINTING

2257. Amsterdam (Netherlands). Stedelijk Museum. *Jonge schilders uit Uruguay; Stedelijk Museum, Amsterdam, 21 dec. 1956-21 jan. 1957.* Amsterdam, 1956? 22 p.

> Also exhibited at the Gemeente Museum, The Hague, Netherlands, February 1957.

2258. Argul, José Pedro. *Exposición de pintura; proceso pictórico del Uruguay.* Buenos Aires, Argentina: Argos, 1952. 142 p.

2259. Banco de la República Oriental del Uruguay (Montevideo, Uruguay). *Exposición Premio Blanés; pintura, I, agosto 1961.* Montevideo, 1961. unpaged.

2260. Carbajal, Juan Pedro. *Trece pintores uruguayos.* Montevideo, Uruguay: Imagenes, 1980.

2261. García Esteban, Fernando. *Algunos lineamientos característicos del desarrollo de la pintura uruguaya.* Montevideo, Uruguay: n.d. 48 p.

2262. García Esteban, Fernando. *Panorama de la pintura uruguaya contemporánea.* Montevideo, Uruguay: Editorial Alfa, 1965. 189 p.

2263. Heine, Ernesto. *11 pintores uruguayos.* Montevideo, Uruguay: A. Monteverde, 1964. 83 p.

2264. Laroche, Walter E. *Algunos pintores italianos en el Uruguay.* Montevideo, Uruguay: Instituto Italiano de Cultura, 1965. 36 p.

2265. Laroche, Walter E. *Pintores italianos del siglo XIX; su permanencia y su obra en el Uruguay.* Montevideo, Uruguay: Instituto Italiano de Cultura, 1963. 29 p.

2266. Montevideo (Uruguay). Concejo Departamental. *Pintores del Uruguay; generaciones jovenes del pasado, catálogo.* Montevideo, 1957. 40 p.

2267. Montevideo (Uruguay). Museo Nacional de Bellas Artes. *18 pintores nacionales; cien años de la pintura en el Uruguay, 1830-1930; {exposición, agosto 1960}.* Montevideo, 1960. 48 p.

2268. Punta del Este (Uruguay). *26 artistas uruguayos contemporáneos; exposición, enero y febrero 1962.* Montevideo: Comisión Nacional de Bellas Artes, 1962. unpaged.

2269. Salón de Pintura Moderna (1st : 1964? : Montevideo, Uruguay). *Salón de Pintura Moderna, 1964?-* Montevideo: Instituto General Electric, 1964?-

URUGUAY—SCULPTURE

2270. Instituto General Electric (Montevideo, Uruguay). *Primer jardín de escultura actual al aire libre.* Montevideo, 1946? 28 p.

Text in Spanish, English and French.

2271. Laroche, Walter E. *Apuntes para una historia de la estatuaria en el Uruguay; extractado de derrotero para una historia del arte en el Uruguay.* Montevideo, Uruguay: Museo y Archivo Ernesto Laroche, 1960. 64 p.

Venezuela

VENEZUELA—GENERAL

2272. Acevedo Mijares, José F. *Historia del arte en Venezuela*. Caracas, Venezuela: Ediciones TEC, 1951.

2273. Antillano, Sergio, and Figueroa Brett, Hugo. *Artistas del Zulia*. Maracaibo, Venezuela: Edilago, 1977. 252 p.

Dictionary of Zulian artists, p. 155-252.

2274. Antillano, Sergio. *Los Salones de arte*. Caracas, Venezuela: Maraven, 1976. 184 p.

2275. *Arte de Venezuela*. Caracas, Venezuela: Consejo Municipal del Distrito Federal, 1977. 160 p.

Text by Alfredo Boulton, Juan Calzadilla, Carlos Contramaestre, Clara Diament de Sujo, Carlos F. Duarte...{et al.}.

2276. Artists Market Association Gallery (London, England). *An exhibition of Venezuelan art; 5 July to 29 July, 1978*. London, 1978. 32 p.

2277. Banco Central de Venezuela (Carcas, Venezuela). *Aspectos históricos y culturales*. Caracas, 1970. 99 p.

2278. Bienal Nacional de Artes Visuales (1st : 1981 : Caracas, Venezuela). *Doce maestros: {exposición, 12 de julio a 16 de agosto, 1981}*. Caracas: Galería de Arte Nacional, 1981. {12} p.

2279. Bogotá (Colombia). Biblioteca Luis Angel Arango. *Pintura y grabado hoy en Venezuela: {exposición}, noviembre 1968*. Bogotá, 1968.

2280. Calzadilla, Juan. *El abstracionismo en Venezuela*. Caracas, Venezuela: Vargas, 1961. 32 p.

Offprint of the magazine Crónica de Caracas, v. 11, no. 44 {April-June 1960}.

2281. Calzadilla, Juan. *El arte en Venezuela*. Caracas, Venezuela: Círculo Musical, 1976. 239 p.

2282. Calzadilla, Juan. *El artista en su taller*. Caracas, Venezuela: Compañía Anónima Nacional Teléfonos de Venezuela, 1977. 216 p.

2283. Calzadilla, Juan. *Movimientos y vanguardia en el arte contemporáneo en Venezuela*. Caracas, Venezuela? Comisión de Educación y Cultura del Consejo Municipal del Distrito Sucre del Estado Miranda, 1978. 159 p.

2284. Calzadilla, Juan. *Obras singulares del arte en Venezuela*. Bilbao, Spain: Editorial La Gran Enciclopedia Vasca; Caracas, Venezuela: Euzko Americana de Ediciones, c1979. 81, 449 p.

2285. Calzadilla, Juan. *El ojo que pasa (crónicas sobre la actividad artística)*. Caracas, Venezuela: Monte Avila Editories, 1969. 189 p.

2286. Caracas (Venezuela). Ateneo. *Confrontación, 68; Alvarez, Mérida, Morera, Nedo, Regulo: {exposición}, julio-agosto 1968*. Caracas, 1968. 60 p.

2287. Caracas (Venezuela). Consejo Nacional de la Cultura. *Las artes plásticas en Venezuela, 1978; {exposición anual}*. Caracas, 1976. 72 p.

2288. Caracas (Venezuela). Galería de Arte Nacional. *Arte constructivo venezolano, 1945-1965; genesis y desarrollo; {exposición}, diciembre 2, 1979, a febrero 3, 1980*. Caracas, 1979. 79 p.

 Bibliography: p. 78-79.

2289. Caracas (Venezuela). Galería de Arte Nacional. *Indagación de la imagen, (la figura, el ámbito, el objeto), Venezuela, 1680-1980; exposición temática, segunda parte, Caracas, marzo 1981*. Caracas, 1981. 32 p.

2290. Caracas (Venezuela). Galería de Arte Nacional. *Pro-posición 20: exposición colectiva, Caracas, septiembre-noviembre, 1981*. Caracas: Consejo Nacional de la Cultura, Galería de Arte Nacional, {1981}. 31 p.

 Bibliography: p. 26-31.

2291. Caracas (Venezuela). Museo de Arte Contemporáneo. *Creadores al margen: {exposición}, julio 1977*. Caracas, 1977. 54 p.

2292. Caracas (Venezuela). Museo de Arte Contemporáneo. *Nueve artistas venezolanos; Domingo Alvarez, Jacobo Borges, Carlos Cruz Diez, Mateo Manaure, Marisol, Francisco Narváez, Alirio Rodríguez, Francisco Salazar Martínez, Jesús Soto; {exposición, julio 1974}.* Caracas, 1974. 41 p.

Text in Spanish, French and English.

2293. Caracas (Venezuela). Museo de Bellas Artes. *Aire; {exposición, noviembre 1970}.* Caracas, 1970. 30 p.

2294. Caracas (Venezuela). Museo de Bellas Artes. *Las artes plásticas en Venezuela, 1a exposición, 19 de marzo-16 de abril 1972.* Caracas, 1972. 46 p.

2295. Caracas (Venezuela). Museo de Bellas Artes. *Presencia 70; primera exposición colectiva, 17 al 31 de mayo 1970.* Caracas, 1970. 14 p.

2296. Caracas (Venezuela). Museo de Bellas Artes. *Presencia: Cruxent, Dávila, Guevara, Jaimess, Regulo, Vigas, Hurtado; {exposición}, mayo 1971.* Caracas, 1971. 12 p.

2297. Caracas (Venezuela). Museo de Bellas Artes. *Veinte años del Salón a través de sus premios; {exposición}, inauguración, domingo 19 de julio 1959.* Caracas, 1959. 26 p.

2298. Caracas (Venezuela). Universidad Simón Bolívar. *Artistas venezolanos de hoy, 1971; {exposición, junio 1971}.* Caracas, 1971. 24 p.

2299. Diament de Sujo, Clara. *Venezuela.* Washington, D.C.: Pan American Union, 1962. 77 p.

English translation by William McLeod Rivera and Ralph E. Dimmick.

2300. Estudio Actual (Caracas, Venezuela). *Joven actualidad venezolana, 2; {exposición}, agosto '71.* Caracas, 1971. 32 p.

2301. Fundación Eugenio Mendoza (Caracas, Venezuela). *Muchos tipos en once tipos; {exposición}, agosto 19, 1979.* Caracas, 1979. 22 p.

Eleven young Venezuelan artists.

2302. Fundación Eugenio Mendoza (Caracas, Venezuela). Sala de Exposiciones. *I Premio Ernesto Avellán; {exposición, 28 de octubre-18 de noviembre 1973}.* Caracas, 1973. 24 p.

2303. Fundación Eugenio Mendoza (Caracas, Venezuela). Sala de Exposiciones. *II Premio Ernesto Avellán; {exposición}.* Caracas, 1974? 28 p.

2304. Guervara, Roberto. *Arte para una nueva escala.* Caracas, Venezuela: Maraven, 1978. 159 p.

2305. Le Havre (France). Musée Maison de la Culture. *Venezuela; du paysage a l'expression plastique; 10 artistes contemporains; {exposition}, 18 mai-15 juin 1963.* Le Harve, 1963. 98 p.

2306. Nucete-Sardi, José. *Notas sobre la pintura y la escultura en Venezuela.* Caracas, Venezuela: Cooperative de Artes Gráficas, 1940. 62 p.

 Bibliography: p. 62; 2nd edition, Caracas, Venezuela: Avila Gráfica, 1950, 111 p.; 3rd edition, Caracas, Venezuela: Ediciones González y González, 1957, 145 p.

2307. Salón de las Artes Plásticas en Venezuela (3rd : 1974 : Caracas, Venezuela). *3 Salón de las Artes Plásticas en Venezuela, Caracas; {exposición}, noviembre 1974.* Caracas, 1974. 34 p.

2308. Salón Oficial Anual de Arte Venezolano (1st : 1940 : Caracas, Venezuela). *Salón Oficial Anual de Arte Venezolano: artistas nacionales y extranjeros residentes en el país, 1940-* Caracas: Museo Nacional de Bellas Artes, 1940-

2309. Tabacalera Nacional (Valencia, Venezuela). *Las obras de arte del Salón Arturo Michelena, 1943-1976.* Valencia: Edición Compañía de Acciones Tabacalera Nacional, 1977. 136 p.

 Exhibition held at the Ateneo de Valencia, Venezuela.

2310. Villanueva, Carlos Raúl. *La integración de las artes.* Caracas, Venezuela: Universidad Central, 1957. 12 p.

2311. Traba, Marta. *Mirar en Caracas; crítica de arte.* Caracas, Venezuela: Monte Avila Editores, c1974. 133 p.

VENEZUELA—GENERAL—COLLECTIONS

2312. Caracas (Venezuela). Galería de Arte Nacional. *Galería de Arte Nacional; un destino para el arte venezolano.* Caracas, c1978. 39 p.

 Descriptive booklet.

2313. Caracas (Venezuela). Galería de Arte Nacional. *1976/1981, cinco años de la Galería de Arte Nacional.* Caracas, 1981. 31 p

2314. Caracas (Venezuela). Museo de Arte Colonial. *Guidebook to the Museum of Colonial Art.* Caracas: Friends of Venezuelan Colonial Art Association, n.d. 16 p.

2315. Caracas (Venezuela). Museo de Arte Contemporáneo. *Breve resumen sobre las exposiciones y actividades del Museo durante los últimos 4 años, {1977-1981}.* Caracas, {1981}. {24} leaves.

2316. Caracas (Venezuela). Museo de Arte Contemporáneo. *3 años de actividades, Museo de Arte Contemporáneo, 1974-1977.* Caracas, 1977. 56 p.

2317. Caracas (Venezuela). Museo de Bellas Artes. *Adquisiciones y donaciones, 1970-71.* Caracas, 1971? 20 p.

2318. Caracas (Venezuela). Museo de Bellas Artes. *Adquisiciones y donaciones: exposición, 12 de mayo 1963.* Caracas, 1963. unpaged.

2319. Caracas (Venezuela). Museo de Bellas Artes. *Catálogo del Museo de Bellas Artes.* Caracas, 1958. 85 p.

2320. Caracas (Venezuela). Museo de Bellas Artes. *El Museo de Bellas Artes de Caracas y algunas de sus obras.* Caracas: Cromotip, 1975.

Text by Miguel G. Arroyo C.

2321. Caracas (Venezuela). Museo de Bellas Artes. *Obras cubistas y 'collages', II; colección Pedro Vallenilla Echeverría, Caracas, 1959.* Caracas, 1970. 56 p.

2322. Caracas (Venezuela). Museo de Bellas Artes. *20 obras de la Colección Hans Neumann, Caracas, octubre de 1960.* Caracas, 1960. 44 p.

2323. Caracas (Venezuela). Museo de Bellas Artes. *20 obras de la Colección Pedro Vallenilla Echeverría; primera exposición de un ciclo dedicado a las colecciones privadas en Venezuela, junio de 1959.* Caracas, 1959. 18 p.

2324. Granados Valdés, A. *Obras de arte de la Ciudad Universitaria de Caracas; guía.* Caracas, Venezuela: Comisión de Conservación de las Obras de Arte de la Ciudad Universitaria, 1974. 95 p.

VENEZUELA—GENERAL—COLLECTIONS

2325. La Guaira (Venezuela). Museo Fundación John Boulton. *Catálogo.* La Guaira, 1970. 43 p.

Catalog of the Museum's collection when it opened Oct. 28, 1970.

VENEZUELA—GENERAL—DICTIONARIES, ETC.

2326. Caracas (Venezuela). Instituto Nacional de Cultura y Bellas Artes. *Diccionario biográfico de las artes plásticas en Venezuela; siglos XIX y XX.* Caracas: Ernesto Armitano Editor, 1973. 300 p.

VENEZUELA—GENERAL—PERIODICALS

2327. *Arte e investigación.* 1977- . Caracas, Venezuela, 1977- .

2328. *Arte quincenal.* 197?- . Caracas, Venezuela, 197?- .

2329. *Artes plásticas en Venezuela.* 197?- . Caracas, Venezuela: Fundación John Boulton, 197?- .

2330. *Buzón.* v. 1, no. 1 (Jan. 1976)- . Caracas, Venezuela, 1976- .
Mail art magazine.

2331. *CAL; crítica, arte, literatura.* 196?- . Caracas, Venezuela, 196?- .

2332. *Imagen; quincenario de arte, literatura e información cultural.* no. 1-97 (May 15-30, 1967-May 1971); new series, no. (June 18, 1971)- . Caracas, Venezuela: Instituto Nacional de Cultura y Bellas Artes, 1967- .

2333. *Integral; arquitectura, urbanismo, ingeniería, artes plásticas, cine, folklore.* no. 1 (Sept. 1955)- . Caracas, Venezuela: Sociedad Venezolana de Arquitectos, 1955- .

2334. *Visual; Museo de Bellas Artes.* no. 1 (1957)- . Caracas, Venezuela: Museo de Bellas Artes, 1957- .

2335. Estudio Actual (Caracas, Venezuela). *Pinturas y esculturas venezolanas clásicas y contemporáneas; exhibición, 1-10 1979; subasta, 12 junio 1979.* Caracas, 1979. 64 p.

> Auction held in collaboration with Sotheby Park Bernet, New York, N.Y.

VENEZUELA—ARCHITECTURE

2336. Gasparini, Graziano. *La arquitectura colonial en Venezuela.* Caracas, Venezuela: Armitano, 1965. 379 p.

> Photographs by the author.

2337. Gasparini, Graziano, and Posani, Juan Pedro. *Caracas a través de su arquitectura.* Caracas, Venezuela: Fundación Fina Gómez, 1969. 573 p.

> Part 1; 1567-1899; part 2; 1900-1967.

2338. Villanueva, Carlos Raúl. *Escritos.* Caracas, Venezuela: Universidad Central de Venezuela, Facultad de Arquitectura y Urbanismo, División de Extensión Cultural, 1965. 53 p.

VENEZUELA—DESIGN

2339. Caracas (Venezuela). Museo de Bellas Artes. Departamento de Dibujo, Artes Gráficas y Diseño Gráfico. *El Museo y el diseño, 1959-1970.* Caracas, 1970. {68} p.

> Exhibition catalog?

VENEZUELA—GRAPHIC ARTS

2340. Caracas (Venezuela). Galería de Arte Nacional. *Manos de siempre, signos de hoy; exposición itinerante del dibujo actual de Venezuela; 1979-1982.* Caracas, 1979? 16 p.

2341. Caracas (Venezuela). Galería de Arte Nacional. *La nueva estampilla venezolana; diseños de Gerd Leufert, Nedo, Santiago Pol, Alvaro Sotillo; 2 de abril al 7 de mayo de 1978.* Caracas, 1978. 20 p.

2342. Caracas (Venezuela). Galería de Arte Nacional. *Senderos en el papel; exposición de fin de curso, primera promoción, del Centro de Enseñanza Gráfica (CEGRA), Caracas, 9 septiembre a 21 de octubre 1979.* Caracas, 1979. 12 p.

2343. Caracas (Venezuela). Museo de Arte Contemporáneo. *La mano, la seda, el color; estampas sobre seda de nueve artistas venezolanos; Carlos Cruz-Diez...{et al.}.* Caracas,
{1978}. {15} p.

Catalog of an exhibition, September 1978.

2344. Caracas (Venezuela). Museo de Bellas Artes. *Gráfica venezolana; aguatina, intaglio, serigrafía, litografía; {exposición, abril-mayo 1979}.* Caracas, 1979. 58 p.

2345. Estudio Actual (Caracas, Venezuela). *Pequeña historia del dibujo en Venezuela; {exposición, 1978?}.* Caracas, 1978? 60 p.

2346. Exposición Nacional de Dibujo y Grabado (1st : 1959 : Caracas, Venezuela). *Exposición Nacional de Dibujo y Grabado, 1959-* Caracas, 1959-

2347. Fundación Eugenio Mendoza (Caracas, Venezuela). *Grabados venezolanos; {exposición}, 18 de julio a 1 de agosto de 1965.* Caracas, 1965. 8 p.

2348. Fundación Neumann (Caracas, Venezuela). *Venezuelan engravers; {exhibition, 1965?}.* Caracas, 1965? 8 p.

2349. *De Hedendaagse graveerkunst in Venezuela; {tentoonstelling, België, 1965...}.* Brussels, Belgium: Belgisch Ministerie van Nationale Opvoeding en Cultur, 1965. 20 p.

2350. Salón Oficial Anual de Arte Venezolano Dibujo y Grabado (1st : 1939? : Caracas, Venezuela). *Salón Oficial Anual de Arte Venezolano Dibujo y Grabado, 1939?-* . Caracas, 1939?-

2351. Acquavella, Galería (Caracas, Venezuela). *Pintores nacionales; {exposición}, marzo 1979.* Caracas, 1979. 30 p.

2352. Aele, Galería (Madrid, Spain). *Ocho artistas venezolanos; {exposición, 18 de febrero al 9 de marzo 1974}.* Madrid, 1974. 22 p.

2353. Arroyo C., Miguel G. *22 pintores venezolanos de hoy.* Caracas, Venezuela: Dirección Cultural del Ministerio de Educación & Fundación Neumann, n.d. 22 plates.

2354. Bienal Armando Reverón (1st : 1961 : Caracas, Venezuela). *Bienal Armando Reverón, 1961- .* Caracas: Museo de Bellas Artes, 1961-

2355. Bienal de São Paulo (8th : 1965 : São Paulo). *Venezuela; VIII Bienal de São Paulo, 1965; Jacobo Borges, Francisco Hung, Gerd Leufert: {exposición}.* Caracas, Venezuela: Instituto Nacional de Cultura y Bellas Artes, 1965. 36 p.

2356. Bogotá (Colombia). Biblioteca Luis Angel Arango. *Pintura contemporánea venezolana; {exposición}, Biblioteca Luis Angel Arango del Banco de la República, Bogotá, junio 18-julio 8, 196?* Bogotá, 196? 32 p.

2357. Boulton, Alfredo. *Compendio de la pintura en Venezuela.* 3a ed. Caracas, Venezuela: Museo de Arte Contemporáneo, 1977. 35 p., plus 140 color transparencies.

 Bibliography.

2358. Boulton, Alfredo. *Historia de la pintura en Venezuela.* Caracas, Venezuela: Editorial Arte, 1964-72. 3 v.

 Volume 1: Epoca colonial, 483 p.; v. 2: Epoca nacional, 416 p.; v. 3: Epoca contemporánea, 309 p.

2359. Boulton, Alfredo. *Los retratos de Bolívar.* 2a ed., aumentada. Caracas, Venezuela: Editorial Arte, 1964. 204 p.

2360. Calzadilla, Juan. *El abstracionismo en Venezuela.* Caracas, Venezuela: Vargas, 1961. 32 p.

 Offprint of the journal *Crónica de Caracas*, April-June 1960.

2361. Calzadilla, Juan. *Pintores venezolanos.* Caracas, Venezuela: Ministerio de Educación, Departamento de Publicaciones, 1963. 197 p.

2362. Calzadilla, Juan. *Pintores venezolanos del común.* Caracas, Venezuela: Compañía Anónima Nacional Teléfonos de Venezuela, 1975. 119 p.

2363. Calzadilla, Juan. *Pintura venezolana de los siglos XIX y XX*. Caracas, Venezuela: Inversiones M. Barquín, 1975. 159 p.

2364. Calzadilla, Juan, and Montero Castro, Roberto. *Visión de la pintura en Venezuela*. Caracas, Venezuela: Edición de la Dirección de Cultura de la Gobernación del Distrito Federal, 1975. 55 p.

2365. Calzadilla, Juan. *Una visión de la pintura venezolana*. Mexico City, Mexico: Librería Madero, n.d. 20 p., 152 plates.

2366. Caracas (Venezuela). Galería de Arte Nacional. *Guaraira-Repano: La Gran Montaña; {exposición, junio 1977}*. Caracas, 1977. 40 p.

2367. Caracas (Venezuela). Museo de Bellas Artes. *Pintura venezolana; 1661-1961; {exposición, 19 de abril de 1960-5 de julio de 1961}*. Caracas, 1960. 102 p.

2368. Caracas (Venezuela). Museo de Bellas Artes. *Tres siglos de pintura venezolana*. Caracas: Ministerio de Educación Nacional, Dirección de Cultura, 1948. 51 p., 106 plates.

 Exhibition catalog.

2369. Caracas (Venezuela). Museo Nacional de Bellas Artes. *Exposición del paisaje venezolano; interpretado por artistas nacionales y extranjeros, antiguos y modernos*. Caracas: Taller de Artes Gráficas, 1942. 31 p.

2370. Conferencia Interamericana (10th : 1954 : Caracas, Venezuela). *La pintura en Venezuela*. Caracas, 1954. 220 p.

 Text by Mariano Picón-Salas.

2371. Erminy, Perán, and Calzadilla, Juan. *El paisaje como tema en la pintura venezolana*. Caracas, Venezuela: Compañía Shell de Venezuela, 1975.

2372. Fundación Neumann (Caracas, Venezuela). *Venezolanische Malerei von Heute; {Ausstellung, Städtisches Kunsthaus Bielefeld, 29. 1. 1965-28. 2. 1965}*. Caracas, 1965? 34 p.

2373. Goslinga, Cornelis Chareles. *Venezuelan painting in the nineteenth century*. Assen, Netherlands: Von Gorcum, 1967. 128 p.

2374. López Méndez, Luis Alfredo. *El Círculo de Bellas Artes*. Caracas, Venezuela: Instituto Nacional de Cultura y Bellas Artes, 1969. 80 p.

2375. Otero, Alejandro. *La pintura abstracta.* Caracas, Venezuela: Universidad Central, 1957. 15 p., 8 plates.

2376. *Pequeña enciclopedia de pintura venezolana.* no. 1, 1967- .
Caracas, Venezuela: Moranduzzo S.R.L., 1967- .

Pamphlet series devoted to individual Venezuelan painters.

2377. Picón-Salas, Mariano. *La pintura en Venezuela.* Caracas, Venezuela, 1954. 85 p.

2378. Pineda, Rafael. *Retrato hablado de Venezuela.* Caracas, Venezuela: Lagoven, 1980. 2 v. (149, 179 p.).

2379. *Pintores venezolanos.* no. 1, 1967- . Madrid, Spain: Edime, 1967- .

A series of pamphlets on individual Venezuelan painters.

2380. Planchart, Enrique. *La pintura en Venezuela.* Buenos Aires, Argentina: López, 1956. 292 p.

Second edition: Caracas, Venezuela: Squinoccio, c1979, 292 p.

2381. Rodríguez, Bélgica. *La pintura abstracta en Venezuela, 1945-1965.* Caracas, Venezuela: Maraven, 1980. 293 p.

Bibliography: p. 292-293; prologue by Juan Calzadilla.

2382. *Visión de la pintura en Venezuela.* Caracas, Venezuela: Dirección de Cultura de la Govbernación del Distrito Federal, 1975.

VENEZUELA—PAINTING—COLLECTIONS

2383. Caracas (Venezuela). Museo Boggio. *Pintores en la colección del Palacio Municipal = Painters in the Municipal Palace Collection.* Caracas, 1974. 72 p.

Cuadernos de Arte del Museo Boggio, no. 1.

2384. Caracas (Venezuela). Museo de Bellas Artes. *Exposición de pintura venezolana de la colección del Museo de Bellas Artes, febrero 13 de 1959.* Caracas, 1959. 12 p.

VENEZUELA—PAINTING—COLLECTIONS

2385. Caracas (Venezuela). Museo de Bellas Artes. *DMOS: Donación Miguel Otero Silva, obras de la colección de pintores venezolanos destinadas al Museo de Bellas Artes de Caracas y al Museo Regional de Barcelona (Edo. Ahzoátegui), {1965}.* Caracas, 1965. 48 p.

VENEZUELA—PAINTING—DICTIONARIES, ETC.

2386. *Anuario de la pintura venezolano, 1975-* Caracas, 1975-

Text by Teresa Piñana Vives. Summation of the years artistic activity in Venezuela.

VENEZUELA—PHOTOGRAPHY

2387. Caracas (Venezuela). Galería de Arte Nacional. *Cien años de fotografía en el Estado Bolívar, 1979-80; {exposición}.* Caracas, 1979? 88 p.

2388. Caracas (Venezuela). Galería de Arte Nacional. *Fotografía anónima de Venezuela.* Caracas: Consejo Nacional de Cultura, Galería de Arte Nacional, 1979. 56 p.

Text by Claudio Perna; catalog of an exhibition, July 15-Sept. 9, 1979.

2389. Dorronsoro, Josune. *Significación historia de la fotografía.* Caracas, Venezuela: Equinoccio, Editorial de la Universidad Simón Bolívar, 1980. 140 p.

2390. Venezuela. Biblioteca Nacional (Caracas). *Origenes de la fotografía en Venezuela.* Caracas, 1978.

VENEZUELA—SCULPTURE

2391. Briceño, Pedro. *La escultura en Venezuela.* Caracas, Venezuela: Instituto Nacional de Cultura y Bellas Artes, 1969. 55 p., 24 plates.

2392. Briceño, Pedro, and Calzadilla, Juan. *Escultura-escultores.* Caracas, Venezuela: Maraven, 1977. 233 p.

2393. La Victoria (Venezuela). Cuartel Mariano Montilla. *Once escultores; {exposición, 2/5/80-2/14/80}.* La Victoria, 1980. 28 p.

2394. Rodríguez, Bélgica. *Breve historia de la escultura contemporánea en Venezuela.* Caracas, Venezuela: Fundarte, 1979. 75 p.

Bibliography: p. 75.

Index

The numbers below refer to entry numbers, not page numbers.

About the Compiler

JAMES A FINDLAY is Director of the Library, Rhode Island School of Design, Providence. His previous publications include a bibliography for the catalog for "!Orozco! 1883-1949," an exhibition held at the Museum of Modern Art, Oxford, England; and another bibliography in *José Clemente Orozco 1883-1949*, a catalog of an exhibition held at the Orangerie Schoss Charlottenburg, Berlin, Germany.